EYEWITNESS

ALSO BY JED PERL

Paris Without End

Gallery Going

EYEWITNESS

REPORTS FROM

AN ART WORLD IN CRISIS

JED PERL

BASIC BOOKS

A NEW REPUBLIC BOOK

A MEMBER OF THE PERSEUS BOOKS GROUP

Published by Basic Books,
A Member of the Perseus Books Group

Most of the material in this book originally appeared, in somewhat different form, in *The New Republic*. "A Pageant" was first published in *Modern Painters*.

Library of Congress Cataloging-in-Publication Data

Perl, Jed.
 Eyewitness : reports from an art world in crisis / Jed Perl.
 p. cm.
 "A New Republic book."
 Includes index.
 ISBN 0-465-05520-6
 1. Art, Modern—20th century. 2. Art. I. Title.
 N6490 .P389 2000
 701'.18—dc21
 99-049794

Book design by Victoria Kuskowski

00 01 02 03 / 10 9 8 7 6 5 4 3 2 1

CONTENTS

Contents

EYEWITNESS

ARTISTS AND AUDIENCES

The Entertainment Industry

About a decade ago, when Cindy Sherman started showing her big Cibachrome self-portraits and it seemed as if every hot artist in New York was into photographic imagery, an editor from a general interest weekly magazine called me to ask if I'd be interested in doing a story about Sherman. Actually, the piece he had in mind would look at much more than Cindy Sherman. This editor wanted a writer to survey the whole phenomenon of artists who appropriate photography; Sherrie Levine had been rephotographing classic images for a couple of years, and Doug and Mike Starn were beginning to cause a stir with their collages made of stained and ripped photographs. The editor knew that I didn't have any patience for Sherman's work. In fact, he was interested in me in part because I'd already written a thumbs-down piece. My opinions, he assured me, weren't a problem; I could say anything I wanted in the article. He wasn't interested in whether the work was good or bad. He was interested in all the excitement that Cindy Sherman and these other artists were generating.

In the week or so between his call and the lunch date that we arranged, I found myself regarding the project with increasing trepidation. I didn't think I could do the piece, and when we got together I explained why. I disliked Sherman's work passionately; but my decision was based on something more than my reaction to the work. My feeling was that Sherman's notoriety was basically a public relations gambit, and I didn't want to become a part of the PR. At that point my lunch companion began to act rather uneasy. He had meant the assignment as an opportunity for me, and he found my qualms more than a little bizarre. The more we talked, the

more hostile he became. He accused me of careerism; and an odd kind of reverse careerism it was that would have me turning down what was clearly a major assignment. He was so upset that he suggested that I pay for my half of our meal.

Things calmed down a little by the time we got to the espresso. He asked if there was another story that I wanted to do. There was. I suggested that in fact there is a whole other art world out there—what a lot of us have come to call, shorthand style, the real art world. There are artists who are working consistently, evolving in boom times and in bust times, and I proposed that they deserve a hell of a lot more attention than they receive. I explained that I didn't want to add fuel to the Sherman boom precisely because booms like this one are sucking life and energy out of the other art world. Art stars like Sherman—and David Salle and Julian Schnabel—have distorted the art scene. Their exhibitions don't give public expression to private feelings so much as they offer canny responses to market pressures. The mass appeal of an artist like Schnabel has everything to do with his indifference to what ought to be an artist's most urgent concern, which is the internal logic of a work of art. As for the artists who do care about what goes on inside art, they are being left with fewer and fewer outlets for their work. By now the serious artists are desperate; they're gasping for air.

As it happened, I was able to name at least one member of this other, private art world that the editor knew. "Oh her," he said. "Is she important?" I told him that to many people she is one of the best sculptors alive, but he seemed nonplussed by the thought, and also by my idea for an alternative story. He'd called me up to commission an article about an art star, not to find out that there is a completely different, unglamorous, half-buried scene out there.

You don't have to know anything about art to know that the art world is surefire cultural entertainment, and that was the one thing this editor

knew for sure. A bit of Sherman bashing would be okay; a little outrageous-
ness on the part of artists and critics alike helps to give the art world its ap-
peal. People like to hear that the art stars are overinflated. That's part of the
titillation. But when you tell an editor that something more is at stake, that
the hype around the public art world may actually hurt somebody, that is
too much. Nobody wants to believe that the art stars are destroying the vi-
sual arts. If that's the case, things could begin to get depressing. You might
even end up feeling guilty for having treated the art world as a playground,
as little more than high-end media gossip. But of course the editor found
somebody who would do the job he wanted done. A couple of months later,
I opened up that magazine and there was Cindy Sherman, larger than life.

What Is Art?

Taken at face value, that lunch date, though a less than perfectly amiable
encounter, wasn't really worth worrying about. But I think something fun-
damental was at stake. The editor I was talking with is a serious fellow, and
he obviously felt that by looking at some much-talked-about new art, and
how it's being promoted and discussed, and who's selling and who's buying,
we could learn something not only about the work of these photo artists
but also about ourselves. I can appreciate this line of thinking, but only up
to a point. People have always been fascinated by the relationship between
the context in which art is experienced and the content of art itself. Why
shouldn't they be? But when an editor tells a critic that it doesn't really mat-
ter if you like the work or not, just so long as you report on what everybody
is saying about it, my alarm bells start going off. We are at a point where con-
text is in danger of swamping content.

The assumptions I brought to that lunch date are the same ones I bring
to a gallery or a museum show. I believe that a work of art must have a free-

standing value. Formal values are one element in the equation; I take it for granted that a work we experience visually must be visually resolved. But the artist who gives this work its value is pulling together all kinds of experiences. Narrative may be as important as color; the startling character of the imagery may be what fuels the vigor of the line. What counts is that whatever the artist is thinking or feeling is absorbed into the look, the character, the intricacies of the work. The painting, the sculpture, the collage, the assemblage makes its own terms, and we judge what we see.

Now I'm sure that that editor believes in the freestanding value of a work of art. But I'm also fairly certain that he believes that such value is colored, mutated, *re*valued by the context in which we see the work. A painting or sculpture that he might agree is not especially engaging gains interest—which for him may be equivalent to value—because there's a lot of buzz around it, because it's expensive, or because it's being promoted by the right collector, dealer, curator, or critic. Of course people have always been interested in some version of what we now think of as market forces and fashion shifts, but never before have so many intelligent people been so willing to believe that art is at the mercy of life, that art is less a thing unto itself than a habit of mind, a sort of accent or highlight that can adhere to anything. And so we are urged to regard fashion as art, career as art, money as art.

The ever-deepening divide between what I think of as the public and private art worlds is less the product of market forces than the result of this fundamental disagreement about the nature of art. The freestanding value of art is essentially an insider's idea, born of the experience of the studio, where emotions, sensibilities, and experiences are given a form that can carry meaning. That the whole world should revere the stand-alone magic of such works—of a Rembrandt self-portrait, for example, or of Mondrian's *Broadway Boogie Woogie*—does not make this any less a private ideal. The world goes to

the Rembrandt or the Mondrian for the explosively, expansively private experiences that they afford. Or so I believe. The contextualists see it differently. For them, Rembrandt's self-portraits are mostly of interest as reflections of a seventeenth-century idea of the individual; they're about marketing individualism. And Mondrian's *Broadway Boogie Woogie* is a sort of seismographic record of twentieth-century atomization and alienation. Art, in short, does not so much shape the world as it is shaped by the world. Paintings and sculptures are tokens and artifacts; they're regarded as the sloughed-off shells of cultural or social experiences. This view may originate in a nineteenth-century reaction against the bourgeois sentimentalization of art. But what began as an anticapitalist critique has turned out to be a marketer's dream. The Marxist who says that no artist's imagination is free has provided a comfortable context for the corporate executive who wants to fund only the museum retrospective of the artist whose work has the widest appeal.

Of course I'm drawing the lines a little more clearly than they are generally drawn in life. Many people who concern themselves with the visual arts know that a painting or sculpture ought to stand alone; they are contextualists only to a certain degree. But the drift of current thinking is invariably in the contextualist direction, and contemporary artists who don't tilt that way are bound to have a hard time. Take the painter Joan Snyder, whose wonderfully extravagant presentations of high-flying emotions ought to give her work a wide appeal. In large, panoramic paintings such as *A Sad Story Told by an Optimist*, Snyder gives almost operatic colorings to themes of death and hope; she does this kind of thing more convincingly than any other artist of our day. Yet Snyder, who was born in 1940, has not yet had a significant New York museum show, a fact that I believe is linked to the emphatically private, freestanding nature of the work she does. Her paintings don't appeal to the contextualists, and they pretty much control the upper echelons of the art establishment.

Cindy Sherman, by contrast, is a phenomenal success precisely because her work is all about the cultural context. In her early *Untitled Film Stills,* Sherman managed to give these contextualist themes some visual musicality. I don't think that the *Untitled Film Stills* are a galvanic achievement, but Sherman's small-sized self-portraits, in which she enacts dozens of movie and TV scenarios, offer such delicate variations on cinematic conventions that the camp sensibility achieves a certain detached, dream-like unity. In the work that Sherman has done since the *Film Stills,* however—and this includes everything from her stagey impersonations of figures in Old Master portraits to a recent series focusing on battered GI Joe and Ken dolls—the dramatics are little more than talking points and polemical flourishes. Sherman's costumes and disguises are custom-made for the contextualists; her mutating imagery is just right for an audience that believes that art has no substance, no essence.

Sherman's defenders will argue that her house-of-mirrors images are part of a long tradition, and there is no denying that the assault on the stand-alone integrity of art has come from within art itself and has been aimed with a deathly precision that only insiders could muster. As early as the 1880s, a group of Parisian artists who called themselves the Incohérents highlighted the preposterousness of official art by creating what amounted to the first anti-art. The Incohérents turned artistic conventions into howling absurdities when they carried lyric elusiveness into mind-numbing emptiness and twisted expressive dramas into cartoonish confusions. There is certainly some intellectual allure to the games that the Incohérents played. And no one can deny that Marcel Duchamp's steel-trap enigmas have had a vast appeal. Yet when a skepticism about the essential value of art is built into art, we are in for bad times.

Whether you call this approach Dadaist, contextualist, situationist, or some other name, the assumption is that art is born, lives, and dies in the public sphere. Such an art can have no freestanding value; the very idea of

value is regarded as a social construct. It's difficult to defend art against this contextualist assault, especially if we are honest enough to admit that although art has a freestanding value it stands in different places at different times. Once we have acknowledged that art is always on the move, the contextualists will say that we have given away the game. But to argue that a stained-glass window in Chartres Cathedral or a painting of lovers in a park by Watteau achieves its stand-alone authority in relation to a particular time and place is not to deny that each work has a life of its own. And for those of us who still crave the thrilling experiences that only art can offer, understanding exactly where the contextualist assault came from may be far less important than figuring out where we go from here. I know that there are still plenty of artists and gallerygoers and museumgoers who want that stand-alone experience. But in a world where the art market seems to have more intellectual cachet than art itself, there may be nothing more difficult than finding a way for artists and audiences to come together and actually, simply, look at art.

Hidden Achievements

The glamour factor in the art world is nothing new. Art chat has been keeping people amused, annoyed, seduced, irate for a very long time. In America, the modern publicity mills began to crank up with the Armory Show of 1913, but they only really got going in 1949, when *Life* magazine gave its readers a good laugh by suggesting that Jackson Pollock, a moody Greenwich Village legend who liked to drip paint, just might be the greatest artist alive. Once the public had wondered at and howled over Pollock, the pattern was set and people were screaming for more. Pop Art was hog heaven, and everybody hopped on the art merry-go-round. If you couldn't afford a Jasper Johns *Flag*, at least you could afford the American flag canisters that

were sold at hip shops like Azuma. By the 1980s it was taken for granted that Wall Street money fueled the carnival, and everybody was talking about the waiting list to buy paintings at the Mary Boone Gallery and about the size of the latest art star's loft in SoHo.

Looking back on all of this, there are those who will say that my talk with that magazine editor was just business as usual. The media, after all, have their share of fairly sophisticated status quo types, and if you begin to say that the hype has gone out of control, they'll probably tell you that it was just as bad back in the nineteenth century, when Baudelaire and Daumier were complaining about the philistines at the Salons. But of course knowing that things were bad once upon a time does not mean that they are necessarily okay today. In any event, things are *not* all bad. Far from it. In the galleries there is good work to be seen. In the studios of New York— and, for all I know, across the country—artists in their 30s and 40s and 50s and 60s are making the incremental developments and the leaps that take art to a new place. But even as the headlines have shifted from Julian Schnabel's plate smashings to Jesse Helms's NEA bashings—and now, in the late '90s, to the architects who design the museums where all the overscaled art of the past quarter century is going on permanent display—the most important story in the art world remains untold.

The support system of galleries, grants, collectors, curators, and publications that makes it possible for artists to have slow-developing, serious careers is in a state of near total collapse. Most of the people who believe in the free-standing value of art have been silenced—if not swept away. This is what you hear if you talk to the artists. Living in the midst of an overinflated art world, an art world where context is all, painters and sculptors no longer know where to turn. Fewer and fewer shows get reviewed because the work has some inherent quality; fewer and fewer galleries are willing to make the commitment to an artist's gradual development. The art world, to the extent that

it supports a vital evolutionary process, is on the verge of extinction. The artists—let me emphasize—are still at work. But they are in despair, and their despair is turning into a masochistic malaise that threatens them from within, even as career options disappear. What follows is a description of an art scene in crisis. Some of the names I am going to mention will be unfamiliar, but the unfamiliarity of this story is a part—a big part—of its significance.

Who exactly are these artists who are not receiving the support that they need and deserve? I could name many, each a different case, each unable to receive a proper hearing. To begin, I want to point briefly to two: Barbara Goodstein and Stanley Lewis. Both are in their 50s, both have shown at small cooperative galleries in New York City for years. Goodstein is probably the most original sculptor of her generation. The landscapes in her show at the Bowery Gallery in the spring of 1999 announced a new pastoral mode, a pastoral in which serenity seems to be wrenched from the jangling upheavals of modern life. As for Lewis, some of the landscape paintings and drawings that he has produced in the past quarter century are as beautiful as any that have been created anywhere in the world during this period. And the large, densely worked drawings of studio interiors that he exhibited in 1995 are among the most eloquent impressions of the space where an artist creates that I have ever seen. Goodstein and Lewis come out of an underground art world where tradition and innovation are still believed to be reconcilable. New Yorkers may pay lip service to this viewpoint, but if you're looking for a clever career move, you'd be advised to look elsewhere, which basically means you'd be advised to join forces with the contextualists.

Goodstein's sculpture is in low relief, and her technique is absolutely her own. She works in plaster on plywood boards, building up this wonderfully fluid material into forms that are a sculptor's reconsideration of the traditions of painterly painting. Her subjects are the figure and the landscape, but every-

thing in her works is simplified, reduced, so that what meets the eye is a sequence of iconic, telegraphic signs. A panoramic landscape is transformed into a couple of undulating arabesques. A house next to a tree is evoked with the deliberate brevity of Chinese calligraphy. Some of Goodstein's finest figure pieces are variations on classical themes—the *Three Graces*, the *Pietà*—and here she seems to feel the pressure of the whole tradition pushing her forward. Often she paints the boards black or dark green, so that the pats and lines and jabs of plaster stand out like stars in a night sky. Her figures are summations, abbreviations. The cycle of *Three Graces* is her memory of Raphael remembering Pompeii. Goodstein's work, with its passionate mix of conventional sources and unconventional methods, is astonishingly concise.

Stanley Lewis's representational paintings are also informed by a taste for abstraction. Lewis has a gift for ripe, painterly surfaces and for plangent, gray-purple-green tonalities. His landscapes may remind people of the work of contemporary English Expressionists, of Leon Kossoff and especially Frank Auerbach. The jagged forms in Lewis's landscapes could even strike some gallerygoers as borrowings from Auerbach, but I find Lewis at his best to be an infinitely more satisfying and original artist than Auerbach ever is. In Lewis's smallish paintings, the angles and elisions that suggest a fascinatingly labyrinthine sense of space really add up; they give us a complete view. And no one else has rendered the odd, edgy spaces in suburban America—the sides of roads, the gas stations—with quite the lyric delicacy that Lewis achieves. His America, shambly and appealing, is not unlike Kossoff's London. In recent years, some of Lewis's most complex and beguiling inventions have been his drawings. The big, heavily worked views of his own jam-packed studio, with pencil lines jabbing into and even tearing at the paper, have a thrillingly overelaborated Mannerist power.

Terrific work—by artists who range in age from their late 30s to their early 70s—isn't always ignored entirely, but it rarely receives the concen-

trated, serious attention that it deserves. Why isn't there more focus on the abstract sculpture of Geoffrey Heyworth and the figure sculpture of Robert Taplin and Natalie Charkow; on the abstract paintings of Spencer Gregory, Bill Barrell, Pat Adams, Shirley Jaffe, Thornton Willis, and Trevor Winkfield; on the geometrized realities that we encounter in the work of Jacqueline Lima, Richard Chiriani, and Alfred Russell; and on the various kinds of representational painting that are done by Rita Baragona, Richard La Presti, Carl Plansky, Temma Bell, Mari Lyons, Louisa Matthias-dottir, Gabriel Laderman, Lennart Anderson, Helen Miranda Wilson, Lisa Zwerling, and Ned Small? I could mention more artists who are equally gifted, equally deserving of additional attention. Even when painters who are doing major work have reasonably big followings—I'm thinking, again, of Joan Snyder, and also of Bill Jensen—they seem to remain co-terie tastes, admired in art departments, collected to some degree, but not really part of the American art establishment that is known around the world.

As for Barbara Goodstein's and Stanley Lewis's work, it's rarely seen by anybody beyond a small circle of admirers. And despite the extraordinary ability these artists have demonstrated to go it alone, to stay focused on the freestanding value of art, the long-term effects of such a restricted audience cannot be healthy. The absence of significant financial rewards is one prob-lem, and by no means a minor one. Lewis, especially, has had a significant teaching career, which can fill the financial void. But even if we assume that committed artists do find a way to survive financially, there remains a larger question. What happens to an artist whose development receives so little public recognition? I am not speaking here about unfulfilled promise. I am referring to artists who have done an immense amount and now, at mid-ca-reer, are at the point where they have to find it within themselves to do even more. Can artists keep on doing their damnedest when the wide world

doesn't give a damn? The question needs to be addressed right now. A generation that is coming into its own—that really has already come into its own—is having a terrible time making contact with the audience it deserves.

Both Goodstein and Lewis owe a debt to the painter Leland Bell, who died in 1991 at the age of 69. Bell's grandly scaled figure compositions have a hard-edged yet free-flowing exuberance, and there's an astonishingly elegant vehemence to many of his self-portraits and portraits. These paintings, with their from-the-ground-up structural concision, suggest a number of ways in which a representational artist can learn from abstraction. Certainly both Goodstein and Lewis have built on some of Bell's ideas. But a comparison between his career and theirs makes it clear how much more dangerous it is to be an independent artist today than it was a generation or two ago, when Bell was making his way.

Bell was often described as the archetypal art world outsider. Emerging in the years when Pop Art's clever Zeitgeist readings were dominating the news, Bell insisted that art has its own logic, its own power. True, he hardly ever sold a painting. But he had a distinguished dealer in Robert Schoelkopf, and over the years he was the subject of feature articles in *Arts, Art News* (by John Ashbery), *Art in America* (by John Hollander), and the *New York Times,* and in 1987 he finally received a retrospective at the Phillips Collection in Washington, D.C. Barbara Goodstein, although her sculpture doesn't look anything like Bell's painting, is the artist who I expect will carry Bell's brand of radically simplified representation into the next century, yet she has never had a dealer committed to her work, has never been the subject of a feature article in an art magazine, has never even had a work in a museum show. The difference in their careers tells you something very scary about the ever-diminishing opportunities for serious art since Bell arrived in New York in the 1940s.

In Public, in Private

In order to see why it is so much harder for authentic independent work to prosper now than it was a generation ago, we have to look beyond career specifics to the overall structure of the art scene. The art world that was born in New York after World War II is moving into its sixth decade, and what we've been seeing in the past few years is a systemic crisis. Matters have reached the point where nothing in the art world really seems to work any longer—not in a way that encourages what I would call major art, anyway. We're living in a dysfunctional art world. And to understand this disorder, we must understand what made the scene function (although often haltingly and half-heartedly) in the first place.

The New York art world has always had two dimensions: one public, one private. To the extent that there was ever a meaningful relationship between these realms, the public art world was an outgrowth—and at best a reflection—of the private art world, of the artists' art world. It is always in the artists' art world that forms are reimagined and reinvented, and that new expressive possibilities come into their own.

Of course this split between a public and a private art world is nothing new. The Salons and academies of eighteenth- and nineteenth-century Europe, which generally operated under government auspices, acted as clearinghouses, making career defining decisions about which artists would gain access to commissions, patrons, and the public that visited major exhibitions. Need I point out that these premodern and early modern institutions had more than their share of bureaucratic rigidities? The every-man-for-himself free-for-all that began to take shape in the late nineteenth century, as artists found themselves competing for representation by an ever-growing number of commercial galleries, was a welcome change. In many respects the commercial dealers succeeded in giving individual artists a more

direct access to the public. The relatively rapid acceptance of as radical a development as abstract art would have been inconceivable without the more fluid relationship between artist and audience that was fostered by a new generation of activist dealers.

In the years after World War II, when the New York art world as we know it was first coming into focus, the private and public spheres were in a fairly healthy balance. Avant-garde Paris was a huge inspiration. And an all-American distaste for official patronage and the rigidities of tradition helped to give the New York situation a lively, improvisational character. Many people believed that a new kind of audience was coming into being—an audience that was more adventuresome, more independent. This was true, at least up to a point. There was an educated public that took an interest in developments at the Museum of Modern Art and the Whitney, in art coverage in *Time* and *Life*, in the lineup at international shows such as the Venice Biennale, and in exhibitions at a few blue-chip commercial galleries, such as those of Sidney Janis and, later, Leo Castelli.

But if avant-gardism was in certain respects in sync with an older American feeling for the importance of the individual, there were also danger signs. In the egalitarian atmosphere of New York, even casual gallerygoers could begin all too easily to imagine that they understood more about the avant-garde imagination than they really did. Context was beginning to overtake content. The sophisticated public's gossipy familiarity with the life and times of Jackson Pollock or Willem de Kooning set the stage for a new kind of ultra-hip philistinism. And artists who wanted to be better known were sometimes glad to confuse the public imagination with their own. "Let your monstrous subconscious make a quick buck for yourself," the painter Ad Reinhardt announced in one of his cartoon collages, published in the magazine *trans/formation* in 1952. "Hollar 'Hang the museums!'" he urged, "until they hang you, then clam up and collect."

The curators, dealers, and editors who were shaping this fast-growing public art world had been weaned on the legendary doings of early-twentieth-century figures such as Ambroise Vollard, Daniel-Henry Kahnweiler, and Gertrude and Leo Stein. The tastemakers at New York's museums, galleries, and magazines saw that their predecessors had looked to artists for guidance, and they meant to do the same in New York. They cared, especially after the war, about what the younger painters and sculptors were doing, and they agreed with the artists who saw the blue-chip galleries as fitting into a wider constellation of galleries and exhibitions, which included developments at some important artist-run cooperatives and artist-organized exhibitions (the Tenth Street annuals are an example). The artists were certainly aware of the expanding coverage in the more popular magazines, but they were also deeply absorbed by the discussions that went on at the Artists' Club, and by the hundreds of short reviews of exhibitions that appeared in the art magazines each and every month and added up to a blow-by-blow account of what artists were doing.

The line between the public art world and the private art world was not always clear, and that porousness could be a good thing, at least when it worked to give private expressions a public dimension. The art magazines themselves had both a public and a private side. You might say that the feature articles in the art magazines were public, whereas the short reviews of one-person shows were a part of the private world. Art coverage in literary and political magazines such as the *Nation* and *Partisan Review*, despite their small readerships, could span the two realms, as did certain galleries, such as Betty Parsons' and Martha Jackson's. And when Alfred H. Barr Jr., the founding director of the Museum of Modern Art, took a part in artists' gatherings downtown, he was showing how involved he was with that more private art world. In 1960, in a letter to the *New York Times,* Barr said, "The artists lead: the museum follows, exhibiting, collecting and publishing their

work. In so doing it tries to act with both wisdom and courage, but also with awareness of its own fallibility." Surely this was the truth, but the very fact that it needed to be stated so bluntly suggested that by 1960 there was reason to wonder if things were really still working this way.

The essential point is that through most of the '50s, and to a lesser degree even into the '60s and '70s, the values and reputations that dominated the public art world were often formed in the artists' private art world. The fame that de Kooning and Pollock achieved in those years was an outgrowth of their downtown reputations. I do not mean to suggest that there was ever a time when everything went right. Far from it. The gonzo careerism that we think of as characteristic of the '80s had its origins in the '50s, and there were always reputations that were largely shaped by the public art world. But the fact is that, especially in the '50s and '60s, a great deal of the art that made its way uptown had its origins downtown, in a culture in which public renown, although desirable, was not a formative value, not the litmus test it would be once contextualism was king. Thus in the '50s, and to a lesser extent all the way into the '70s, the public art world could be said to be an imperfect but still pretty reliable mirror of the artists' art world, where what really mattered was the freestanding value of a work of art.

More than that, there was a sense among artists, and among those who followed art closely, that a public reputation was of value only to the extent that it was seconded by artists. Many of the painters and sculptors who crowded into the Cedar Tavern, the Greenwich Village hangout that the Abstract Expressionists made famous in the 1950s, took it for granted that even those who had succeeded uptown would ultimately be judged downtown. Some of this was lip service, but much of it was not. There was a story that circulated about how delighted Jackson Pollock was when Earl Kerkam, a marvelous painter of figures and still lifes who had an archetypal artists' art world reputation, let him know that some recent work was "not

bad." The point of the anecdote is that Pollock, despite his public fame, hungered for a kind of approval that only the artists' art world could provide.

In the criticism that the painter Fairfield Porter was writing in the early '60s, the famous and the not-so-famous and the barely known are discussed next to one another, and they are judged basically not in terms of their success in the big public world but in terms of the value that their work has for their peers. No matter how well-known an artist became, the judgments of fellow artists continued to be extremely important. Mark Rothko's depression in the 1960s cannot be separated from his awareness that many artists and writers believed—and this belief was reflected in essays in little magazines such as *Scrap* and *Evergreen Review*—that he had fallen into a formula, which his spectacular success, including a retrospective at the Museum of Modern Art, somehow only underscored.

Rothko committed suicide in 1970, dying in a pool of blood in his studio, and there is probably more than a kernel of truth to the luridly elaborate hagiography that has grown up around that terrible event. There were surely many factors that fueled his massive depression. But who can deny that Rothko was at least in part undone by a fame that, however much he had hungered for it, dissolved the very values that had once sustained him? In Rothko's later years, the public art world and the private art world were less and less able to function effectively as two sides of a single, relatively well-integrated organism. And if this two-part organism has continued to operate at all since the '70s, it is only because it's now operating in reverse, with the public art world dictating the terms of the private one. The growing prestige of American art gave the freestanding value of art a new context. Artists of Rothko's generation benefited. Then the context devoured the art.

If we consider Duchamp's gnomic observation, made in 1957, to the effect that the spectator "adds his contribution to the creative act," we may

begin to see that this reversal has a kind of Dadaist logic. Certainly, the Dadaists have done their damnedest to undermine the stand-alone integrity of art. But their authority probably originates in their having been the first people to see the writing on the wall and to bow to what they were not sorry to believe was an inevitability. By now, in any event, we are all, Dadaists and anti-Dadaists alike, at the mercy of developments that we are at best ill-equipped to control. And although we can describe these developments with a good deal of accuracy, we may never come up with a theory that explains them entirely to our satisfaction. What we do know is that in the nineteenth century the collapse of the old system of Salons and academies set the stage for an increasingly improvisational interaction between artist and audience—and for the incandescent excitement of the avant-garde. But apparently a creative relationship between the artist and the audience could also turn into a collusive relationship between avant-gardism and populism. Ultimately, this increasingly compromised alliance endangered the artist's hard-won modern status as the person who makes private experiences public.

The beginning of the end came with the explosion of Pop Art in the early 1960s. But if I am correct in believing that the hostility to art's stand-alone power has a long history, then Pop Art was less a catalyzing force than a neat conclusion. Pop Art's subject matter dramatized the shift from a private to a public avant-garde because so many of those Pop images and motifs were drawn from material that had no private meaning for the artists. Andy Warhol, who came out of the world of advertising, defined a new kind of art world career—the career that was conducted entirely in the public eye. At that point the public art world became self-perpetuating; or at least it was then that avant-garde art came to be tied to market values rather than to artistic values.

A whole culture has grown up in Warhol's wake, a culture that by now includes its own educational institutions, such as the California Institute of the Arts, where students are taught little, it seems to me, beyond how to have public art world careers. At such institutions, the freestanding value of art is an arcane idea—as odd, and maybe as oddly charming, as not wearing white shoes before Memorial Day. The public art world has become self-perpetuating. Contextualists are, of course, masters of self-perpetuation. As for the private art world, it has become increasingly isolated, fractured, frozen.

Diminishing Options

When I talk with literary people about what's going on in the art world, they often see parallels between art hype and book hype, and to some extent I suppose these analogies make sense. As a parallel to the artists' artists, to figures like Barbara Goodstein and Stanley Lewis, literary friends will think of writers' writers and poets' poets. The literary world, especially in the midst of the conglomeration of publishing in the '90s, offers plenty of analogies. But I think that there is reason to believe that the art world is even more vulnerable to media forces than the literary world. Works of art, which can be taken in with a single glance, create an illusion of instant capture, instant expertise. Although even a vaguely credible opinion about a novel will involve putting in the number of hours it takes to get through at least a part of the book, all it takes to have a vaguely credible opinion about a painting by David Salle is a swerve of your head around a gallery. Visual art provides people with the promise of instant access. And the art that gets the attention satisfies that need for quick satisfaction—it's all up front, there are no nuances or mysteries to unravel. It never takes you out of this world.

Museums have become the places where the contemporary art hype reaches the boiling point. The museums expect to draw audiences of a size

that they never dreamed of before, and they understandably feel that this enlarged public needs to be given a carefully shaped and predigested view of contemporary art. In order to create this neatly tailored picture, curators willfully deny the variety of the contemporary scene; they can't be bothered with stand-alone, private experiences. Even as the number of artists at work has expanded geometrically, the number of artists included in major surveys has plummeted. A generation ago, the important contemporary overviews held at the Whitney in New York and the Carnegie in Pittsburgh contained 100 or more artists; today they often include a half, or a quarter, of that number. The truth is that the old surveys were often criticized for their eclecticism and their aimlessness, but in retrospect we can see that at least they gave a large number of artists some access to a museum audience—and vice versa. At the same time, they kept curators out of the godlike position they have achieved in recent years. Those older surveys weren't summaries of trends, they were designed for an audience with some sophistication, an audience that could deal with the variety of contemporary developments. Today's surveys aren't really surveys at all, they're more like quickie summaries. Museumgoers may feel less overwhelmed, but from the artist's point of view the result is that there are far more artists jockeying for far fewer places. And this means that there's less chance of an artist's work getting to the public. The new surveys are a big lie, snow jobs that distance the audience from what's really going on.

The changes in survey shows are only one sign of the increasingly restricted opportunities open to those artists who are determined to follow their own lights and create work that does not fit easily with the art world's formulaic expectations. Another problem is the art magazines, which have in the past twenty years largely abandoned their old job of reporting what goes on in the galleries and instead have become publicity machines for art stars and art star wannabes. In the '50s and '60s any artist who managed to

have a show in New York City was virtually guaranteed at least a brief review. Most reviews at that time were really substantial; they really delved into the work. They were written by amazingly astute critics, such as the artists Donald Judd, Sidney Tillim, and Fairfield Porter, and the poet James Schuyler. The importance of short reviews for the art community cannot be overestimated. They amount to a kind of written conversation about art, a reflection of the dialogue that's going on among the artists. Yet now, even with hundreds more galleries, fewer shows are reviewed than ever before.

The art market, like any area of life in which large sums of money are at stake, has exerted a fascination practically forever, yet there has probably never been a time when the writers and curators and gallery owners who present art to the public have been so willing to allow content to dissolve into the marketing context. In the past decade, an extraordinary amount of attention, both in the art press and the mainstream media, has focused on the crazy prices paid for contemporary art at auctions and on the waiting lists at the blue-chip galleries. In the spring of 1999, works by contemporary artists, among them Robert Gober, went at auction for a number of prices in the hundreds of thousands of dollars. This news has a fascination; but it also leaves a lot of people feeling distanced from contemporary art.

Thirty years ago, collecting contemporary art was something that many educated people did, at least in a small way. If you couldn't afford the paintings, you might buy original graphics by Picasso and Matisse—not to mention works on paper by contemporary Americans. In fact, it is still possible to collect works of quality for a few thousand dollars. But the news of the immense prices that are being paid for works by Schnabel and Basquiat—and, now, Sherman and Gober—makes people believe that all art that's worth having is expensive. And that ties right into the deeper feeling that art no longer has a stand-alone impact, an impact that people can respond to irrespective of prices, labels, reputations. And so we're losing the old au-

dience of sometime art collectors—the collectors of moderate means. The hype makes people feel that art is out of reach.

Everywhere I look there are signs of diminishing opportunities for serious work to be seen and discussed. In an article in the *Art Journal*—published by the College Art Association, which is the professional organization for artists and art historians—the painter Philip Pearlstein has discussed a kind of censorship that is not often even recognized. Pearlstein tells of sitting on art panels at the NEA and other institutions where the basic assumption is that certain styles in which the public art world isn't interested can simply be excluded from consideration. Among the styles Pearlstein cites are various kinds of representational painting and what he calls traditional abstraction; types of work, in short, that are grounded in a belief in the stand-alone value of art. Grants, even small ones, have sustained many unconventional artists. But in recent years, most grant-giving processes have become hopelessly tied to the market values of the public art world.

We live in a trickle-down art world. Whatever attention and support doesn't go to the art stars seems to go to their clones. Art teaching is dominated by the wannabes; and all they do is teach students to mimic art-star values, which is all they, the teachers, know how to do. What's going on in the art schools may be the most disastrous development of all. In the past forty years, the teaching of art in structured academic settings has helped sustain painting and sculpture in New York and the rest of the country. Far from being hiding places for failed artists, art departments have been places where artists who were too unconventional or independent to prosper in the marketplace have been able to sustain an art culture of their own. After the war, artists, among them Ad Reinhardt and Mark Rothko, made Brooklyn College one of the country's great art departments. In the early '70s, when I was planning to be a painter, some schools still had that kind of generative power, notably the painting department of the Kansas City Art In-

stitute, under the direction of Wilbur Niewald, and the Graduate Program of Queens College, where Louis Finkelstein, Rosemarie Beck, and Gabriel Laderman, among others, were all teaching.

As late as the '70s, the academic network, the grant-giving network, and the gallery network were functioning much as they had in the '50s, and in some cases functioning better than they ever had before. In the '80s, however, every aspect of the art world began to feel the pressure of the market, for there seemed to be fewer and fewer people who believed that what commanded high prices might not be more or less synonymous with what was good. University administrators became all too conscious of the public art world, and they began to expect their departments to reflect public art world values. Something in the ineffable mix of art and glamour that had attracted Wall Street to SoHo in the first place had an equally strong impact on academics and other intellectuals who have little, financially speaking, to gain. The academics, who are more often than not inclined to think contextually, didn't want to be excluded from the party. The party was in full swing in SoHo in the early '80s. Then Warholism and Reaganomics fell into bed together. Then their love child, Robert Mapplethorpe, was transformed from a clever aesthete into a martyr at the altar of political art. And once all this had happened, nobody could tell any longer where market pressures left off and the pressures of political correctness began.

The Left might have been expected to approach a booming art market with a certain degree of skepticism, but in recent years this does not seem, by and large, to have been the case. For those who are inclined to see artistic vision as essentially grounded in economic or social factors, the ever-growing power of the market is so perfectly logical a development that it can inspire glee as easily as dismay. Warhol may be regarded by Leftist scholars as a kind of demonic figure, but they can hardly help feeling that he's just the demon the story needed. In the early '80s, when Warhol filled canvases with

nothing but dollar signs, he gave these art historians the perfect finish to all their studies of the rise of the market. And the market itself can begin to look like a radical force—a force that explodes what many are inclined to believe is an antiquated idea of the artist as an individual.

In the '70s and early '80s an artist painting small landscapes or abstractions would have been told by dealers that what the money people wanted wasn't "just another" landscape or abstraction, no matter how good. By the late '80s that same artist—if that artist happened to be a woman—would be told by many critics that she had no right to paint in a traditional genre because those genres were male-dominated. For intellectuals who were basically familiar with nothing but public art world values, the economic rationale and the political rationale began to converge. It doesn't seem to matter that we are living in a period when, for the first time in history, women are making the high-art traditions absolutely their own and proving in the process that tradition is gender blind. The bottom line is that the whole structure that has sustained art in this country has come to be dominated by public art world values—that is, by market-driven art. The artists who are committed remain, but they are frighteningly isolated.

The Deal Makers

As the '90s got underway, the Wall Street money that had fueled the art orgy of the '80s evaporated. From all sides there were announcements that the unholy marriage of Warholism and Reaganomics that had set the art world spinning had collapsed. Art hype, many imagined, was a thing of the past. Auction prices plummeted, and galleries that had only recently opened their doors were closing. This, at least, is the story that is generally told. It is accurate in some of its specifics: the unsold auction lots, the collapsing real estate values. But those who imagined that the insane expecta-

tions of the '80s—art as a fix, as an ever-changing decor—would die along with Drexel Burnham Lambert were totally mistaken. It was simply impossible that reputations on which so much attention had been lavished would be allowed to disappear. The people who hype art still believe that the hype makes sense. One of the most depressing developments of the '90s has been the insistence with which reputations that not even the trendies care about are pointlessly sustained. Who any longer gives a damn about Haim Steinbach's shelves lined with buyables? Yet the work is still reviewed in the *New York Times.* To do otherwise would be to reveal that the emperors of the '80s never had any clothes.

In the '80s a lot of people would have said that we were living in the Age of the Art Stars. As for the '90s, I think we'd probably have to call this the Age of the Deal Makers. This is the apotheosis of context, the final annihilation of content. Of course the deals are often designed to keep the art stars' reputations alive. The deal makers include some commercial dealers, along with some curators, some museum directors, and some collectors—who not infrequently double as museum trustees. But the individuals—and this is the key to understanding the Age of the Deal Makers—are less significant than the synergy between the players. The deal maker isn't in the business of making judgments about art. These people may represent the ultimate triumph of the public art world in that they couldn't care less what artists think or feel or do in the privacy of their studios. Deal makers approach artists and art in the same spirit that they approach museums, galleries, collectors, curators, and critics. For the deal maker, nobody and no thing has a freestanding value; there is no such thing as an artist's imagination. If you're a deal maker, you will find an artist's work interesting because you think it will look good in a certain space; you want to fill the space so you can get press attention and bring in the crowds; and you want to bring in the

crowds so that donors will decide that yours is the hot institution and give money for a building expansion.

The most spectacular representative of the Age of the Deal Makers is Thomas Krens, the director of the Guggenheim Museum for the past decade. From the beginning, Krens looked at the Guggenheim in terms of its assets. He had a legendary building designed by Frank Lloyd Wright; he had a world class collection of classic modern art; he had name recognition. Does Krens like modern art? Does he like Wright's building? Who knows? Who cares? At first Krens's plan to turn the Guggenheim into an international operation came up against a considerable amount of hometown resentment; New Yorkers felt that the Guggenheim was a Manhattan institution and ought to remain that way. But the ineluctable logic of the deal makers is always centrifugal movement, and what Krens saw in the Guggenheim were marketable assets. Krens has a sensibility, but it has nothing to do with art. This is a marketer's sensibility, a feel for international deals that involve powerful people playing ball with other powerful people. The Guggenheim collection and the Guggenheim name could be offered to foreign governments. Those governments would pay to build new satellite Guggenheims, such as Frank Gehry's museum in Bilbao, Spain. And the expanding empire would attract new money.

"The Art of the Motorcycle," the exhibition of more than a hundred big bikes that filled Frank Lloyd Wright's Guggenheim Museum in the summer of 1998 and broke all the museum's previous attendance records, was the apotheosis of the art of the deal. As a museum concept, "The Art of the Motorcycle" was bottom feeding for the fashion conscious. Krens, a bike aficionado himself, who could not have done the show without the corporate support of BMW, was reassuring anybody who has ever had a guiltily ambivalent feeling about the mysterious otherness of modern art that the dream was dead and they were off the hook. He acted as if "The Art of the

Motorcycle" was a public service—a "very serious project." If he was serious about anything, it was about fulfilling some ultimate macho fantasy. Basically, what you had here was an exhibit that was tailor-made to delight the Wall Street Masters of the Universe who helped Krens transform the Guggenheim into an international entertainment consortium. With Krens, the public art world becomes the multinational art world.

Dennis Hopper, who was motorcycle crazy long before he directed *Easy Rider,* observed in the exhibition catalog that what had first attracted him to bikers was their not being "corporate tie-wielding execs from Wall Street." But of course a great many of the bikes at the Guggenheim were always rich men's toys, and there is no way this show ever would have played the Guggenheim if a lot of the "corporate tie-wielding execs" who support Krens had not liked the bike-as-art equation. Krens is telling the new museum tycoons that they don't have to like paintings and sculptures much in order to get into this exclusive club. "An art museum's special exhibitions programming should fit into a strategic plan," Krens explained of "The Art of the Motorcycle." And what better strategic plan could Krens have offered his patrons than one that began by giving them the opportunity to trade in their rep ties for black leather jackets?

Perhaps the deepest irony of Krens's tenure at the Guggenheim is that he has raised this mega-public institution on the foundations of a museum that was originally dedicated to some of the least popular of all modern art. In its first incarnation, as the Museum of Non-Objective Painting, the Guggenheim opened on East 54th Street in 1939 and featured abstract paintings by Kandinsky and others that were still less than beloved at the Museum of Modern Art, where the audience had only recently made its peace with the Postimpressionists. The Museum of Non-Objective Painting was meant to bring the public up to speed with what the most aloofly experimental artists were doing; non-objective painting still remains a reach for many museum-

goers. Yet the very idea of cultural aspiration, which once fueled the public's struggle to grasp an artist's most private expressions, is now regarded as fuddy-duddy stuff, at least by Thomas Krens.

Krens has become the cheerfully dark prophet of museological pragmatism. Small—as the Guggenheim once was—is not only no longer considered beautiful; it's seen as stupid. Krens claims to face hard facts that other museum directors avoid, when he argues that he needs glamorous international partnerships to pay the bills and that he must turn the museum into an art multiplex in order to bring in the crowds. But what some call bowing to the inevitable may in fact be a tragic lack of imagination that turns our worst-case scenario into our only option.

What Is to Be Done?

In the '80s, criticisms of the art world status quo had a certain cachet. But in their own way the brilliant critiques—which reached a peak of comic mischevousness in "The Sohoiad," Robert Hughes's "Satire in Heroic Couplets Drawn from Life," published in the *New York Review of Books* in 1984—could be as destructive as the hype. When a witty writer turns the art world into a grotesque carnival, we have another, cleverer form of contextualization, and the result may be that people give up on contemporary art entirely. And when that happens, brilliant, dedicated artists are in danger of being ignored along with the hype artists. In the '80s, it was all too easy to mock the big money and the glamour; anti-hype could become another kind of hype. In the '90s, though, a milder tone of bemused acceptance has come into favor, maybe because critics are aware that nothing they say makes much of a difference. When the 1995 Whitney Biennial opened, three major critics whom one would not have expected to agree about much of anything came out with the phrases "I like this one" or "I like it." This was said with a cer-

tain archness, with a sort of sigh. "Like" is such a bland word, and it was used for its blandness. I think that critics were struggling to find a way to respond to the Age of the Deal Makers. They knew that if they tried to argue with the art, or with the curator's underlying assumptions, they would get nowhere. The deal had been cut. The case was closed.

But of course the case is not closed. The artists are still working, and there is an educated audience that wants to understand why things have gone so wrong. The only experience I find more depressing than walking through the Whitney Biennials is reading the critics who say, "Yes, it's bad, but this is what there is." When I go through those Biennials, my reaction is different. "Yes, this is bad," I think, "and it's bad because it excludes everything vital and exciting in contemporary art." I'm wondering why Barbara Goodstein and Stanley Lewis and dozens of other artists haven't been included—and among the artists we haven't seen in these shows in recent years are painters as well-known as Bill Jensen and Joan Snyder. Today the most radical thing an artist can do is paint a tightly structured and internally coherent painting, yet even if there is a single major curator in this country who has the brains to recognize such work, there is not a single one who has the guts to give that work institutional support. The real artists are still working. The tragedy is that they have no way of making contact with the audience that really cares.

What is to be done? The only solution is for people to begin to put back together the structures that have historically supported the artists' art world in the United States. We need dealers, collectors, critics, and curators who will stand up for the freestanding value of art—day by day, case by case. Given how far matters have gone, I am not sure this renewed support is any longer feasible, but there is nothing to do but give it a try. I can understand why the big museums are unable to respond to all the dissatisfaction out there; they're basically in thrall to the money interests, to the deal makers.

But I do wonder why we aren't seeing more innovative programming in the smaller museums, where there may still be some independent curators and trustees left. And what about the colleges and universities, which have their own network of galleries and small collections?

People who still believe in a private art world must pool their resources. The effort has begun. One example is the small retrospective of work by Louisa Matthiasdottir, the grandest still life painter of recent decades, which toured roughly a dozen colleges and universities in the mid-'90s. We need more shows like this. I am also looking for a new generation of art dealers who, beginning slowly and building on that tremendous stock of gifted artists now in their 30s and 40s and 50s, create galleries where, as Clement Greenberg once wrote of the Betty Parsons Gallery, "art goes on and is not just shown and sold." To be sure, it's harder to operate such a gallery than it was for Betty Parsons or Julien Levy; it costs so much more to run a dignified operation than it did forty or fifty years ago. But our best hope may still rest with the rise of a new generation of gallery owners who are independent and committed—who carry on in the great tradition of early-twentieth-century Paris and mid-century New York, when dealers knew what it meant to cast their lot with a community of artists.

The greatest danger is the sense of hopelessness among the artists. They desperately need a new wave of dedicated dealers; more eager, informed collectors; a determination on the part of smaller museums to exhibit, document, and preserve uncompromisingly independent contemporary art; an upsurge of serious critical writing; additional forums where artists can get together and talk. The public art world has become such an overwhelmingly oppressive force in artists' lives that many painters and sculptors have already given up hope that the revelations that sustain them in the studio will ever again have a public presence. Once upon a time a major artist was a person like Willem de Kooning, who came up through the ranks and

never forgot that he was a part of a community of artists. Today a major artist is a person like Jeff Koons, who has oversized knickknacks manufactured by hired hands and doesn't know that there is a community of artists and is proud of his ignorance. So far as Koons is concerned, the deal makers are the only artists left standing. Koons is one of them. What you see when you compare de Kooning and Koons is not a difference in quality or degree. It's a difference in kind.

The art world has become the most glamorous wilderness imaginable, bewitching and numbing at the same time. It may be overstating the case to say that the future of art is in the balance. But most of the artists to whom I talk believe that we are living in very dark times. If artists and audiences can confront the full extent of their alienation, maybe then people can begin to shake off that sense of hopelessness and things can start to turn around. If this is going to happen, it will involve a lot of small acts of courage, all of them animated by a willingness to reject conventional taste and conventional wisdom all along the line. The artists who are most deeply committed to what they're doing in the studio have to reestablish contact with the audience that hates the hype.

CONTEMPORARY DEVELOPMENTS

The idea that art began when somebody impulsively scratched something on a wall will do just fine as a creation myth for painters. Why that first artist made that first mark, however, is subject to as many different interpretations as there are times when artists have thought about the origins of art. In the late 1700s, when European painters were on the verge of a century of realist revolutions, some artists were attracted to a Greek legend that stated that the inventor of painting was a woman, a Corinthian maiden who decided to trace the profile of her soon-to-be-departed lover on a wall. This story, which combined a classical setting, a romantic sentiment, and a realist impulse, suited an age that occasionally could weld such apparently divergent sensibilities into bold historical drama. But in more recent times, when abstraction rather than imitation has been the artist's defining experience, the origin myths that have interested people have had a less clear-cut narrative.

Henri Focillon, the French writer whose 1936 essay "In Praise of Hands" came out of the Expressionist impulses of early-twentieth-century European art, pushed the beginning back from Corinth to the Age of the Titans. He suggested that what was essential was not hand-eye coordination, but the hand's inherent capacities—its delicate yet forceful muscularity and its tactile sensitivity. Focillon imagined a centaur in a forest, and how, while moving along on his four hooves, the mythological beast would be "inhaling the world through his hands, stretching his fingers into a web to catch the imponderable." "The hand's trials, experiments and divinations," Focillon believed, were still going on in artists' studios in the twentieth century. And when Focillon's essay appeared in New York in 1948, under the imprint

of the art book publisher Wittenborn, there was a New World audience that was primed to receive the message that the magic is in the making.

It has been just about fifty years since Focillon's essay appeared here. That is both a very long time and a very short time so far as art is concerned. And even though the idea of the artist as a magician has been attacked from every imaginable angle in the past several years, this remains the only myth by which anybody who goes into a studio and gets down to work on a regular basis can seem to live. Artists still believe that the impulse to make marks predates the impulse to represent, and they have made painterliness the Manhattan version of naturalness—a naturalness that can be turned to contradictory ends and that often seems, even when it is ignored or attacked, to be honored in the breach. In the past few years we have seen a number of museum retrospectives in which contemporary artists are intent on demonstrating that in the beginning and in the end there is nothing but the mark. These shows—devoted to Robert Ryman, Willem de Kooning, and, now, Cy Twombly—have underlined both the potency of a great origin myth and the dangers in store for any artist who expects a limited definition of painting to be relevant to the far-from-limited number of situations that present themselves over a lifetime of work.

Cy Twombly, whose retrospective is at the Museum of Modern Art this fall, likes a classical association, and he probably wouldn't mind our imagining that in more than a few of his canvases a centaur has done some finger painting. That Twombly has often made his painterly marks with pencil or crayon doesn't suggest a rejection of the painterly gesture so much as the relevance of that mark to a range of unconventional situations. Twombly is saying that he's painting even when he's not painting. There are classical titles and inscriptions derived from Greek and Roman writers scattered through the work of this artist who has made his home in Italy since the late 1950s (he's 66). These antique allusions give his late modern improvisa-

tional manner, with its big expanses of empty white canvas, a feeling of being grounded in the white marble landscape of classical legend. Twombly gives the impression that he's a contemporary artist with fine premodern credentials.

The Twombly show, which was organized by Kirk Varnedoe, Chief Curator of Painting and Sculpture at the museum, is deftly done. The eight galleries add up to a fluid, unforced view of the career. Varnedoe does not present more work than a museumgoer can be expected to take in at one go. Although his catalog essay presents a careful, chronological view of the career, the show suggests that the way to understand Twombly is in terms of a cyclical, rather than a linear, development. A small repertoire of themes and motifs, almost all of them in place very near the beginning, have been reappearing for more than forty years. Twombly's most ardent fans may leave the retrospective feeling that they would like to see more, which is not the worst feeling to have at the end of a big show. Those who don't care for the work will find that they've reached the end of the show before they've reached the end of their rope.

Twombly knows how to maximize his gift for deft, elegant effects, or at least he used to know how, in the first part of his career, up until the mid-1960s. Looking at these sand- and snow- and ivory- and slate-colored paintings, a museumgoer takes in one incident and then another incident, and there's pleasure to be derived from the sensitivity with which Twombly engraves a pencil line into thick paint or twirls together little puffs of pigment. His work can be interpreted as a textbook example of late modern Expressionism; the living painters who end up with retrospectives at the Museum of Modern Art are often the ones whose work appears to have an educational purpose. Twombly presents self-conscious awkwardness as virtuosity. He uses substructures as surfaces. He asks the part to stand in for the whole. All of these are familiar, and in some cases downright venerable, modern

techniques. Especially in the paintings of the mid-1950s, Twombly makes good use of an image that is derived from de Kooning: the stroke that turns abruptly at a ninety-degree angle, and in the act of "bending over" creates a hairpin turn in space. In space-making terms, this is the most that Twombly ever manages to do.

The paintings are full of small, beguiling effects. Twombly sees a canvas as an idiosyncratically ornamented surface. This sort of surface, somewhere between a notebook page and a graffiti-scarred wall, was already in danger of becoming overly self-conscious when Miró was doing his emptied-out picture poems in the 1920s. Twombly's rectangle of canvas, with the weave of the fabric either showing or covered over by a thick layer of white or gray paint, is a bulletin board on which the artist posts lots of messages. (The gray paintings with white lines from the 1960s have been referred to as chalkboards or blackboards, for obvious reasons.) Although Twombly may inscribe more words in his hard-to-parse handwriting than most people are going to want to take the time to read, these bits of poetry and verbal graffiti do add another dimension to his scrawled and scratched abstract images. Among the cryptic and not-so-cryptic messages that Twombly includes are classical place names and pornographic squiggles. All announcements, he seems to suggest, are equal.

There's taste and intelligence and wit to these canvases, but there is no heedlessness. Twombly knows how to scatter bits across a big surface, he understands how to crowd things for an effect, and he knows how to adjust the rhythms. Yet the experience of the paintings remains additive—that's the biggest problem with the work. The painters who give us an experience of magical amplitude find ways to make their effects expand almost geometrically; they convince us that the world they've created is somewhat beyond their control, that two plus two equals a lot more than four. Twombly never manages to make that happen. His paintings are designed, not composed.

It doesn't help that Twombly is no colorist. There is some variety to his palette, and he's certainly attuned to the individuality of the patches of pigment that he arranges on a canvas, but he doesn't know how to orchestrate colors. For most of the show, he makes a virtue of this liability; only in the last few rooms does he attempt some color combinations that are really beyond him. In the recent *Four Seasons* cycle, Twombly seems to be trying to learn a thing or two from the late Joan Mitchell, but his juxtapositions of yellow and blue and purple and green have no impact. The work doesn't take off. The key to Twombly's small poetic originality rests in the way that he isolates each element. Even when he overlaps things—a crabby scrawl, a doodle of paint—each bit retains its cool, stand-alone personality. The self-consciousness of this work makes a museumgoer feel self-conscious. A day or two after you see the Twombly show, what you may recall is all the careful looking that you did, rather than anything that you actually saw.

Visitors to the Twombly exhibition at the Modern—and anybody who's been reading about Twombly in the press—will quite naturally wonder why it is that so much attention is focused on a particular artist at a particular time. The retrospective provides an occasion, but of course some retrospectives garner more attention than others. In Twombly's case, the avidity with which he and his work are being examined suggests something about the mysterious movements of artistic sensibility. Transformations in taste may appear to be shaped by the people in the museums and the auction houses and the blue-chip galleries. But as often as not, taste percolates upward, with ideas and apprehensions that first take hold in the studios of a considerable number of artists somehow finding their way into the wider world. Although fashion can be a crude but useful barometer of evolutionary trends and geological shifts in the thinking of artists, there are transformations that occur over periods of years and even decades with a

slow-moving force that the audience, if it's overly concerned with what's happening this month or this season, will be hard put to comprehend.

In Twombly, Kirk Varnedoe has surely found a big-name artist whose ability to be both unabashedly lyrical and dryly ironic about his own lyricism defines, through its very paradox, haute taste in 1994; you might say that Twombly's charm rests in his not resolving a paradox so much as he enshrines it. Historically speaking, Twombly's brand of painterliness comes a generation or two after de Kooning's (whose retrospective is currently playing opposite Twombly's at the Metropolitan Museum of Art) and perhaps half a generation before Robert Ryman's (whose retrospective was at the Modern a year ago). Twombly certainly offers a museumgoer a lot more than that painterly Minimalist Robert Ryman, whose white brushstrokes are so evenly inflected that every mark is canceled out by every other one— and a viewer is left feeling becalmed. An artist who marshals his slim painterly resources as rigidly as Ryman must have some inkling of the numbing effect that his work is going to have on many museumgoers. But the off-putting regularity of some of the later galleries in the de Kooning retrospective suggests that even an artist of infinitely greater gifts than Ryman, when his essential subject is the individualism of the brushstroke within the pluralism of the painting, cannot expect the most beautiful passes of the brush to sustain our interest over the course of a long career.

De Kooning, who at 90 is no longer painting, used to handle a paint-saturated brush with more wit and elegance than anybody else in America. No lifework based on the cult of the brushstroke rivals the brilliance and fascination of de Kooning's. Still, by the late '50s, the preoccupation with passagework over broad compositional movements led to a diminishment in de Kooning's work, and at that point Twombly kicked in with his own take on de Kooningesque diminishment. Twombly didn't study with de Kooning, but de Kooning had taught at Black Mountain College in North Car-

olina before Twombly got there, and the Dutchman's work was, of course, a major influence at the school. Twombly joins a studied severity that is not unlike Ryman's to a giddy painterliness that is not unlike de Kooning's, and brings out a strain of coolly nihilistic painterliness that runs straight through fifty years of the School of New York.

We didn't need a Twombly retrospective or a de Kooning retrospective to demonstrate that these veteran artists are on a lot of younger artists' minds. Even without the shows, it's abundantly apparent that '50s–style painterliness is resurgent, often with an ironic edge. In part this is a generational thing. Artists in their 40s are fascinated by the mid-century years; they feel an almost magnetic pull back to the world as it was when they were young. There have been months in New York when—between the shows at the Painting Center, Andre Zarre, 55 Mercer, and a number of other downtown galleries—it's been clear that the impact of de Kooning's bravura brush-work on Twombly and countless artists who were exhibiting along 10th Street in the 1950s has reappeared, phoenixlike, in the SoHo of the 1990s. Some of this may be copycat stuff; a lot of it is much more than that.

Painthandling has become such an issue among the artists that for the first time in anybody's memory New York has a hometown brand of pig-ments that rivals the best produced in Europe. And make no mistake about it: when artists are going back to basics in the studio, the repercussions are going to be felt way beyond the studio. Materials matter, and even non-artists know it. At the de Kooning retrospective at the Metropolitan, muse-umgoers are taking a long, hard look at a color photograph of de Kooning's paint table that has been installed in the galleries: they want to see how it's done. Today a lot of artists are doing it with Williamsburg Paint, the brand that's favored by Bill Jensen and Brice Marden and that is now sold from a street-level store on Elizabeth just below Houston. This is the kind of spare, unprepossessing retail shop—with artists' exhibition announcements

posted all around on the walls—that people don't believe can make a go of it anymore. The entrepreneur behind Williamsburg Paint is a painter named Carl Plansky, whose first show at 55 Mercer in 1992 contained some thickly worked landscape-based abstractions of a fairly high caliber. A gallerygoer who'd seen Plansky's debut show—together with a number of other distinguished exhibitions, most recently Temma Bell's at the Bowery Gallery and Paul Resika's at Salander-O'Reilly—could well ask why anybody imagines that virtuoso painthandling is not alive and well.

Painthandling has always defined the New York School, much as color was the defining experience for Venice and composition was for Paris. But for artists the question isn't how painterly painting looks in the gallery; it's what they can do with it in the studio. Twombly's way of treating the canvas as a page in an aesthete's journal is something that artists can pick up on. His version of flatness gains unexpected implications in the work of Joan Snyder, who gives diaristic painting a more explosive, heart-on-the-sleeve character. And Carroll Dunham's paintings—in which comic-book-bright color and psychedelic imagery achieve some elegance and weight—are rather like Twombly's Delphic pronouncements translated into New Yorkese. Terrific painthandling is alive and well.

But there is reason for concern. For every painter who handles a brush eloquently there is now another painter who is glad to make a joke of that kind of virtuosity. There is a new kind of painterly painting that's so arch and jejune that it deserves to be taken no more seriously than the beatnik styles that are surfacing in the downtown clubs. In some cases the mischievousness is right out in the open, as is the case with the cartoonish styles of Karen Kilimnik or Sue Williams. In other cases—Mary Heilmann and Terry Winters come to mind—the pose is subtler, so that you may not even be sure if the artists themselves understand that they're slyly distancing themselves from the past. I suspect that some of today's Twombly-watchers

aren't all that different from today's archeologists of the Beat movement; some may even regard Twombly as the Paul Bowles of the visual arts.

Today's painters have one fundamental choice: their brushwork can be honest or their brushwork can be ironic. Yet when Twombly, who is being granted old modern master status, creates paintings that seem to sweep aside the concept of choice in favor of the possibility of being all things to all people, he's hailed for giving downtown pluralism an aristocratic sheen. The hip audience regards painting with such ambivalent skepticism that it can hardly tell the difference between the ambiguities and ironies that are built into a painting and the ones that they project onto a painting. Gallery-goers may read the ebullient passages in the canvases of Joan Mitchell as ironic high spirits, and perhaps there is something to this interpretation of the work of the Abstract Expressionist who died in 1992 with her reputation soaring. It's also possible to discern an element of irony in middle-period de Kooning, where he occasionally appears to be gently satirizing the heaviness of his own earlier work. But when we talk about Mitchell and de Kooning we're talking about the gambles of artists who, whatever their limitations, can construct a painting in which irony is one element in an emotional equation.

Twombly, unlike many of the Young Turks who take him for their old master, knows how to express dispassion with a little painterly passion. When he evokes Mitchell in some of his passages of full color, he may not make the allusion work for him, but he is acknowledging that a painter has some options. As an accompaniment to the Modern show, the Gagosian Gallery, in its elegant made-over garage on Wooster Street, is presenting an enormous three-part painting by Twombly. He worked on this untitled fifty-two-foot-wide painting for fifteen years and finished last spring. It's an engaging composition—a sort of guide to Twombly's predilections. Moving from left to right we pass through a landscape of choices. There's the land of

no color; there's a broad plain crossed by thickets of lines and inscribed with the words "The Anatomy of Melancholy"; and there's a grand burst of fireworks in orange and violet and yellow. This painting embraces several different moods, yet it's so large and spare a work that each mood is wrapped in its own aureole of skepticism. Twombly's triptych reminds us that the use of a painterly mark to shatter the illusions without which painting cannot live isn't something that was dreamed up by today's just-out-of-art-school skeptics. There are old skeptics, too.

Much of what is best and worst in this old skeptic's mature achievement can be traced back to Twombly's Black Mountain College experience. I should say that when I speak of Black Mountain, I am not necessarily thinking of the experimental North Carolina college as it flourished in the '40s and '50s and is described by historians, but as it lives on in the imaginations of artists. Twombly, after all, was there for not more than a year. Black Mountain, no matter how long ago it closed its doors, endures as a tradition—a myth, if you will—by which artists live. At Black Mountain, painting had less to do with an immersion in the studio than with a painter's efforts to synthesize all kinds of avant-garde activity and in general open up the studio to the world; some people still believe that's what a painter does. There's another, alternative tradition that also continues to have a kind of mythic status; it's the one that held sway in the '40s and '50s at the Hofmann School in New York and Provincetown. When you studied with Hans Hofmann, you were on a completely different wave length than you were at Black Mountain. Hofmann showed young artists how to go into the studio and express anything and everything that they knew about the world through the dynamism of the composition, the weight of the color, the liveliness of the brush. Some people still believe in that, too.

Twombly's attitude toward the classical past—his creation myth, if you will—has everything to do with Black Mountain relativism. He is surely capable of understanding antiquity as a fairly solid arrangement of literary and artistic monuments, but what attracts him about those monuments is the extent to which time has wreaked changes on them rather than the extent to which they have remained the same. There are no absolutes in this view of history. The most beautiful line of poetry can be a fragment—orphaned words. The most beautifully painted passage on the walls of Pompeii is fascinating because it has been ravaged by time. To be interested in the pastness of the past is a perfectly natural attitude for an artist, but it is by no means the only viable way to approach the past, and it is certainly a view that's irreconcilable with Hofmann's belief in the immediacy of painterly expression. Pompeii, alive for Twombly, is alive for other kinds of artists as well. Six months ago, a few steps from where Twombly is now showing his mural painting at Gagosian, Temma Bell, in her exhibition at the Bowery Gallery, seemed to simply pick up where the Pompeian painters had left off. Bell is a painter who has no interest in historical relativism; she's involved with a completely different tradition than Twombly. If he's Black Mountain, she's Hofmann School.

The key to Bell's off-handed lucidity is her immersion in an idea of calligraphic realism that she finds equally alive in the art of ancient Pompeii, Renaissance Venice, Corot, Dufy, and Giacometti. Twombly has his own calligraphic method, but it is a critique (and not always a persuasive critique) of old drawing styles. For Bell, painterliness isn't a paradoxical modern position; it's just the thing that painters do. In Bell's show the walls were packed, almost wallpaper-like, with paintings of upstate New York, and the artist took in everything: rolling hills, fields, trees, fences, barns, houses, animals, figures. She presented it all with a flowing, comic-elegant speed that we know from some of the great Pompeian wall paintings. Not every paint-

ing reached the high level of the fifty-eight-inch-long *From Tree to Trees*, but the attack of Bell's brush always had a definiteness that Hofmann would have approved. Although Bell is too young to have actually studied with Hofmann, I imagine that he would also approve of the way she strengthens her grip on the present by assimilating the experience of the past. Twombly, ever the son of Black Mountain College, positions himself in the present by giving a riveting late modern austerity to each thought that he has about the past.

What an artist makes of painting is not so much a matter of freely choosing among a variety of options as it is a matter of making the most of a few intuitions that are absolutely one's own. Every time a painter paints, we want to see what those intuitions are. To paint is to show your hand. It is left to the audience to decide whether the way the artist handles paint reveals unselfconscious virtuosity, a canny imitation of virtuosity, or an inability to achieve any level of virtuosity. New art very often challenges and even confounds taste, but the rules of the game have become so obscure that the question of whether willed inauthenticity can be a new kind of authenticity can scarcely be addressed. The audience has a hard enough time recognizing the old kind of authenticity. Twombly rather plays into all these confusions.

There is a debate going on that is basically about the status of painting in a time when photography is dominant. This debate is as old as photography itself, but it does seem to be heating up right now. Today's museumgoer frequently learns about painting, and keeps abreast of developments in the visual arts, by looking at photographic reproductions. This makes it difficult to evaluate a painter's work. The actual surface of a painting, of any painting, with its uneven texture, can seem like a bad parody of the real thing, if the real thing is the seamlessness of a photographic print. Painting has been looking problematical for so long that it has come to the point where every time a painter paints, somebody thinks that painting is on trial. Artists may

reject the prosecutorial spirit, but in recent seasons there has been a whole slew of highly regarded theme shows that amount to art-world trials in which the real painterliness faces off against the mock. And what better place to seek a verdict than New York, the city that gave us the last unambivalent definition of painting fifty years ago?

Cy Twombly is the type of painter that the Museum of Modern Art has liked for a long time: a Dadaist in Classicist's clothing. Both the Dadaists and the Classicists among New York artists, however, may find that Twombly's victories are, for the most part, too easy. In the galleries of New York City, the wars between the Dadaists and the Classicists, who are also the Black Mountain people and the Hans Hofmann people, rage on. Market forces may be with Twombly, but market forces are not the be-all and the end-all. That elegantly scribbled world of Twombly's is one opinion about what 1994 thinks that 1950 thought about 50 B.C. Artists, often close-mouthed in public, are vehement when they get down to work in their studios. They have their own opinions about what the recent past is telling them about the distant past. And why not? What is at stake is nothing less than the creation myths that artists are living by.

NOVEMBER 14, 1994

SHRIEKS

You hear the Bruce Nauman show almost before you see it, because the cries and commands that provide the audio component for some of the artist's videos are so loud that they cut straight through the galleries to the entrance of the exhibition. Coming off the escalator onto the second floor of

the Hirshhorn Museum in Washington, where the retrospective of this 53-year-old artist is up over the winter, unsuspecting museumgoers may wonder if something awful is going on in the galleries, but for visitors who know the Nauman routine, this is just business as usual. The works with soundtracks include *Clown Torture*, in which a man in a clown costume keeps saying "No," and *Shit in Your Hat—Head on a Chair*, in which an off-camera voice puts the mime on the video through a series of hard-to-follow, repetitive movements. Noise in a museum is by no means Nauman's invention, but like silence on a concert stage, that other rather shopworn experimental ploy, it's a break with convention that's still fairly certain to put the audience on tenterhooks. That, no doubt about it, is where Nauman wants us.

Nauman has dealt with all the big topics—sex, power, violence—but he has dealt with them impersonally, as media-grabbers, as contemporary flash points. If you compare a large-scale Nauman with a large-scale Donald Judd or Mark di Suvero or Nam June Paik—all these artists were very much on the scene in the late 1960s—you see that Nauman's overwhelming statements are anti-grand grand gestures. There's no personal fervor to his megalomania. The retrospective is wildly heterogeneous: there are movies, holograms, videos, and pieces ranging from bantam weight to behemoth-size, made of wax, neon, cast iron, aluminum, wallboard, two-by-fours, Plexiglas, steel, and foam. Yet the net effect is curiously tamped down—a muffled shriek. This is message art, but the messages don't quite get across, which is (of course) the message. Nauman has been well known for a quarter century. In the past half decade he's become a living legend. This work has a queasy ambiguity that a lot of art world movers and shakers seem to love.

The Nauman retrospective, which was organized by the Walker Art Center in Minneapolis and was seen there last spring, makes its next stop at the Museum of Modern Art in New York this spring. During the thirty-year

period that is surveyed, Nauman has made use of lots of new or newish media, but he's always used them offhandedly, as if they were all old hat. It's possible to understand Nauman as one of the first avant-garde artists who has been indifferent to style. He wants to prove that the next style is not the better style, and he wants to make that point while he's doing the latest thing. Most of Nauman's work looks reheated, intentionally so. He regards Minimalism, Body Art, and Environmental Art as the same stuff in different packages. And he's right. This is avant-gardism for the microwave generation. Nauman has become a renegade superstar hero for younger artists, such as Cady Noland, Kiki Smith, Matthew Barney, and Jessica Stockholder, who see the art of the '60s and '70s as their image bank, their junk pile.

Bruce Nauman gets us nervous and twitchy and ill at ease—that's the main thing. In some of the earliest works included in this show, he films himself putting on theatrical makeup and photographs himself playing with his toes, and we're left with the feeling that we've invaded his privacy. In a lot of the later work—the torture videos, the neon drawings of erect penises, the neon signs that tell us that we're going to "FUCK AND DIE"— it's easy to feel that Nauman has invaded our privacy. The environmental works consisting of oddly shaped passageways and rooms are meant to disorient us. I presume that the recent assemblages made of animal casts that Nauman purchases from a taxidermy supply house are supposed to put us off. And yet a lot of the time Nauman does not, so far as I am concerned, exactly succeed in unnerving us. Maybe he doesn't care about that, either. Certainly, it's impossible to sink into Nauman's work or feel overtaken by it. In the course of the show, museumgoers have to adjust to so many different media, and to so many oddly mixed media, that they may never get to the point where they're having anything but first impressions.

Nauman gave himself the starring role in the photographic work that he was doing in the late 1960s, and only here, at the beginning of the show, does

he manage to make us feel a bit emotionally involved. At 26 or 27, the age at which he did the *Art Make-Up* movies and the *Hologram Series*, Nauman had the slender build, pleasingly shaped shoulders, and slightly masklike face of an Ancient Greek kouros figure. He was not wildly good-looking, but it is a time in life when moderately attractive people can look wildly good-looking, and Nauman's imperturbable, unto-myself manner—that youthful self-absorption—was part of his college-bohemian charm.

In *Art Make-Up,* Nauman, barechested, slowly plasters thick opaque makeup on his face in four tones—white, pink, green, and black. Although I can't imagine watching this quartet of films for more than a few minutes, Nauman is an interesting camera subject, nobody is forced to stay any longer than they care to, and his narcissism does have some humor and appeal. The same goes for the *Holograms,* with their outer-space red depths in which Nauman, wearing a striped shirt and jeans, scrunches up his body, tweaks his nose, tickles his toes. He's enjoying his own body—this is innocent, nongenital masturbation—and I can see the appeal of these kooky intimate scenes.

In these first works, Nauman is the kouros as bohemian clown. In a few other videos, although his peregrinations round his empty studio are already too deep into neo-Beckettland for my taste, I can appreciate his flat demeanor and the no-style stylishness of his standard-issue T-shirts. I do not think it is amiss to see a hint of sexiness in his bare feet in *Dance or Exercise on the Perimeter of a Square*; Nauman probably imagined that he could turn on half the world by taking off his shoes, and perhaps he wasn't far from wrong. *Neon Templates of the Left Half of My Body Taken at Ten-Inch Intervals* makes me stop and look and think. When Nauman distills his own body into icy green neon curves, one can grant him the ingenuity of using Minimalism as the stealth weapon of an erotic sneak. But this isn't anything that deserves a six-city museum tour, and after the first group of works the show col-

lapses. The youthful quiet egotist who wants to grab our attention becomes a middle-aged raving egotist. We're on the receiving end of a mixed-media mugging.

The show is a sprawling, chilly experience. It's easy just to walk by Nauman's nothingish drawings, but there are other works that, by virtue of their size alone, can hardly be avoided, even when you're mostly looking for the way out. *South America Triangle* is one of a number of pieces that hang from the ceiling: a cast iron chair hovers in the center of a Minimalist triangle of steel beams. *One Hundred Live and Die* is a wall of neon lettering, with messages flashing on and flashing off, among them "PISS AND DIE/PISS AND LIVE." Neon color, which can be magic in the darkness of a city, looks like nothing in a well-lit gallery, but then for Nauman no-thing is a metaphor. There's a series of silhouetted figures done in neon that recall the sleekly anonymous ones that made Ernest Trova famous in the '60s, only in place of Trova's space-age androgyny Nauman gives us jumbo-size penises that flash erect and then flash limp and then erect and then limp.

Nauman is almost as attached to repetition as he is to inconsistency. If inconsistency represents the self-indulgently experimental side of his personality, repetition is apparently the only way he thinks he can get anything through our thick skulls. The museum is a lab. The artworks are the lab equipment. Nauman experiments on us, and in case we aren't quite sure that this is what he has in mind, he includes a rat bumbling through a maze. On a video projection, the rat makes its way through its orange Plexiglas labyrinth while a young man thumps on a drum set; the work, called *Learned Helplessness in Rats (Rock and Roll Drummer)*, also includes the maze (without the rat). In installations such as *Corridor Installation (Nick Wilder Installation)* and *Yellow Room (Triangular)*, Nauman is testing our reactions to unfamiliar spaces, so we become the rats who are put through the maze. And then, like a lot of lab animals, we end up in the morgue, which Nauman suggests with his

heaps of cast animal carcasses and his casts of decapitated human heads—
many of them—in a variety of Crayola colors.

There is nothing that can be said against Nauman that hasn't already been
said in his favor. Peter Schjeldahl, whose elegantly written columns in the
Village Voice are our most reliable guide to what the art world fast set is
thinking, says that Nauman's gift "consists in observing and being true to a
'failure to communicate' built into every language, every style." This may
be a savvy way of describing the sense of drift that a Nauman show induces,
but isn't it something like the ultimate cop-out to say that an artist's failure
to communicate is actually his way of communicating?

Less is more may be one of the great high modern revelations, but it does
not contravene the fact that what you see is what you get and that what you
get in Nauman is nothing much. Schjeldahl says that Nauman creates art
that "cannot be handed down as a tradition." It seems to me that Nauman's
real achievement is to have persuaded the public that he operates in a uni-
verse where neither the high art traditions nor the most rudimentary stan-
dards of popular entertainment ever come into play. Nauman's oddly
shaped walk-in environments provoke a mild, rather metaphorical sense of
claustrophobia, which will not impress anybody who has encountered the
Mannerist gardens and interiors that were being constructed in Europe 450
years ago. And what can the average museumgoer, who takes the technical
wizardry of MTV for granted, possibly make of the shoddy production val-
ues in Nauman's videos? Somebody is sure to explain that Nauman's home-
video ineptness is his 1960s version of old-modern primitivism. It seems that
whenever historical precedents are invoked in support of late-twentieth-
century experimentation, it is in order to intimidate the audience, to shut
people up. Once upon a time, artists challenged conventional beliefs. Now
some of them just want the audience to suspend judgment.

This is Nauman's first major museum show in the United States since 1972, and although he has never been out of the public eye, the timing is impeccable for a man who is now seen as the middle-aged dad of a new mixed-media generation. Nauman's anti-aesthetic is taught in the art schools. So are his marketing strategies. Although this has never been the kind of work that most upscale collectors were going to put in their homes, the market-proof look of a lot of Nauman's pieces can be a selling point among the museum and foundation people and the blue-chip collectors who pride themselves on going where the business-as-usual art world fears to go. In the 1980s, when collectors were betting serious money on new painting, experts might have dismissed the whole mixed-media bag as a leftover from the self-righteous '60s. But since the early 1990s, the market has been in the doldrums, and galleries that can't sell paintings anyway have been more inclined to give precious show slots to work that is practically unsaleable. At least the dealers can feel virtuous while they're surveying the red ink.

Nauman's marketing skills are relevant to our experience of his work. When the pieces that are on display are as no-dimensional as most of Nauman's, the question that ends up sticking in our minds is why people allow him to bore them on this truly staggering scale. Our aging youth culture likes artists who survive their youth without ever growing up, and in middle age Nauman has a knack for making his helter-skelter productions look like a consistent development, even if it's sometimes only in a consistently inconsistent way. He understands that the chamber-scale sexual sensationalism in his early work, which included a video of his own genitals smeared with black pigment, looks visionary a quarter century later, when law enforcement officials in California are allowed to photograph a pop star's private parts, and a New York City tabloid prints a photograph of the knife that a woman used to cut off her husband's penis. The hard-edged view of sex and violence that we get in Nauman's more recent work is as emotionally

dissociated as what we're seeing on the talk shows and the celebrity trials on television. A Nauman show is just artsy pay-per-view TV.

Visitors will most likely leave the retrospective thinking about Nauman's videos of a tortured clown and a tormented mime. Nauman has been dressing up actors in these generic costumes since the late 1980s—they're the most recent rats to be run through the maze. In an interview in the magazine *Parkett*, he referred to such costumes as masks behind which "there's something you don't know and you're never going to find out." But Nauman's theatrical folk are so much the passive figures—even when they're howling at us—that their costumes register less as masks than as straitjackets. *Clown Torture,* which Schjeldahl has described as a "masterpiece" that "pries open a big, scary contemporary sublime," is a six-screen video show in which we see an actor in a clown costume sitting on a toilet, getting bonked on the head by a pail of water, reciting a tongue twister that begins "Pete and Repeat were sitting on a fence," and saying "No" over and over again. There's no mystery to this clown; he's just Nauman's vision of the wretched of the earth as a robotic kitsch puppet. In *Shit on Your Hat—Head on a Chair*, the puppet is a female mime and the oppressor is heard but not seen. The pathetic mime goes through her paces—a series of tortuous bends and movements—in response to the droning off-screen commands of a male voice that orders her to "Put your hat on the table. Put your head on your hat. Put your hand on your head with your head on your hat. . . . "

Nauman wants us to know that his videos of confinement and torture are a response to recent political events. In 1981 he read Jacobo Timerman's *Prisoner Without a Name, Cell Without a Number* and it made a big impression. Yet Nauman's torture videos are such a fashion-conscious mix of Minimalism and kitsch that it seems a little silly to imagine that they're going to help us connect with the nightmare of life under a totalitarian regime. Nauman shows no interest in the victims in his videos. There are no nuances to his

representations of the oppressor or the oppressed, and he doesn't get at what goes on between them. These videos are startling, but they are essentially inert. Nauman doesn't create a work of art that has complex internal dynamics. Perhaps he doesn't intend to. But he does expect us to have all kinds of complicated reactions. We're supposed to take his shock treatment and transform it into an artistic experience. No wonder critics like to dig in.

I have no idea whether the psychopathology that rages through Nauman's recent work is a put-on, a mid-career strategy, or straight from the heart. Frankly, I don't care. What's extraordinary isn't that Nauman shrieks, but that people listen. His relationship with the museum world is pure S&M. The museums invite him in, and he lets them have it. He's a control freak—he hurls neon thunderbolts, builds detention chambers, shouts commands. Since the museums keep coming back for more, one has to assume that the people who make the decisions are getting exactly what they want. In the get-tough 1990s, Nauman is the Now Man.

JANUARY 23, 1995

SOLITARY IN THE CITY OF ART

Two contemporary figure painters have for all intents and purposes chucked their surnames and their given names in favor of singular, rather exotic appellations. Balthus is a childhood nickname that the young artist was urged to use professionally by no less an authority than his mother's friend Rilke. Kitaj is the name of the man whom the artist's mother married when the boy was 8 or 9, and although it is prefaced by the initials R. B., the Ronald that the "R" stands for is used so little as to be almost a secret. These

are artists of different generations—Balthus is 86, Kitaj is 62—who were born and have lived in different places and whose work is in many respects as different as night and day. But I think there is a link between these two figure painters who have made big, singular reputations for themselves in a contemporary scene in which abstraction comes first, and their stand-alone names are not irrelevant to that link. At least this is how it seemed to me last summer in London, when the Kitaj retrospective that has just opened at the Metropolitan Museum of Art was at the Tate Gallery at the same time that the Lefevre Gallery was hosting a Balthus show, which consisted of a single new painting, an almost six-and-a-half-foot-high canvas of a blond-haired girl playing with a cat.

Balthus is painting slowly these days, so the appearance of *The Cat with Mirror III*, the first work to come out of his studio in five years, is an event. And what a painting it is, with its rainbow luxuriance of color harmonized and melted together by means of a magical chiaroscuro. There's a density to this painting that you will not find in anything in the Kitaj retrospective. In their intentions and ambitions, however, Balthus and Kitaj are interestingly complementary figures. The realist-in-an-age-of-abstraction equation doesn't even begin to describe the unusualness of their situations. True, these artists often appeal to people who are dissatisfied with the more reduced forms of classic abstract art. But there's a nonconformism and an art-for-art's-sake feverishness about Balthus and Kitaj that paradoxically links them all the way back to the nonconformist beginnings of the modern movement against which they're often said to be in revolt. The painters and writers who revere Balthus as a Classicist in spite of his sometimes incendiary erotic subject matter may not countenance Kitaj, who is an idiosyncratic Expressionist in spite of his obvious reverence for the modern canon. But for those who keep close tabs on what both painters are up to, Balthus and Kitaj can look like the true inheritors of early-twentieth-century revo-

lution. The two artists paint paintings that poke holes in the modern pieties, and wherever and whenever they exhibit, polemics fly.

These artists are not easy to place: that's key to their appeal. They paint apparently popular subject matter—a blond girl in Balthus's *The Cat with Mirror III;* a street scene in Kitaj's *Cecil Court* (1983–84), the dazzling melange of figures that was plastered all over London's Underground last summer on the posters advertising the Tate show. Yet Balthus and Kitaj have such insistently personal ideas about how a painting ought to be put together that they transform the bare realist facts into enveloping formal puzzles, so that reality itself begins to seem somehow abstract. Their work leaves the old debates about abstraction versus representation where they ought to be, which is in tatters. With the triumph of abstraction, which brought the evolution of Western art toward ever greater verisimilitude to such a startling conclusion, the possibility opened up of beginning all over again, with realism as just a choice among choices. Looking at the work of Balthus and Kitaj, who have made that choice, you may begin to have the impression that the essential polarity in twentieth-century art isn't between realism and abstraction, but between the public and the private—between the extent to which an artist makes use of forms and structures that are already widely understood and the extent to which an artist invents a language that is entirely his own.

Kitaj, who wrote much of the text for the catalog of his retrospective, has been extremely forthcoming about how it feels to live at a time when, as far as art is concerned, anything goes. He has a conversational prose style that's slangy, erudite, and bold, and that sometimes recalls the writing of an earlier idiosyncratic American mythmaker, Edward Dahlberg. Kitaj writes of "the crazy drama of painting," and of being "a painter who snips off a length of picture from the flawed scroll which is ever depicting the train of his interest." Although Kitaj's insistence on explaining himself to his audience is

rather unusual for an artist, I don't think that he's mistaken in believing that an artist who goes his own way will do well to blow his own horn. "Some people," he observes, "live out their lives in places they don't come from, assigning themselves to a strange race and an alien sense of land and city. Who is to say why they do what they do with their lives, or for that matter, why painters do what they do with their painting lives?" By now twentieth-century art is such a maze of depersonalized "isms" that an artist has to insist on exactly how he does or does not fit in.

Could it be that even Balthus, who has for most of his sixty-odd-year career taken the position that the work should speak for itself, is beginning to suspect that those who remain silent are condemned to being misunderstood? In recent years Balthus has encouraged his literary friends, who were once instructed not even to mention the date of his birth, to examine the ins and outs of his biography. And he has himself been doing something he never did—granting interviews. The most extensive of these, published in the English quarterly *Modern Painters* this past fall, is a conversation that Balthus had over the course of an afternoon with the rock star David Bowie (who is a serious collector of contemporary English art and has lately begun to show his own paintings). This interview is an essential addition to the Balthus archives, a great old painter's most sustained effort to tell us what he believes.

When Balthus and Kitaj speak out, they present contemporary variations on a theme that goes all the way back to Baudelaire. They believe that in order to know himself, the artist must know his public. And they believe that if the artist's imagination is powerful enough it can goad, skewer, refute, ignore, correct, and in rare instances even transform public perception. Balthus and Kitaj take this complex relationship with the public in very different directions. In the *Modern Painters* interview, Balthus observes that "probably . . . what people hate so much in my work is harmony. Everything is so contrary to harmony today." If you examine this statement for a moment,

you realize that here we have our preeminent figure painter asserting that the reality he presents in his paintings is a reality that contradicts the facts of life. Kitaj, on the other hand, can sound like an eccentric populist when he sets out his ideas. He has written that his paintings are "pictures of an imperiled world you may know only as imperfectly as I do, if at all." In Kitaj's writing, the line between what's within the studio and what's beyond the studio is never drawn very clearly. He argues against the ivory tower by suggesting that public experience is a magnification of private experience. Yet in his own roundabout way he arrives at an attitude that is, as much as Balthus's magisterial isolation, a version of the Baudelairean stance—the artist is forever ruminating on his troubled relationship with the public.

The typical Balthus painting is of a person alone—the solitary girl in the barely furnished room. The typical Kitaj is a crowd scene. But Kitaj has also painted retreats; there are some canvases of deserted interiors, especially bedrooms, that he has described as his recollections of time spent with friends and lovers. And Balthus has painted street scenes full of strangers who, unbeknownst to one another, are taking their places in what amount to surreal urban pantomimes. In fact one of the grandest images of modern public life comes from Balthus, who completed his final salute to the Parisian streets, *The Passage du Commerce Saint-André*, in 1954, just before he moved his studio from the city that formed him as an artist. Kitaj saw the *Passage*—in which Balthus appears as the figure carrying a baguette—at the Balthus retrospective in 1983 in Paris, and it inspired what is certainly Kitaj's best painting so far, the phantasmagoria on the subject of London street life, with the meandering title: *Cecil Court, London WC2 (The Refugees)*.

Cecil Court is a real place—a teensy street of antiquarian bookshops just off Charing Cross Road—but the theme of Kitaj's painting, which is the city as a theater in which we act out our lives, will be familiar to anybody who has lived in a great metropolis. Kitaj (who was born in Cleveland, Ohio, and

grew up there and in Troy, New York) has become a connoisseur of cities: New York, Paris, Amsterdam, Los Angeles, and, of course, London, which has been home base for more than thirty years. *Cecil Court* is about the London phase of Kitaj's life, but it is also about the inside-outside status of an artist who keeps his own counsel amid the crazy circus of the world. The schematic perspective and bright coloring that Kitaj uses in *Cecil Court* recall a Victorian toy theater, and through this mad-cap setting—all billboard bright colors and acid-etched lines—rush a cast of characters that define London's heterogeneity. They include a bald old man grasping a nosegay, a doll-like pair of kids, a young woman who, legs ajar, throws herself at the world. These men and women are memorable in the way that people we catch sight of in the street can be memorable: we comprehend a personality in a glance, or at least we think we do. Yet each of Kitaj's figures is absorbed in some private reverie, and they are all apparently oblivious to the artist, who reclines in the midst of the urban maelstrom on a chrome Le Corbusier lounge chair, a book at his side and another object, which may well be a book, in his hand.

So far as I know, Kitaj's *Cecil Court* and Balthus's *Passage* have never hung in the same room, but they would make an interesting pair. Kitaj is basically developing a variation on Balthus's absorbing theme, except that the street life that is depressive in the Paris painting becomes manic in the London painting. Where the mood of *The Passage du Commerce Saint-André* is misty and grayed-down and quietly discreet, *Cecil Court,* painted thirty years later, is hard-edged and almost brash. Balthus sees himself from the back, walking away from us; you might say that he's forever retreating from the twilit scene he has imagined. Kitaj, reclining in the midst of everything in Cecil Court, is the lead player who does not—or prefers not to—fit in. Kitaj, an American living in London, paints paintings that give the London streets an American vehemence. Balthus, although born in Paris, has spent more of

his life in Italy and Switzerland (where he lived as a child, passed some of World War II, and has now settled down), and his imagination is perhaps more at home in the Rome or Siena or Kyoto of art history than in the Paris of fact. Both artists have gone in their own directions—they're solitaries in the crowded city of art.

Cecil Court comes near the midpoint of Kitaj's retrospective. This is the painting to which everything we have seen before seems to lead, and it is the measure against which every work that comes after, including such interesting recent paintings as *In the Sea* and *The Wedding*, must be judged. The period of *Cecil Court* and of another first-rate painting, the recollection of an American boyhood that is called *Baseball,* is Kitaj's most fertile phase; these works are both dated 1983–84. But I'm not sure how much people will be able to focus on them within the context of the show because, like most retrospectives that are mounted these days, the Kitaj show is way too big. A dozen paintings and three dozen drawings would have given a far better sense of what Kitaj can do than the more than one hundred items that are included here.

As it is, the drawings get a little bit lost, and that's a shame, because they are among Kitaj's finest achievements. Kitaj's way with a pencil or a stick of charcoal or pastel is absolutely intuitive: drawings that catch the eye this easily can't be willed into existence. Kitaj draws in a naturalistic and at times even journalistic vein that owes something to Degas and something to Lautrec; he uses elegant knife-edge linear effects to create close-up views of the people he knows and loves, and the end product is a casually encyclopedic contemporary portrait gallery. The studies of public figures who also happen to be good friends, such as Isaiah Berlin and Philip Roth, show an easy, idiomatic grasp of the way that a face unlocks a personality. Kitaj draws Quentin Crisp using a mix of charcoal and muted pastel that is one of his most successful chromatic conceptions; the result is a stunning Expressionistic image, terrifying and appealing. The studio nudes, both female and

male, exude a physical self-confidence that gives us Kitaj's definition of grown-up erotic experience. Who else has done male nudes that convey a man's sense of sexual power? There are also extraordinary drawings of Kitaj's family—his mother, daughter, and son. The drawing of his son Lem reading a book is among the very best—exact yet meltingly romantic.

When an artist draws from life, he wants to give an imaginative dimension to actual things. Kitaj is by now an old hand at this kind of transformation, yet when he turns from drawing to painting he often seems to have no compass to guide him. As a draftsman, Kitaj uses nature to discipline his imagination. As a painter, he has an imagination that is larger than life, so much so that there are rooms in the retrospective where nothing that he imagines is plainly, simply alive as art. He turns his intellectual gifts into hyperbolic effects. He wants everything from his figures: he means them to hold together complicated allegories involving themes such as memory and obsession, which I can't help concluding must be painting-proof. In *Against Slander* (1990–91), he paints a city full of gossips; in *Women and Men* (1991–93) a battle is brewing between the sexes; *Greenwich Village* (1990–93) is a landscape of memory. The ideas are thrillingly serious, but a lot of these paintings are just silly-putty spaces. Foreground and background, left and right, up and down slide into one another with a casual willfulness that forecloses any possibility that the canvas can cohere. *Cecil Court* and *Baseball* are fluid dream spaces that somehow simultaneously respect an idea of spatial and temporal unity. *Greenwich Village* may follow a dream logic, but it does not make pictorial sense, and that is the only kind of sense that ever really matters in painting.

Kitaj's fascination as an artist has to do with his way of pulling disparate ideas and inspirations together into an insouciant scrapbook style. He certainly gives new panache to a collage-soaked sensibility that runs through classic modern art and literature and is exemplified by Ezra Pound's *Cantos*

and Max Beckmann's triptychs. I salute Kitaj's intellectual nerviness. Who else would even imagine that it was possible to paint Walter Benjamin's ideas, the experiences of Walter Lippmann, Talmudic concepts, a scene from the life of Henry Adams, the details of one's earliest sexual encounters? Kitaj has dared to go where no one with his sophistication has gone before. Yet there are just too many paintings in which Kitaj is letting the pieces fall as they may and then plugging up the compositional cracks with blocks of bright, flat color. He tolerates far too many grating, stop-and-start effects.

Disjuncture, which is key to Kitaj's work, is a method he has adapted from the copybook of abstraction. Disjuncture once brought fresh drama into art by challenging the idea that a painting represents a single slice of time and space. But today abstraction is all too often a virtually academic enterprise, dedicated to preserving some small trove of painting's possibilities, and Kitaj's very craziness has a strong dose of the formulaic. Still, it is Kitaj's way of using the Cubist-derived idea of disjuncture to rehabilitate older forms of story-telling that has endeared him to many of today's unconventional realists, who say that they want to bring narrative back into art. If you like Kitaj—or the idea of Kitaj—it is going to be because he has so many stories to tell. Yet last summer in London, when the only painting that Balthus has finished in the past five years was hanging across town from the Kitaj retrospective, each exhibition was in its own way a stark reminder of how problematic narrative is today. Balthus had rejected exactly the kind of complex narratives that his fans desperately wanted him to produce. And Kitaj, with 1,001 stories to tell about our overpopulated world, was in the midst of a project that no living artist could possibly bring to completion.

In the *Modern Painters* interview, Balthus sounds both cheerful and austere, a latter-day *philosophe* ensconced in a Swiss "retirement" from which he's pleased to contemplate his turbulent past in Paris and Rome. Balthus is perfectly aware of what is going on around him and of the contemporary ap-

peal of Kitaj's overload of images. Yet he has no complaints. Sometimes he simply turns aside a line of questioning, and a few of those silences tell us everything that we need to know. Listen carefully to Balthus on the subject of subject matter; after all, his sexually explicit imagery was controversial long before Robert Mapplethorpe was born. "The subject has no importance," Balthus says. "The subject for me is always a pretext to make a painting." This is not an evasion but a considered high modern position. Balthus wants both the provocateurs and the prudes to know that they're missing the point.

What, then, is the point? I think that according to Balthus it is that the real story is the story of the making of the painting. Balthus is, after his own fashion, a formalist, but he hastens to distance himself from what he sees as the solipsistic situation of the artist who is "obsessed by painting." What Balthus believes is missing in much modern painting is "tension . . . a sort of no repose." As far as his own practice is concerned, he finds the needed tension not in his subject matter but in the very process of looking—"looking at a chair, looking at a cup of tea, or any object at all." The looking out is also a looking in, for the truth is that much of the apparently naturalistic material in Balthus's paintings has been dreamed up in the studio. There's an almost metaphysical dimension to perception. As Balthus explains it, even "when I paint something after nature, I'm always recognizing something in myself."

Balthus's rejection of the question of subject matter—although probably to some degree strategic, a jibe at the people who imagine themselves to be his disciples and who believe that subject matter is the engine driving painting—contrasts dramatically with Kitaj's manic cultivation of a dozen subjects at once. And yet even Kitaj cannot escape the essential fact of modern art, which is that the way that a painting is made, once a matter of behind-the-scenes magic, is now the key to a viewer's heart and mind. It doesn't matter whether the painting is more or less abstract, more or less

realistic. Since reality is no longer a given, everything is a gamble. If Kitaj is an extreme case of the tendency of modern art to mirror a world that many people believe has gone all to pieces, Balthus is our most triumphant current example of an artist who knows how to put it all back together. In the *Modern Painters* interview he says that he is "always tapping on the same nail. I think what I have kept in a certain way, is my vision as a child. That sort of surprise in front of things." With this parable of a child banging a first nail into a first piece of wood who turns into an old man who's doing exactly the same thing, Balthus takes his rightful place among the great simplifiers. "I'm considering myself as a craftsman," he says. "I don't want to be an artist. I have a horror of the word."

Since completing the melancholy *Passage du Commerce Saint-André* in 1954, Balthus has become an increasingly inward-turning painter. He has put no more than two figures in a painting in the past twenty-eight years; mostly he paints one figure at a time. The raw materials that go into his paintings don't vary that much. There are the juxtaposed planes of floor and wall and furniture, the curves of the model's body, the angle of the light. But through subtle shifts in the way that he carpenters together these essential elements, he now seems to be able to make just about anything happen. He's a master craftsman who works unhurriedly, deliberately: the authenticity of the product is guaranteed by the austerity of the process. Balthus has become as much of a back-to-basics artist as Mondrian. I think it is Balthus's insistence on simplicity that frequently dismays those who look to his work for what Mondrian does not give them. And those who find something wanting in the figure paintings of Balthus may well end up being happier with the work of Kitaj, who keeps knocking together memorably crazy whatnots out of all kinds of found materials.

In London I heard it said that Balthus's new canvas was perfect but somehow not satisfying. Balthus has answered this complaint in the *Modern*

Painters interview, in which he observes that if people look to his paintings for the disharmony that they know in life they will be disappointed. He says that people are "shrinking back from beauty. . . . If you speak of beauty, you are at once suspected of . . . kitsch."

When David Bowie asks Balthus which of his paintings he likes the best, he answers, as many artists do, by talking about his recent work. I agree with Balthus when he says that the new *Cat with Mirror* is one of the finest things he has ever done. It's a painting that unites the Biedermeier solidity of the compositions that first made Balthus famous in the 1930s with the overripe color that was enchanting him in the 1950s: that is its particular kind of harmony. Here the old Balthusian erotic charge has cooled to an androgynous tingle. The young girl, dressed in a contemporary tunic-and-leggings combination that looks a lot like a medieval costume, might easily be mistaken for an extremely handsome young prince. The painting offers a distant, philosophical view of beauty. The key to everything is the work's extraordinary scale. *The Cat with Mirror III* is at once intimate and monumental, and that union of opposites leaves us with a feeling of almost preternatural calm. There is a story to be read in this densely worked yet utterly spontaneous canvas, and it is a very simple one. Balthus began to paint a fairy-tale princess; he worked for five long years; and when he was finished the princess had been granted eternal life.

MARCH 13, 1995

WAR STORIES

Deep into the second decade of the culture wars, with the assaults and counterassaults unfolding with undiminished ferocity, the contemporary art that generally receives the most attention is jingoistic, one-dimensional, a placard raised in a debate. This sloganeering that masquerades as art comes from all sides and is seen everywhere. On an average day in SoHo, a gallerygoer will be unable to avoid the canned chaos of retro-'60s assemblage, the if-you-can't-lick-'em-join-'em cartoon styles, and a prefab traditionalism that ranges from Los Angeles Minimal to Mediterranean Classic.

Some artists combine classics and cartoons. They may, at least temporarily, be hailed as savvy politicians. As for the best painters and sculptors, they have basically decided not to take positions. Excellent artists are working and exhibiting, but when they do exhibit what may first strike a gallerygoer is the inwardness of the work, a self-absorption that can be mistaken for irrelevance. This quality is not necessarily linked to the size of an artist's reputation; a resolute self-containment is as essential a factor in the enigmatic abstractions of Bill Jensen, who is the most original painter to have achieved a top-flight reputation in recent years, as it is in the work of many less well-known artists. The strongest work that's being done today suggests no dominant style, but it all has something of the fierce clarity and complicated inwardness that one expects from private journal entries made in wartime.

This is not a moment when casual excursions to the SoHo galleries hold much appeal, and I cannot blame the sophisticated public that has sworn off contemporary art, preferring to return to the Old Masters in the Metropolitan and the Frick. Even the critics are in denial. The muffled, apologetically evenhanded reviews of the Whitney Biennial that have appeared since

the show opened in March suggest that the very people who make contemporary art their business don't expect much and are in a make-do frame of mind. Klaus Kertess, who organized this year's Biennial, is passing the peace pipe around when he writes in the catalog that he supports "not a return to formalism but an art in which meaning is embedded in formal value."

Like so many late-breaking developments in the culture wars, the 1995 Biennial is born of reaction, in this case a reaction to the Whitney's last Biennial. The theme of the 1993 show was announced in a catalog preface in which the museum's director, David Ross, praised the artists for their rejection of "cynical formalism" in favor of "the geopolitical, the psychosocial," and what he called—in an attempt at hyperliteracy that sounded more like illiteracy—"the body's politic." This was a show in which an artist with degrees from Brown and Stanford reflected on man's inhumanity to man by dressing up in kitsch ethnic garb and spending several hours a day locked in a metal cage watching old westerns on TV. A whole museum full of that kind of poststructuralist radical chic turned out to be too much even for the people who live for political art, and Ross and his curator, Elisabeth Sussman, found themselves with what became regarded as The Biennial That Had Gone Too Far. Ross had played the art-and-politics card and lost, and having hit bottom he knew that there was nowhere to go but up. Since then the Whitney hasn't eschewed political gestures, it's just become better at packaging them and distributing them. This season's political show, "Black Male: Representations of Masculinity in Contemporary American Art," got the generally white male critics into exactly the sweat of guilt and remorse and accommodation that the Whitney had hoped to trigger in 1993. And now, just a month after "Black Male" went down, we have the payback, a Biennial that the white boys can say is nice to look at.

Klaus Kertess has mounted the ultimate nonthreatening Biennial. Who, after going through this show that fills every floor and nook and cranny of

the Whitney, believes that Kertess stands for anything at all? Kertess has been spoken about as a man who cares about painting, but these days caring about painting is often nothing but a debating point, and the Biennial that Kertess has come up with is little more than a truce among rival factions. There are no high points; the low points are familiar ones; the message is that what is is what is.

The scariest thing about the mid-'90s mood is that people are so withdrawn that they're missing the point of, or even missing entirely, a lot of the new work that has a concentrated force. Trevor Winkfield's first show of paintings in six years, which was at E. M. Donahue, presented a complicatedly allegorical view of postmodern chaos that if taken to heart could probably cure a case of the Biennial blahs. But given that nobody any longer believes that miracles can happen in art galleries, I won't be surprised if even the people who saw Winkfield's work have difficulty distinguishing it from the overfull eccentric abstractions of Lari Pittman, which are part of the Biennial blahs.

Winkfield's was one of the two shows in recent weeks that have given a gallerygoer something to take out of the gallery and play around with in the mind's eye. The other was Stanley Lewis's first completely coherent show in eight years, which was at the Bowery Gallery. Lewis's jagged yet delicate painterly realism is in every obvious way unlike Winkfield's zany Surrealist onslaught—they're probably totally unaware of each other's work—but this time around both artists were dealing with the same subject. The best work in Winkfield's show was a painting called *The Studio,* and the strongest group of works in Lewis's was a series of drawings of his studio. The studio is always where the action is, and Winkfield and Lewis, by putting the action in italics, are telling us that they're hanging in there for the duration.

What happens when an artist gets down to work is always essentially the same. It has to do with pushing forms as far as they will go, with allowing

the logic of the forms to unfold as you go along. There must be logic, but the mystery is that the logic is always changing, and an artist needs an extraordinary combination of open-mindedness and precision to be able to go when the going gets good. Going deeper into the studio is literally the subject of Lewis's big, romantically Expressionist pencil drawings, and he makes the theme work for him because he makes a gallerygoer believe that each plunge into real space is an emotional adventure.

There were several startlingly lovely paintings in the Bowery show, with unforced yet precise passages of autumn foliage set against hard blue sky, but the studio drawings were the main event. Lewis has a gorgeous way with his jabbing pencil lines; he erases so much that the paper starts to give out; and then he collages on more paper and starts again. He makes me feel dizzy as I go through this jumbled labyrinth of easels, tables, shelves, sculptures, paintings, paint cans, and miscellaneous junk. These convoluted Mannerist spaces are full of contradictory vistas and alarming leaps in scale. Lewis gives his drawings some of the space-fantasy element that we know from Piranesi's *Carceri*, and this makes perfect sense, because the artist's studio can feel like a prison (in spite of all the potential escape routes).

Lewis uses abstract velocities for realist effect, and he's right to bring this kind of dissonance into his work, because we're living at a time when homogeneity strikes us as an impossibility—a dream that failed. Purism looks illogical; more than that, it looks dishonest. The work that seems to be racing ahead admits of the simultaneous presence of opposing forces—abstract and realist, Classic and Romantic—and revels in the unexpected affinities. Modern art began by taking the nineteenth century's encyclopedic cataloging of the past for granted. The artists admired that past, played with it, leaped forward from it. Creation was a reaction. But in the best work that's coming out of the studios today, there's less of an us-and-them feeling

about the relationship of the old and the new, the sophisticated and the vernacular. The artists who are now in their 40s and 50s took in everything at once—pop culture, Old Masters, modern art—and the result is that mix-ups don't surprise them, and they are able to think of certain kinds of mix-ups as suggesting new kinds of unity.

Klaus Kertess has included all kinds of styles in his Whitney Biennial, but this does not mean that the artists he is spotlighting know what to do with their freedom to choose. Kertess has an eye for arresting images, but he doesn't know how structures bring imagery to life. So what's the point? The show preaches open-mindedness, but at heart it's product-oriented, ends-oriented. Kertess's idea of a good painting is an elegant surface that does nothing (as in Brice Marden) or next to nothing (as in the Agnes Martins). His choice of a painterly realist is the likable but limited Jane Freilicher, who knows how to nurse her naïveté so that it registers as a curious poetic mannerism. When he digs up a younger abstract artist—Sam Reveles is a case in point—the work is so flaccid and inept that it leaves one wondering if Kertess has any idea of how a brushstroke achieves dynamic power. And Kertess doesn't do much better with photography, although Jeff Wall's photographic variation on a Hokusai print—in which a gust of wind lifts a bundle of papers into the air and men clutch their headgear—does uncover pleasing poetic double entendres within the pearly light of an unexceptional day.

In his catalog essay, Kertess looks to Borges's famous story "The Library of Babel" for an analogy to the art scene, which he speaks of as the Museum of Babel. Kertess doesn't press the analogy, but he does, in an eight-page picture essay that precedes the title page, juxtapose photographs of the Tower of Babel and the Whitney Museum, and he obviously believes that contemporary artists are caught in the midst of a Babel of meanings. Kertess reasons

that the artists who are confronted with this overload must reach beyond meaning by turning "a mental concept into completely sensory experience." And he goes on to say that "this transference that takes place in time and space is metaphor."

Kertess isn't much of a writer, but the ideas he's alluding to are as obvious as they are amorphous, and contemporary artists won't have any trouble knowing what he has in mind. You can count on the fingers of your hands, however, the artists in this Biennial who can present metaphor as a process, not an attitude. A room-size assemblage, such as the Jason Rhoades piece with the heaps of donuts, is, like the rest of the neo-Allan Kaprow and neo-Bruce Nauman stuff in the show, ideologically metaphorical, nothing more. So is most of what we see here of cartoon-inspired art, although Carroll Dunham and Philip Taaffe, who both adapt some of the surface effects of popular illustration and design, do prove that pop color and pop form have metaphorical possibilities. Taaffe's abstractions, with their Middle Eastern patterning and retro-chic biomorphism, may add up to little more than great graphic design, but the artist's way of stenciling and printing his colors gives impersonality a piquant visual character that can heat up a work. The problem for artists who see real picture-making possibilities in pop imagery is that it's almost impossibly hard to follow an intuitive visual logic when one is using forms that have been devised to make everybody see and feel the same thing. No artist has been caught in this dilemma more often than Dunham, a psychedelic sophisticate who can be hard and calculating in his paintings (see the Biennial selection) and generally loosens up in a good way in his diaristic drawings, where he remembers where R. Crumb ends and C. Dunham begins.

As for Trevor Winkfield, whose show at E. M. Donahue opened in the same week as the Biennial, he gets going at exactly the point where the Kertess show's cartoon side runs out of steam. Winkfield's work is cartoonish in

ways that the mass-market people couldn't imagine in their wildest dreams. Winkfield makes a metaphor out of Kertess's Babel, but I doubt that Kertess really wants to have his conflicts resolved. Winkfield's abstractions are the products of a delightfully split sensibility—half orthodox Constructivist, half Edwardian pack rat—and that split gives him intuitive access to the high-versus-low confusions. Winkfield presents a construction-paper-bright world in which people are amalgams of weird thingamajigs and even inanimate objects fly off the handle. Although one never knows what's going to happen next in Winkfield's hard-edged Surrealist spaces, he does understand that it is his responsibility to demonstrate that the center ultimately holds. He's an anthologist of kitsch drawing styles, each considered through his eyes, his sensibility. He's also a connoisseur of the shifts in emphasis that turn style into neo-style and then into new style. Of the ten paintings in the Donahue show, five or six are of an Art Deco intricacy that's almost too clever, three or four are first rate, and *The Studio,* an audacious treatise on the art of painting, is probably the best thing that Winkfield has ever done.

In *The Studio,* Winkfield presents both the creator and the creation—to the right is the Dadaist marionette of an artist, to the left is what he's wrought—and Winkfield shows them to be both distinct and intertwined. The artist is a harum-scarum comic hero who advertises his lofty aspirations with a sort of medieval headgear and a bit of schoolboy's Roman-hero drag, but basically he's so busy trying to hold the line in the studio that he can't give us the time of day. His easel, composed of Suprematist angled lines and a couple of pipes that recall Magritte's *Ceci n'est pas une pipe,* is in a state of near-collapse. And the painting-within-a-painting—a hard-to-parse creation that includes, maybe, a bit of Grand Canyon kitsch—is dangerously askew. *The Studio,* with its inspiriting orchestrations of deep reds and blues, is the self-portrait of an artist who knows the world is going crazy and who just presses on. The message is altogether upbeat. If you

have your feet firmly planted on the ground—as this artist's sandled ones, shown from above, clearly are—then everything else can float and fly and spin.

What I love about this painting is the carefully weighted details that Winkfield gives to his wildest fancies. A treatise on painting must have its color theory, and Winkfield presents his in the form of a shelf with glass beakers full of paint that appears in both a six-color and a seven-color version; it's reminiscent of the rows of laboratory-precise jars of pigments in photographs of Kandinsky's Paris studio. On the right side of *The Studio* the cache of colors is in good order, as neat as in Kandinsky's atelier. On the other side of the painting, however, something is amiss. The shelf is slipping, and the beaker of purple paint is nowhere to be found. I wondered what had become of that royal purple, and then I found it clutched in the marionette-like artist's hand. With the brush in his other hand, he's busy giving his painting a few purple passages. Of course the shelf is at an angle: inspiration has struck. And through a process of transformation, whereby the paint within the painting is picked up by the painter in order to create the painting, Winkfield, for perhaps the first time in his career, pushes beyond dazzling design to the freedom of composition.

Winkfield's eclecticism can be called postmodern. But postmodern implies reaction, as in the new taste for the old reacting against the old taste for the new, and Winkfield is too much the unconflicted antipurist to be an ideologue of any stripe. The best artists of Winkfield's generation—he's 51—are all committed to an idealistic eclecticism. Such an open-ended aesthetic could never gain wide acceptance amid the perpetually redrawn battle lines of the art scene, and by now its origins are lost forever in the prehistory of the culture wars, but artists are dreamers and they just keep on dreaming. Apparently they're not the only ones. Damned if Klauss Kertess, who's 54, doesn't believe in that openness, too. And he's gone right out

and sold the dream to the devil by turning idealistic eclecticism into a Whitney Museum product. When it comes to contemporary art, nobody can make a difference at the Whitney; the place is too far gone for that. But doesn't it ever occur to anybody to just say no?

<div align="right">MAY 8, 1995</div>

LONDON GRIT

Leon Kossoff paints a gritty, untouristy London, and he does it with such wonderful roiling paint surfaces and pearly opalescent grays that even people who know the city fairly well may feel some regret at the things they have missed. Kossoff is representing England at the Venice Biennale this summer, and in the couple of dozen paintings that hang in the beautiful galleries of the British Pavilion—they include portraits, nudes, and landscapes, as well as city views—he gives this shambly, rumpled, humdrum London of his an exhilarating, flowing grace.

Kossoff is a city dweller to his fingertips. He knows that ordinary sights can have a talismanic power precisely because we're seeing them all the time. In some recent paintings of people rushing to and fro in front of a flower stall at the Embankment Station of the Underground, he uncovers a grayed-down-yet-coruscated 1990s version of the poetry of the everyday. Another series of paintings, which he's been working on for decades, features the boldly piled-high facade of one of the monuments of English Baroque architecture: Nicholas Hawksmoor's Christchurch, which rises out of the rough-and-ready neighborhood of Spitalfields, not far from the city. In Kossoff's Christchurch paintings, the magnificent formal inventiveness of

a masterwork that's just down the street becomes one element in the dynamics of neighborhood life. Kossoff, who's 69, grew up near Christchurch, and in these paintings one feels how much has gone on around the church, with its dramatically soaring clock tower. Spitalfields has been home to waves of Russian Jewish, Irish, and Bengali immigration and is now being gentrified (the art team of Gilbert and George live around the corner). I mention this neighborhood history because Londoners with whom I looked at the paintings in Venice told me about it, but in a sense it's implicit. The social forces that underlie Kossoff's churning surfaces are familiar to anybody who's spent time in the urban maelstrom, in London or New York or a number of other cities.

Although Kossoff hasn't had all that many one-man shows in England, he is now a major figure in London, where he's viewed in the context of an ongoing English Romantic-Expressionist tradition. In the past twenty years he has also had two shows in New York and three in Los Angeles, and these American appearances have left a strong impression. Around 1950 Kossoff studied with David Bomberg, a painter who's gone into the history books with a few angular Vorticist abstractions from 1912–13 but who devoted most of his working life (he died in 1957) to an emotive, painterly realism. The relationship between Bomberg and Kossoff (and Frank Auerbach, another Bomberg student with a flair for London grit) is a case of an influence that's so clear that the younger generation's work almost becomes an organic extension of what the older generation was doing. Some of Kossoff's drawings, with their heavy, jutting lines, might be mistaken for the studies of London architecture that Bomberg was doing fifty years ago. And in Bomberg's early Vorticist works there's an equation between the overall activation of the surface and the overwhelmingness of city life that Kossoff has had the inspiration to bring all the way into the open through his ever-present network of thickly drawn dark lines.

These insistent lines give Kossoff's paintings the magnified clarity of children's book illustrations. Such linear overdetermination is a calculated risk for a painter, and although this kind of thing can work well in the cityscapes, where it gives contemporary life a once-upon-a-time magic, in many of Kossoff's portraits and figure paintings the results are less satisfactory. Not that extreme linear reduction can't work for a figure painter; it's what gives Léger's people their placid monumentality. But Kossoff wants his heavily weighted contours to suggest psychological depth, and although he manages to tell us something about a person, his noses and eyes and mouths have a jotted-down quality that doesn't really pull together the animated surfaces of these tan-and-brick-colored figures.

I think Kossoff is aware of the problem. Some recent paintings of female nudes slumped in a chair are convincingly weighty; the movement from part to part suggests a kind of unrelaxing exhaustion. But the drawing in the figures doesn't give us the specificity that we want from a portrait or a studio nude, and the color in the figures, although nuanced, is a bit oppressive. Sometimes Kossoff's paint surface, which has generally been very, very thick—the artist's equivalent of a geological build-up—suggests muddle rather than depth. Most of the recent heads are too thickly painted; it's mummified flesh. Part of what's exciting about some of the recent London views is that Kossoff is stopping before the surface closes down, so that you feel fluidity as well as weightiness in the handling of the paint.

All of Kossoff's figures have somewhat oversized features and a weary look in their eyes. I've come to think of Kossoff's people as his lovable, superannuated munchkins. That's not necessarily a bad thing: Poussin did munchkins, too. The comparison occurs to me because it occurred to Kossoff, who did loose copies of a Poussin painting, *Cephalus and Aurora*, some years ago. But then Poussin rarely gives his munchkins the starring roles; he sees them as toy people set in overwhelming landscapes. In Kossoff's

cityscapes, the figures have an echo of that toylike charm that we know from Poussin.

I can see that all the hard work that Kossoff has devoted to the studio nudes pays off in the cityscapes, where the little people who scurry through a London downpour or hurry home from the Underground station are rendered with such summary force. In the Christchurch paintings, the figures moving along the sidewalk don't look at the church, and we find ourselves following their glances even as we look both at them and at the architecture; it makes for a satisfyingly layered experience. Kossoff plays with an interesting idea of likeness-in-unlikeness by describing the architecture and the figures with the same dark lines. There's an equivalence created, so that the building becomes a living, anthropomorphic presence that presses down against the people even as they're pounding the pavement.

Kossoff takes the exact measure of Christchurch's grandeur, but he also likes to bring out the beauty-in-ugliness of a kind of urban architecture that's grown up almost by accident. The Embankment Station and Hungerford Bridge paintings, with their veritable collage of clashing volumes and textures, are as much about the weird fascination of an unplanned environment as are the paintings of New York City's Union Square and 56th Street that Fairfield Porter did in the '70s. (That won't surprise people who've found themselves thinking that there are more than a few similarities between today's sprawling multicultural London and our sprawling multicultural New York.) Kossoff's color is at its best in his cityscapes, more varied and open-ended than in the figures, but even here he sometimes depends too much on surface design.

The children's-illustration flatness gives the cityscapes a nice element of surprise; I feel that Kossoff is allowing himself to have immediate, uncomplicated reactions to a complicated environment. The cityscapes aren't ever blandly reductive, but there's not always enough space to breathe. When

Kossoff paints a shadowy area that's supposed to suggest some depth, the color can go dead on him. He likes to squash his perspective, so that diagonals turn into concavities and the planes that are meant to go back in space lean toward the surface. This spatial indecision, which might be a painterly equivalent of the feeling that moviemakers achieve with their hand-held cameras, is something that Kossoff occasionally overplays. His pulsating city is sometimes just a wobbly city.

Kossoff is growing as a painter; the recent cityscapes seem to be the work of an artist who is breathing more easily, who's not so tense, so clutched. In the newer canvases, the surfaces have a welcome openness and fluidity, so that I begin to feel that everything is changing, evolving, expanding, right before my eyes. Unfortunately, though, in Venice, where the British Pavilion happened to be just about the only place where contemporary painting was presented as a gamble worthy of a large talent, most people seemed to regard Kossoff's work as a take-it-or-leave-it proposition. He was a painterly painter, and that was all there was to say. For some New Yorkers who've watched in recent years as London painters have received a surprisingly large amount of attention—in addition to Kossoff I'm thinking of Lucian Freud, R. B. Kitaj, Howard Hodgkin, Rodrigo Moynihan, and Frank Auerbach—the British presence in Venice could look like more of the same. This year's big theme show in Venice, which the Biennale's director, Jean Clair, devoted to the figure in twentieth-century art and gave the title "Identity and Alterity" (that's their English), included work by Kossoff as well as Francis Bacon, Freud, and Kitaj. Kitaj, on the basis of his paintings in "Identity and Alterity," was awarded the Biennale's grand prize.

In Venice, where the American Pavilion was devoted to a group of video installations by Bill Viola called *Buried Secrets,* you could see an Anglo-American face-off between mind-numbing traditionalism and healthy innovation

or between healthy traditionalism and mind-numbing innovation—it all depended on your point of view. Yet the English situation was more complicated than the British Pavilion might have led one to imagine, for the British choice was deeply resented by those who regard themselves as being on London's cutting edge. They had their own Biennale show, which featured video and installation art, in the Scuola di San Pasquale, a twenty-or-so-minute walk from the Biennale grounds. (Like Kossoff's exhibition, it was under the auspices of the British Council.) Dinos and Jake Chapman were the stars of the Scuola, with their three-dimensional appropriation of the "Great deeds—against the dead!" plate from Goya's *Disasters of War*. I'm not really sure if the Chapmans meant to declare themselves antiwar or anti-art by reducing the harrowing delicacy of Goya's etching to the camp spectacle of several life-size Ken dolls with their genitals ripped out, but nobody could doubt that the Chapmans know how to cause a stir.

English painters may feel that they're as much at the mercy of anti-painting as anybody else is today, but at the Biennale they looked like practically the only artists alive who care to paint pictures of the world. Although I don't think that's the case, there are certainly people in a lot of places, including New York, who do. Painting from London is becoming a popular export. After closing in Venice in September, the Kossoff show travels to the Stedelijk in Amsterdam. An exhibition called "From London," which opened in Edinburgh this summer and includes Kossoff, Bacon, Freud, Auerbach, Kitaj, and several other artists, will be traveling to Luxembourg, Lausanne, and Barcelona. William Lieberman, the chairman of twentieth-century art at the Metropolitan Museum, has had enough retrospectives of London-based artists (Hodgkin is slated for this fall) to make it seem that whatever the financial advantages of transatlantic cooperation, he certainly believes that the Brits are the painters for the '90s. A Kossoff retrospective will be mounted at the Tate in 1996. American museum officials

who watched in 1994 as the Lucian Freud retrospective at the Metropolitan Museum became the number-one topic at Manhattan dinner parties might want a piece of the action, even if it's hard to imagine Kossoff having the knock-'em-dead impact of Sigmund Freud's grandson, who's convinced half the world that he has the last word on how we're living now not in spite of but on account of his small, cold talent.

English art is no more one thing than American art, but there is something to the idea of a national artistic character, and who can doubt that today the English artistic character has an international appeal? In England, where the cultural bedrock is literary, artists have always been inclined to tell stories or illustrate dramatic moments of the kind that one knows from poetry, and Kossoff's cityscapes have that literary quality, even if what he offers is as pared-down a poetic vignette as "I walked by Christchurch one stormy summer day." There are masterpieces of Romantic poetry that begin with little more. The literary disposition in English art has given it an ambiguous status for much of this century, and in our postmodern environment the British resistance to the modern idea that the content emerges from the form can look quite appealing. People are right to be fed up with such modern clichés as art-can't-tell-a-story and art-must-look-like-nothing-you've-seen-before. They're right to admire Kossoff. But we are in danger of being swamped by an equally arbitrary set of postmodern clichés, and they do Kossoff no good.

Contemporary English artists may feel that foreigners exaggerate the significance of a national artistic character. The English themselves, however, are making an assumption about national norms when they insist that an artist's work be understood in terms of some other strong sense of belonging, which in Leon Kossoff's case has to do with his having grown up in a poor London Jewish family. When Waldemar Januszczak, reviewing the Biennale in the *Times* of London on June 18, observed that "you can take a man

out of the shtetl but you cannot take the shtetl out of a man," he did not exactly intend a put-down—Januszczak hastened to add that the same could be said of Soutine and Rothko—but he was suggesting that Jewishness might limit an artist's options. Although Januszczak is possibly the only London critic who said as much in print, there were quite a few people at the Biennale, pro-Kossoff and anti-Kossoff, who were saying more or less the same thing. To Londoners who are tired of all the talk about the Englishness of English art, their comments about the Jewishness of Jewish art are probably a case of giving as good as they get. They have a point. But Jewishness has a way of being posed as a fixed condition, rather than as something that an artist is born into and grows through and then subjects to imaginative transformation.

However Kossoff may choose to regard or disregard his Jewishness, it's unquestionably a factor in the work. It has been observed that Christchurch, for a Jewish boy, must have had the seductive-scary fascination of the unknown. There's probably something to the fact that the student-teacher relationship between Kossoff and Bomberg was a relationship between two London Jews. (Bomberg, who had lived and painted in Palestine in the '20s, would have been perfectly aware of this.) And there is of course much in Kossoff's paintings that brings Soutine to mind. All of this counts—but its significance must be read from the work, not into the work. The connection to Soutine has to do with a lot of artistic factors that have nothing whatever to do with the shtetl. What Kossoff's best recent work brings to mind is Soutine the Francophile, who gave us one of the century's most original reinterpretations of the tradition of Courbet and Corot. That in turn may relate to Kossoff's oft-remarked affinity with Constable, whose place in English art is in certain respects not unlike that of Courbet in France.

Although some in England will regard Jewishness and Englishness as irreconcilable, it may be that in imaginative terms—which are the only terms

that really matter to an artist—they are reconcilable. If English culture is essentially literary, so, too, is Jewish culture. And the English artist who, as an outsider to the modern movement, feels at home with postmodern storytelling may find that his Jewishness fits right into a developing equation. This may help explain why so many of the painters who are grouped under the rubric of the School of London are Jewish. A year ago, when Kitaj reacted to the critical drubbing that his Tate retrospective received by saying that anti-Semitism was involved, a lot of Americans didn't know what to make of his claims. There was a feeling in New York that he was exaggerating. Now that I've been to Venice and seen how insistently Kossoff's painting is linked with Kossoff's Jewishness, I think Kitaj was onto something.

Whether London's high-cult postmodern publicity machine loves you or hates you, it's definitely something to see it swinging into action. Readers of David Sylvester's essay for the Kossoff show in Venice may find themselves thinking back to Lucian Freud, because Sylvester makes on Kossoff's behalf the same overreaching comparison to Rembrandt that a number of writers make on behalf of Freud. (I may be getting whimsical here, but is Rembrandt, who took such an interest in Amsterdam's Jews, viewed as another element in the School of London's Jewish connection?) The comparison to Rembrandt doesn't say anything useful about either Kossoff or Freud, but qualitative distinctions are irrelevant to a public that accepts Rembrandt's name as part of the back-to-tradition PR mystique.

Kossoff, an apparently modest man who just means to mind his own business, may be a little startled to find that his perfectly understandable reluctance to permit studio visits or give interviews is now reported in Garboesque terms. That Kossoff works in a paint-encrusted studio seems remarkable to some; Rudi Fuchs, the curator of the Stedelijk, writes about this workplace as if it were some kind of shrine. Sylvester quotes Lawrence Gowing as describing Kossoff's painterly surfaces as a "confessional net-

work." Haven't we already had enough mumbo jumbo made out of the fact that there's a lot of paint on somebody's canvases? Sylvester, who knew Giacometti and has recently published a book on him, is so into the existentialism of process that he ends up confusing Kossoff's fine paintings with Giacometti's sublime ones. But then literary types have always mistaken Giacometti for a process-oriented artist, as if his greatness had to do with his changing things so much and not with the perfect accuracy and eloquence of his finished canvases. (If indecision made masterpieces, there would be a lot more of them.)

The point is not more paint or less paint, or more subject matter or less subject matter; it's the appropriateness of what's there. I think Kossoff would agree. Even as he's being hyped as the art world's latest anti-star, his paintings are becoming less mannered, more direct. There have been times, especially in the '60s and '70s, when Kossoff was into paint for its own sake, and the results were overly impastoed surfaces, clotted dark color, and a disturbingly webby overlay of gray-white drips. In recent years he's been simplifying his painthandling, and the result, especially in the newer Christchurch and Embankment flower-stall paintings, is an admirable openness and lightness. These are just about the best canvases that he has ever done.

When he paints the flower stall, Kossoff is declaring his interest in the power of pure color. Although he's not giving up his gray-and-tan vision of London, he is allowing more and more brightness to seep into the moist atmosphere, and the result is a glinting richness, a buoyancy. Kossoff is moving from not-enough-color to no-color color. This is something that you can learn all about in Venice, where Titian filled big canvases with rainbow-rich grays. Kossoff won't bear comparison with that ultimate Venetian master, but I think it says a good deal about this Englishman's work that it does not look ridiculous in the Venetian context.

SEPTEMBER 4, 1995

BORN UNDER SATURN

The work that Bill Jensen has been doing in the past several years is as exciting as any painting that has ever been done by an American. This 49-year-old artist is a master of inchoate, muffled-yet-fierce emotions, and no other artist alive has given us so many haunting impressions of the lowering, saturnine side of the artist's spirit. By contemporary standards Jensen's abstract canvases are small—generally two or three feet high—and this focuses us on the autographic force of the surface, which he builds up and rubs down and then builds up again with a concentrated lyricism that's so intense that it can be a little scary. Jensen has an alchemist's gift for turning piled-high brushstrokes and flotsam-like bits of pigment into the substance of a mythical natural world. It's an ugly-beautiful universe, where the vistas are eerie, the color is febrile, and every landmark has a scintillating allegorical power.

The poetry of Jensen's work is a matter of hints and flashes, of meanderings, unfoldings, unfurlings. There's a marvelous slowness to these paintings; you feel Jensen's contemplative pace. One way to explain what Jensen does is by explaining what he does not do. He never employs an end-to-end structure that takes its essential logic from the rectangular shape of the canvas. That's the French way—composition as a discipline that leads to a revelation—and it has nothing to do with Jensen's piece-by-piece, questing approach. Although there are many Jensen paintings that contain a singular, looming image, he arrives at that all-in-one impact indirectly, incrementally. You get the feeling that he's begun each painting by focusing on some tiny element—the color of a brushstroke, the weight of a line, the thrust of a curve—and that for him the process of making a painting is the process of watching that first mark or gesture grow. In Jensen's work,

growth is gradual, uneven, surprising—like bits of moss and lichen appearing on decaying branches and then spreading unpredictably, creating romantically irregular patterns.

There are six paintings in the Bill Jensen show at the Mary Boone Gallery in New York, and in order even to begin to look at them a gallerygoer has to tune in to the artist's quietest, slowest, doing-almost-nothing mood. Two paintings, *Colossus* and *Pagan,* are very impressive. Both are vertical, a bit over three feet high, with a horizon line dividing the surface into nearly equal parts and summoning up, with almost diagrammatic abruptness, a view of sky above and earth or ocean below. *Colossus*, with cold blue brushstrokes spread out before the orange-yellow haze of the sun, is the primordial, Homeric sea. In *Pagan*, clouds of that same cool blue scutter across a greenish sky, a sky that's as uninviting as the rough, red-and-black terrain below.

These symbolic landscapes contain no trace of a human presence; no path cuts through the gloom of *Pagan;* no boat could navigate the dangerous waters of *Colossus*. In the lower portions of the paintings, Jensen curves his elements to give just a suggestion of perspectival depth, but he's not invoking a particular place so much as summoning a harshly sublime mood. He's an ultra-sophisticated artist creating barbaric scrawls. And the painthandling, with its complete lack of charm, underlines the peremptory spirit of these works. When I look at the paintings close up, I feel the chill of the palette knife rather than the softness of the brush. The roughed-up paint has some of the quality of Eastern calligraphy, of those complicated, iconic gestures that seem to emerge almost involuntarily out of an artist's reserves of calm. These landscapes, which feel both worn-out and untouched, are about mapping unmappable experiences, about being in a place that has no beginning and no end.

In the Boone show there's a third painting, called *Winter Light*, that does a remarkable job of evoking frozen desolation by means of a few brown marks

set on a beautifully distressed surface. But after *Colossus, Pagan,* and *Winter Light,* the quality of the work drops precipitously; the three other paintings are so understated that in each case I can conclude only that Jensen has left some essential part of the story inside his head. As I moved around the gallery, every other painting drew a blank. And since Jensen's dominant theme here is the fascination of near emptiness, the outright emptiness of one half of the selections can't but undercut even his subtlest efforts.

The show is sunk by all this weak work. It's an out-of-focus exhibition, one that conveys no sense of the variety of Jensen's recent painting, and I can't see how people leaving Boone will understand what kind of an artist Jensen really is. This show is a very disturbing event. In the 1940s, Clement Greenberg often complained in print that the best American painting was to be seen in the artists' studios rather than in the galleries. This fall Bill Jensen confounds us with the case of a remarkable artist who is showing at what is generally regarded as one of the most prestigious galleries around, but has left the majority of his strongest work a few miles away, in his studio in Brooklyn.

I realize that by comparing the show at Mary Boone with the much larger group of paintings I saw in Jensen's studio some six months ago, I'm making a value judgment that's based on insider information. I'm loath to take advantage of such information, but the mismatch between what Jensen has been doing in his studio and what's on display at Boone does such a disservice to the gallerygoer that a critic cannot but offer a behind-the-scenes view. This is only Jensen's second show at Boone, and the gap between his authenticity and her stylishness is wider than it was two years ago, when he first exhibited on West Broadway. There is no excuse for his not showing at least a half-dozen more paintings, including some of his recent underwater universes and fiery nightscapes. There's certainly enough room at Boone to demonstrate that Jensen is now able to present complicated emblematic subject matter with intuitive ease.

At the beginning of the '80s Mary Boone pioneered, almost single-hand-edly, an overbearingly austere, Zen-Fascist style in gallery design, and by now it dominates the upscale scene. Boone's space at 417 West Broadway gave the slob-job work of Julian Schnabel and David Salle the VIP send-off that it so desperately needed, but this gallery flattens out paintings that are discreetly emotional. The Mary Boone Gallery turns Jensen's paintings into postage stamps; even his strongest canvases look underpowered. The real stars are Boone's perfectly smooth, nearly empty gallery walls. This is a hell of a spackle-and-paint job, but it doesn't make for an artist-friendly envi-ronment.

At the very least, Boone could have let gallerygoers in on what Jensen is up to by presenting, in one of the other rooms in her capacious building, the suite of intaglio prints that he completed in the spring of 1994 for an artist's book titled *Postcards from Trakl.* This collaboration with the poet John Yau is an homage to the Austrian poet Georg Trakl, who died in 1914 at the age of 27. In these prints, which are a mixture of aquatint and etching and just about everything else that can be done on a copper plate, Jensen is do-ing what we don't see him doing at Boone—alternating skyscapes and land-scapes, fading-away images and rushing-forward images, getting into the details of an imaginary world. So why is the public being denied access to this work? Has somebody calculated that Jensen's fecundity will not go over with the SoHo audience? To the extent that the Boone show represents Jensen as a visionary wandering in the wilderness, it's not a completely in-accurate view of the artist. But Jensen is a lot of other things. He's an artist who knows something about complexity and richness and paradox, and in an art scene that's desperate for variety and expansiveness, it's maddening to think that people aren't seeing what Jensen can do.

Like so much that's urgent in contemporary art, Jensen's work draws some of its force from the artist's essentially solitary position, from his very

lack of significant relationship to anything that anybody else is doing. True, Jensen's small formats, biomorphic forms, and impastoed surfaces have been widely imitated. They have by now generated a whole new kind of art-school product. The allegorical power of his work was an element in the '80s art experience, but even so Jensen's paintings never lost their somber detachment. At Boone, Jensen's solitude is turned into a commercial cliché, and it's easy to forget that he's just about the only artist who's given some internal coherence to Neoexpressionism—which was the '80s way of finally trying to deal with all the overwhelming emotions that were left over from the '60s. Whereas most of the Neoexpressionists have treated generational feelings with trivializing irony, as Zeitgeist bulletins, Jensen has *visualized* the post-'60s feverishness.

Jensen's first breakthrough came late in the 1970s, when he uncovered new life in a strain of mystical nature poetry that had run through American art from the storm-tossed seascapes of Albert Pinkham Ryder to the musical abstractions of Arthur Dove and the Maine forests of Marsden Hartley. These were not exactly underknown or underappreciated artists. What was significant about Jensen's encounters with an earlier American art was that he uncovered a contemporary urgency in paintings that were generally regarded as of little more than historical interest. Jensen avoided the risks of antiquarianism; he made the experience of these early American moderns feel very much his own. People saw Jensen's small formats, and the specificity with which he drew his enigmatic visions, as signifying a break with the overbearing scale and homogeneous look of postwar American art. That led to the conclusion that Jensen was anti-Abstract Expressionist. In retrospect, however, it seems that Jensen was only finding his own way back into Abstract Expressionism.

Jensen came to New York from Minnesota, where he'd studied with Peter Busa, an old friend of Pollock's, and when he first exhibited the paintings

in which small redefined beautiful it was his way of rejecting not Abstract Expressionism but a calcified view of the movement. Jensen wanted to get away from the chilled-out imagery of the later '50s and '60s, back to the high-pitched, densely figured, gritty, even Gothic temperament of Pollock and Gorky and de Kooning in the '40s. His inward-turning scale, which is as much of an extreme statement as the Abstract Expressionists' wall-sized canvases, was a personal way of refocusing attention on the surface. And once Jensen had gotten down to basics, he knew that he could go anywhere, that he could question all the underlying New York School assumptions. In the mid-'80s he experimented with a sort of Surrealist landscape that was so literal it risked academicism. He's learned much from the streamlined forms of Arp and other Purists; and in recent years he's looked farther afield, at the mountains in Trecento painting, at Goya and Michelangelo and Chinese scrolls.

Whether Jensen is reaching for a dense, cloisonné effect or something glancing and open-ended, he takes the same from-the-ground-up approach to form. Everything begins with the drawing, whether it's being done with pencil, ink, or oil paint. When Jensen is drawing, he's cultivating his garden, watching things grow. In recent years he has developed a way of working in black and white with brush and ink that's his alone; in the spring of 1994 there was a remarkable show centered on these drawings at the Washburn Gallery (where Jensen began exhibiting in 1980 and continues to show his graphic work). Jensen lays strokes down on thick paper, blots and sponges them while they're still damp, and then works back into the surface. He's literally watering the paper, so that it becomes the soil from which the images emerge. He pushes into that dense, loamy surface (he uses gorgeous paper) over and over again, so that the result is an enveloping, dark-pewter mysteriousness. This is parallel to what he does with pigments and oils in the paintings. Although the highly worked paint surface has become a

mannerism in many of his imitators, with Jensen it's tied so closely to the discovery of forms that even his most exquisitely rubbed-down effects have an invigorating straightforwardness.

In his printmaking, Jensen is doing just about everything that's possible on a copper plate; he seems to be working inside the metal, extracting its secrets. For the past six years, some of the motifs that dominate his paintings have also been cropping up in the plates that he's been preparing for *Postcards from Trakl*. The finished book, which presents the Jensen universe between hard covers, bears comparison to some of the finest illustration that French artists did in the first half of the century. True, John Yau's poems, despite some striking lines, are mostly Surrealist boilerplate, but many remarkable artists' books have had unremarkable texts, and in any event Jensen's real subject isn't Yau's poetry but Trakl's. This Austrian writer is generally seen as a bridge between fin de siècle dreaminess and Expressionist simplification, and in many respects Bill Jensen is a kindred spirit. Jensen may have had Trakl's "nocturnal wing-beat of the soul" in mind when he created several birdlike forms out of lightly inscribed lines. In Trakl's poetry "Scarlet banners whirl through the mourning of the maple-tree," "The tree of grace blossoms golden out of the cool sap of the earth," and "All roads end in black decay." It's a late-autumn atmosphere that one knows from Jensen's paintings, and in *Postcards from Trakl* this American contemporary is in a German Romantic state of mind, weaving themes of earth and air, heaviness and lightness, growth and decay into a shadowy, interior drama.

Postcards from Trakl opens with a composition of looming forms framing a barren land. There are hovering heraldic devices, and bizarre tubular shapes that are like root systems refracted through a Baroque imagination. Jensen even manages to bring comic grace notes to the saturnine spirit of *Postcards from Trakl*; he sees the humorous side of his weird visionary landscapes. *Postcards from Trakl* is something rare in contemporary American art: a collabora-

tion between a painter who glories in the demands of intaglio printmaking and a master printer—Bill Goldston of Universal Limited Art Editions in West Islip, New York—who probably spends much of his time holding the hands of big-name artists who just want to make a quick buck with some print editions. With this collaboration between Goldston and Jensen, ULAE has become the first American print studio since World War II to produce an artist's book that actually capitalizes on the almost limitless emotional possibilities that are inherent in the printmaker's art.

Atmosphere is a central protagonist in much of Jensen's work. This is why he has such an intuitive feeling for the velvety chiaroscuro of intaglio printmaking. Many of his strongest drawings, prints, and paintings leave us in a state of pleasurable suspension, because we can't exactly say what we're seeing, even though we know precisely how it's making us feel. In the paintings at Boone this fall, Jensen takes nonspecificity as far as it will go; even the clearest paintings give us little to touch down on, save for those casually drawn horizon lines that separate earth from air. Obviously Jensen is testing the limits of his anticlassical, antiarchitectonic method, and that's perfectly legitimate. The problem is that some of these paintings that are meant to be emotionally elusive are also formally unresolved, so that Jensen's homegrown, unto-myself strength begins to look like homegrown obtuseness.

I think Jensen meant to offer us a key to this evanescent world of his when he gave a number of the Boone paintings homage-to-great-moviemaker titles. One of the weakest canvases is named after Andrei Tarkovsky's film *Stalker*. There are three that refer to Bergman: the delicate *Winter Light*, the inconclusive *Hour of the Wolf*, and the vacuous *Madame de Sade* (Bergman directed a production of the Mishima play that was presented at the Brooklyn Academy of Music last season). I don't want to bear down on the relationship between particular titles and particular paintings—it would only underline the problems with these works—but I take Jensen

absolutely seriously when he encourages us to believe that there's a connection between movie atmosphere and painting atmosphere. That connection is at the heart of Jensen's recent work, especially some of the work that we're not seeing at Boone. I think Jensen is the first artist of his generation who's done what so many have talked about doing: he's brought something of the movie experience into painting.

Jensen understands that the essence of the movie image isn't its composition but its flow, its changeableness, its kinetic feel. Whereas David Salle will focus on the campy dissociated qualities of the film still, Jensen wants to use his antiarchitectonic kind of painting to evoke the flooding-over-us high of movie emotion. People who know Tarkovsky's movies see immediately why Jensen is drawn to them; Jensen's looming enigmas and watery and misty effects parallel Tarkovsky's allegorical universe. What the critic Paul Coates says of Tarkovsky—that he creates a world that "exists simultaneously in the monochrome of depression and the color of joy"—goes for Jensen, too. With Tarkovsky, it's the wildness and the strangeness that Jensen is responding to. In the case of Bergman, the affinities are subtler, more emotionally complex, so much so that it's tempting to believe that Jensen has closer artistic ties to this Swedish director than to any painter living or dead.

Jensen shares Bergman's taste for looming, spiky Gothic imagery. And Jensen, who comes from a Minnesotan-Scandinavian background, has a feeling for the beauty of desolation that's part of a Northern European tradition that Bergman has defined for American audiences practically since Jensen was born. If such early Jensens as *Crown of Thorns* and *The Tempest* suggest the dark medievalism of Bergman's *Seventh Seal* (which was an art-house chestnut by the time Jensen went to college), some of the more recent Sienese landscapes and ebulliently striped snaky shapes suggest the exuberant Bergman of *The Magic Flute*. In Bergman, sensuousness can flash up in the

midst of severity, and an allegory can leap into startling life. I think Jensen is bringing these same strong, contradictory forces into his painting. He, too, can give ponderous emotions an immediate, flowing grace.

The Northern artist is the sensualist who is forever at war with his own sensuality, and more and more Bill Jensen has been reaching toward a daringly complete portrait of a divided self. Jensen's dominant note remains one of chilly winter light, but his feeling for that kind of beauty leads him to explore other kinds of beauty, to yearn for and sometimes evoke southern gentleness, even southern heat. More than anything else, it's the clashes of gravity and exuberance that make Jensen an artist whom we want to watch. By looking into his own emotions, he's gotten at a generational truth. His sliding-one-into-the-other emotions are our emotions. With his darkly burning conflicts, his full-out lyricism, his feeling for a beauty that's sometimes indistinguishable from the grotesque, Jensen keeps us baffled and unnerved. He knows more about us than we sometimes care to know about ourselves. Melancholy? Divided? Marooned? This is not how the generation that started out in the '60s ever expected to feel.

OCTOBER 23, 1995

THE THIRD DEGREE

Why is it that the critics who trumpet the death of painting, or even the end of art as we know it, rarely have anything dire to say about the state of sculpture? The apocalyptically minded could certainly find danger signs if they wanted to. A well-constructed new sculpture is much more of a rarity than a well-constructed new painting. And even in the galleries that are re-

garded as strong supporters of experimentation, works that hang on the wall not infrequently outnumber works that sit on the floor. Yet not a season goes by without somebody declaring that painting, at least painting that's any good, is going to disappear or has already disappeared. In some quarters there is a strong desire to dismiss all the painters, for simply by doing what they do they have resisted the modern principle of perpetual artistic change.

Painters are still working where they've always worked, which is up against the wall. The sculptors, meanwhile, have allowed themselves to be backed into quite a few corners, but any jam that they've found themselves in has been turned into yet another case of healthy experimentation. If sculpture remains the art that the trendwatchers feel most comfortable with, it's because sculptors have by and large accepted the avant-garde agit-prop about being constantly on the move. Just when somebody might have thought to declare the death of sculpture, sculpture has slipped away and reinvented itself as a Primary Structure, a Specific Object, as Scatter Art, as something Site Specific, Environmental, or Conceptual.

This season, like every other season, sculpture is in the news. There has been a much-talked-about show at PaceWildenstein of new work by Kiki Smith, who probably has the fastest-growing reputation of any contemporary American artist; and there are other shows of young-to-mid-career artists, among them Jessica Stockholder and Mel Kendrick, each of whom has turned sculpture inside out, apparently for no other reason than to keep people's attention. But this is not the half of it. If one needed to be reminded that sculpture's quick-change status is not exactly a recent development, there's Claes Oldenburg, who specializes in teaching old hats (and erasers and clothespins . . .) new tricks, with an exhibition called "An Anthology" that opened at the National Gallery in Washington last winter and is now at the Guggenheim in New York. Some may regard Oldenburg as a

modern classic, but then where does that put Constantin Brancusi, who is the subject of a retrospective that opened in Paris last spring and is now at the Philadelphia Museum of Art? It would be nice to be able to say that Brancusi, a titan who died in 1957 at the age of 81, set modern sculpture on its way and is always there for those who'd like to get back on track. But the truth is that Brancusi has nothing much to do with where sculpture is today, and to the extent that modern sculptors look to him they hopelessly misconstrue him.

Oldenburg, not Brancusi, is our founding father, a fact that will offer no comfort to museumgoers who, while taking in thirty-five years of work in a chronological ascent around Frank Lloyd Wright's spiral ramp, find that, artistically speaking, it's downhill all the way. The brusque, wayward charm that Oldenburg could achieve in 1960 and 1961 with some painted plaster replicas of cheap clothes and high-calorie deserts evaporated pretty fast. He's spent decades asserting ever larger claims for the same everyday subject matter that he first brought together in The Store that he set up in his studio on East 2nd Street in December 1961. The thought that you might make anything into high art by literally inflating it was a fair joke the first time, but does it bear repeating twice, not to mention hundreds of times?

Of course nobody expects subtlety from this cheerfully megalomaniacal artist. Everybody just wants Oldenburg to be himself, and that includes younger artists who look at his huge popular success and are encouraged to imagine that they, too, have a future north of 14th Street. He's a downtown boy who made it, and with *Knife Slicing Through Wall* (done in 1986 and, like all the recent work, in collaboration with Coosje van Bruggen) he presents a kind of oversized polemical flourish that today's retro-conscious artists would do themselves if only they had the wherewithal. Near the top of the Guggenheim's ramp, this twelve-foot knife blade, made of plasterboard, sticks straight out of the wall, creating the impression that somebody has

thrust a gigantic piece of cutlery into the gallery. *Knife Slicing Through Wall* is far too calculated to kick off a visceral, emotional reaction, but as an insider view of sculpture as contemporary aggressor its meaning is as unavoidable as a tabloid headline: ARTIST STABS MUSEUM.

Dadaist gestures are exactly what we expect from Oldenburg, who was labeled a Neo-Dadaist when Pop Art was still a movement in search of a catchy name. Actually, he's remained more of a Neo-Dadaist than a Pop Artist; he's still basically wreaking variations on the transgressive potential of sculpture that Marcel Duchamp first defined in 1915, two years after he'd begun to put his name on store-bought objects and send them out into the world. Among those early Readymades were a bicycle wheel, a bottle rack, a urinal, and a snow shovel. Duchamp's essential insight was that it would be easier to make anti-art out of sculpture than out of painting. Go up against painting and you were challenging the vigor of Impressionism and Postimpressionism, of Fauvism and Cubism. But go up against sculpture and all you were really doing was puncturing a lot of nineteenth-century hot air— all those rows of plaster casts of classical sculpture in the academies, all those dull bronze figures in all those city squares. The urinal sent up centuries of icy marbles; it pissed on the whole classical tradition.

Although the early Oldenburgs are domesticated Duchamps—homemade Readymades—in recent years Oldenburg has become a Corporate Dadaist. Like just about all high-profile contemporary sculpture, however, his work makes its bid for attention on the basis of a paradox, which is that Dadaism, having turned sculpture against sculpture, has brought sculpture to the fore. Sculpture has become the Other (it can be anything!), and it's popular for that very reason. Sculpture can be a friendly neighborhood Other, what arts organizations erect at outdoor sites for summer fun. As for sculptors who are in the limelight, they are almost invariably doing work that's thought to be interesting insofar as it is whatever it isn't expected to be. And

this season, what is sculpture not expected to be that it's being? Duchamp, who perhaps thought that painters deserved a bigger piece of the action, once observed that "since the tubes of paint used by the artist are manufactured and readymade products, we must conclude that all the paintings in the world are 'Readymades Aided.'" Well, at the Dia Foundation on West 22nd Street, sculpture is now a giant painting that's galloped off the wall.

Jessica Stockholder is the artist, and the long title of her Dia installation is *Your Skin in this Weather Bourne Eye-Threads & Swollen Perfume*. Stockholder knows all the moves of the Oldenburg generation. She roughs up the big ground-floor Dia space with inexpensive materials—stacking crates, carpeting, electric cords—and then she pulls it all together with an intelligent feeling for abstract color and theatrical pacing and three-dimensional design. It takes some taste to arrange that huge pile of purple plastic crates near that salmon-colored wall, and it's nifty how the yellow extension cords run from each light socket on the ceiling into a gigantic heap of table lamps mounted on a platform to one side. But when Stockholder manipulates assemblagist conventions—and seventy-five years after Kurt Schwitters these *are* conventions—she treats them generically, almost academically. There's a blandness to the work; it lacks individualization, tension, point.

Stockholder is probably expecting us to do the emotional work for her, but then no sculptor who's achieved a big reputation in recent years seems prepared to take emotional responsibility. Everybody has adopted the Meret Oppenheim approach; line the tea cup with fur and let the audience do the rest. Kiki Smith understands that all the tea cups have already been lined with fur, and that by now the bad-old bronze figure, under the right conditions, is the newest thing around. In her show at PaceWildenstein on Greene Street, lumpish figures, mostly executed in bronze, hung or sat or stood in odd places, while a flock of dead birds, also in bronze, was scattered across the floor. It was Symbolist salon art given a Minimalist presentation.

Of course Kiki Smith has her carefully cultivated little quirks. In addition to the figures and birds, there were chains and charms and baubles hanging here and there. And her figures have names like *Lilith* and *Ice Man,* so that we get the idea that myths are being retold for our time. But her figure modeling—which is insecure, to put it kindly—demonstrates no interest in the body except insofar as it can kick off wan sentimental-humanist thoughts in gallerygoers who've secretly hoped that art would come back around to their way of seeing things. It's the off-the-pedestals, topsy-turvy installation in a huge, white downtown space that gives this mawkish stuff its zing. In the late '60s, Robert Morris flung felt strips around a gallery and they called it Scatter Art. In the '90s, Kiki Smith dribbles bronze crows in a gallery and it's Eco-Feminist. A great deal of trouble probably went into casting all those crows, but the emotion was readymade.

Duchamp turns up in the background of the Brancusi retrospective in Philadelphia, or he does if you read Ann Temkin's catalog essay on "Brancusi and His American Collectors." A central theme here is the strong advocacy of Brancusi by Duchamp, who was a key figure in the Franco-American avant-garde. Duchamp got American dealers and collectors interested, and that's in part why there are so many Brancusis in our museums. Temkin—the Curator of Twentieth-Century Art in Philadelphia, who organized the show with Margit Rowell, Chief Curator of Drawings at the Museum of Modern Art—recounts an anecdote about Duchamp, Brancusi, and Léger going to an aviation show in Paris. "Observing a shiny metal propeller," Temkin writes, "Duchamp allegedly asked Brancusi how any artist could possibly do better." I expect that Duchamp knew—and Brancusi knew that he knew—that a Brancusi *Bird in Space* was better. Then again Duchamp devoted a great deal of his life to work that begged the question of better and worse, or at least led people to believe that it did. The propeller is a red her-

ring, but as a question that never seems to go away it detracts attention from the essential paradox of Brancusi's work, which is that his streamlined, erotically charged modern forms are grounded in a vehemently premodern, an almost medieval, sense of craft.

In Philadelphia the Brancusi show has been presented a little too coolly. The installation includes walls with translucent insets that are an intelligent attempt to echo the look of Brancusi's studio, and the low platforms on which the sculptures are arranged are certainly attractive. But it's all in such damn good taste that the show begins to look like one of the ads for Calvin Klein's new line of home products. There's an evenness to the pacing, a lack of surprise. Brancusi could do with some unapologetic showmanship. You should feel the light flashing off *Bird in Space* as a direct, unmediated experience; you want to be awestruck, the way you are by a glimpse of an Alpine peak. Sculptured form is present in the world in a way that no form in a painting ever is; the Philadelphia installation pictorializes the work, sets it in a handsome, slightly grayed-down context, and that's no good. The bronze version of the *Blond Negress*, with its shimmering surfaces, is probably the most luxuriantly beautiful use of metal in the entire European tradition; it ought to flash out at us, with the blinding force of a tropical sun. In Philadelphia, the *Blond Negress* doesn't make enough of an impression, it's just an exquisite Parisian souvenir.

Although Brancusi lived in Paris for fifty years and entertained a long list of famous names in his Montparnasse studio, his achievement stands at a remove from that complicated, fast-moving period in European art. Matisse and Picasso could build on Cézanne and Seurat and Ingres and Delacroix; but for Brancusi, who arrived in Paris in 1904 at the age of 28, there was only the equivocal, high Romantic example of Rodin, in whose studio he worked briefly. The profound connections that Brancusi established through his sculpture with India, Greece, and Africa, do tie into a whole series of early-

twentieth-century interests in the archaic, the primitive, the non-Western, and the naive; but whereas Picasso and Matisse drew general conclusions about the nature of form and structure from far-flung sources, Brancusi put everything he knew into singular, solitary objects. If Brancusi had no significant artistic parent figures, he has also probably had less impact on succeeding generations of sculptors than Picasso, who worked in three dimensions only part-time. Even those who really learned from Brancusi have tended to focus on his sense of quality rather than on his sense of form.

The seamless magic of Brancusi's greatest work is not unrelated to this paucity of ancestors and descendants. Perhaps because he worked on the same subjects or close variants for so long, Brancusi was able to cover his tracks completely, so that museumgoers don't find themselves working their way into the sculpture so much as they comprehend it at once. A Brancusi is a particularity that contains all generality. He's an idealist, a mystic. The various versions of the *Endless Column*, with their piled-high rhomboids, embody just about everything that Brancusi had to tell us about decorative rhythm, and that's a lot. The *Bird in Space* is his definitive statement on the gravity-defying power of stone carving at its greatest. *Nancy Cunard* and *Mademoiselle Pogany* are definitions of the Modern Woman. Brancusi, who by contemporary reports spent days on end polishing his bronzes and marbles, knew how to give them the irreducible and maybe unanalyzable force of natural wonders. The great Brancusis feel as if they've always existed, and it's in this sense that they recall such premodern monuments as Michelangelo's *Slaves*.

It's an artist's responsibility to help us see the masters in a contemporary way, and it's no surprise that a generation of artists trained to think in terms of context and environment has looked at the way that Brancusi set streamlined volumes on rough-and-ready wood bases and has frequently been more interested in the bases than in what they support. These bases do raise

fascinating questions that lend themselves to traditional art-historical treatment. Brancusi tried different sculptures on different bases and documented his thinking in the beautiful photographs that he took of his studio and its contents. He also frequently sold sculptures without bases. At the Philadelphia Museum of Art even the most peculiar installation decisions, such as the wooden *Cup* that is mounted atop a *Column,* can be supported by Brancusi's own photographic record. But which photograph is one to believe, when Brancusi often arranged the same works differently at different times?

If you think about Brancusi's bases long and hard enough, you may find yourself getting into all sorts of subversive thoughts. Was Brancusi highlighting the pedestal because he was afraid that sculpture was losing its pedestals? Are the bases the key to a more contemporary Brancusi, a man who is troubled, insecure, maybe even baffled about how to position sculpture? It was Scott Burton, the artist who made a reputation for himself in the '80s with furniture that was meant to double as sculpture and became a staple in public spaces, who brought these questions into the open. In 1989, the year of his untimely death, Burton organized a show at the Museum of Modern Art called "Burton on Brancusi." Given that Brancusi had done benches and tables and stools—many of them for a site in his native Romania—Burton was certainly justified in pointing to him as an ancestor. Yet apparently Burton could not accept the possibility that for Brancusi, making a table or an arch was no stranger than it had been for Bernini to make a fountain or a stairway three centuries earlier. In the brochure for the Modern show, Burton insisted on renaming the bases of Brancusi's sculptures "pedestal-tables." The "pedestal-table," he said, is "an object simultaneously performing a function and acting as its own sign. It is a *usable* meditation on utilitarian form." Burton's thinking is fairly deft, if you like the when-is-a-table-not-a-table? kind of question. But does this really tell us anything about tables or about art?

Modern art was born amid a lot of woolly metaphysics, and it seems to be dying surrounded by more of the same. The difference is that whereas the early moderns tended to philosophize about the transcendent and the ideal, contemporary artists tend to philosophize about the working process, about what you'd think are the most basic facts of what they do. There is a kind of contemporary sculpture—I'm thinking of works by Martin Puryear and Richard Deacon—that in its all-in-one sense of form and its emphasis on the abstract value of natural materials might be thought to be Brancusian, but artists such as Puryear and Deacon bring to craft itself the same kind of willful complication that Scott Burton brought to the base. These artists are so intent on demonstrating their fascination with materials that they highlight every detail of joining and construction, so that the work loses whatever formal coherence it might have had.

Mel Kendrick, somewhat less well-known than Puryear or Deacon, is caught in the same confusions, and I mention his work because Kendrick has from time to time demonstrated a strong sculptural feeling that makes his chaotic show at the John Weber Gallery this fall all the more disturbing. In his last exhibition at Weber, Kendrick sent a row of jagged wooden constructions that were raised off the floor on pieces of pipe straight down the center of the gallery, and they added up to a zany, engagingly rough-hewn futuristic fantasy. There's one work in the current show—a tree trunk raised aloft on more metal poles—that does have something of that gangly, gravity-defying feel, but the rest of the show is just theorizing about sculpture, with tree trunks doubled by rubber castings of tree trunks, and castings turned inside out to show us how it's done.

Mel Kendrick has taken modern sculpture apart, and I see no way on earth that he's going to be able to put it back together. The Brancusian themes that are lodged somewhere in the depths of his mind have a lot to do with his occasional bursts of energy, but mostly he seems to want to de-

construct Brancusi. Apparently Brancusi is of no help to anybody right now; he's thoroughly misunderstood. In 1989, Scott Burton wrote that "Brancusi's enlargement of the nature of the art object is as original as Duchamp's new kind of object, the Readymade." This is the kind of ludicrous compliment that is now being paid to a supremely intuitive artist. Burton is telling us that what Brancusi did with a piece of oak bears comparison with a store-bought snow shovel. Burton isn't praising Brancusi—he's giving him the third degree. How long is it going to take people to get over the idea that every three-dimensional object that's set in a gallery has to have a theoretical subtext?

Leonardo da Vinci, perhaps the most intellectual artist who ever lived, showed a grudging comprehension of his arch-rival Michelangelo, when he wrote in his *Treatise on Painting* that "the sculptor in creating his work does so by the strength of his arm." Leonardo went on to say that sculpture "is done by most mechanical exercise, often accompanied by great sweat"; he offered a picture of a sculptor so covered with marble dust that "he looks like a baker." Duchamp has often been compared to Leonardo—they're both slow-working, thought-provoking artists—and although Duchamp is surely no Leonardo, he must have regarded the marble-dust-covered Brancusi as a spirit as alien to him as Michelangelo was to Leonardo. In one of his sonnets, Michelangelo wrote, "The best of artists never has a concept/A single marble block does not contain/Inside its husk." To carve was to release the concept, to achieve something spiritual through plain hard work. Today's sculptors may not be afraid of hard work, but a lot of them are afraid of the absolutely physical nature of the sculptor's art. They spin theories around sweat and plaster dust. One of the glories of Brancusi's work is that it makes you stop thinking. You just love it. It's that simple.

DECEMBER 11, 1995

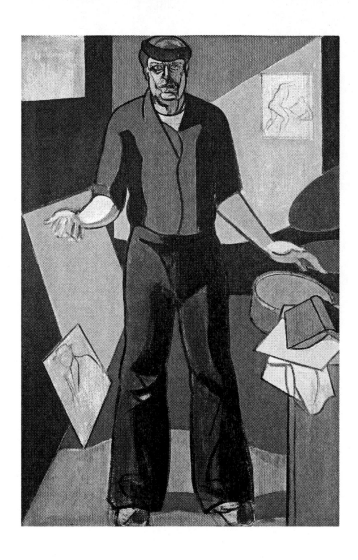

Leland Bell. *Standing Self-Portrait with Drums*. 1980. Acrylic on canvas. 60" x
38 ³⁄₄". Courtesy of Salander-O'Reilly Galleries, New York.

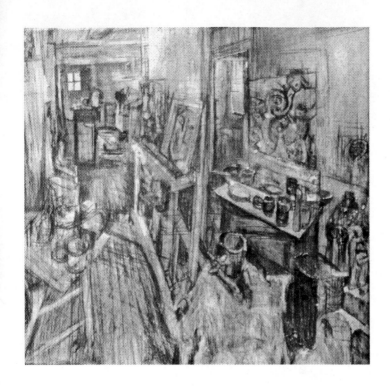

Stanley Lewis. *Studio Interior.* 1994. Pencil on paper. 31" x 31". Courtesy of
Bowery Gallery, New York.

Barbara Goodstein. *Trees and Houses*. 1999. Latex plaster and acrylic paint on board. 36" x 41 ³/₄" x ¹/₂". Collection of Natalie Charkow. Courtesy of Bowery Gallery, New York.

Cy Twombly. *The Italians.* 1961. Oil, pencil, and crayon on canvas. 78 ⁵/₈" x 102 ¹/₄". The Museum of Modern Art, New York. Blanchette Rockefeller Fund. Photograph © 1999, The Museum of Modern Art, New York.

Bruce Nauman. *Sex and Death by Murder and Suicide.* 1985. Neon and glass tubing
mounted on aluminum. 72" x 84" x 12". Courtesy of Leo Castelli Gallery, New York.
© 1999, Bruce Nauman\Artists Rights Society (ARS), New York. Photo: Dorothy Zeidman.

Balthus. *The Cat with Mirror III*. 1989–1994. Oil on canvas. 78 ³/₄" x 76 ³/₄". Courtesy of Lefevre Gallery, London. © 1999, Artists Rights Society (ARS), New York/ADAGP, Paris.

R. B. Kitaj. *Cecil Court, London W.C.2. (The Refugees)*. 1983–1984. Oil on canvas. 72" x 72".
The Tate Gallery, London. © R. B. Kitaj/Licensed by VAGA, New York/
Marlborough Gallery, New York.

Leon Kossoff. *Christchurch Spitalfields, Summer.* 1990. Oil on board. 78 ¹/₂" x 72".
Courtesy of LA Louver Gallery, Venice, California.

Bill Jensen. *Colossus*. 1994–1995. Oil on linen. 37" x 32". Courtesy of
Mary Boone Gallery, New York. Photo: Dorothy Zeidman.

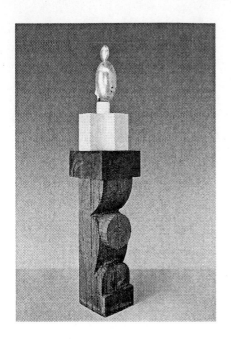

Constantin Brancusi. *Blond Negress II*. 1933. Bronze, on four-part pedestal of marble, limestone, and two wood sections. 71 $^{1}/_{4}$" x 14 $^{1}/_{4}$" x 14 $^{1}/_{2}$". The Museum of Modern Art, New York. The Philip L. Goodwin Collection. Photograph © 1999, The Museum of Modern Art, New York.

Jessica Stockholder. *Your Skin in This Weather Bourne Eye-Threads & Swollen Perfume.* 1995. Plastic stacking crates, stuffed shirts, pillows, papier-mâché, yarn, carpet, concrete, and other materials. 3,650 square feet, 18' high. Courtesy of Dia Center for the Arts, New York, and the artist. Photo: Cathy Carver.

Jean Hélion. *The Last Judgment of Things*. 1978–1979. Acrylic on canvas.78 ³/₄" x 137 ³/₄"; 78 ³/₄" x 57"; 78 ³/₄" x 137 ³/₄". Collection of Galerie Piltzer, Paris. © 1999, Artists Rights Society (ARS), New York/ADAGP, Paris.

Joan Snyder. *New Garden*. 1996. Oil, acrylic, herbs on canvas. 66" x 72".
Courtesy of Hirschl & Adler Modern, New York. Photo: Zindman/Fremont.

Louisa Matthiasdottir. *Tomatoes with Green and Yellow Squash and Black Pot*. 1989. Oil on canvas. 36" x 68". Courtesy of Salander-O'Reilly Galleries, New York.

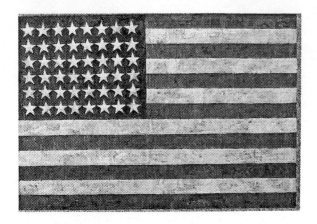

Jasper Johns. *Flag*. 1954–1955. Encaustic, oil, and collage on fabric mounted on plywood. 42 ¹/₄" x 60 ⁵/₈" . The Museum of Modern Art, New York. Gift of Philip Johnson in honor of Alfred H. Barr Jr. Photograph © 1999, The Museum of Modern Art, New York. © Jasper Johns/Licensed by VAGA, New York.

Jeff Wall. *A Sudden Gust of Wind (after Hokusai)*. 1993. Transparency in lightbox.
90 ¹/₄" x 148 ¹/₂". Courtesy of Marian Goodman Gallery, New York.

Temma Bell. *Over the Garden and Through to the Rams*. 1996. Oil on canvas. 48" x 70".
Courtesy of Bowery Gallery, New York.

Trevor Winkfield. *The Studio*. 1993. Acrylic on linen. 47 ¹/₂" x 53". Estate of Michael Sheehe, New York. Courtesy of Tibor de Nagy Gallery, New York.

Gabriel Laderman. *The Dance of Death*. 1995–1996. Oil on canvas. 72" x 90".
Courtesy of Tatistcheff and Co., New York.

Chuck Close. *Alex.* 1991. Oil on canvas. 100" x 84". The Art Institute of Chicago. Acquisition and gift from the Lannan Foundation. Used with permission of the artist. Photo: Bill Jacobson.

Anonymous, Cameroon. *Bafum King Returning from Victory.* Early nineteenth century. 44 ¹/₂" x 12 ¹/₂" x 18". The Walt Disney-Tishman African Art Collection, Los Angeles. Photo: Jerry L. Thompson.

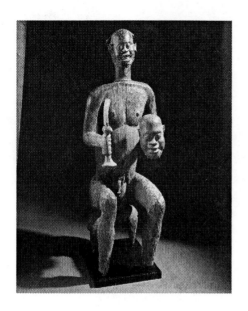

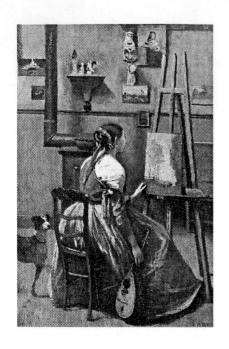

Jean-Baptiste-Camille Corot. *The Artist's Studio.* Circa 1855–1860. Oil on wood. 24 ³/₈" x 15 ³/₄". Widener Collection. © 1999, Board of Trustees, National Gallery of Art, Washington, D.C.

Anonymous, Banteay Srei, Cambodia. *Pediment depicting scenes from the Mahabharata.* Circa 967 AD. 77" x 95". Collection of the National Museum of Cambodia, Phnom Penh, Ka1660. Photo: John Gollings.

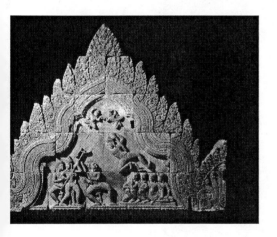

Georges Braque. *Studio II*. 1949. Oil on canvas. 51 $\frac{1}{2}$" x 64". Kunstammlung Nordrhein-Westfalen, Düsseldorf.

Juan Gris. *Costume for a Herald, from 'Les Tentations de La Bergère.'* 1923. Graphite, tempera and/or watercolor, gold and copper paint with white highlights on paper. 13 ½" x 12". Collection of Wadsworth Atheneum, Hartford, Connecticut. The Ella Gallup Sumner and Mary Catlin Sumner Collection Fund.

Jean Fouquet. *Simon de Varie in Prayer Before the Virgin and Child,* from *The Hours of Simon de Varie.* 1455. Gold paint, gold leaf, tempera colors, and iron gall ink on parchment. 4 ½" x 6 ½". The J. Paul Getty Museum, Los Angeles.

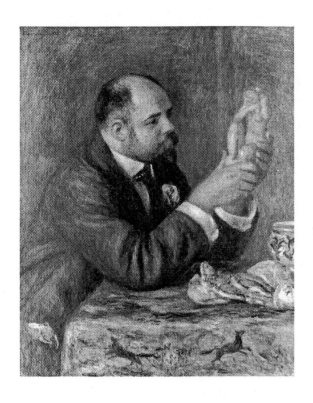

Auguste Renoir. *Ambroise Vollard*. 1908. Oil on canvas. 32 $^1/_8$" x 25 $^5/_8$". Samuel Courtauld Trust. © Courtauld Gallery, Courtauld Institute, London.

Alexander Calder. *Triple Gong.* 1951. Painted steel, wire, and brass. 31" x 68". Gift of Mr. and Mrs. Klaus G. Perls. © 1999, Board of Trustees, National Gallery of Art, Washington, D.C.

Alvar Aalto. *"Paimio" lounge chair, Model 41.* 1931–1932. Bent plywood (lacquered), bent laminated birch, solid birch. 25 ¹/₂" x 24 ³/₁₆" x 36". Manufactured by Huonekalu-ja Rakennustyotehdas, Turku, Finland. The Museum of Modern Art, New York. Edgar J. Kaufmann Jr. Fund. Photograph © 1999, The Museum of Modern Art, New York.

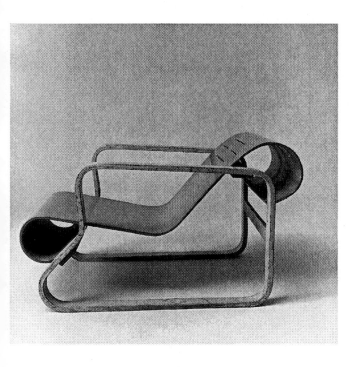

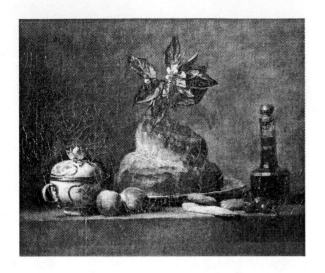

Jean-Baptiste-Siméon Chardin. *The Brioche. 1763*. Oil on canvas. 18 ¹/₂" x 22". Louvre, Paris.

Photograph: Erich Lessing.

AN UNKNOWN MASTERPIECE

Jean Hélion's *Last Judgment of Things*, a twenty-seven-foot-long triptych that is one of the few sure masterpieces painted anywhere in the past twenty years, is being seen in New York for the first time this spring, at the Salander-O'Reilly Galleries. Completed in 1979, when the artist was 75, *The Last Judgment* is an allegory of endings and renewals that takes the wonderfully uncomplicated form of a ramshackle flea market—the sort of sight that's an element in weekly markets all over France—where young men and women are poking around amidst the merchandise, trying on a thing or two, carrying away a bulky purchase. This is a work of magisterial informality, in which the most acute naturalistic observations are recorded in once-over-lightly layers of giddily bright acrylic color. Beginning with an end-to-end orchestration of grayed-down oranges and saturated greens, Hélion has unfurled an ordinary world that's also an extraordinary explosion of telegraphic abstract signs.

Hélion, who died in 1987, has received a number of major European retrospectives in the past couple of decades and has been included in such key exhibitions as "A New Spirit in Painting," at the Royal Academy in London in 1981, and "Identity and Alterity," at last summer's Venice Biennale. He's by no means an unknown artist; in fact, he may be the most grievously underestimated well-known artist of our time. Thirty-five years ago, writing in the international edition of the *Herald Tribune,* the poet John Ashbery remarked that "Hélion is not just one of the great figurative painters; he is one of the greatest painters of any kind today." Five years ago, in an interview that was published in the *Oxford Art Journal,* the late Meyer Schapiro, who owned a cityscape by Hélion, spoke of his having been a "good friend" and

gave a sympathetic account of the work. Yet the complexity of Hélion's career, which includes pure abstraction and naturalistic portraiture and a lot in between, often leaves even interested viewers feeling mystified. The internal logic and overarching originality of this wonderfully unpredictable achievement is almost invariably misread as a series of reactions to other people's ideas. Through most of his career, Hélion was so much at odds with mainstream thinking that there's probably little chance that even an event as important as the arrival of *The Last Judgment of Things* in New York City will have much resonance beyond a few contemporary artists and writers who are as clued in as Ashbery was in the '60s and Schapiro was in the '40s. Yet the painting has finally arrived here, and for those with eyes to see, it may be a conversion experience.

In almost every generation there's at least one painter who brings a novelist's thematic intricacy to the visual description of the modern world. Renoir and Seurat did this in the late nineteenth century with their paintings of Parisians at play; Léger's *City* defined the situation after World War I; and Hélion has done something along the same lines for our own time. Standing in front of *The Last Judgment*, I'm enveloped by its stirring architectural dimensions, and there's so much to look at that the experience becomes supremely active. The story unfolds as it might on an enormous Oriental screen. Hélion includes a baker's dozen of figures and a vast array of buyables that are strewn across a table, a bench, and the ground. In the left panel, clothes shopping is the main event. One man has gone into a tent to try on a pair of pants, another holds up a suit jacket, while a woman looks for just the right pair of shiny black high heels. There's so much going on that it may take you a minute to notice the pair of lovers embracing in the shadowy depths of the tent. Outside, a woman is examining some canvases and a man carries off a table.

Hélion wrests a casually iconic impact from acts as ordinary as shopping for shoes, and then without missing a beat he shifts to an interlude of cheerful Surrealist enigma in the center panel, where two dressmaker's mannequins are making love. A rather unusual aspect of *The Last Judgment* is the size of the panels. Whereas most triptychs contain panels of equal size or a larger central panel, Hélion has joined two broad horizontal side canvases to a much narrower central canvas. This may be his way of expressing a nonhierarchical view, of suggesting that the flea market experience is one of instability—that the center doesn't hold. The abbreviated central panel is a mysterious interlude—like the dream sequence in the middle of a full-evening ballet—after which, in the right panel, Hélion once again pursues what at first may appear to be more mundane matters. There's a big table holding a tuba and a record player, and lots of other stuff is arranged willy-nilly on the ground. A man is examining some candlesticks, a woman looks into a book, while all the way to the right we see a mysterious circular staircase. Scattered near the base of the staircase are a woman's high-heel shoe and a man's hat and pants; obviously, we're meant to understand that another pair of lovers has just disappeared upstairs.

The Salander-O'Reilly show includes, in addition to *The Last Judgment,* some two dozen works ranging across the artist's career. People who haven't seen the scattered gallery shows devoted to Hélion in New York over the past twenty years will get a glimpse of his early Purist abstraction but hardly any sense of the almost Flemish realism of the mid-'50s. While the density and variety of Hélion's career does not lend itself to a brief overview, the Salander-O'Reilly show may enable gallerygoers to see how *The Last Judgment* pulls together themes from all through the work. I think it's immediately apparent that a picture of people rummaging around in a flea market is about see-

ing new life in old forms, and the more you know about Hélion the more you'll understand how this process works.

Hélion always wrote about what he was doing, and a two-volume selection from his notebooks, titled *Journal d'un peintre,* was published by Maeght in Paris in 1992. Going through the sections that cover the years when *The Last Judgment* was on Hélion's mind, it's evident that he's reflecting on events that go all the way back to the '20s. The *Journal* includes some references to *"temps retrouvé,"* which was at one time what Hélion was planning to call the painting. The French title, *Le Jugement dernier des choses,* also suggests more than material things. Hélion probably means us to understand *choses* as having some of the same implications that it has in the title of the third volume of Simone de Beauvoir's autobiography, *La force des choses,* which was published in 1963. *The Last Judgment of Things* isn't just about seeing things, it's also about thinking about things. Another title might have been *The Flea Markets of My Life.*

Hélion was born in Normandy in 1904. He arrived in Paris in 1921 to apprentice to be an architect, but by the late '20s he was already an accomplished painter. The Uruguayan artist Joaquín Torres-García, whom Hélion met in 1927, had a great and in some respects lasting impact on the young painter; there are echoes of Torres-García's canvases, with their mysteriously effective fusion of tenderly folkloric and purely abstract elements, all through Hélion's career. It was also Torres-García who introduced Hélion to a Parisian avant-garde that by the '30s included such expatriates as Mondrian and Kandinsky. Hélion, who always had a gift for friendship, soon joined forces with van Doesburg to form the Abstraction-Création group, which provided a rallying point for nonobjective artists at a time when most sophisticated Parisian painters accepted semiabstraction but not total abstraction. Hélion acquired an excellent grasp of English, and in trips to England and America in the '30s he made the case for his own severely cool compositions even as he talked and wrote about the full range of recent

nonobjective work. In New York he helped Albert Gallatin put together a significant group of paintings, which was exhibited in the '30s at New York University—it was the first public collection in which New York artists could see a Mondrian on permanent display.

By the time World War II was approaching, Hélion was living in America with an American wife. He was already juxtaposing impersonal, silvery-colored forms to create figure-like configurations, and after a while he was painting men in hats, a sort of mid-century Everyman. On the eve of the war, Hélion returned to France to fight. He was taken prisoner by the Germans, spent many months working on a prison farm on the Polish border, ultimately escaped and made his way back to Paris and then to the United States. Before returning to his easel, he wrote an excellent book in English about his war experiences, *They Shall Not Have Me,* which became a best-seller. The book contains a number of accounts of the frenzied black-market activity in the prison camps, and these foreshadow the series of market paintings of thirty years later, which include studies of vegetable and lobster vendors as well as the flea market triptych.

In 1943, Hélion exhibited at Peggy Guggenheim's Art of This Century Gallery in New York. Two years later, he married Guggenheim's daughter Pegeen. Back in Paris they had a family and later separated, but for the rest of his life Hélion maintained ties with the high bohemian world in which Peggy was a great figure. During France's postwar renewal, Hélion painted the whole variety of Paris: the parks and the streets, the men reading newspapers, the poets and the artists' models, the baguettes heaped on the table in the atelier. In those years, Hélion knew both Giacometti and Balthus, and all their work gained force, depth, and plangency from a sense of *temps retrouvé*—from their memories of artistic beginnings in the '30s. A particular spiritual affinity—a twilit poetic unreality—unites Balthus's *Passage du Commerce Saint-André,* with its view of a tiny street not far from the Existentialist

cafes on the boulevard St. Germain, and the canvases that Hélion was paint-
ing around 1950, in which poets fall asleep on the Parisian pavements and
dream their dreams.

In 1967 Hélion embarked on the first of what would turn out to be a cy-
cle of triptychs, a scene of the rue du Dragon in the 6th Arrondissement,
with people sitting in a cafe and some of Hélion's own earlier abstract paint-
ings on display in a gallery window. Here Paris has a light, open, prosperous
feeling, a feeling that we also encounter in the cycle of lithographs that Gi-
acometti was working on at the end of his life for an album to be titled *Paris
sans fin.* The year after completing the *Triptyque du Dragon*, Hélion underlined
his sense of a city that had regained its youth by devoting another triptych
to the events of May '68. Although Hélion regarded some of the ideological
forays of the New Left with the skepticism of a liberal temperament and of
someone who had visited Russia in the early '30s but had been an anticom-
munist well before the end of that decade, he found '68 fascinating as visual
theater, and he was by no means unsympathetic to the students' bold, ex-
perimental spirit.

By the late '60s, Hélion had switched from oil to acrylic, and the change,
initially necessitated by an allergic reaction to the oil solvents, jump-started
his final liberation from tonal color. There's a candy-colored craziness about
his final full decade of work; he's the first artist to find a formal logic in the
startling artificiality of acrylic hues. Hélion's style, which had been elabo-
rately naturalistic in the early '50s, was becoming broader, increasingly ex-
pansive, so that by the end of his life he had recovered his earliest abstract
concerns, but within a representational context. In the '70s Hélion struggled
with a series of eye problems, some ultimately incurable, and, thinking of
the possible loss of his own sight, he sent a stream of blind men tapping
their canes along the sidewalks in many of his canvases. Then, after painting
the most broadly conceived of all his compositions in the early '80s, he lost

his sight in 1983. In his last years he wrote a book, *Memoire de la chambre jaune,* in which he described all the paintings he had not had time to complete.

Ever since Courbet put all the sides of his life into the immense *Studio* in 1855, modern artists have from time to time created encyclopedic pictures that give personal experience a polemical force, and Hélion's *Last Judgment* fits right into this line. Hélion always wanted to come to grips with the most intellectually challenging aspects of twentieth-century life, and his canvases have the plainspoken impact that you sometimes find in the work of artists who are not averse to taking controversial public stands. Whether Hélion was painting or talking about painting, he could suggest the traditional logic behind a pared-down abstraction or the progressive impulse behind a realism that struck many as essentially reactionary. What's so miraculous about his work is the direct, succinct presentation of complicated material. That's something that characterizes Courbet, too. In *The Last Judgment* Hélion lays all his cards on the table, and part of what makes the painting a reach for our postmodern tastemakers is that they are so unused to forthrightness that they mistake it for naïveté.

In *The Last Judgment* we're present at the act of creation, with people and objects summoned up through broad strokes of acrylic paint. Everything is so simply done that the effects make me smile. A table or a figure emerges from a few passes of the brush across the canvas. Hélion doesn't give us all the details of a figure, but after a lifetime of drawing and painting he's a master of gesture, and he paints actions that have hardly ever been painted before. The figure in the tent who's trying on a pair of pants brings a new kind of everydayness into art. Hélion's unrivaled eye for the telling prosaic gesture underpins all the swirling allusions in this painting that is so full of the fascinating clutter of forgotten things. *The Last Judgment* is about collecting the past, and it's only because Hélion's feet are planted so firmly on the

ground that he can make such sensational finds. He's a Fauvist and a Cubist and a Surrealist—and of course a realist—and he's so untroubled about being all of these things at the same time that he can only be himself.

The Surrealists turned a visit to a flea market into a search for the Holy Grail, but Hélion tops them by getting a catch-as-catch-can impetuousness into this treasure hunt painting. Hélion alludes to that Surrealist rallying cry, Lautréamont's description of "the chance encounter of a sewing machine and an umbrella on a dissecting table," by casually leaning a couple of umbrellas against an old-fashioned floor-model sewing machine. This is Surrealism without any fancy cobwebs; so are the dressmaker's mannequins' amours and the stairway to nowhere. And the same kind of loosened-up, almost happy-go-lucky response that Hélion offers to the orthodoxies of André Breton, the man who was called the Pope of Surrealism, is key to the topsy-turvy but somehow nonconfrontational approach that he takes to Christian dogma.

Hélion is so sure of himself that he can walk straight through the allegorical minefield of a painting of modern life with a Christological theme and leave you wondering why you thought there might be a problem. In an early study for *The Last Judgment* (which is reproduced in the *Journal*) he included a grocer's scale, the sort of ordinary object that vendors in the markets use to weigh potatoes or carrots. It's one of the few items in the sketch that doesn't show up in the painting, and I imagine that's because Hélion concluded that the presence of a set of scales in this secular *Last Judgment* would push the metaphor too far. There's nothing discomfiting about Hélion's modernization of the Christian end of days. He observes that we're all making judgments all the time, but he doesn't draw one grand conclusion. Certainly he's tuned into a pixilated, let-the-chips-fall-as-they-may side of Christian iconography that you sometimes encounter in French Romanesque painting and sculpture. He has an affinity for the kind of Romanesque sculpture in which the world is

represented as a complicated pageant with each person playing a small, apt role. And he obviously admires the calligraphic, exuberantly imaginative spirit of some twelfth-century wall paintings, in which people seem to whirl along on the currents of life.

Hélion's *Last Judgment* has a youthful exuberance. In a way, it's surprising to realize that this frieze full of young adults is the work of a 75-year-old man, but of course part of the explanation is that Hélion is recalling his own earlier days. The white soup tureen in the left panel will be familiar to admirers of Hélion's earliest still lifes. Writing in the *Journal* at the time that he was working on the *Last Judgment*, Hélion recalled that he bought that tureen in the Saint-Ouen flea market in the '20s. So in a sense *The Last Judgment* is a recollection of Hélion's first decade as an artist. Hélion goes on to explain that in 1929 he smashed the tureen, and looking back on that smash-up he observes that it seemed to symbolize both the break-up of a marriage and the break-up of his first realist style into his early abstractions. In *The Last Judgment* the tureen is back in one piece, which is surely a demonstration of *temps retrouvé*. Yet there's even more going on here, because the unbroken ceramic is now broken up formally, by lines that run all the way from top to bottom and turn its flowing curvilinear volume into a series of elegantly symmetrical Cubist shapes.

To paint a *Last Judgment* is to weigh the impact of the past on the future, and certainly Hélion would savor the arrival of this vast composition in New York, a city that the great artists whom he knew when he was young, among them Léger and Mondrian, looked to as the metropolis of the future. Hélion's postwar painterly realism, with its celebration of a pure French lyrical style, can be read as a rejection of that American vision, yet it's interesting to find John Ashbery remarking, in a 1960 essay for *Artnews,* that Hélion's stylistic shift would have occasioned fewer shock waves in New York than it

did after the war in Paris, because in New York you could count on a "peaceful coexistence between abstraction and realism." Of course, even as Ashbery made that remark, the old '50s-style New York heterogeneity was collapsing in the face of an academic abstraction that Clement Greenberg insisted was the only viable alternative to the apotheosis of Duchamp. But if there is still a sympathetic audience, however small, for Hélion's work, it's an audience that senses the fundamental coherence of modern art as well as John Ashbery did when he was an American in Paris and Jean Hélion did years before when he was a Parisian in New York. Such insights are not bound by chronology or geography.

There's a great pattern that runs through twentieth-century art, for once an artist has recognized the essentially abstract character of all Western painting, then the naturalness of abstraction is a foregone conclusion. When the young man all the way to the right of *The Last Judgment* picks up the two pieces of a broken record, he's presenting us with a miniaturized, emblematic version of this story: the real thing has turned into an abstract thing that is of course also real. Instead of building a realist painting out of abstract elements, Hélion treats abstraction and representation as dynamic principles, neither of which can exist on its own. Hélion understood that modern art, which was a revolt against nineteenth-century official taste, was a decentering of taste that embraced populism and obscurantism and hedonism and asceticism, and he refused to reject any of the options. He believed that the hyperstimulating atmosphere of modern art's heroic days could continue unabated; he rejected the idea that what the avant-garde giveth the avant-garde taketh away.

In New York we're often told that the grand modern design has faded past retracing, and it's possible to argue that Hélion's view of the world as a flea market fits in with this sense of exhausted possibilities. Hélion confronts the confusion and the breakage and the loss, but he doesn't find all of this

dispiriting. *The Last Judgment* is an optimistic allegory of the arts. Hélion regards the past not as a sinking monolith but as a changeable landscape that he's delighted to encounter every day. Just open your eyes, he seems to be saying, and you'll find whatever you need: the real and the surreal, abstract signs and narrative situations. The possibilities are unlimited, only you must not allow yourself to be overwhelmed. In *The Last Judgment* people are thoughtful but not immobilized. They make their choices and move ahead.

Hélion's message isn't for the faint-hearted or the easily intimidated, and it's precisely his independent subversive spirit that's held the attention of renegade artists in New York from the '30s right down to the present. This is not the place to present the complicated history of Jean Hélion's American impact, but it would be untrue to the inveterate optimism that he inspired in others if I did not give at least one recent case in point. Only a few weeks before this show opened at Salander-O'Reilly, Barbara Goodstein had an exhibition of her recent painterly relief sculptures at the Bowery Gallery, and the near-abstract calligraphy of her landscapes and cityscapes presented a logical extension of the decisive brushwork in Hélion's later canvases. Goodstein has taken Hélion's strokes of paint, which suggest the broad outlines of an object, and reimagined them in dabs and slaps of modeling paste that are in fact precisely plotted acts of suppression—a refusal of detail so elegant that it feels celebratory. In the past Goodstein has done some variations on Hélion's themes, and looking at her triumphantly self-assured new work, in which she occasionally includes found objects such as bits of broken colored glass and rusty metal, it's possible to feel that she is quite literally moving forward from *The Last Judgment of Things.* What really counts are the deep structural affinities, the sense that what's abstract and what's real are both aspects of the same still-unfolding pattern.

The Last Judgment is full of patterns and tools and machines: there's a key, an easel, the dressmaker's mannequins, a sewing machine, eyeglasses, a

record player, an LP record, a pair of drumsticks, some musical instruments. You could say that this painting is a how-to manual for artists—and a celebration of creativity, of putting things together. The shoe fits, the broken things can be mended, and a young painter gets a bargain on an easel that he'll take home so that he can paint his first masterpiece. And then there's that mysterious spiral staircase, with its tight, corkscrew curve. Once you've taken in the bits of clothing casually deposited on the steps, you know that you've been left to imagine what's going on upstairs. This is a painting that gets your mind working overtime. The colors are bright and taut and changeable; they seem to fly along, with some of the gravity-defying speed of ships' sails caught by the wind. Hélion is telling us that the possibilities are wide open and the sky is the limit.

APRIL 29, 1996

ABSTRACT MATTERS

Nothing has less to do with the art experience than a foregone conclusion, yet Mark Rosenthal, who organized "Abstraction in the Twentieth Century" at the Guggenheim Museum, doesn't seem capable of regarding the history of modern art as anything else. This immense survey of an eighty-year adventure that began with Kandinsky, Mondrian, and Malevich was designed to show us how we arrived where we are, and the keen expectations that the exhibition inspired suggested that although mainstream history is out of fashion people still yearn for the big historical sweep. The show had its own kind of forward movement, but "Abstraction in the Twentieth Century" moved right by us, because Rosenthal—who was a

Consultative Curator at the Guggenheim when he embarked on the project and is now at the National Gallery—doesn't know where we are. Even before the exhibit closed, people had blotted it out of their minds, like a dream that had gone bad and was best forgotten.

"Abstraction in the Twentieth Century" was meant to be a shimmeringly pure vision, and the trouble started right there, because anything messy or ambiguous or interestingly unresolved was simply bleached out. At the beginning of the catalog, Rosenthal declared that although recent artists have parodied passages from classic abstract painting, "there is no neo-abstract movement." That comment left me wondering where Rosenthal has been keeping himself in the past few years, because we have been drowning in neo-abstract styles. The most obvious is NeoGeo, but anybody who has gone to the galleries has also been seeing Neo-Abstract Expressionism and Neo-Minimalism. Most of this work is featherweight and forgettable. I sympathize with Rosenthal's desire to believe that the stuff doesn't exist. But you don't help matters by being oblivious. Indeed, you may be ambushed by the very attitude that you abhor. Rosenthal wants us to understand that he is not hostage to "the now-discredited role of doctrinaire formalism," yet his own taste for visual impoverishment combined with theoretical uplift seems like neo-doctrinaire formalism. "Abstraction in the Twentieth Century" was one more variation on the hackneyed idea that abstract art is about removing everything from painting. The show was a broken-down one-way highway to nowhere.

The painters who invented abstract art would have never dreamed of going into a museum in order to find out what was going on (or what to do next), and Rosenthal probably meant to pay tribute to their fearlessness by subtitling his show "Total Risk, Freedom, Discipline." The phrase, which was borrowed from the sculptor Eva Hesse, certainly gave the exhibition a newsy aura of art-world S&M, but when it came to figuring out what artists

actually do, Rosenthal retreated to the most programmatic kind of lecture-hall thinking. According to Rosenthal, this century of abstract art hasn't been about the triumph of personal expression so much as the grinding inevitability of historical forces. Ultimately, what was so appalling about the show weren't Rosenthal's particular decisions, but his inability to bring the work together into a coherent visual experience. He seemed more concerned with what he was keeping out than with what he was putting in. Although I went expecting to disagree with some of Rosenthal's choices—which would have been perfectly all right—I left with the impression that his choices weren't based on what he liked but on what he felt he ought to like.

When it came to hanging "Abstraction in the Twentieth Century," Rosenthal had so little instinct for the internal coherence of classic abstract art that he couldn't even create vivid gallery arrangements with paintings by Kandinsky, Mondrian, and Robert Delaunay, which in the past have looked marvelous in the Frank Lloyd Wright museum that undoubtedly poses unusual challenges for a curator. As for dealing with more recent (often larger) works, which have never fit very well in the Guggenheim's idiosyncratic spaces, Rosenthal was simply helpless. The Pollocks weren't just crowded, they were shockingly underlit. Rosenthal turned Wright's grand flow into a tortuous, stop-and-start procession. A work such as Sophie Taeuber-Arp's lovely 1916–17 embroidery after a design by Jean Arp was hung without any context, so that it looked like an eccentric blip. Agnes Martin was given a protracted, deadeningly repetitive presentation, with each painting failing to make the same less-is-more point.

Even museumgoers who don't know contemporary art felt the detached mood of the show, but if you have followed recent developments you may have been a little astonished at the extent to which Rosenthal insisted on an outmoded evolutionary scheme. He was still thinking about art history in

terms of paintings lined up like dominoes, even though there isn't anything that first-rate artists can agree on any longer except that there are no guiding principles. When I'm really interested in some new work, the question I find myself asking isn't how it fits into a historical scheme, but how the artist has arrived at his or her particular interweave of assumptions. We're in the midst of a fascinating phase in abstract art, but you wouldn't have guessed it from this programmatic, evasive show.

By now abstract art might be expected to be a tradition like any other, and there is certainly a lot of conventional thinking that gets mixed up in the recent nonobjective painting. Still, the rejection of reality remains a fundamentally subversive idea. The old assumptions about stylistic evolution no longer pertain, and each artist is forced to invent a personal history of art that cuts a path straight to the studio door. An artist can be elegantly discrete about all of this, but there's something especially engaging about an abstract painter such as Joan Snyder, who makes the interweave of sources nakedly evident, so that it's not only a subtext but frequently her subject as well.

In her most recent abstract paintings, which were at Hirschl & Adler Modern this spring, I felt that Snyder was quite consciously not merging all the disparate elements. She wanted us to regard each scrawled flower and collaged-on bit of twig as an individual choice. And there were lots of flowers in these paintings. And lots of collaged-on bits of twig. Mark Rosenthal would tell you that Robert Ryman (with his long series of white-on-white canvases—each different, each the same) and the sculptor Richard Long (a sort of Eco-Minimalist, arranging rocks in large, simple geometric shapes) are the contemporaries who grapple with the big questions. But their taste is so predictable that you can't really call it taste—they've made no choices; they're just playing by a set of rules. That's not anything you can say about

Joan Snyder, who's reaching for such a feeling of cheerful decorative elegance in her new paintings, many of which are about gardens, that she seems almost naively unaware of the point where her taste becomes so good that it loses its bite. I don't think these paintings are quite at the level of some of the work that Snyder exhibited at Hirschl & Adler Modern in 1990, but their excesses and confusions will tell you more about risk and freedom and discipline than anything from the past quarter century that was in the Guggenheim show.

Snyder may not be a great artist—I'm not sure that her work has a truly captivating internal logic—but she's a formidable painter, and her best canvases hold perfectly in the imagination. What makes Snyder, who's 56, so unusual is her way of giving personal exigency a formal impact. When Snyder paints she's plotting the fever charts of her moods, and we're doubly engaged, both by what she's feeling and how she's managing to get those feelings into form. Looking at her paintings can be like reading a writer's journals or letters; I want to know what's happening to the person, but I also want to know how the first-person story is transformed into art.

For a gallerygoer who's familiar with Snyder's work, going into Hirschl & Adler Modern was like turning to the next page of this ongoing journal, where the same geometric or painterly forms, the same stylized trees or flowers, the same kinds of found objects reappear, only presented with a somewhat different emphasis or attack. In many of the paintings—they're mostly around five feet high—Snyder is doing yet another series of variations on one of her most effective themes; she's imagined the surface of the canvas as an upended piece of earth on which things grow and decay and grow again. This time around, the result is frequently a carpet of abstract floral fragments—a tapestry effect. I find myself getting caught up in the high-spirited cacophony of color. Even when I'm unconvinced by a particular canvas, I like the theme-and-variations character of the work.

In the new canvases, Snyder uses a mixture of acrylic and oil paint, and the result is a surface on which shiny passages and matte ones intermingle. These are difficult juxtapositions—they could look fussily experimental—but Snyder is a born painter, and she holds everything together with a gift for painterly effects that was already apparent in the big strokes of bright color that she was unfurling on canvas around 1970, when she was just hitting her 30s. Those canvases, and the ones with strokes played against grids from a few years later, were the work of a confident, somewhat conventional artist. They may look more interesting now than they did then, because we can see how far Joan Snyder has taken her first, provisional oppositions between order and abandon. Everybody who's discussed Snyder's move into more and more complicated imagery—it began in the mid-'70s—has spoken of a rejection of a modern tradition of pared-down abstraction. But what's hardly ever acknowledged is that all Snyder's landscape fragments, childlike drawings, word poems, and collage elements echo classic modernism—echo Picasso, Kandinsky, Klee, and Miró. Snyder has defied the less-is-more mode. She has defied it even when she's in one of her iconic moods and seems to be suggesting that less is just one of the limitless possibilities.

In the '70s, Snyder was inclined to explain her rejection of a Minimalist sensibility in terms of a desire to get more of her own life into the work. There's a 1974 triptych, called *Small Symphony for Women,* in which one panel is crammed with words, mostly observations about the marginal status of women in the art schools; Snyder wonders whether any male instructor can really understand a "female sensibility." The *Small Symphony for Women* is a heartfelt piece of work, but Snyder's best paintings have never been the ones with lots of words. Sometimes when she's tried hardest to press our buttons (with subjects drawn from the Holocaust or news reports about domestic violence) she's been unable to find a link between the story and the style, so

that the richness of the work has looked like thematic contrivance rather than metaphoric complexity. Yet even when the results are less than wonderful, Snyder's painterly instincts are leading her in the right direction, and that's often toward the work of certain early modern masters, generally men, who shared her desire to get a lot of themselves into the picture. There's a politically incorrect logic to this artist who can be taken for politically correct, and although there's no mystery as to why Snyder's way of advertising her opinions can make people who love painting uneasy, the ideological edge is part of what gives her canvases their wildness, their beautiful sting.

The brand-new Snyders are about buddings and burstings and an emotional high; a garden full of variegated blossoms is what Snyder often has in mind. Everything hovers at the surface, and we're invited to pay attention to this or that variation on the expansive, upbeat mood. It's like looking at different flowers in a garden; each one makes its separate claim, and sometimes they come together into a glorious blur. Most of the paintings contain swirls of paint that create floral bouquets; but there are also passages where the brush just shimmies across the surface, leaving quirky traces. Even the dark interludes have a punchy elegance; the black velvet rectangle in *Carmina* (which is not exactly a garden painting) is a glamorous touch. And the few murky, scumbled passages—which in earlier paintings suggested nightmares and torments—now pass quickly, like moments of mental unease or anxiety flashing through a basically sunny disposition.

For Snyder, the upfrontness of the canvas is an opportunity to show us everything she's seen and known. She attaches bits of dried foliage to the surface (in the lists of materials they're identified as herbs), and they suggest domesticated pastoral delights, a medieval herb garden, which in turn connects to the paintings' tapestry feel. Those herbs are the polar opposite of the bits of rusty barbed wire that Snyder was including in the sweeping,

dark-toned elegies that she painted a decade ago. Looking at the new paintings, I find myself thinking about everything she's brought in over the years—the scraps of silk and the rough burlap and the handfuls of straw.

Snyder has a wonderful way of quoting from other artists. If the herbs stand for nature, the squares of color, which evoke Malevich or Hofmann, signify culture. Snyder appears to associate different painters with different moods, and when she recapitulates their motifs as if they were her own, she's adding particular emotional colorations. This show included a few paintings with oversized sunflowers. Of course, they make you think of Van Gogh, of his unashamedly, boldly turbulent moods. There's something of Paul Klee in the cheerful pastoral fantasy of the abstracted gardens, and something of Barnett Newman's portentous emotional self-containment in the verticals that run through a few of the less successful paintings. And then, in any number of paintings, there are recollections of Joan Mitchell's brushwork. It's a logical connection, because both painters are nature poets, but when Snyder attempts to assimilate Mitchell's jittery calligraphy she tends to underline their differences. Snyder regards nature symbolically, allegorically—this is an unabashedly urban view of the out-of-doors—whereas for Mitchell nature is part of the ordinary course of events, something experienced day by day.

In many respects Joan Snyder is a '60s person. She has the '60s gift for entertaining contradictory creative impulses, and for a contemporary abstract painter that experimental spirit can provide a link back to the visionary mood of an earlier generation. So much of what has been written about the early years of abstract art has emphasized the struggle to achieve an absolute that we're sometimes in danger of forgetting that abstraction was originally about rejecting certainty and letting the possibilities explode. To a greater extent than we may care to know, the first half century of abstract art was

about wacko people thinking and doing wacko things. Some of them were geniuses; others, such as Hilla Rebay—the first director of the Guggenheim, who was herself an artist and got to know Solomon R. Guggenheim while painting his portrait—were sometimes extraordinarily attuned to the geniuses in their midst and at other times indistinguishable from what we think of as ordinary crackpots.

Part of the reason that "Abstraction in the Twentieth Century" stirred such high expectations was that there was something marvelously apt about mounting a definitive assessment of abstract art in a museum that had had a historic role in bringing the new painting to America. Rosenthal obviously had that connection in mind when he dedicated one gallery at the show to a reconstruction of Hilla Rebay's original Museum of Non-Objective Painting. This show-within-a-show saluted the treasure trove of Kandinskys that Rebay brought to America, as well as her very early support for an admirable American abstractionist such as Ilya Bolotowsky, but it also highlighted her enthusiasm for Rudolf Bauer, whose Kandinskyish canvases are a kind of avant-garde kitsch. By exhibiting the Kandinskys and a Bolotowsky alongside a Bauer and other examples of plodding, claustrophobic '40s work, Rosenthal certainly demonstrated the shakiness of some of Rebay's taste, but what was the point? From the time the museum first opened in 1939, Rebay had an equivocal reputation among the American avant-garde. Young painters went to the museum, which was then located on East 54th Street, and hooted at the Bauers and at Rebay's portentous display techniques, which included gray cloth walls and canned classical music. But they were there because they could learn from the Kandinskys and Klees and Légers. I imagine that Joan Snyder, like so many artists since the '40s, has also drawn her own conclusions from the collection.

Perhaps Mark Rosenthal thought that the insufferably stuffy look of what is called the "Museum of Non-Objective Painting Installation" would

put visitors on notice that this museum has come a long, long way. But what Rosenthal's rigid reconstruction really told us was that he felt alienated from the beginnings of the museum, that he hadn't engaged with the messy, yeasty origins of the nonobjective adventure. It was Rebay who commissioned Frank Lloyd Wright's building—it's the great monument to her imaginative daring—and even allowing for all the impracticalities of this notorious space, there's an excitement about the rotunda that ought to have been harnessed to give the show a visionary dynamic. "Abstraction in the Twentieth Century" should have been related to the essential metaphor of Wright's museum, which is that in the end you arrive back at the beginning; that although you go round and round and see many different things, it's all part of the same expanding, enveloping experience.

It's been four years since Thomas Krens, the director of the Guggenheim and Mark Rosenthal's boss on this job, added a stack of boxy rectangular galleries to the northeast corner of the museum, and by now it takes an effort to remember that Wright's rotunda is anything more than a series of access ramps serving those inertly proportioned new rooms. Rosenthal isn't responsible for this architectural fiasco, but in installing "Abstraction in the Twentieth Century" he put so much emphasis on the new tower galleries that museumgoers could barely relate to Wright's glorious, light-filled container. There's no longer any way to experience the building's miraculous details—its secret rhythms and subtle surprises. Rosenthal justly included Wright's museum among the modern masterworks illustrated in his catalog; but he botched the supreme opportunity of suggesting to museumgoers that the container that held the show was itself a key work of abstract art.

True, the startling unconventionality of Wright's design has frequently been criticized by artists—including de Kooning, whose work was of course in the exhibition. But when the building finally opened to the public in

1959, the year of Wright's death, his breakaway organic form, which had roots all the way back in the Neoclassical fantasies of eighteenth-century architecture, struck many people as regenerative, astonishingly youthful, the first building of the twenty-first century. Wright's museum may succeed all too well as a metaphor for the transcendent impracticality of the abstract experiment, but Rosenthal installed his show with so little sensitivity that Wright's space ended up looking incomprehensible, inert, mundane. And, come to think of it, that's more or less what Rosenthal did with the entire history of abstract art. He removed the crazy curves and wonderful zooming trajectories. He straightened everything out.

At "Abstraction in the Twentieth Century" the decades passed by and the dreams diminished and then diminished some more. Perhaps Rosenthal wasn't unhappy with the result. If it was a wasteland, it was his very own high-fashion wasteland. Yet even those inclined to believe that abstract art is in a period of narrowing possibilities seem to have been rather shocked by a lack of generosity in the show. They had wanted to reconnect with Kandinsky's (and Wright's) let's-try-it spirit, but this was not to be. Certainly after going through "Abstraction in the Twentieth Century" and enduring all the emptied-out images with which Mark Rosenthal filled his show, you could understand why Joan Snyder is scrawling flowers all over her canvases with such loony cheerfulness. Nothing could be farther from the dour calculations that dominated the wasteland up at the Guggenheim than Snyder's show at Hirschl & Adler Modern. The new Snyders, which are about cultivating your own garden, present escapism as a principled stand. There's a vehemence to these insistently upbeat canvases. Joan Snyder wants us to know that we haven't really been banished from modern art's Eden.

JUNE 10, 1996

Still life, that most matter-of-fact kind of painting, achieves an astonishingly unforced monumentality in the work that Louisa Matthiasdottir has been doing over the past ten or fifteen years. Matthiasdottir arranges ordinary objects—a big iron pot, say, and a few squash and tomatoes—so informally that their relationship seems up for grabs. Then her supercharged color and shorthand-naturalistic brushwork go to work, and what at first looks like randomness turns out to be urgency, lucidity, freedom. These good-sized canvases, in which everything is bathed in a bright, clear, gray light, are probably the most off-handedly honest still-life paintings that anybody has ever done. Matthiasdottir has been inventing subtly angled compositions for a quarter century and more, and by now she's pushed beyond plane geometry into the mysterious laws of physics. In her recent paintings, a small glass jar set way off to the side is dense, heavy, magnetically charged, while an eggplant or melon that's right up front has a weightlessness that defies its mass. Matthiasdottir has stripped away still life's allegorical and metaphorical meanings. She's gone back to the basics, which turn out to be startlingly complicated and unpredictable. The objects control the space. And we're exhilarated, because everything seems to be coming together right before our eyes.

Several of these still lifes are included in the first retrospective of Matthiasdottir's work ever organized in the United States. The show—which reaches all the way back to an extraordinarily accomplished painting of a boy at play, done in 1937, when she was 20, and includes landscapes of her native Iceland and delicate portraits and the most spectacular self-portraits anybody has done in years—will be touring the country, with stops at many college gal-

leries, well into 1997. This small retrospective, which has been drawn from the artist's own reserves, isn't all high points. A big outdoor scene, based on a photograph of family members on an excursion, is uncharacteristically fuzzy; the unequivocal color has the paradoxical effect of making everything seem tinted and remote. And certain landscapes become almost mechanical, with their stiff architectonic arrangements of farm animals in green hills. But a fourteen-foot-wide triptych of animals in an Icelandic landscape has a winning decorative charm. The portraits from the 1960s are wonders of tonal control. Many of the small oil studies are quite deft; they highlight the unselfconscious fluidity of Matthiasdottir's brushwork, which is key to everything that this 79-year-old artist has done during the more than five decades that she's been living and working in New York. And the recent self-portraits and still lifes are nothing short of miraculous.

What first impresses a gallerygoer about Matthiasdottir's still lifes is the overall orchestration of the colors and how much it varies from painting to painting. There are compositions that are like ascending color scales, going from purplish gray to yellowish blue, and there are other paintings that are deliberately strident, like crazy quilts of oranges, greens, reds. Then, almost before you have had time to take in this overall effect, each object begins to shine forth with its own unique colors; the heavy green of a painted table, the maroonish purple of wine vinegar, the light yellow of a grapefruit, the deep red of what look like peppers in a jar.

Matthiasdottir knows how to bring out the individuality of objects. She's a master at catching the variety of light reflections that complicate a form even as they articulate it. The summary exactness of the painting of some of these ordinary forms is breathtaking and a little unnerving. And the small violation of naturalistic logic that's involved in the clearest object sometimes also being the one farthest away gives the compositions a delicious air of antinaturalistic possibility. Matthiasdottir refuses to bring a whole painting to

the same level of focus; she knows it would be unbearable to look at—overdone, too tight. And so from the heights of illusionism she sends us off to other objects, which may be painted with little or no surface specifics. John Ashbery, an admirer of Matthiasdottir's work, once wrote that her painting, "despite its tendency toward broad simplification, [has] an air of heightened realism—a kind of trompe-l'oeil that works on a mental rather than an optical level." Constructivism, it turns out, is a natural phenomenon.

In some of Matthiasdottir's recent paintings, vegetables and utensils seem just placed here and there—as if they'd been set down on the countertop in the kitchen without much thought. Yet there's a logic to these objects, a logic that grows out of the experience of handling and using things. Two plump zucchinis, aimed in different directions, become the longitude and latitude of a tabletop. In the *Still Life with Green Table and Blue Cloth* there's a whole grapefruit, a grapefruit half, and a knife, and together these simplest of objects unfold a drama of transformations in which black turns yellow pink, meaning that the black knife has cut through a whole grapefruit to reveal its insides. The plane cuts the sphere to reveal the circle. Matthiasdottir doesn't explode ordinary objects, she just opens up their possibilities, and the decisiveness of her painthandling, which weaves together simplification and complication, makes the multiplicity of meanings seem natural, inevitable. With a tablecloth she can do anything. Pulled tight, the cloth sets up a space as orderly as a quattrocento piazza; rumpled, it's the world in confusion, with space collapsing in on itself and objects teetering on the brink of oblivion.

Over the twenty-five years that I've been seeing Matthiasdottir's pictures, her work has moved closer and closer to the center of an imaginary map of contemporary art that I carry around in my head. Matthiasdottir has always been a first-rate artist, and if what she's doing now seems especially important, it's because her optimistic pragmatism is set in high relief when

so much of the strong new work that we're seeing in the galleries is pro-
duced by artists who are circumspect about their emotions. She's a virtuoso
with paint who can suggest the softness of a tablecloth or the cold gleam of
a knife blade with a few passes of the brush, yet there's never anything
showy about her painterly effects. Matthiasdottir depends on a dramatic
juxtaposition of color shapes to build a space, and then her giddy interludes
of naturalistic extravagance saturate the space with life.

Strangely enough, it's often the more sophisticated gallerygoers who feel
that Matthiasdottir's realism is a little bland. Could it be that the seamlessness
of a naturalistic image, especially if the illusion doesn't call attention to itself,
appears naive to people who are always looking for a subtext? If only they
knew: Matthiasdottir has subtexts galore. When she's working at the top of
her powers, straightforwardness is her way of expressing complicated feelings.
When she lets her brush pass quickly over an object in a still life or the partic-
ulars of her face, she's defining the limits of what we know. And when her
color is astonishingly vibrant, the beautifully structured compositions can
seem like a way of bringing order to big, amorphous emotions.

By giving her best pictures such an unfussy emotional impact, Matthias-
dottir sets a standard against which I find it useful to measure other people's
work. It is interesting to juxtapose Matthiasdottir's new canvases with some
of the paintings in the Alex Katz retrospective—called "Alex Katz Under
the Stars: American Landscapes, 1951–1995"—that was at the Baltimore
Museum of Art over the summer and is now touring. And it's also worth
seeing how some younger realists stack up against Matthiasdottir, such as
Philip Geiger, who has had a string of shows at Tatistcheff and Co. in New
York.

For years, realism was a minority taste in the American art world, and
sometimes even people in the know were inclined to keep fairly quiet. They

didn't want to deflect attention from abstract art, which was recognized the world over as a defining achievement of postwar New York. And now, when abstract painting is often said to have run itself into the ground, there is almost a greater desire to cling to an establishment genealogy that begins with Pollock and goes all the way to Robert Ryman and Brice Marden. Yet nothing could be farther from the truth than the idea that painting what you see is not a New York thing.

Hans Hofmann, with whom Matthiasdottir studied after she arrived from Iceland in the early 1940s, always structured his teaching around the experience of working from a still life or a nude. He certainly encouraged Abstract Expressionists such as Joan Mitchell to bring a strong perceptual element into their work, and the important painters of figures, landscapes, and still lifes who studied with Hofmann include not only Matthiasdottir, but also Nell Blaine and Robert De Niro (the father of the actor). It's sometimes forgotten that Giacometti's mature representational style was first shown not in Paris but in New York, at the Pierre Matisse Gallery in 1948. And it's also significant, I think, that Balthus's first museum retrospective was in 1956 at the Museum of Modern Art, where it ran concurrently with a Pollock show. New Yorkers have always had their romantically speculative streak, which led them to abstract art, but they're also pragmatists who believe that what you see is what you get.

After a decade when everybody has been looking for alternatives to the less-is-more approach of much New York School abstraction, you'd expect that attention would focus on all the other painting that goes on in New York. There has been some revisionist thinking, but it hasn't really amounted to much. People grow weary of the old myths, but they cling to them, too, and when the time comes for a change, there's a tendency just to pile new myths on top of old ones. This helps to explain why, with abstract painting losing its allure, American museumgoers who want to get back to

nature have been inclined to embrace the School of London, which is presented as a realist alternative to New York. In 1994, Lucian Freud's retrospective at the Metropolitan Museum became dinner party conversation all over Manhattan. Freud's high bohemian London, with aristocratic ladies and a drag queen all undressing in the artist's barren atelier, had a hard-bitten documentary impact. And New York succumbed.

Freud's figure paintings are at the Acquavella Gallery in New York this fall. He renders each square inch of flesh—he piles on the paint until it creates weird mounds and ridges—and he wows an audience that sees this nitpicky naturalism as painterly magic. He's transformed a rather traditional studio exercise into a high-concept postmodern game, and although the programmatic thinking makes his paintings feel airless and inert, there's an audience that's willing to accept such overdetermination as a kind of meaning. Freud is so ardently realistic, so intent on proving that he will not be abstract, that he satisfies people's assumption that abstraction and representation are irreconcilable absolutes. Freud is admired for being everything that the New York School is not: he has stories to tell, and he dots all the i's and crosses all the t's. And he's not the only London artist that New York finds increasingly engaging; there is also heightened interest in R. B. Kitaj (an American who's lived in London for decades) and renewed attention paid to Francis Bacon, and a growing curiosity about less-known figures such as Leon Kossoff, Frank Auerbach, and Rodrigo Moynihan. The Brits suddenly seem relevant, precisely because they're outside the New York loop.

The Matthiasdottir retrospective ought to be recognized as a key event in contemporary art. It ought to be at the Metropolitan Museum, where Lucian Freud had his show. But that won't happen, since this artist's major-league emotional impact is so unlike what people have been led to expect from important new painting, especially in New York. Matthiasdottir doesn't care to startle us with the very fact of her being a realist. She insists on

an old idea of visual credibility, but she gives that approach an uncategoriz-able contemporary freedom, and she does so with a feeling for color and construction that comes straight out of abstract art. She's a New York School painter who wants to celebrate the overwhelming reality of the city; her still lifes have a New York clarity, a New York pace. Her work is such a thoroughgoing synthesis that it may be misunderstood as cautiously con-ventional. But if you tune into what Matthiasdottir is doing, you may end up thinking that if this isn't part of the mainstream, then the mainstream can go to hell.

Alex Katz started out at roughly the same postwar moment as Matthiasdot-tir, and there's really no mystery as to why he garners so much more praise than she does. Going through Katz's landscape retrospective, you see a smoothly intelligent man turning the whole world into an abstract paint-ing, which can make sense to people who are inclined to read abstract paint-ings as landscapes anyway. Katz leaves the tension between abstract structure and realist imagery right there on the surface, for all to see. If you can overlook the yawning chasm in recognition that separates Katz from Matthiasdottir, it's clear that they're working some of the same terrain. Katz also wants abstract and realist impulses to flow together. The difference is that he insists on making the synthesis look synthetic—and therefore hip.

Katz has always ignored all the annoying details and done one-color-per-shape work. His preferred brand of flattened-out, everything-up-front space was already in place in the landscapes he was doing in the mid-'50s, which included small colored-paper collages as well as bigger oils. A tree be-comes an interesting ragged-edged form. And whatever details Katz does in-clude are treated autonomously, as if they were visual stage directions indicating the weather or the season or the time of day. In *Thick Woods, Morn-ing* (1992) the all-over dark green is given a dappling of whitish strokes—

those are the leaves flickering in the wind, only freeze-framed. *Gold and Black #2* (1993) is a big yellow Barnett Newman, except that Newman's black vertical stripes have been angled slightly and hung with a few leaves so that they're transformed into early spring trees.

Katz's bare-bones enigmatic look, which turns dark city streets and brilliant New England mornings into Minimalist icons, seems especially suited to our been-there-done-that moment. His paintings have this built-in déjà vu. He knows that we know that abstract art emerged as artists from Monet to Mondrian rethought the landscape, and the way he reverses their march toward nonobjectivity gives the paintings a swank pop allure. His nighttime canvases are Ad Reinhardts, except that the silhouette of a tree or a bank of windows in a loft building has suddenly appeared. These are simple, almost arithmetic propositions: abstract impact plus naturalistic detail equals Alex Katz. And Katz, who knows that an artist ought not force his effects, brings off the visual frissons with casual aplomb. These are effective pictures, but the abstract-into-representation equation is stated so starkly that a viewer can't really engage. Even the awkward bits are meticulously preplanned. I admire Katz's panache, but these paintings don't amount to much more than ingeniously personalized wall decor.

The devil's bargain that Katz has made with abstract art is easiest to grasp when you take a look at the work he's done with his cutouts, a radically different medium that he dreamed up in order to create some deft studies in downtown charisma. The cutouts—which have focused on several generations of art-and-literature notables, from the poet and dance critic Edwin Denby to the painter Francesco Clemente—are about the fun that people have when cutting a figure in public, and because the cutouts are literally cut out and stood up in a gallery, the comic implications are absolutely delicious. I'm glad to see Katz letting loose with his naturalistic gifts; the cutouts tend to be suavely executed, with a good deal of elegantly meticu-

lous detail. Yet there is a paradox built into the cutouts, because it seems that Katz only takes seriously the whole question of how to give painted form an imposing solidity when he's gotten away from the discipline of a rectangular canvas—when he's not, in other words, really painting paintings. Katz is a tease. He wants to undermine the very illusions he's creating.

I'd like to see a Katz cutout set next to one of the self-portraits that Matthiasdottir has done in recent years, say the *Self-Portrait with Green Shoes*. Matthiasdottir's self-portraits are about going solo; she's a great-looking bohemian lady who's reached old age. And when she regards herself, she is every bit as amusing an observer of the inexpensive chic of downtown artistic circles as Katz was when he did his cutouts of the poet and dance critic Edwin Denby, except that she's also painting a painting. She knows how to make the smallest details link up organically with the broad compositional moves, and that's way beyond Katz. This slim woman with the beautifully shaped head has the same kind of penetrating though guarded gaze that Katz saw in Denby; it's the look of the ad hoc aristocrat. With her ramrod-straight posture, boldly striped sweater, and bright green shoes, she's almost an allegory of her own severe hedonism. Her head, with every important plane in place, presides over a naturalistic essay on the proposition that less is more. And the scenes-from-everyday-life props in certain other self-portraits—an umbrella, or a pitcher on a table, or a big shaggy dog—suggest the same back-to-basics spirit that we know from her still lifes.

Matthiasdottir has a sense of humor and a sense of play. I presume that she paints her self-portraits looking in the mirror, but interestingly she does not represent herself in the act of painting. These self-portraits without brush, palette, or easel are not about a painter at work but about a painter reimagined as an individual who can be in a painting. Painting herself full-length, unencumbered by brush or easel, Matthiasdottir creates a fictional world that she finds livable. There's a wonderful element of theater in these

paintings. She sees portraiture as associated with the theatricality of personality, something we know from the Baroque masters. Her affinity with the Baroque is intuitive; it comes out in the almost sneakily comic way that she has of presenting herself as director, set designer, and star all rolled into one. The self-portraits are about Matthiasdottir romancing Matthiasdottir. And her straight-forward, absolutely unflamboyant demeanor makes the egotism all the more elusive and interesting. Though Matthiasdottir's expression is invariably a little grave, these are wonderfully happy paintings. She is where she wants to be. She's in the painting, looking out at us.

Some portraitists make us believe that a person's deepest emotions are inscribed on the face, if only we can read the signs. It's a view with which Matthiasdottir apparently does not concur, at least where her own face is concerned. Still, she has a way of getting at psychological truth, which has to do with showing us not what she knows about herself but what she knows we know about her. The self-portraits suggest what a person can and can't see of another person; they get at the familiar feeling of being absolutely in the world and yet not really known or understood in the world. Matthiasdottir expresses this paradox formally, in terms of a tension between the forthrightness of her stance and the elusiveness of her face. In the paintings, it's a contrast—a disjuncture—that we experience through different kinds of contours, different ways of handling paint and color. In the body everything is crisp edges, decisive planes of color; in the face the contours are often smudged and the contrasts are often reduced. In the best self-portraits, the unclearness within the clearness is true to something that everybody probably experiences, namely the idea that a person's purely physical presence has a lot to tell us about the mysteries of personality.

Matthiasdottir's brushstrokes, broad and forthright and unshowy, pull everything together. In America, where virtuoso brushwork has been so overdone that it has become a cliché, many punctilious realists have a hard

time remembering that a painterly brushstroke isn't a dead end but a means to an end. Some realists now recoil from the freedom of the brush. That is their loss; but there is also hell to pay if you get so caught up in the mystique of painterly painting that oil-on-canvas turns into an artsy philosophic quagmire. Katz first came to prominence as an artist who rejected painterly painting, but in his big landscapes the brushstroke has returned—like a handprint of the 1950s, a jokey recollection of the days when paint was king. As for Matthiasdottir's view of the brushstroke, it's poetically matter-of-fact. Go through her retrospective and you'll see an artist who understands that the paint that reveals can also veil, and who wants to do a bit of both.

The problem is deciding when to do what, and why. These aren't necessarily conscious decisions. The character of an artist's brushwork ought to emerge out of the painting process itself, and there is always one or another realist who is just making a name and knows how to give a painterly style some tantalizing unpredictability. Philip Geiger, who is 40—his most recent show at Tatistcheff and Co. was in 1995 and another is slated for next spring—constructs contemporary interiors out of a weave of jagged, nervous strokes. Pictures that are filled with a distinctive contemporary instability are the result. Geiger's smallish canvases are updates on the old idea of the conversation piece: a relaxed group of family members or close friends, who in these paintings are talking or having a coffee or daydreaming. Geiger has an intelligently understated way of getting at some of the complexities of their relationships; he does it by keeping the painterly rhythm of his canvases open, uneven, a bit unpredictable. When he leaves a face a little blurred, he's picking up an undercurrent of tension or uncertainty; he won't let everything come into focus, and it's that not-quite-all-there ambiguity that holds our attention.

Geiger's suburban American interiors are pleasantly but rather sparely furnished: a couch, a table, a desk, a computer, nothing much on the walls,

few rugs, no curtains. These might be the homes of younger middle-class people who don't have the money for a lot of fancy things and maybe don't want to be stifled by possessions, anyway. The expanses of empty white wall suggest that the people who live here aren't dug in too deeply; they want some mobility. But those blank spaces also create a structural challenge, because Geiger can't let them become holes in the compositions. These paintings are about a slightly cold domesticity, and in an odd way the prairies of wallboard relate to the gray walls that Matthiasdottir leaves above her objects, although Geiger has nowhere near her gift for giving such intervals a positive force. If Geiger understands abstract structure—and I'm not sure to what extent he does—it's not in a start-from-scratch Constructivist sense but in a more act-and-react Abstract Expressionist way.

Geiger's narrative improvisations and Matthiasdottir's absolutist realism are separated not only by a vast difference in quality but also by an essential difference in expectations. You could say that we're seeing a generational difference here, and maybe that's an element, but there's more to it, too. Geiger is the kind of realist who means to make sense of the randomness of life, whereas Matthiasdottir's idea is that if she looks hard enough at the world it will turn out to have the classical order that she knows already from art. That's an ethical position. In the tan-and-gray portraits that she was doing in the '60s, Matthiasdottir was a painterly Expressionist with Neoclassical leanings; she looked at the model and saw afterimages of Corot and Courbet. A quarter century later, she has complicated the equation further; you might say that now she's looking at nature and seeing afterimages of Mondrian and Léger. She still wants nature to confirm her ideas about art, but the process is extremely complicated, because ideas about art are always in a state of flux, which must mean that nature is changing, too. There are realists who seek an inviolable truth that they can oppose to the relativism of modern art, but their neatly polished work suggests a refusal to see.

Geiger is not without his conventional ideas, but at least he doesn't quite know what he's going to find, so that his work has an interesting spark.

More than anything else, it is Matthiasdottir's clearheadedness that sets her apart. In her recent still lifes, where she leaves much of the table bare, she's reminding us that the tabletop is as primary a rectangle as the canvas itself. This is the kind of consideration that you find in the very greatest still life painters—in Chardin, in Matisse. Is Matthiasdottir that good? John Ashbery, writing in *Artnews* all the way back in 1972, observed that her work "will be remembered long after the big names of this season or next season are as forgotten as those of the *pompiers* of yesteryear." I agree, but we're still waiting for the shakedown to occur. A quarter century has passed and many more "big names" have come and gone, and many people have still not had their first look at the work of an artist who came to New York when she was in her 20s. Through it all, she's stayed on course. In the recent still lifes, Matthiasdottir *does* bring Chardin to mind. You can't say that about any other painter who is working now.

November 11, 1996

FLAG BURNING

Jasper Johns cultivates the same gloomily ambiguous mood in just about every painting in the huge survey of his work that is at the Museum of Modern Art this winter. These canvases are about stalemates and dead ends and insoluble puzzles; they're headaches waiting to happen. Over and over again Johns replays the same old Dadaist is-it-art-or-not? routines, until the everything-is-nothing mantra has turned your mind to mush. Johns's

white-on-white *Maps* are unreadable, his numbers blend one into the other, and when he paints the *Seasons* he gives spring and summer the same murky chill as autumn and winter. This artist's craftsmanlike punctiliousness serves only to give his negativity a distinguished patina. His idea of fine finish is a nihilistic grace note: a solitary drip here, a blackish smudge there. The retrospective surveys a forty-year-long funk.

Kirk Varnedoe, the Chief Curator of Painting and Sculpture at the Modern, has organized the show himself, rather than delegating the job to one of his lieutenants. He loves Johns's frosty-Olympian Dadaist forays. He may think that Johns's sourness is what museum-quality art is all about, but his support is not a selfless act. Varnedoe knows that there is peril in presiding over a great collection of early modern paintings when he also wants to dominate a postmodern scene that's inclined to regard all painting as irrelevant. Johns, who is both a Dadaist and a nearly universally admired painter, can function as the master of détente. And détente is what Varnedoe needs.

Marcel Duchamp is the ghost who stares out from every painting and sculpture and drawing in the show. Johns knew Duchamp in the '60s, and his own polished persona may in some respects be modeled on the likable aspects of Duchamp, who could appear a paragon of bohemian taste, elegance, and unflappability as he followed all the new developments in New York right up until the time of his death in 1968. Johns may want us to think of Duchamp as an august historical figure, but what he and his friends saw behind the facade of the impeccable aesthete was an incendiary genius whose anti-art aperçus could be accepted as law precisely because they came from the lips of a man of such vast sophistication. In an interview in 1966, Duchamp dismissed André Breton, the poet and polemicist of Surrealism, as "a man of the '20s, not completely rid of notions of quality, composition, and the beauty of materials." The point was that Duchamp was a man of the present who had escaped from all those outmoded ideas.

If Johns sometimes looks likes Duchamp's truest disciple, it is because he trumped the old aesthete's rejection of the idea of beauty by resurrecting "notions of quality, composition, and the beauty of materials" as parodistic imitations. Johns's slurpy surfaces are a send-up of paint quality, just as his what-you-see-is-what-you-get subjects are send-ups of subject matter. By now Johns is such a pervasive influence that it's sometimes difficult for people to separate his send-ups from the real thing, but that is a confusion that Kirk Varnedoe seems to welcome. In a catalog essay he explains that Johns has helped him to see that one can unite Duchamp's Dadaism and "the more traditional mainstream lineage of Cézanne and Picasso." These artists might have once appeared "antithetical" and "incommensurable," but after Varnedoe looked at Johns's work he understood that all of this "can be grafted together . . . to produce a hybrid of potent fertility." Johns is a hybrid, all right, but I'm not so sure about the potent fertility.

Nothing in this retrospective is what it seems, and this conundrum is supposed to keep us on our toes. In 1959, Johns stenciled the word "yellow" on a painting with blue letters, and the confusion delighted him so much that he's done the same thing over and over; a recent canvas has the word "red" written (this time backwards) in gray. Johns doesn't go anywhere with this paradox. He lacks the mastery of color that might enable him to give a gray the rousing heat of a red. Maybe he just wants us to mull over our confounded expectations. After Duchamp died, Johns wrote that the older artist "declared that he wanted to kill art ('for myself') but his persistent attempts to destroy frames of reference altered our thinking, established new units of thought." Does Johns imagine that his mismatched colors and words signify a new unit of thought? Johns has said of one of his white paintings of a flag that he meant to create something that was "neither a flag nor a picture. It can be both and still be neither." That has a nice enigmatic twang, but what does it mean?

The contemporary art audience will generally take a crack at a puzzle, even if there is reason to suspect that no solution exists. The challenge for the artist is to keep people's attention after the initial novelty has worn off, and certainly Johns is some kind of genius when it comes to weaving and reweaving his phony-baloney spells. His manipulative savvy can sometimes bamboozle even more discriminating museumgoers, because he bases his effects on a close study of the way that other—mostly better—artists have managed to grab the audience. Johns will take a nifty method of handling paint from de Kooning, a dazzling image from Picasso. He provides something for everybody: a bit of trompe l'oeil virtuosity for collectors who want their money's worth, a little porn for younger artists who might otherwise suspect that Johns has lost his edge.

Johns's work does have a certain fidgety elegance. But his effects are so drearily localized that the refinements close down a picture instead of pulling us into a world that has an integrity all its own. He probably wants it this way, but those of us who want something different are perfectly justified in rejecting not only the product but also the approach. This artist moves around bits of pigment as if painting were some kind of post-Armageddon game, like Duchamp at his chessboard. It's easy to argue that Johns has rescued the dying embers of a vanishing art, as long as you ignore the fact that he stood by applauding while his hero poured the gasoline and lit the match.

Johns, who is 66, emerged at a sea-change moment in American art. In the late 1950s, success was coming to the generation that had arrived in New York after the war and had watched as Pollock and de Kooning achieved national and then international fame. Much good work was being done, but there was also talk of Abstract Expressionism turning into a new academy. With galleries and museums responding to the enthusiasm of a rapidly growing audience, there were beginning to be signs that the public's

appetite for innovation might eventually outstrip whatever surprises the artists had to offer. All of these developments peaked with the Pop explosion of 1962, but already in 1958, when Johns showed the paintings of flags and targets that he'd been doing since the mid-'50s at the fledgling Leo Castelli Gallery, there were signs of discontent. People wanted change, and in Johns they found just enough. If his readymade subject matter had a startling Dadaist impudence, his rugged-but-elegant surfaces seemed to prove that there was life left in Abstract Expressionism.

This work was an immediate success when it was shown in 1958. Alfred H. Barr Jr., the founding director of the Museum of Modern Art, earmarked four paintings for the museum's permanent collection, thereby beginning an institutional relationship that has culminated thirty-eight years later with the current retrospective. And Thomas B. Hess, the editor of *Artnews* and one of de Kooning's most loyal supporters, reproduced a Johns *Target* on the cover of his magazine. This was an amazing response to an artist's first show. Perhaps even more remarkable is the fact that all these years later people who care little for Dadaism and still less for Pop keep a warm place in their hearts for those first *Flags* and *Targets*. Even many skeptics want to give Johns some credit for having fussed so mightily over the *Flags*. The artist would cut his stars out of newspaper, glue them down, then wash over some milky, translucent paint (it's encaustic, a wax medium). There's lots of detail involved—close work, I guess you'd call it. Johns worries over those surfaces, inch by inch, but this is basically an amateur's idea of technique, since it has no cumulative impact.

With those first *Flags*, Johns turns an American icon into his own kind of thingamajig, and if that's not saying much, it's more than I can say for the rest of the work in the show. In the '60s, when Johns tried his hand at big, horizontal works with lots of heterogeneous elements, such as *According to What*, he couldn't achieve even the vapid decorative sweep that his old friend

Rauschenberg was bringing to oversized surfaces. And there is always trouble when he introduces collage elements (another Rauschenberg specialty). Johns is far too intent on keeping everything under control to allow for the explosive metaphoric possibilities of assemblage. The painted body parts in the early *Target with Plaster Casts* (1955) and the broom in *Fool's Home* (1962) look both feeble and pretentious. I can't imagine a worse combination.

Johns is too much of a control freak to let loose with the possibilities of paint. When his work goes abstract in what are known as the cross-hatch paintings (they dominate the '70s) he leaves us with practically nothing to look at, because there is no feeling for color to give some dynamism to his broken patterns of parallel lines. Johns supplies these abstractions with fancy metaphoric titles such as *Scent, Corpse and Mirror, Dancers on a Plane,* and *Between the Clock and the Bed.* Nothing in Johns's work goes unanalyzed, and museumgoers who are disposed to work out the metaphors can certainly get their minds spinning. The *Barber's Tree* from 1975 is apparently based on a photograph that Johns saw in *National Geographic*, which showed a Mexican man concocting a sort of barber's pole by painting stripes on a tree. Michael Crichton, the author of the catalog of Johns's 1977 retrospective at the Whitney, reproduced this photograph and observed, "It was probably the underlying idea of painting over reality that interested Johns." Oh, of course, painting over reality. For an artist who's already painted over the North American continent in his *Maps*, painting over reality is just the next cosmic leap.

When you see the cross-hatch paintings in this big retrospective, where they mark roughly the halfway point, they look like Johns's way of putting some distance between his Pop-oriented beginnings and the painter-philosopher that he has always wanted to become. Viewed this way, the cross-hatch paintings provide the perfect lead-in to the work of the '80s, in

which Johns attempts to situate himself among the immortals by crowding his paintings with selected references to Grünewald, Leonardo, Picasso, and, later, Holbein and Cézanne. Johns presents these snippets from the masters in the same deadpan spirit as he once presented the icons of the American heartland. His art-historical potpourri has no particular logic, but he insists on his quotations with his trademark cool belligerence, so that you can scarcely believe that they really mean this little. Over and over, he reproduces the outlines of several fallen soldiers from Grünewald's *Resurrection*. And two Picassos from 1936, *Woman in a Straw Hat* and *The Minotaur Moving His House*, crop up more than once, as does a skeletal figure from Picasso's 1958 *Fall of Icarus*.

Johns's admirers know their art history, and in his recent work they imagine that they're seeing a replay of the mysterious process by which a very great artist sometimes becomes most himself when he quotes almost line by line from a work that he passionately admires. This extraordinary phenomenon cannot be willed into being, yet some of our postmodern painters are so tired of the present that they would just as soon pretend that they're immolating themselves on the altar of the past; it's the nouveau-traditional thing to do. Meanwhile the critics offer specific explanations for some of Johns's alleged acts of self-immolation. We are told, for example, that a fragment from Picasso's *Minotaur Moving His House* first appeared as an element in the *Seasons* of 1985–86 because Johns was changing his address. That's perfectly logical, but it says nothing about the impact of the quotation in the work.

When Picasso salutes Ingres, he's reexperiencing the magisterial academician's sensuous arabesques in terms of his own feeling for line and color; each stroke is a sympathetic response. Johns just copies elements: a few outlines here, a complete image there. He treats great paintings as an art director might. He crops and edits, cuts and pastes. His canvases are message

boards, sometimes literally so, as in *Racing Thoughts* (1983), in which a silk screen reproduction of the *Mona Lisa* is affixed to a bathroom wall by several trompe l'oeil bits of tape. He notes down things he likes and personalizes them with a little joke, as in a recent series of tracings done on clear plastic after a reproduction of one of Cézanne's *Bathers*. Any art student ought to know that a tracing of a painting isn't a response or an interpretation; and even the Dadaist sex-change operation involved in turning one of Cézanne's women into a man with an erection hardly registers amid Johns's lackluster washes of sepia-toned ink.

In the paintings that are gathered in the final room of the show, bits of Picasso and Grünewald are combined with floor plans that are said to represent a house in which Johns lived as a child. Here he is supposed to be in one of his meditative moods, a sort of fugue state in which art history and personal history begin to merge. This man whose idea of an homage is to do tracings after Cézanne is trying to convince us that he is keeping the high art tradition alive. Johns's tamped-down palette doesn't achieve the twilit poetry that he's probably after, but the gun-metal color scheme does put us on notice that this is sober work. The most recent canvases are meant to convey an impression of middle-aged maturity, lessons learned, challenges met. These high-priced gray paintings are the art-world equivalent of a very expensive gray suit. They are engineered for importance.

Some people say that Jasper Johns has been making an impression for so long that by now he's beyond the reach of criticism. Michael Kimmelman explained in his *New York Times* review of the Johns show that he doesn't care for a lot of the work, but he also observed, "It's pointless to argue about Mr. Johns's place in history; this issue was settled decades ago." By reassuring his readers that Johns really is an important artist, Kimmelman may intend to soften his own discomfort at finding himself on the wrong side of current taste. When Kimmelman concedes Johns his "place in history," however,

he's jumping the gun. The idea than an artist who has been acclaimed for thirty-five years is a permanent fixture reflects a shortsighted view of history. Johns's long relationship with the Museum of Modern Art proves nothing except that he is the closest thing to an official artist that we have, and that doesn't prove much at all.

There are official artists, such as Velázquez, whom we count among the immortals. And their are official artists, such as Lebrun, who dominated France in the second half of the seventeenth century, filling Versailles much as Johns now fills the Modern, who hardly count with anybody today. Artists are hailed in one generation and forgotten two or three generations later. I wonder if Johns recalls an observation that his friend Duchamp made in 1966: "Success is just a brush fire, and one has to find wood to feed it." Kirk Varnedoe has thrown on lots of wood, and the fire is burning furiously. This huge retrospective is the ultimate accolade that Johns will receive from his contemporaries. What remains after the flames die down is another matter entirely.

<div align="right">DECEMBER 2, 1996</div>

THE AGE OF RECOVERY

The art world is in recovery. The economic climate is soberly optimistic, with an improved auction situation and a smattering of new galleries. But recovery means different things to different people. Artists and dealers who built big reputations and fat bank accounts in the 1980s may still be trying to get over their disappointment that the boom screeched to a halt when the art market plunged in 1990. Then again, if they were into the downtown

mix of art, sex, drugs, and rock 'n' roll, they've probably considered the losses to heroin and AIDS and are just glad to be alive. As for the countless artists who felt swamped by the glamourmongering of the '80s and breathed a sigh of relief when it was over, they're finding that, so far as the gallery scene that they once expected would support them over the long term is concerned, recovery is nowhere in sight.

Nan Goldin, the photographer whose this-is-our-life slide shows made her an East Village celebrity in 1981, kept her camera focused on her friends through all the weirded-out adventures and terrifyingly bad times, and this winter found herself with a big Whitney retrospective. In the show's hefty catalog, each downtown memory has a darkly shimmering allure. Darryl Pinckney revisits the old neighborhood and comes upon the entrance to the building where Nan lived, which "begins to resemble the entrance to a tomb." Luc Sante observes that "we were living in a movie of youth in black-and-white that in order to be grand needed to be stark." Goldin uses New York as the setting for a portrait of the artist as a young hipster, and she obviously knows something about the unfocused, mood-swinging intensity of youth. That feverishness reintroduces a wonderful old theme—the heartaching fervor of *la vie bohème*—but after a while you may wonder if these kids who are supposedly so head-over-heels about art and visit museums and pin lots of art postcards to their walls know that there's more to creativity than letting it rip. Although some artists who never really cared for the Old Masters are now glad to regard the museums as the places where they go for their retrospectives, most painters who spent a lot of time in the museums in the '80s are finding that the '90s is a decade much like any other. The signs are not all bad, but how you read them depends on where you're coming from.

An interesting art season in a great city requires some formidable museum shows, some contemporary work with a magically personal aura, and

an audience that's involved. In New York the elements are all in place, but I wonder how many of the gallerygoers who are willing to take the time to see what there is to see, are either open-minded enough or hard-nosed enough to make the most of what comes their way. How many people are ready for a marvelous surprise, like the small, perfectly paced retrospective of Edwin Dickinson (1891–1978), that most poetically mysterious of modern American realists, at Tibor de Nagy's new space on Fifth Avenue? Well, it's good to know that there's a gallery that believes that some people are ready to revisit Dickinson. Certainly there have been days this season when a gallerygoer could find something to enjoy, and if that's the case it can hardly seem to matter that a lot of the audience is probably being pointed in the wrong direction, that much of the best new work is in danger of being overlooked, and that the museum shows are frequently botched. If this sounds depressingly familiar, all I can say is that recovery often means returning to where you started.

The European visitors who form so large a proportion of New York's current museumgoing audience help to quicken the city's pace, even as their presence returns the compliments that we've paid to their cities over the years. The Nan Goldin show provides foreigners with one kind of insider's New York, but visitors were also enthralled by the spectacle of the huge Ellsworth Kelly show at the Guggenheim on Fifth Avenue. Kelly, who has in the past exhibited photographs taken on his visits to Gaudi's *Park Güell* in Barcelona, where the colored patterns of broken tiles are arranged on curved forms to such sumptuous effect, must have enjoyed the way his own colored patterns mosaicked the walls of Frank Lloyd Wright's rotunda. The Kelly retrospective was far too large to establish any fine discriminations among his works, but it had a thumping magic. This artist has taken the old modern idea of formal reduction as emotional intensification and honed it until intensification becomes its own rationale. Kelly is always going for a

big, fast, precise impact, and he's still achieving that kind of immediacy in works such as the huge, single-color, shield-like compositions in black, red, yellow, and green (painted in 1996) that filled a large room at the lower end of the Guggenheim ramp. The show was Ellsworth Kelly's apotheosis as the ultimate Manhattan artist: always reaching for the bigger effect, always slicing through.

Institutions seem to be in a do-what-must-be-done-to-survive mood, and that's not necessarily a bad thing. The Guggenheim—which in recent years, under the direction of Thomas Krens, has often placed its dreams of global empire before its obligations to the hometown audience (and by some reports has nearly gone bankrupt in the process)—came through this season with both the Kelly show and "Max Beckmann in Exile," at the Guggenheim SoHo. The Beckmann exhibit had its own kind of Manhattan synergy because this German artist found a home in New York, where he finished his last triptych and died in 1950. If Kelly's charged-up color planes come out of the city's postwar ebullience, Beckmann's triptychs, with their overlapped allegories and convoluted narratives and brilliant colors muffled by black lines, evoke a New York of Old World exiles who were mostly ghosts long before this new generation of tourists arrived. In New York, artists have always wanted to set their own brilliance in high relief against the European achievements, and in Beckmann's triptychs, one of which has hung in the Museum of Modern Art since 1942, the artist's self-conscious pile-up of memory is a challenge and a spur to action. I find Beckmann's work too impacted and willful to rank near the top level of modern art, but displayed at the Guggenheim SoHo, in the midst of New York's highest-density art neighborhood, the show was right on target.

When the Guggenheim SoHo first opened in 1992, there was the exciting prospect of being able to look at modern classics amid the contemporary flux, and from time to time, to some degree, that promise has been fulfilled.

I saw Mari Lyons's landscapes of Montana at the First Street Gallery just after coming out of the Beckmann show, and an affinity that I noticed immediately in Lyons's emphatic dark linear framework was confirmed on her curriculum vitae, which indicated that she studied with Beckmann when he taught at Mills College in 1950, not long before his death. Some will find echoes of Beckmann's Weimar period night life in Nan Goldin's work. As for what a painter can learn by just looking at Beckmann's paintings, there's an essay in the Guggenheim catalog about that by the painter Eric Fischl, and if Fischl's own painting seems to take off from the most indulgent of Beckmann's ambiguities and just confuses them further, well, that's part of the story, too.

Fischl had a show of new paintings at the Mary Boone Gallery this fall, and it would have been a two-minute walk from the Beckmann exhibit, except that Boone has moved her establishment to Fifth Avenue and Fifty-seventh Street. She's looking for the high-end shoppers who still cross the golden intersection that's home to Tiffany and Bergdorf Goodman, but other dealers are expecting those shoppers to follow the art to Chelsea, where, in the West Twenties, between Tenth and Eleventh Avenues, the gradual development around the 10-year-old Dia Center building has suddenly turned into a stampede. With SoHo overrun by fashion and home furnishing shops, a number of the galleries that like to give an ironic spin to consumer culture are turning to Chelsea for some critical distance. Perhaps painting is the only art so intently handmade and noncommercial as to be able to make an impression in a SoHo now dominated by Armani A/X, J. Crew, and Banana Republic. (Banana Republic is saluting the painters by sponsoring the show of Willem de Kooning's late work that is at the Modern.)

In the end, Chelsea will be just another posh locale, as it has already become for Matthew Marks, the wunderkind among the dealers of the '90s, who this fall exhibited portraits of children by Nan Goldin in his Madison

Avenue gallery while he had paintings by Ellsworth Kelly hanging in Chelsea. Kelly fits right in with Chelsea aesthetics, which are about doing ingeniously elegant things in smashingly scaled spaces, the most recent instance being some lengths of string that Fred Sandback stretched as drawings-in-space in Dia's spectacularly austere rooms. Such environmental interventions beg the whole question of the freestanding authority of art. But then Chelsea is not an artists' neighborhood; it is an invention of well-heeled dealers and real estate interests that are turning factory spaces into high-end co-ops even as the galleries open their doors. As for the artists, forget Manhattan—they can't even afford to live on the Lower East Side.

An art scene that has received a lot of attention in New York never dies, it just disappears into the museums. A decade ago each season brought a new constellation of stars, and the mid-career retrospectives came in rapid-fire succession, so that last year's news could be bumped over into preclassic position. Nan Goldin, who has been on the scene since the late '70s, may feel that she's had to wait an awfully long time for her retrospective. Yet she also seems to feel that the time is right. After years of living by night, photographing friends who often had trouble getting out of bed and seldom saw the sun, Goldin is ready to trade her flash bulbs for natural light. She's been on "Charlie Rose." It's a new day downtown, and a lot of people seem to be tuned in to Goldin's somewhat hardened, skeptical spirit. It's part of the recovery. Her show has an elegiac impact that it couldn't have had a decade ago.

Goldin has the true photographer's gift, which is rarer than is generally imagined. She's avid for appearances; she brings a restless attentiveness to everything she sees. This alertness probably has at least as much in common with a novelist's intuitions as with the structural instincts that are a painter's essential tools. There are great photographers who compose "like

painters," but if you look at the work of Sander or Hine or Atget, you'll see that for them composition is an almost involuntary outgrowth of their reactions to a subject. The close-up textures and double-strength color in Goldin's pictures convey the intensity of her relationships, and at least at the beginning of the show I was glad for the explanatory labels, which told us who she was sleeping with, who was her best friend, and who was his boyfriend of the moment.

Goldin gets at the thrill of intimacy, and at how that thrill can turn scary. She zooms in on disheveled bedrooms and couples caught in the act, and she finds ways to show people with their defenses down and still not turn them into grotesques. She reveals a friend in the midst of a bad night or a really crazy time, and the emotional nakedness lets some poetic beauty come through. It helps, of course, that so many of her strung-out gang are so good-looking. Still, considering their frequently blanked-out looks, it can't be that easy to draw us in. Goldin has terrific instincts about angles and expressions, so that the camera's eye feels affectionately direct.

The title of the Whitney show, "I'll Be Your Mirror," which is the title of a Velvet Underground song, brings to mind all of Goldin's shots of people in those between-the-acts moments when they're checking out how they look. Goldin understands that kind of all-by-yourself-with-yourself intimacy. She gets at the narcissistic charge of the behind-the-scenes interlude when a woman fixes her lipstick, or a drag queen makes sure that her persona is in place. And Goldin pushes the boundaries pretty far in the photographs of friends on the john. You may wonder if you want any camera to reveal that much, but there's something remarkable about the absence of sensationalism in these photographs. Goldin's imperturbability recalls Brassaï's work in the night world of Paris in the '30s, where he recorded a prostitute on a bidet and people dancing till dawn in a gay cabaret. Goldin's cool appraisals turn out to have their own romantic impact.

Goldin keeps her openness all the way through the show, at least inter-
mittently. Yet as the exhibition moves forward it doesn't sustain its focus,
and the intimate impact of picture after picture begins to be overtaken by a
whatever-happened-to-the-East-Village? narrative that the pictures don't
so much advance as illustrate. The show is way too big, but Goldin's ambi-
tions for her photographs are too big, too. To the extent that she means to
tell not just her own story but also the story of her community, where
drugs and AIDS have taken such an enormous toll, the onslaught of events
makes her work look inadequate, and the disjuncture becomes a huge prob-
lem. Surely Goldin sees a metaphor in the way that the unmade beds in
which people frolic and argue in the earlier part of the show turn into the
hospital beds that they die in later on, but I'm not sure that there's anything
a photographer can do with this material that doesn't end up seeming
small. By the conclusion of the show, when Goldin is photographing in Asia
and Europe and finding more unmade beds and more people falling in and
out of them, the show has turned into a fashionable, one-world orgy.

Goldin bonds with her subjects and produces some terrific photographs,
but her attitude toward those photographs is pious. When she gathers her
work together into slide shows and books and exhibitions, she glorifies the
imagery, she turns her friends into downtown poster kids. And when the
photographs deal with death, we're forced into an emotional bind, because
the real-life tragedy becomes the trump card that's supposed to ignite the
art, and if we have reservations we can be accused of callousness. Goldin is
being promoted as a photographer who hit New York running and kept up
the pace for a decade and became a profound artist along the way. I don't
think that she's anywhere near that important.

In his essay in the catalog, Pinckney observes that in the East Village
many people fell "under the spell of the ruinous message that a wild life in-
dicated a fertile imagination." I'm not so sure that that idea has really been

rejected. The people who have survived need only to look around to see that a large swath of the art scene has conflated wildness with fertility, and that lots of artists have proceeded to build successful careers on the shifting foundations of an ever-deepening aesthetic morass. According to the new artistic dispensation, everything is on a continuum, and you can go from producing wild parties to performance pieces to paintings to movies. Pinckney mentions Jean-Michel Basquiat and Keith Haring and believes that drugs at least fueled their scrambling of personal assertion and artistic expression, but of course artists such as Salle and Schnabel, who attended reputable art schools and didn't live quite so close to the edge, simply have a more cleanly packaged version of the same art-is-life-is-art confusions.

There's a high-art aesthetic that's derived from advertising, and it goes much deeper than an Andy Warhol look. What artists have learned from commerce is that they have to go out and meet the public where it lives, or where it thinks it lives. A lot of artists really believe that their job is to psych out the Zeitgeist and then play into it. (That's what Goldin does.) But what's most striking about some of the best gallery shows of the fall—the paintings by Harriet Korman at Lennon, Weinberg; by Trevor Winkfield at Donahue/Sosinski; and by Rita Baragona at Bowery—is that these artists are wholly focused on what they are doing and expect us to come to them. I have no idea how many people got to these shows. Whether it was twelve or twelve hundred, it wouldn't alter the nature of the relationship between the gallerygoer and the painting. For the gallerygoer, there's an enchantment in accepting art on its own terms; but if our Age of Recovery is about facing hard realities, painting fails the test.

Painting, even the most naturalistic painting, is about impractical propositions carried to refined conclusions. There's an imposing weight to Harriet Korman's casually clunky calligraphy, which, in three or four paintings, she pulls together into mysterious escutcheons composed of densely worked

figure eights and triangles. Trevor Winkfield, who probably regards his repertory of zany, hard-edged geegaws and humanoids as a personal tarot deck, scores a triumph in three big paintings; he's extended himself and found a new security in architectonic composition, an amplitude that gives his awesomely nutty iconography a pageant-like authority. Rita Baragona, in her eighth show at Bowery, combines an overall soft luminosity with a steely pinpoint accuracy and brings this unpredictable painterly attack to her quiet violet-and-yellow bouquets and to her gardens raging with rainbow-hued flowers.

All of this painting, of course, can be said to be old hat, but if there's any advantage to living in an art scene where everyone claims to have already seen everything, it's that painting shares its retro status with lots of other things. "The gee-whiz factor is perishable," Anthony Haden-Guest announces near the close of *True Colors: The Real Life of the Art World*, and although that might seem like an admission of defeat at the end of his gee-whiz survey of the past several decades, it doesn't keep him from looking for the next thing. What the postmoderns have learned from painting, with its august traditions, is the trick of dignifying the present by invoking the past, and so Matthew Barney's videos or Robert Gober's sinks or Janine Antoni's performance paintings made with hair dye are bolstered by pointing out that Dali did movies, Picasso wrote a play, Courbet was a political activist. For all we know, Leonardo da Vinci was the first couturier. By now everybody has dealt with painting and the end of painting and painting again, with ugliness and beauty and the beauty of ugliness, with political art and art-for-art's-sake and political art as art-for-art's-sake. We've seen it all before; we've seen it all simultaneously, sometimes in one work of art. Everybody knows all the angles, and the result is a know-it-all detachment.

It can't have escaped Anthony Haden-Guest or his publisher that *True Colors* arrived in bookstores on the tail of *Primary Colors,* the satirical novel

about Clinton's run for the White House. When you think about it, the appeal of these bright, jokey titles is related. They describe absolutes, and for that reason they amuse us, because we know that the books are full of half-truths and out-and-out lies, which are delivered by characters who are satisfied with their second-rate ambitions and would, in a rational world, play minor roles. In the '90s, many people have found themselves asking the same questions about the art world that we've asked so often about the Clinton administration. How can people who are so intelligent go so wrong? How can you know so much and miss the point so completely? How can you believe in everything? Some of our most prominent artists, curators, and critics know so much about the situation that there's no space left for the dumb fact of the imagination. They've been through everything, they've recovered, and still it doesn't make a difference.

FEBRUARY 17, 1997

IMPERSONAL ENCHANTMENT

Jeff Wall brings an unsettling, fire-and-ice dissonance to his mural-scale photographs. He catches some of the quotidian romantic poetry and the lustrous, blue-gray light of his native British Columbia in Cibachrome transparencies that are mounted in light boxes and edged in silvery-gray metal. The hi-tech ad campaign style of the work makes it possible for Wall to freeze-frame his sensuous reactions to colors and textures. He zooms in on scrappy roadside sites and the faces of people who are sometimes in the midst of heated conversations. These huge images—often ten or twelve feet wide—make familiar objects look special, preternatural. It's as if Wall were

putting his perceptions under the microscope. Although I wouldn't say the results add up to a wonderful experience for a gallerygoer, this is clearly the work of a man with a deft visual sense and an interestingly complicated mind.

Wall, who was born in 1946, is the subject of a retrospective that is at the Hirshhorn in Washington this spring. The show was organized at the Museum of Contemporary Art in Los Angeles, where it will be next summer, and after that it goes to Japan. Although his name hasn't yet become widely known beyond art circles, Wall is a regular in the big group shows that many curators, dealers, and collectors depend on to track reputations. These exhibitions include "Post Human" (which toured Europe in 1992–93); the 1995 Whitney Biennial; "Hall of Mirrors: Art and Film Since 1945" (at the Los Angeles Museum of Contemporary Art last summer); and "Face à l'histoire" (at the Pompidou Center in Paris this winter). Wall's work is post-paint and pro-narrative, which links him to better-known contemporaries, among them Christian Boltanski, Annette Messager, Bruce Nauman, Cindy Sherman, and Bill Viola. I don't subscribe to what I believe is the unspoken assumption of much of this work, which is that painting is no longer a suitable vehicle for complex figurative expression. I am far from being convinced that photography or video can ever achieve the subtly nuanced power that we expect from large-scale visual art. But I do believe that Jeff Wall makes the case with a rare wit, perspicacity, and panache.

This is no one-note artist. He does landscapes, still lifes, and figure groups; and he experiments with different kinds of dramatic intensity, ranging from mild genre scenes to macabre fantasies and film-noir-style scenarios. He's attuned to the melting-pot experience of the Pacific Northwest, where the invitingly open look of fast-growing cities is an unusual backdrop for multicultural tensions. Some of his photographs look like slices of life; but even some of his most direct-feeling images are elab-

orately staged constructions. In recent years, Wall has been using lots of computer-generated effects. He will add or subtract figures from a photograph, or move around the shadows, or sometimes even practically dream up a composition from scratch, using elements from a number of photographs. Wall's work is distantly related to the fancy combination printing techniques of mid-nineteenth-century photographers such as Oscar G. Rejlander and Henry Peach Robinson, whose attempts to create grandiose narrative structures were grounded in an idea, hardly unfamiliar all these years later, that painting is going to fade away. The artificiality of Rejlander's and Robinson's collage techniques has turned their allegories of good and evil and life and death into period pieces, into camp; but Wall may have less trouble with the antinatural element in his photography, since by now the long shadow of Surrealism has convinced us that disjuncture is as real as anything else.

Wall is infatuated with the dream of painting and the technique of photography. He is caught between Old Masters and modern methods. For decades now, men and women with no abiding involvement in drawing or painting have been flooding out of the art schools, and a curious outgrowth of this situation has been the appearance of artists such as Wall who have an avidity for classical pictorial values but little or no feeling for a hands-on creative process. When Wall borrows Caravaggio's chiaroscuro or Ruisdael's panoramic effects, he shows an appreciation for the classics that you don't get, say, in Cindy Sherman's slick jokes on Old Master portrait styles. Wall also has an unusually expansive response to photographic techniques. The way that he illuminates his pictures from behind gives the surfaces a pearly glow that ingeniously parallels movie images experienced on the big screen. Yet the range of his themes is so broad that he can strike a museumgoer as less an artist than a sort of impresario who stages all kinds of fetching visual ideas. Wall is a brainy postmodern aesthete. He gives the old painterly magic

a fascinating clinical chill, and in the end I find myself thinking of even his best works less as dramatic events than as essays in dramatic possibilities.

All of Wall's strengths come together in *A Sudden Gust of Wind (after Hokusai)* (1993). Here he is a likable, almost a happy-go-lucky artist. What first catches my eye is the great sheaf of papers that's spinning through the sky, mixing with the autumn leaves. Then I go to the unlucky man who has lost control of his bundle; he's in an overcoat and sports jacket and white shirt and tie, all the way to the left of the scene. This bold, odd composition has a specificity that holds me. It is very big, over twelve feet wide. There are four men in the foreground, and although they seem to break up into two groups (the ones in business dress, the ones in casual work clothes), they are also united in their balletic efforts to hold on to their headgear and keep their balance against the strong gust of wind that's whizzing across this flat, scrappy landscape. I like the low horizon, the gigantic sky, the city glimpsed in the distance. The effect is ordinary, but with a touch of the sublime. I wonder about the seemingly shallow body of water, which might be an irrigation canal. I also wonder what's brought this odd assortment of men together in this particular place. But the enigmatic quality isn't troubling; it's actually rather enjoyable. The softly pervasive light sweetens the shambling picturesqueness of crooked power lines and corrugated metal huts.

This modern scene is based closely on a Hokusai woodcut print, *A High Wind in Yeijiri*, from the *Thirty-six Views of Mt. Fuji* (1831–33), but the shift in size and in medium makes it Wall's own. There is nothing calculated about his adaptation. My guess is that he was excited by the wit of the Hokusai work and couldn't resist responding. And his version—which lacks the picturesque grace note of Fuji, looming above the action like a giant calligraphic exclamation point—accrues some distinctly European associations. I'm reminded of landscapes by Hobbema and Ruisdael, which are also about traveling beyond the city limits. There's a Dutch sort of poetic practicality

here, a feeling that happenstance can have an emblematic power. We may wonder what sort of agricultural work is under way. We may suspect that the men in business dress are engineers or entrepreneurs. That sheaf of papers lost in space could be the specs for some big-time project. But Wall doesn't insist, and we are left with the pleasantly speculative emotions that we might have after driving past a curious scene on a country road.

Unfortunately, Wall isn't always this circumspect. He can overplay the drama, as in *Outburst,* a scene in a sweatshop, where a male supervisor lashes out at a woman seated at a sewing machine, while several other female workers look on meekly, obviously afraid for themselves. I suppose Wall means to dramatize the terrible conditions under which many people work; and the fact that both overseer and workers are Asian certainly gives the power politics an extra twist. Yet the scene is so keyed-up that the sentiment turns kitschy; it's basically a politically correct cartoon. The same goes for a series of heads called *Young Workers,* each of which focuses on an ordinary person looking off into the heavens. Maybe Wall means to ennoble his subjects, but mostly he seems mired in a campy response to Stalinist-era Social Realist photography. There's also a reclining male nude (wearing headphones) that is a reversal of the old odalisque idea and comes off as just plain silly.

Wall is most convincing when the sociological insights in his work register as undercurrents, as a troubling pressure. In *Milk,* we find ourselves wondering what this disheveled, attractive man is doing sitting on the pavement, squirting milk from a carton inside a paper bag. It's hard to figure this guy out. Is he homeless or crazy or what? I notice that he's wearing shoes without shoelaces, and that makes me wonder if he's from a mental institution or a prison. The ambiguity makes for a striking image. But it is also a puzzle with a naturalistic resonance, since we have all had the experience of finding that we can't really read as much from appearances as we

had hoped. The bright light in *Milk* somehow heightens the mystery; we're seeing everything clearly, and yet we don't know a damn thing.

Wall finds beauty in the hard-edged ambiguities of everyday life. His work has reminded many people of Godard's movies. In an interview he turns aside the comparison, for, although he eagerly acknowledges the impact of the movies, he apparently feels that his images are closer in spirit to the storytelling coherence of, say, Bergman. Still, it is Godard who comes to mind when you see the way that this bright, articulate artist can give even his most politically strident ideas a surprising, throwaway beauty. Sitting at a Godard movie, I'll find myself losing track of the story and feeling annoyed at the fancy obscurities, and then suddenly there's an image as simple as the headlights of a car coming through a dark afternoon forest or the rhythmic lapping of waves on the beach, and it's so alive and instinctive and lovely that I can scarcely believe it. Even when Godard is losing himself in flashy polemical ideas, his eye for color and light and composition keeps operating. That goes for Jeff Wall, too.

There is a streak of independent-mindedness in Wall's work that gives it an off-center appeal. You feel the idiosyncratic intelligence in some conversations that are included in a new volume on Wall in Phaidon's "Contemporary Artists" series. (It's a much better introduction to the artist than the catalog of the show.) Especially interesting is a conversation between Wall and two of the biggest names in theory-oriented art history, T. J. Clark and Serge Guilbaut, with whom he spars in a friendly but heated manner when they try to fit his work into a Post-Conceptual framework. Wall can talk their talk; big words trip easily off his tongue. Yet when he's questioned about his desire to achieve a narrative power, he obviously wants to demonstrate that he's not hemmed in by a particular set of ideas. "Serge," he says at one point, "you and I once had a discussion in a class in which I accused

you art historians of being more avant-gardist than the artists, because art historians were trying to keep thinking about what avant-gardism meant, and by implication, what it means, or, where it went. They were more interested in it than many artists, who seem to have gone on to other things, like expressing themselves."

The clinical look of Jeff Wall's photographic light boxes may tell us that he's dissatisfied with the high-art traditions of the past, yet we can see that he wants to keep company with the Old Masters, too. "The most orthodox way of thinking about culture now," he reminds Clark and Guilbaut, "is to talk always about discontinuities, breaks, ruptures, leaps." He goes on to say that "discontinuity does not exist in isolation from what seems to be its polar opposite, so I think it is just as valid to talk about reinventions and rediscoveries, not to mention preservations." After his own fashion, Wall is a traditionalist. He is far too intelligent to entirely dismiss the old artisanal methods.

And yet I'm not really sure how much he knows about those traditions. Alluding to the deep space in his new work, and the way that the figures are "absorbed in the environment," Wall suggests that "it's a move from Caravaggio to Vermeer or Bruegel." That is rather glib, even for a remark in a taped interview. Wall is moving around compositional elements, but that's not what painting is about. He salutes the past, but he also gives a cleaned-up, romanticized view of a tradition that is grounded in hands-on labor, in creating a universe painted inch by painted inch.

In a couple of photographs from the early '90s, Wall takes pre-photographic picture-making as his theme, and his attitude seems equivocal and sentimental, as if he regarded drawing and painting as quaint, retro activities. I'm thinking of *Adrian Walker*, a photograph of a young man working on an anatomical drawing, and *Restoration*, in which several people are involved in the meticulous care of an enormous circular panorama by the nine-

teenth-century painter Edouard Castres. These images are about Wall's fascination with the intelligent attentiveness involved in an older artisanal tradition. The atmosphere is quiet, cloistered, silvery. Wall is suggesting that an artist who makes something by hand inhabits an autumnal universe. I don't know if he's ever photographed a person at an easel painting a modern painting, but here are self-consciously old-fashioned images of an anatomical illustrator and restorers working on a period piece. He is at once saluting and saying good-bye to the dense-textured oil paints and lead-primed canvases, to the conté crayons and 100 percent rag papers. Wall seems to see working by hand as a custodial activity, as a way of shoring up older traditions. There is an aura of gentle industry and slightly out-of-it, never-give-up concentration to these images of a Biedermeier dream world.

Wall would probably say that that's just the way it is, that representational painting is basically an outmoded activity, and there is nothing we can do about it. But I don't think that his wistful reveries are quite as disinterested as he wants them to appear. When he presents one of his hip valentines to a vanishing (or vanished) craft, he must do so with a sigh of relief, because if painting is dead, then there can be no doubt that the painter of modern life has become a photographer with some digital know-how. We are living in a period when there is an ingrained assumption that new media will overwhelm old ones, and despite his carefully reasoned arguments, Wall is too quick to overlook some of the underlying dynamics that shape a museumgoer's experience. When photographs get too big, they lose the fine-tuned qualities of a graphic art. They become something else.

But what? I'd say photography becomes a wannabe form: painting for people who can't paint. Wall's backlit images are an improvement over the glossy opacity of other artists' huge photographic surfaces, but I question whether he can ever compete with the dynamism of a magnificently painted surface. His oversized photographic transparencies, despite their al-

luring details and overall glow, push a museumgoer away. In one interview, Wall announces that now is the time to transgress "against the institutions of transgression." He's saying that the avant-garde has become an institution, and that artists can liberate themselves by adopting older storytelling conventions. I heartily agree, but I think that there's still nothing like painting on canvas as a way to transgress transgression.

Wall speaks of wanting to find coherence in a complicated world, but his street scenes don't have a fraction of the dissimilarity-in-similarity of Leon Kossoff's paintings of a ramshackle multicultural contemporary London. As for modern allegory, I don't like Wall's Cibachromes anywhere near as much as Gabriel Laderman's *House of Death and Life* (1984–85), a noirish thriller staged in a series of cubicle-like rooms; or R. B. Kitaj's *Cecil Court* (1983–84), that comic ode to dislocation and bookishness; or Balthus's nightmare vision, *Large Composition with Crow* (1983–86), in which the artist makes a mysterious appearance as a miniature figure carrying an enormous cage. These painters know at least as much as Wall about the strangeness of modern life, and they complicate the equation with all the risk-taking that's involved in handling paint.

There are painterly precedents, of course, for the chilliness of Wall's work. Manet, that darling of the postmoderns, cultivated a don't-give-a-damn mix of old and new styles, and Wall, never missing a beat, had already created his own homage to the Parisian's cool demeanor in 1979, with *Picture for Women*. This response to *A Bar at the Folies-Bergère* might be said to be Wall's signature piece, since it doubles as a portrait of the late-twentieth-century artist in his studio. In Manet's famous essay on seeing and being seen, a bored barmaid is center stage. At first she appears to be focused on nothing at all, but then we notice in the mirror behind her (at a skewed perspective) the man who must be standing where we are, ordering a drink. In Wall's version, the Parisian nightspot has become the artist's studio, but the

woman, now standing to the left, dressed in a simple blouse and jeans, is still lost in a dream. All the way to the right is a slim boyish figure in black T-shirt and black pants. That's Jeff Wall. He has an abstracted look, too, but we know that he's hard at work, because in his left hand he is holding the shutter release mechanism of the big camera on a tripod in the center of the room. Artist, camera, and model are lined up in front of a mirror, and what we're seeing is the studio reflected in that mirror.

The fascination of *Picture for Women* is in the shimmering details that are like amusing punctuation marks. There are rows of glistening bare light-bulbs on the ceiling, lots of shiny metal pipes, some old-fashioned office furniture that looks great in the big loft space. This photograph is full of appealingly anonymous stuff. *Picture for Women*, in which the camera's eye examines us while a man and a woman subtly avert their eyes, is about the poetry of impersonality. Both artist and model step aside, but in doing so they solidify their control. We look at them, but they won't look at us—that's their power play. Jeff Wall is taking this picture by remote control. Emotionally speaking, he takes all his pictures that way. He's an anti-hands-on artist. At his best, he offers depersonalized enchantment, and as a museum-goer I find myself responding in kind. At the Hirshhorn I felt as if I were being affected by remote control. I registered many interesting emotions and left untouched.

APRIL 28, 1997

EARTH

If you want to see the bedrock of contemporary painting, you might begin by looking at the work that landscape painters do. Although the strongest recent painting is by no means all landscape, landscape painters grapple with an essential paradox of the creative act, because they make something of their own out of a world that they have not made. Their raw materials are the surroundings that everybody knows, but what the painter needs to know is how to find nature's basic structures and how to then anatomize them and recreate them on the canvas. In a fascinating study published in 1947, the art historian Max J. Friedländer wrote that a landscape "rises up before us like something mysterious, a melody rather than a statement." Making sense of that ineffable spirit may pose an especially interesting challenge for the current generation of painters, who took the back-to-nature ethos of the late 1960s as a starting point. Certainly landscape is the only kind of painting that enables artists to explore museum-art conventions even as they're slipping Thoreau and Gary Snyder in their knapsacks and following the nineteenth-century Japanese poet-painters to the hills. The afterglow of that toss-off-the-cares-of-the-city attitude can still be felt in the consistently strong showings that landscape painting makes in New York galleries, year after year.

The best new landscape painting that I saw this season was the six-foot-wide view of upstate New York farmland that was the centerpiece of Temma Bell's exhibition at the Bowery Gallery. I imagine that Bell means to suggest a storyteller's power with the name of her big painting, *Over the Garden and Through to the Rams*. Her ear may have failed her in that rather jejune title, but the hand of a master is evident in the unfurling rhythms of her brush. She

seems to pull her subject straight out of the day-to-day life that she's living far from the metropolis. The garden enclosure in the foreground, with its dogs and poultry and fence twined with grape vines, is like the scene-setting opening description in a novel. And from there, moving past a beautifully rendered treetop to a golden-green field and deep blue hills, she holds us through the casual assurance of her dashes and scratches and scumbles of paint. What sets this painting apart from Bell's smaller-sized landscapes is the complexity that she is able to encompass here, and the avidity for experience that such complexity implies. By the time my eyes reach the top of the canvas, a whole world has been revealed.

Bell combines pinpoint accuracy with heedless ease to give the American Northeast a funny sweetness, a once-upon-a-time magic. She's one of those rare landscape painters who thinks both literally and lyrically, so much so that the two impulses become echoes of one another. The smallest naturalistic incident conveys a shuddering emotional intensity, and the most sweeping movement feels taut and particular. This marvelous dynamic has its origins in the early fifteenth century, when the Limbourg Brothers painted a cycle of miniatures depicting the occupations of the months for the Duc de Berry. The same dynamic is there in Bruegel's encyclopedic panoramas of Flemish life; in Rubens's wide-angle views full of exactly rendered details; in Marquet's pellucid harbor scenes; and in Balthus's pastoral reveries, with their grayed-over light and gently rolling terrain. Bell may not be on a par with all these artists, but when I look at her painting I feel that their concerns are alive. No landscape this complex yet easygoing has been exhibited in a New York gallery in many, many years.

The taking-it-all-in spirit of Bell's big new painting is more than a matter of what the eye can see. Bell, who is 51, has been written about in most of the major art magazines over the years; this April marked her sixteenth one-woman show. Yet she is nowhere near as well-known as she ought to

be, and it's possible to feel that she's defying her underground reputation through the broadness of her gaze. In doing so, she suggests the general situation of landscape painters today. They see the natural world in terms of complicated interactions between nature and culture—and, meanwhile, the curators and dealers and collectors who put the big money on contemporary art assume that landscape begot earthworks, after which Robert Smithson's *Spiral Jetty* sank beneath the surface of the Great Salt Lake and landscape became an emblem, an icon, a special case.

There is always somebody who wants to paint the landscape to end all landscapes. In the nineteenth century it was Frederic Edwin Church, the American maestro of gaudy sunrises in exotic locales, who wowed them at the Salons. In the 1980s, it was Anselm Kiefer, whose scorched-earth images, those gray-on-gray hymns to diminishing possibilities, were by some perverse logic of the times celebrated as a resurrection of possibilities. Church and Kiefer (the British painter John Martin also comes to mind) favor an apocalyptic mood that generally involves treating a large surface in a pointedly singular way. That may have a certain potency as a statement, but it is a statement that denies the very idea of difference-within-wholeness that is the essence of landscape painting.

Max J. Friedländer wrote that "land is the 'thing-in-itself,' landscape the 'phenomenon.'" To respond to such complex phenomena, a painter must be open-minded yet assured. Temma Bell threads through all the variety with an easy-flowing, quicksilver virtuosity. Stuart Shils, a Philadelphia artist who had his first New York one-man show at Tibor de Nagy in January, suggests more abrasive reactions through his dramatically broken brushwork; he has a feeling for sensuous verisimilitude, and in a few compositions in which all we see is the green of foliage and the gray-blue of the sky, his riled-up surfaces make convincing poetic flashes. Lennart Anderson, a painter a generation older than Bell and Shils, had a landscape retrospec-

tive at the Salander-O'Reilly Galleries in January and demonstrated an amazingly poetic conversational tone in his luxuriantly green views of America, Italy, and Greece. Anderson uses a combination of strictly constructed volume and near-abstract surface design to make us feel as if we're right there with him as he muses on the scene. When Anderson passes lightly over certain details, it is a kind of discretion. And when he turns from a passage of summary description to a more naturalistically structured area, I feel his candor, his desire to be absolutely clear.

Obviously these one-person shows represent only a small fraction of the work artists are doing, and certain galleries, aware that much more is going on, mounted useful group exhibitions during the season. There was "Landscape as Abstraction" at Graham, and "Landscape" at the Painting Center, and "Cityscape" at Marlborough. Of the new paintings I saw in the landscape group shows this season, among the most convincing were several by Carl Plansky at the Painting Center. Plansky carries his impressions of trees and branches into such overall swirling effects that it's not especially easy to know what you're seeing. The landscape becomes a painterly effusion. Yet the choppiness of the strokes conveys a brash immediacy, a Zen-like thunderbolt of revelation. Plansky's canvases capture some of the roistering thrill of days when it's so sunny or windy or rainy that the weather feels hyperbolic.

The Romantics were the first artists to regard the natural world as a reflection of their moods. And once Friedrich and Turner had painted landscapes that could be described only in terms of emotional states—as, say, exalted or depressed—the matter-of-factness of nature began to give way to the otherworldliness of abstraction. Joan Mitchell, who died five years ago, is a touchstone for many mid-career painters, Plansky among them, because she built a whole career at the point where landscape became abstraction. There's something opulently inscrutable about Mitchell's work, since so

many of her shimmering naturalistic effects appear to be pulled straight out of an intently nonobjective approach. What Mitchell takes from nature is the idea that there are no strict boundaries, no absolutely definite forms, and it sometimes seems that this view of nature has become such an article of faith in New York that an artist such as Temma Bell, who does not care to equivocate, can be regarded as naive. Although Bell is a modernist in her offhand painthandling and brilliantly concise renderings, her telegraphic way of creating an illusion does not lead her to question the legitimacy of that illusion.

As far as quality is concerned, of course, the decisive factor is not where an artist ends up on the nature-into-abstraction continuum, so much as the character of the small, discrete decisions that build the image. What matters ultimately is how the painting makes us feel, and the feeling has everything to do with the way the paint is laid on and the parts are brought together. Some revealing, almost technical observations on the way an artist constructs a landscape can be found in a brilliant essay, "Abstract Expressionism and Landscape," written in the early '60s by Fairfield Porter, who was as gifted a critic as he was a painter. Porter liked the rapid-fire evocation of landscape mood and light in his friend de Kooning's abstractions, but he was always also attracted to particularity and an exacting kind of reportage. In a sense, this essay is Porter's version of the age-old dynamic interaction between literalism and lyricism, only instead of beginning with the Renaissance, he begins with Abstract Expressionism. Porter recalls de Kooning remarking "that European abstractions derive from still life, while his referred to landscape." De Kooning, Porter tells us, had an idea about "the difference between European and American painting in general, that even European landscape has an objective center, as if the landscape were a still life, of, say, a mountain, while American painting does not have this sort of center, this division into 'subject' and 'background.'"

Porter, who was fond of a certain kind of wordplay, is leading his readers to the idea that there is something nonobjective—that is, not having objects—about American landscape. This is obviously a sweeping generalization, but it's also a useful one. Alex Katz's landscapes, Porter explains, are nonobjective. Porter says that Katz "once said that in nature he preferred a field." And then Porter adds, parenthetically, that "a field is not an object." It occurs to me that Temma Bell paints lots of fields, but she fills them with animals, which is a way of giving an objectivity to the nonobjectivity, a way of introducing a subject that turns the field into a background. As for what Porter does in his own landscapes, he is sometimes more objective and sometimes more nonobjective, and often he seems to seek a rapprochement between the two. Porter was the subject of a small retrospective in May at the Tibor de Nagy Gallery. In one of the largest paintings, *Dog at the Door* (1970), he renders the side of a house in Maine with the greatest fidelity, but then knits it into a pattern of grass, water, boats, distant shore, and sky, until the view becomes nonobjective, which Porter defines as a landscape that is "a continuum of relationships."

Porter had fifteen one-man shows at Tibor de Nagy between 1952 and 1970, and he is now being presented by this gallery as a sort of father figure for a contemporary realism that the gallery strongly supports. This is an admirable effort to shore up an embattled contemporary tradition, but I sometimes fear that Porter's paradoxes are being turned into another generation's pieties. I don't know if Stuart Shils, the 43-year-old painter who exhibited at Tibor de Nagy four months before the Porter retrospective, is familiar with Porter's essay on landscape, but there are certainly lots of fields in Shils's paintings, and sure enough they give the paintings a nonobjective look. That's perfectly all right, except that Shils doesn't know where the nonobjective landscape ends and the objective landscape begins. He is attracted to fields because they're as flat as the canvas, but he also wants to

use the volume of the paint to suggest a lush, light-filled atmosphere, and so the result is all too often an atmosphere in a void.

Working in oil on paper mounted on board, Shils practices a sort of Expressionism-in-miniature that makes us acutely aware of the way the painting is put together. These paintings, generally only a foot high, are a little like haikus; and, just as the word in a haiku is scaled big in relation to the poem, so in Shils's paintings the brushwork is scaled big in relation to the landscape. The side of a building or a tree or a hill is suggested with one pass of the brush. It's the brisk agitation of the surfaces that gives these views of fields and stands of trees and broad skies and city streets and red brick houses their appeal. But things are locked up too quickly. Shils reinforces an overall look by reining in the complexities. He pushes all the information into clipped, repetitive, rectilinear compositions. What he has going for him is a charmer's way with a painterly surface, but the surfaces don't get your imagination going. Judged as nature poetry, they're vague. Judged as painterly abstraction, they're formulaic.

Shils's show stirred up a fair amount of interest among people who care about landscape painting. In part that was because the Tibor de Nagy Gallery was giving to a less-than-well-known representational painter a kind of major presentation that is now rare in New York. Yet going through a room full of these small paintings, all basically the same size, I began to suspect that most of the artist's critical decisions had been made before he ever put paint to paper. Although this is no way to do a landscape, the elegantly levelheaded consistency that results may be mighty appealing to an audience that is tired of overhyped art and is willing to settle for something that looks sort of like a Porter or a Morandi or a Ryder.

If Temma Bell fails to find a following among the same audience, it could be because she has gone her own way and cared not one whit what Fairfield Porter or anybody else thinks that a landscape ought to look like in the

wake of Abstract Expressionism. Such a skepticism about Abstract Expressionism also has a long history in New York; and, although Bell is without doubt an original, her particular brand of independence does owe something to the impact of her parents, Leland Bell and Louisa Matthiasdottir, two of the most independent-minded painters of the previous generation. In a painting by Leland Bell or Matthiasdottir, a realist's experience is organized in a Constructivist's terms. And those principles have an afterlife in Temma Bell's work, if only as an instinctive recoil from the toss-of-the-dice chanciness that an immersion in painterly landscape can, for better or for worse, imply.

Temma Bell does not see instability and confusion as part of the modern experience, but her rejection is personal and idiosyncratic, and it has nothing to do with the imperious chill of a reactionary gesture. She keeps so close to the immediacy of the act of painting that we experience things right along with her. Her dogs, poultry, vine-covered fence, and arching tree seem casually described, but they have a weight, a force. Bell's exhibition this spring, like most of her others, included cozy interior scenes, with children reading books and cats sitting on tables heaped with pumpkins and squash. The variety of her interests and the lightness of her touch could have led some people to miss the incisiveness of her thought. In the landscapes, certainly, the slightest shift in tone or touch conveys a topographical sensitivity that bears comparison to Ruisdael and Courbet. Bell gives a contemporary exuberance to an older kind of objectivity. She reclaims the storytelling richness of landscape for our generation. This is a major achievement.

JULY 14 & 21, 1997

A PAGEANT

There have always been artists who dreamed of reviving the elaborate costumes and stylized affections of the Middle Ages, and Trevor Winkfield, whose paintings are packed with absurdist heraldic devices, is one of the dreamers. Winkfield, who was born in Leeds in 1944, brings tough-mindedness to his whirling arabesques, and there's something ineffably English about the resulting combination of fantasy and precision. I find distant echoes of the delicate Lady Chapel in the fourteenth-century Ely Cathedral and the labyrinthine work of the nineteenth-century painter Richard Dadd. Using flat, crisply modern shapes, Winkfield imagines scenes from some zany toy theater and fills them with the elegantly florid patterns of a chivalric age. He's written that he still has vivid memories of 1953, the year of Elizabeth II's coronation; 9 at the time, he was struck by all the "ceremony and religious ritual (particularly the handing over of regalia from archbishop to sovereign, and the hierarchical poses adopted by the sovereign when weighted down by this regalia)." The boy saw a modern princess transformed into a Gothic heroine, and he probably saw it all filtered through the newsreel footage and crude tabloid images that were available in a provincial English town. It must have seemed as if medieval manners were zooming straight into the pop present, and that's exactly where Winkfield takes up the story.

Winkfield fills his paintings with court jesters, tournament props, and monkish hoods, yet this is also unmistakably the work of a modern man, who sees abstraction as a fact of life—a visual equivalent of a more general cultural disarray. He's basically attracted to medieval pageantry because it's an idealized order, and if his own post-abstract sense of structure leaves lots

of room for upheaval and confusion, that's his way of measuring the distance that we've traveled from the time of *The Romance of the Rose*. What Winkfield understands is that the pomp and circumstance that may have been a medieval reality have become a modern fantasy, and because he has such an intuitive feeling for that never-never land, his paintings, although chock-a-block with off-beat pedantry, aren't overly self-conscious. His exuberant color and get-the-job-done painthandling lend even the most labyrinthine imaginings a streamlined ease. We're able to glance easily over mysteriously antiquarian encounters. In Winkfield's paintings, bizarre juxtapositions are everyday occurrences. He's telling us that modern life is a crazy pageant.

Like much strong painting that's produced today, Winkfield's work suggests an ambiguous universe where naturalistic forms are reshaped by abstract forces. In his canvases, the clash of apparently irreconcilable traditions has an underlying biographical meaning, because the artist, although born and educated in England, has pretty much become a New Yorker since moving here at the end of the 1960s, when he was still in his 20s. Thus whereas the nautical doodads and general air of Edwardian nursery room humor say "English"—and say it even to those who don't know Winkfield's story—the hard-edged, joyfully strident look of the paintings could be stamped "Made in USA." In Winkfield's canvases the old English eccentricity is reconsidered from the vantage point of mad Manhattan, and if his best paintings summon up a feeling of cheerful panic, how could it be otherwise? Winkfield is living in New York and contemplating somewhere—or something—else, which is a fairly common situation.

This is an art of cool surfaces and madcap subjects. Frequently, the central attraction is a figure, and there's something both touching and troubling about personages that are such odd amalgams of household objects and hardware and old-fashioned costumes. Winkfield's jerry-built hu-

manoids call to mind eighteenth-century automata or avant-garde mari-
onettes. They're ghosts who've ransacked the flea market for an identity,
and the loopiness of the outfits is obviously a burden, a freakishly jolly cara-
pace that must be carried everywhere. Winkfield's weirdos, in spite of their
up-for-anything smiles, are ambivalent about the roles they play; it's over-
whelming to be center stage or to bump into the strangest props when you
make the slightest move.

Winkfield has said that among the key influences on his work he counts
"the pinball machine effect of Duchamp's *Large Glass*—how one object leads
to another, and in so doing activates it." His paintings have their own as-
sembly-line-like absurdism; they're Surrealist pinball machines. This painter
loves sleek, machine-tooled forms, and he's creating a whimsical, cottage-
industry version of mass production when he fills one painting with half a
dozen or so identical forms—balls or wheels or matchsticks or cubes or
mallets. Arranged at various odd angles, these rising and falling doodads
create arcs and trajectories that take us on a twirling journey. The littered
objects give some paintings a William Morris-like busyness, which Winkfield
is often inclined to oppose to a backdrop of bold planes of color, so that the
little incidents turn out to be neatly pinned down, like butterflies in a curio
cabinet.

In several recent paintings the strong-willed nut case who's trying to call
the shots is actually an artist. It turns out that putting brush to canvas is as
good a way as any to cope with the maelstrom of emblems. In *The Painter and
His Muse,* the birdlike painter works on his small seascape while the muse,
equally birdlike, holds up a schematic plan of a sailboat. There's so much go-
ing on here that it's difficult to know whether the painter is in control or
just soldiering on. A sort of chessboard that doubles as a palette may refer to
Duchamp, but I have no idea what to make of a group of forms that sur-
round the muse; they look a bit like medieval halberds and a bit like the

jacks that a boy keeps in the bag with the marbles. The artist who negotiates this unpredictable universe is a cross between an anonymous medieval craftsman and a character in a slapstick comedy. He's also a sort of harassed director-type, overseeing a production that's taken on a life of its own.

Considering the on-the-go feel of so many of Winkfield's paintings, it's quite logical that travel is one of his favorite themes. He fills his paintings with things that move—birds, boats, wheels, fish, even pairs of hooves. All these symbols of travel tie into a taste for the exotic and unknown, which Winkfield then domesticates, so that a journey to faraway places also suggests a journey home. The pageant becomes a pilgrimage, and of course there are lots of stories to be told along the way. Among the clearest of the recent travel paintings is *Voyage II,* which, with its wave-like scallops, stylized splashes of water, ship's mast, gull, classical head, and Greek harp, adds up to a fantasy about cruising the Mediterranean. Here the pilgrimage involves a flashback to the Age of Odysseus.

Voyage II—part of a six-canvas cycle on the theme of travel, and, at 45 by 72 inches, among Winkfield's bigger paintings—is a grand reflection on the iconography of ocean voyages. It's about everybody's dreams of distant horizons, which are often as affected by advertising brochures as by trips that can be measured in nautical miles. All the dazzling color and procession-like movement may also imply a voyage of life, although Winkfield is too subtle to insist on the Big Theme as anything but a sly aside. The mood is grand yet unaffected. The full tilt, surprising color—which includes ecstatic blues and oranges in addition to some oddly chilly greens—gives this elaborate conceit a brisk, businesslike esprit. There are elements in *Voyage II* that I can't decode at first, such as the rows of tomatoes and the ice-cream cones. But then it occurs to me that when I remember a great trip to Italy or southern France, bursting tomatoes and melting ice-cream cones are part of what comes to mind. And in any event, the strong, leftward move-

ment of Winkfield's composition carries along even the most enigmatic bits. Winkfield knows that this cargo of lunatic fancies will sink if it doesn't swim, so swim it does.

The confounding occurrences in Winkfield's paintings are something more than accidents; they suggest a general principle of poetic unpredictability, which we may be more familiar with in the work of writers than of painters. Winkfield would no doubt say that painters can learn from writers (and vice versa); he has devoted much time and energy to editing and translating, and he has also written critical essays and prose poems. For some of the artists and writers who first came to know Winkfield a quarter century ago, when he was single-handedly editing an impressive literary magazine called *Juillard,* painter may still seem like only one of the hats that he wears, although I can't imagine anyone doubting that it's the one that suits him best. A look at *Juillard,* whose contributors included the novelist Harry Mathews and the poet James Schuyler, helps to place Winkfield's work within the renewal of interest in Dadaism and Surrealism that was a part of the '60s experience, both for artists and for writers. Edited in England but with the accent on a distinctly New York–Paris axis, the mimeographed *Juillard* was obviously based on some more impressively produced far-flung manifestation of the New York School, such as *Art and Literature,* which came out of Lausanne, dashingly typeset and printed on good paper.

The wonderful visual garrulousness in Winkfield's work of the past decade can be traced back to the crosscurrents of art and literature a quarter century ago. Recalling how he came of age in London in the '60s, Winkfield has written that "everybody . . . seemed to have donned the American aesthetic, and it became absolutely taboo to promote the old bugbear the 'Englishness' of English art. . . . Nobody could see the point of a suburban snow scene when there was Oldenburg to aspire to." But when Winkfield invokes

this orthodoxy, which was related to the powerful impact of Pop Art and Color Field painting, he really does so in order to argue against it and to assert the importance of alternative or parallel currents, which included a resurgent painterly realism, a scholarly reexamination of Duchamp, and what Winkfield called, in praising the range of work that his friend Simon Cutts showed at his Coracle Gallery, "the whole kit and caboodle of suppressed Englishness." Some of this eclectic spirit found its way into Winkfield's *Juillard,* which at one time or another included texts by Jasper Johns and a drawing by Fairfield Porter. It was among the more independent-minded spirits of the '60s that Winkfield found friends and supporters, first in England, later in the land of Oldenburg.

Winkfield shares with writer friends such as John Ashbery and Harry Mathews a great enthusiasm for the early-twentieth-century French author Raymond Roussel; he named his magazine after one of Roussel's characters, much as another of the little magazines of the period, *Locus Solus,* took its title from a Roussel novel. Decades ago, Winkfield translated an essay of Roussel's, "How I Wrote Certain of My Books," and more recently, in 1995, he edited a valuable Roussel anthology. One of Roussel's methods of composition, which involved generating plots from the double meanings of carefully selected phrases, probably inspired some of the visual double-entendres in Winkfield's work. Winkfield has a passion for word play that can become visual play; he edited two collections of Lewis Carroll ephemera, including some word games that suggest logical procedures for generating idiosyncratic sentences. He must like Carroll's multifacetedness, the fact that the inventor of Alice was also a mathematician, a poet, a photographer. Lewis Carroll was a Victorian who wore many hats, and of course paradoxical headgear is a specialty in Winkfield's work.

And as far as dreaming up weird images goes, Raymond Roussel is in a league of his own. There are passages in Roussel's elaborately bizarre fictions

that can almost function as descriptions of the oddballs and panjandrums in Winkfield's paintings. Here are some lines about Le Quillec, the "one-eyed and repulsive" court jester in *Locus Solus.* "To exaggerate his physical grotesqueness," Roussel writes, he "always dressed in pink like the daintiest squire. Witty in repartee, he hid within a comic sheath a good and upright heart." It's possible to image more than one of the denizens of Winkfield's canvases as relatives of the one-eyed Le Quillec: there is the boy with the palm-leaf collar in *Tripoli;* the four-armed figure with the upside-down pot of tulips in *Trapping Birds and Bees;* the winged investigator holding the beaker in *The Mermaid's Revenge;* and the yellow-faced gent with the ornithological head-dress in *I Will Not Tolerate Such Insubordination from My Pets!* Winkfield presents his wildest imaginings with an imperious austerity that echoes Roussel.

Making pictures tell stories is never easy, and Winkfield has spent the better part of two decades figuring out how to turn an aura of literary fantasy into an immediate visual experience. In the '70s and early '80s, he painted on paper and could never quite give his intricately plotted emblems a freestanding poetic ferocity. Even after he made his critical shift to stretched canvas he was at first overly dependent on black, illustration-like outlines. He also had a tendency to depend too much on black-and-white dappled effects that may have been meant to mimic photomechanical reproduction but did not really engage the eye. When the breakthrough finally came, in 1986 or 1987, it had to do with taking the antinaturalistic risk of edgy Constructivist color, which Winkfield found that he could use to give designs that were sometimes close to dangerously quaint a contemporary theatricality. Winkfield's masks, signs, and emblems gain in ambiguity as they gain in force; their brilliant clarity makes them all the more difficult to figure out.

The daylit mystery is nothing new in art, and Winkfield has drawn from a variety of sources, as recent as Duchamp, as distant as Vermeer and

Uccello. Anyone who is seriously interested in Winkfield's work will be able to trace some of these influences. And through his work as an editor and author, he has helped the curious along. The full range of his inspirations, however, is something that I don't believe you can know unless you know the artist himself, and I'm glad that we've become friends—something that does not always happen between critics and artists, even if they are on the same wavelength. We've ended up exchanging enthusiasms, as often for writers as for artists, and Winkfield has urged me to look at the work of a number of literary figures whom I've come to think of as mystery men. Winkfield is especially keen on literary and artistic personalities who cut a figure in public while remaining emotionally elusive.

Recently, Winkfield has written essays on Vermeer, perhaps painting's greatest mystery man, and Florine Stettheimer, the American artist who turned Jazz Age Manhattan into her own kind of rococo bohemian enigma. Of course Raymond Roussel fits right in with this group of artists and writers who are both outrageous and enigmatic. So does a figure of the World War II London literary scene, the Ceylonese editor Tambimuttu, founder of *Poetry (London)*. Winkfield, who has of course done a lot of editorial work, loaned me a book of reminiscences of Tambimuttu, a sort of kaleidoscopic collective portrait of an exotic figure who slipped in and out of people's lives, sometimes living splendidly, sometimes barely getting by, but always a dramatic presence. Probably even closer to Winkfield's heart is A.J.A. Symons, the British author, bibliophile, gourmet—and magazine editor—who is mostly nowadays remembered as the author of *The Quest for Corvo,* his study of another literary eccentric, Frederick William Rolfe. A.J.A. Symons managed to live elegantly on so little money that even his brother, Julian Symons, couldn't quite figure out how it had been done when he wrote a biography of his older sibling that might be called *The Quest for A.J.A.*

When Winkfield gave me a xeroxed copy of one of Julian Symons's pieces about his brother, he called my attention to a photograph of A.J.A. Symons who, seen in profile, looks like an extremely attractive, overgrown child. He's smiling subtly to himself, while holding a small glass (it looks eighteenth-century) that contains some rare vintage or delicious *eau de vie*. Winkfield seemed extremely fond of that photograph, and when I thought about it afterwards it occurred to me that the man-child's profile, the smile, and the glass are all reminiscent of elements that frequently appear in Winkfield's paintings. That photograph of Symons may or may not have inspired some of Winkfield's iconography, but its inimitable aura of oddity and aplomb, the two sensationally mixed, is something that you find in all Winkfield's best work.

Many of the figures that career through Winkfield's paintings might be said to be—like Florine Stettheimer, Tambimuttu, and A.J.A. Symons— aesthetes with nerves of steel. So is Winkfield himself, who has gone his own way yet managed to exert a subtle and (for New York) surprisingly nonaggressive fascination. In the past few years, as the letters and journals of the New York School of the '60s and '70s have begun to be published, I've been amused to find Winkfield make a number of fleeting but engaging appearances. His name comes up at least twice in a recent selection of James Schuyler's correspondence. There is a 1968 letter in which Schuyler is imagining what the poet Ron Padgett is doing. "Answering the phone: it is Dick Gallup. He wants to read you an item from page 41 of yesterday's *Sooner* but you have already cut it out, altered a few words and sent it to Trevor Winkfield." Two years later, in a list of things to do, Schuyler offers these possibilities. "Go pick wild strawberries? Uhmn. Take a photograph? Bleh. Type something up and send it to Trevor? Gmorch. Write John? He owes me a letter." The John is of course John Ashbery, who, in Joseph Cornell's journals, brings Trevor Winkfield along when he visits the reclusive artist in his house

on Utopia Parkway in Queens. "11/6/69[.] Ashbery Winkfield visit[. . .] cerise rabbit presented to Trevor Winkfield[.] pink in John Ashbery's shirt— vertically striped[.] raspberry red in the linzer tart."

I'm sure there will be more Winkfield sightings as more letters and memoirs are published. What makes these initial anecdotal slivers so much fun is how they begin to compose a portrait of the artist. It's a veiled portrait that, not surprisingly, resembles one of his own paintings. The clipping from the *Sooner* (whatever that is!), the unwritten letter, the wild strawberries, the cerise rabbit, the pink shirt, the vertical stripes, the raspberry linzer tart make an exciting collage but are difficult to explain entirely. The thrill of the juxtapositions has something to do with the puzzle pieces not quite falling into place. The quest for Winkfield continues.

FALL, 1997

DEATH AND REALISM

Realism, a clarion call of radical utopian empiricism for artists in the nineteenth century, suggests very different ambitions today. For Gabriel Laderman, whose *Dance of Death* is the most exciting new figure composition to be exhibited in New York in many years, realism is melancholy and nostalgic; as he constructs a complicated illusionistic image, Laderman is also spinning a haunted, hyperbolic mood. For Chuck Close, whose large portraits, many of art world notables, are the subject of a retrospective at the Museum of Modern Art, realism is a puzzle hidden in a photograph, which he grids off and elaborates by means of painting techniques that are deliberately abstruse. Laderman and Close are intent about the details, but in their

very different ways they are reaching for effects that have less to do with clarification than with complication. They labor to create ambiguous illusions. Laderman's figures have the doll-like mystery of Japanese *bunraku* puppets. Close gives faces an unnervingly fractured look. I do not want to create an equivalence between the work of these two men, because I like Laderman's a great deal and Close's not at all; but both artists give the figure an anxious, preoccupied aura. Their work is pervaded by a feeling that reality is the shadow kingdom of twentieth-century art.

Most everybody will agree that important contemporary art does not have to be abstract. Still, whenever impressions of the world around us get into the picture, we are forced to confront one of the great myths of modern art, which is that realism has died. This myth has many versions, some of which are contradictory, and the more that you look at all the crisscrossing stories, the more you will believe that although realism is frequently changing shape and playing hide-and-seek, it never really dies. Art terminology, which is like alphabet soup, can confuse matters plenty, because it's easy to make too much of the differences between, say, the realism of 1850 and the naturalism of 1870. But even leaving aside the mismatch between what happens in a painting and how it is described, you could still say that artists have spent the past 150 years pondering the question, "What is realism?"

"The title of Realist was thrust upon me," Courbet announced in 1855, and although he embraced the title as his destiny, he was such a boldly adventuresome artist that he was exploding the definitions even before they were fully formed. Courbet's scintillatingly experimental use of pigment and palette knife, especially in his later landscapes, dematerializes nature in favor of a poetry of paint, and in so doing leads straight into abstract art. As for Courbet's thematic obsessions—with sleep, with childhood—they make him the granddaddy of the Surrealists. In a rapturous essay about

Courbet, de Chirico announced that "Courbet, who felt more profoundly than Delacroix the sense of reality, is for this very reason more poetic and romantic." Observations such as this can be dismissed as little more than critical play, except that sublime visual play was what the Cubists (who admired Courbet and who influenced, and were in turn influenced by, de Chirico) used to turn reality on its head. Pretty soon Mondrian was explaining that abstraction was "the true vision of reality." And after all these themes and variations, there is no surprise in hearing Giacometti remark, to the critic Pierre Schneider during a visit to the Louvre, that realism is "balderdash."

A contemporary realist is under no obligation to grapple with this paradoxical history, but the artists who are regarded as bellwethers do tend to. Chuck Close, who is 57, would not have a retrospective at the Museum of Modern Art if many people did not believe that he has brought off an elaborate synthesis of naturalistic imagery and Minimalist-Conceptualist principles. And Gabriel Laderman's strong underground reputation is fueled by a sense that even when the work of this 68-year-old painter isn't totally successful, he is wrestling with ways to give naturalistic form a late-twentieth-century pulse. In interviews, Close tends to steer clear of the realist label, which is the last thing you need if you're hoping to maintain a blue-chip New York reputation. As it happens, though, Close and Laderman were both included in the show that first brought the return of realism into a major museum, the Whitney's "22 Realists" in 1970. Although Close and Laderman have lately been incorporating loosened-up painterly elements and higher-keyed color into their work, they both started out as sharp-focus, tonally conservative painters, and they are still concerned with the dramatic power of illusionistic effects.

Sharp-focus is often regarded as the acid test for contemporary realism, no doubt because naturalistic detail can play such tricks with the

kind of paint-as-paint literalness that is celebrated in some classic abstract art. Yet only an artistic reactionary can overlook the strange fact that it was realism that gave birth to abstraction when the exquisitely rendered optical shimmers of Impressionism began to dissolve the very objects that they were meant to describe. Realism is always a process of abstraction, and the more subtly true a realist's work becomes, the more you will find that a feeling for abstract forces comes into play. When I see some of Fairfield Porter's brushily worked yet acutely observed landscapes, or Louisa Matthiasdottir's still lifes, in which the almost Constructivist compositions somehow add to the astonishing credibility, I know that the free-standing power of a brushstroke is a direct response to what the artist has experienced in the world. Painters who want to catch all the lights and shades of nature will be working against the fundamental flatness of a canvas, but the urge to play against the plane is as old as art itself. There is every reason to believe that realism is as much about the essence of painting as abstraction.

But if abstraction is born, does realism die? And can abstraction and realism live together? These are the questions that Laderman is confronting in his *Dance of Death*. In his show at Tatistcheff this past fall, the majority of the paintings were of women, clothed or nude, in unprepossessing interiors. Some of these canvases contained provocative or convincing passages, and there were a couple of beautifully painted heads, but I don't find that Laderman has the intuitive feeling for paint that is required to bring these moody psychological portraits to life. In the middle of this show, however, there was *Dance of Death*, a hugely rich and complex vision that Laderman has brought off with dazzling force and assurance. Laderman is an artist who comes into his own when he is pushing himself to the limit. Compressing an elaborate choreography of seven figures into space that, though large, can barely contain all the action, he not only fills up his subject, he also

breaks the bounds of the subject, until *Dance of Death* becomes a reflection on what painting can and cannot do right now.

This isn't the first time that Laderman has done a painting about death. Indeed, his best figure compositions always seem to be about dying: in 1984 there was *Murder and Its Consequences,* and in 1984–85, *House of Death and Life.* These multipanel paintings were made up of beautifully plotted, brilliantly juxtaposed episodes. Now, by merging a complex narrative into a single allegorical moment, Laderman has deepened the dynamics. In *Dance of Death,* the life-against-death theme is fueled by the painter's hard-won ability to invent fully dimensional figures. The large picture—it is seven and a half feet wide—is a stylistic daredevil act, a nerve-jangling combination of sharp-focus realism, impastoed paint, high-pitched Expressionist color, and angled, neo-Cubist forms. Laderman's burnt reds, lemony yellows, and brownish purples lack the inevitability of great color, but they create the mood he needs. The color launches some of the most inventive figure painting of the past twenty or thirty years. Laderman seems to be saying that if realism lives, life goes on. And realism does live, and life does go on.

In this perfervid meditation on lovers cut down in their prime, a young man and woman, who should be dancing together, are instead partnered by two skull-topped stick figures. Laderman's dreamily interiorized vision of Death has little to do with the figure in Holbein's famous woodcuts. Holbein's Death likes to sneak up on men and women as they go about the ordinary business of their lives; those unannounced appearances, sparing neither the humblest nor the mightiest of men, are a reminder of the vanity of all human desires. Laderman's death figure, by comparison, is almost passive.

This Reaper, composed of a few pieces of wood hinged together and attached to a skull, doesn't quite have the power to snatch people away, or to lead them in the meandering medieval line-dance that inspired the most fa-

mous image in Ingmar Bergman's *The Seventh Seal*. Laderman's young man and woman are evenly matched with their strange partner. They join with Death in an intimate, almost waltz-like dance. They are getting to know Death. This is closer to a nineteenth-century Romantic conception of the Dance of Death, except that in place of the fascinating dark stranger of Romantic ballet, there is an almost Constructivist stick figure. Laderman has invented a Bauhaus death figure; it is, come to think of it, an image of the figure in an age of abstraction.

Dance of Death is set in a not-quite-inside-not-quite-outside space that is just right for the elaborately compressed narrative construction that fills the painting. We begin with the two women, seated at a table, each sunk deep in her own thoughts. They seem to be sitting in the privacy of their home; but Laderman is presenting inside and outside as interpenetrating states, and so this interior is also an exterior, with a glimpse of yellowish, desert-like landscape to the left and, behind the table, a wall punctuated by a window that reveals a darkened interior. The woman at right, in the red dress, with her head leaning on her hand, suggests the contemplative saints of seventeenth-century paintings, and those reverberations jibe with Laderman's sense of overlapping and triangulating relationships. The woman in red appears again, behind the table, hands in the air, as if leading the dance. And the young woman, dancing with Death all the way to the right, reappears once, maybe twice, for we see what must be the same figure, now naked, walking off into the yellow landscape, and, perhaps again, peering through the window of Death's house, where the table reappears, now holding a skull.

In the darkened room, the dance is over. But Laderman is also telling us that the dance goes on. The entire composition, with its doubled figures and its enigmatic locales, has a cyclical rhythm. We feel that everything we are seeing might have been dreamed up by one of the participants. And their

experiences hold us. Laderman knows how to give dramatic point to each clenched fist, outstretched arm, and furrowed brow. The nightmare of the dance is reflected in seven pairs of sadly averted eyes.

Laderman understands that a realist's power to disturb has much to do with how unnatural naturalism feels to sophisticated gallerygoers. And that is only one of the conundrums that he is addressing. By presenting painting as a compelling vehicle for meditations on death, Laderman is turning on its head the idea that painting is on its deathbed. *Dance of Death* might be taken as a counterallegory, an argument against those who believe that what has really happened in the past fifty years is that reality has demolished painting. By that logic, Duchamp's urinal was the ultimate realist statement, a time bomb that had been ticking since Caravaggio painted his down-and-dirty saints. If you take this logic a step farther, the true heirs to Caravaggio and Courbet are Edward Kienholz, who did sensationalist full-scale reconstructions of end-of-the-line flop houses and sleazy bars, and Bruce Nauman, in some of his videos of torture sessions and angry couples.

Painters and sculptors who still think of themselves as realists of some more or less traditional stripe are nowadays in the odd position of trying to set time back on the time bomb, which is perhaps what gives some of their work its strange, twilight-zone fascination. Helen Miranda Wilson, who is a generation younger than Laderman, exhibited nearly two dozen small skyscapes at the Jason McCoy gallery this winter, and her precise renderings of what she sees when she looks up to the heavens, with their great variety of cloud formations and daylit and nighttime skies, give a slowed-down, hallucinatory power to fleeting effects. In this fascinating show—it's the best work she has ever done—Wilson creates her own eerily marmoreal Impressionism, a verisimilitude so divorced from earthbound experience that it becomes enchantingly abstract. And a completely different kind of gravity, but also imbued with an out-of-time realist feeling, held me in some of

Robert Taplin's figure sculptures, which were at Trans Hudson in the fall. There are problems with Taplin's work, but at his best (particularly in one of the seated male figures) his modeling is heartfelt, tough-minded, lucid. Taplin brings a great rhythmic fervor to the representation of the most ordinary appearances. Looking at his depiction of the creases and folds of a man's shirt, I begin to feel the very weight of life's troubles in these exacting renderings of rumpled surfaces.

Realists need to know the idiosyncratic power of detail. Artists such as Taplin, Wilson, and Laderman will emphasize the little things in ways that play funny tricks with scale and give the work an absolutely modern tilt. These choices about the degree and complexity of articulation are what give their work its openness, its life. And it is precisely that kind of life that tends to get lost when painters depend too much on photographs. A photographic model can give a painted image a sensationalist all-in-oneness, as is the case in Anselm Kiefer's new paintings of brickwork structures in India, which were at Gagosian this winter. Kiefer's jazzily overwrought painterly surfaces lend these huge compositions a personal impact. When I have looked at this photo-derived work for a while, however, I find it difficult to avoid the conclusion that an artist who takes the basic relationships and values of a painting from a photograph has lost his freedom to choose. Painters who depend on photographs are admitting that all the time bombs have gone off. They have turned a painter's sneaking-up-on-you revelations into a snap-of-the-shutter fact.

The Chuck Close retrospective at the Museum of Modern Art is realism with a no-illusions-left pose. Basically, Close is a realist for gallerygoers who hate realism, and you cannot imagine a more fashionably paradoxical attitude than that. This work has a tough, analytical look and is obviously labor-intensive, but conceptually it's lazy, lazy stuff. Close makes something

that looks like a face out of fingerprints or funny little circular marks, which is on the order of making a model of Manhattan out of matchsticks. These paintings are not about people, they are about what Close does with photographs of people. These billboard-scale portraits have a sideshow fascination. Close shows technical know-how, but this is different from technique. In an effort to provide this work with a bit of historical context, the Museum of Modern Art has given museumgoers an opportunity to see, before they enter, a self-portrait by Alex Katz and a double nude by Philip Pearlstein. Neither of those canvases is a great work of art, but they were the last paintings with which I could connect at all, until I had made my way through the Chuck Close sensory-deprivation experience and laid eyes on them again.

The portraits that Close began to do in the late '60s are the work of an artist who has no sensibility and is proud of it. Once Close has blown up a photograph, to be sure, he still has to decide how many fingerprints he will use to describe a particular feature, or what kind of bright paint he will use to indicate the color in a particular area of the photograph. Basically, though, all Close's decisionmaking is boxed in. The mug shots on which he has based his canvases for the past quarter of a century dictate all the shapes and all the tonal relationships with which he will be working during the months that he is painting. And the grid that he so often clamps over the photograph gives the structure a Draconian inevitability. There is nothing wrong with an artist using a photograph to get his imagination going (Vuillard did); and the grid can be a terrific starting point for rhythmic invention. But Close doesn't use the photograph and the grid as jumping off points. He uses them as mazes, and he is the rat running through the maze.

"I still make art the old-fashioned way, one stroke at a time, all by myself," Close comments in an interview with Robert Storr, the curator in the Department of Painting and Sculpture at the Modern who organized the

show. Well, so what? There has always been plenty of boring art produced in "the old-fashioned way." So Close is an old-fashioned rat running through a newfangled maze. This work is highfalutin paint-by-numbers. It's not about grids; it's about grid-lock. Close's recent paintings, which fill the last room of the show, have a heated-up look that may get some museumgoers excited. He has given these more tightly cropped images a chicly improvisational look, but in a few years they are going to feel as much like period pieces as the airbrushed horrors from the '60s with which the show begins. It's all just piecework. Close's coolness isn't interestingly matter-of-fact; it's deadeningly mechanized. The photograph is always a photograph. The grid is always a grid. Every one of these portraits is a case study in dissociation. But for museumgoers who have spent decades training themselves to accept the latest hooey, dissociation may be the only experience left.

A Museum of Modern Art retrospective is the ultimate accolade that a living artist can receive. Some of the Modern's recent choices, such as Cy Twombly and Robert Ryman, suggest an interest in artists who present the logical conclusion of a dominant twentieth-century trend, who show modern art going to extremes. But the museum is also interested in artists who are synthesizers, and in this category I would place Frank Stella and Jasper Johns, along with Chuck Close. The work of each of these painters is in some way seen as bringing order to contemporary art's disputed claims and contested definitions. These artists are said to make bold yet neat equations about where modern art is now. Chuck Close's recent work, in which photography, painterly realism, and Minimalist abstraction are all wrapped up in a celebrity portrait package, tells you a lot about the Museum of Modern Art's agenda.

The curators at the Modern like to emphasize the eccentric, go-it-alone side of Close's portraitist-in-an-age-of-abstraction status. Yet Close also comes across as a mediator, a consensus builder. His work is all abstract-

meets-realist gambits. And that makes a perfect fit with a museum that, though committed to the idea that modern art moves inexorably toward abstraction, can hardly ignore the stubborn persistence of one or another kind of realism. The Modern habitually treats such work as a quirk, a divertimento—as bread and circuses, and fundamentally unserious.

When Close grids up his faces, the curators at the Modern feel that realism is at long last getting down to business. Sophisticates like to see faces frozen, blown-up, digitalized, caged. If they must have realism, they prefer that it be dead, and Close's gargantuan mugs do the trick. Close gives realism a creepy impact. This show is an update on the Magic Realism that the Modern favored half a century ago. Close's not-quite-there faces could be interpreted as the descendants of *Hide-and-Seek,* Pavel Tchelitchew's exercise in dissolving everything into everything else, which went into the collection in 1942, the year it was finished, and was for decades just about the most popular painting in the museum.

At the Museum of Modern Art, realists are generally presented as being obsessed with freaks, loners, and outsiders. There is Balthus's portrait of Miró, who some people will think is a little too close to his young daughter. There is Giacometti's portrait of his mother, a tiny figure lost in an enormous room. And there is Edward Hopper's decrepit Victorian house, isolated against the gray sky. At the Modern, realism tends to be regarded as a marginal endeavor, a kind of painting that is always at odds with the twentieth-century mainstream. In a sense, that's not far from the truth; you could argue that the very essence of the realist enterprise, which is its empirical nature, means that this is an anti-grand-tradition tradition. Since realists are by definition artists who celebrate particularity, they are always breaking down the generalizations, which relates them to the essentially dissident spirit of twentieth-century art. Yet the only kind of break-up that seems to interest the Museum of Modern Art is the break up of realism it-

self. What is disheartening is how often in recent decades the monuments of realist painting have been seen, at the Modern and elsewhere, as foreshadowing the death of realism. And Duchamp's followers are not the only guilty parties.

In Clement Greenberg's 1960 essay on "The Early Flemish Masters," painters such as Gerard David are pressed into the service of an argument about the abstract value of color that seems to segue into Color Field painting. At the beginning of this strange essay, Greenberg observes: "As far as I know, not a single important painter since the end of the sixteenth century has, in either works or words, betrayed any significant interest in anything in Flemish painting before Bosch." And having declared that this work is disregarded by artists, Greenberg feels free to rule that the detailed naturalism of Flemish painting was a liability. It had to be counterbalanced, in Memling and in David, by the "sheerly pictorial power color—translucent, vitreous color—is capable of even when it doesn't 'hold the plane.'" From there it's only a hop and a skip to Morris Louis's floating veils of color.

In the early '60s, however, no less a figure than Giacometti was copying Jan van Eyck's *Man in a Turban* and observing that "I see a tree like Mantegna and van Eyck rather than the Impressionists." Such concerns would not have registered on Greenberg's radar screen, since they were the concerns of a realist, and for Greenberg a realist was almost by definition not an important contemporary artist. I would say that Gerard David and Morris Louis is a marriage made in art-theory hell. But once you've wrapped your brain around that equation, you have seen how realism can be used to bolster just about any argument against realist painting, and you are ready for the comments that the video artist Bill Viola, whose work is currently the subject of a retrospective at the Whitney, recently made in the *New York Times Magazine*: "Van Eyck was an incredible craftsman working with the most advanced image-making system on the planet at that time—he was using high-defini-

tion." The implication, of course, is that Viola's videos (and perhaps Close's Polaroid camera close-ups) are on a continuum with van Eyck's brush.

Painters who are bothered by Viola's remark, and I think they ought to be, would do well to bring the discussion back to Giacometti's interest in van Eyck. Nobody knew better than Giacometti what being modern meant, and it is significant that this artist, who had gone through abstraction and Surrealism and was never a nit-picking realist, was so fascinated by van Eyck. Giacometti saw that van Eyck's scintillating verisimilitude was grounded in the abstract patterning and intricate fantasy of medieval art. And he must have sensed that this early Renaissance evolution was a model for the twentieth-century realist, who is also building on a more abstract and fantastical kind of art. The gravity of van Eyck's imagery grew out of the artist's sense that realism was not so much birth as rebirth—living things brought back to life on the canvas. And if there is a mortuary aura to realism in this century, it is because realism in the wake of abstraction is always exhumation.

You could write a whole history of death and realism in the twentieth century. It would include Balthus's *Victim,* painted in the late '30s, in which we see a young woman reclining with her eyes closed and a knife nearby but no wound on her body. Sabine Rewald, in her catalog for the Metropolitan's 1984 Balthus retrospective, observes that this woman is "not really dead, perhaps only momentarily drained of life," and in that thought is an allegory of realism in our time. The work of the English painter Stanley Spencer, who was the subject of a retrospective at the Hirshhorn last fall, is full of images of death and resurrection. Even his most searchingly direct nudes, landscapes, and self-portraits have a grayed-down look that makes us feel that the life has gone out of things.

This troubled modern realist tradition echoes through Gabriel Laderman's *Dance of Death.* He has filled his composition with a marvelous play of

purplish shadows that are doubled and tripled into mysterious patterns, so that beneath the dancers' feet realism seems to be dissolving into abstraction right before our eyes. Laderman is going beyond realism into emblems, fantasy, magic. He makes us believe that this is all part of the realist's territory. His theme comes out of the late Middle Ages, and as you study the iconography of the Dance of Death, you realize that some of the most famous representations of this strange confrontation are also among the great monuments in the rise of European naturalism. I am not sure that Laderman was aware of all of this while he was painting, but it hardly matters. In confronting death, he has recovered realism as a life principle.

APRIL 20, 1998

AROUND THE MUSEUMS

FORMAL AFRICA

Carving is metamorphosis. Working in wood and stone, the great sculptors make intractable material pliable, they turn hardness into softness, they transform the vegetable and mineral kingdoms into animal kingdoms right before our eyes. At "Africa: The Art of a Continent," the immense survey that fills the uptown Guggenheim this summer, these changes take place, again and again. There is more extraordinary carving, especially wood carving, than museumgoers are used to seeing in one place at one time. Certainly in New York, a city where painting generally takes precedence over sculpture, this show induces an almost unique kind of exhilaration. You take it in with your eyes, but you somehow end up feeling that you're experiencing all those marvelously variegated surfaces with your fingertips. Although much of the work and virtually all of the wood carving dates from the past hundred years, the show does reach all the way back to prehistoric times. This encyclopedic exhibition, which originated at the Royal Academy in London (and has also been seen in Berlin), is the first attempt to survey the entire artistic production of the continent, from Ancient Egypt to twentieth-century South Africa. In addition to figurative work in wood, stone, and metal, "The Art of a Continent" includes furniture, pottery, textiles, tools, and other everyday objects. In all there are more than 500 items, and that's down some 300 from what was seen in London.

Unwinding around the ramp of the Guggenheim and filling most of the adjacent galleries, the show looks better in the space than anything since Margit Rowell's pathbreaking Constructivist show, "The Planar Dimension," back in 1979. The sleek Plexiglas cases and starkly curving white walls provide a suave yet neutral setting that allows this panoramic display to ex-

pand; the sculpture is a commanding presence. Like most of the pioneers of the modern movement, Frank Lloyd Wright had an abiding interest in non-Western art, so it's not surprising that the theatricality of his rotunda provides such a spectacular backdrop for this pageant of African art. Adegboyega Adefope and W. Rod Faulds, who are responsible for the Guggenheim installation, deserve special praise.

"Africa" is a spellbinder, but New York appears to be sidestepping the spell. It's strange. In London last winter the show was a huge hit for the Royal Academy, an institution where you're more likely to see nineteenth-century English watercolors or paintings by Poussin. The London installation was as overcrowded and inelegant as the New York one is spare and refined, but apparently in Britain the warehouse approach only added to the show's revelatory impact. Visitors felt as if they were discovering things for themselves. That installation was especially apt in London, where the work is less familiar to the general museumgoing public than in New York, yet Americans who saw "Africa" in London expected the show to strike like lightening here. The American media ought to have taken one look at the catalog and seen that this is a blockbuster to be reckoned with. Three of the biggest names in black studies have contributed. Cornel West wrote the introduction. Henry Louis Gates Jr. offers an essay on European reactions to African art. And Kwame Anthony Appiah confronts the mysterious fact that "neither *Africa* nor *art*—the two animating principles of this exhibition—played a role *as ideas* in the creation of the objects in this spectacular show." Appiah knows the dangers of what he is basically regarding as a crossover event. When objects created to fill practical or magical functions arrive in the museum, who can doubt that they are somehow changed? But Appiah also finds the change exciting. He's glad to see an Asante goldweight or an Oron ancestor figure transcend time and place.

These African-American intellectuals must have hoped that the show would take the museum world by storm. And they surely knew that juxtaposing material from Ancient Egypt and Islamic North Africa with work from south of the Sahara suggests a provocative rethinking of the relationship between the African continent and the Mediterranean world. "Africa" might be having a somewhat different reception if it weren't at the Guggenheim, a museum that the media likes to dump on, and often with good reason. But now the Guggenheim has done itself proud, and the response is by and large the same sputtering dismissal. I can't help feeling that the generally chilly reaction to this dazzling, complicated show is just one more demonstration that all anybody wants any longer from our big museums is bland cultural respectability. The Winslow Homer retrospective, which opened at the National Gallery in Washington last winter and is currently at the Metropolitan, a few blocks south of the Guggenheim, is an overblown event, yet people are flocking to see what they regard as Homer's feel-good Americana, and they've been encouraged by the commentators in the newspapers and magazines and on TV. Homer was a great graphic artist in his *Harper's Weekly* illustrations, but he generally overreached when he went into full color; he's a better Andrew Wyeth for people who ought to know better. As a museum experience, certainly, he's a play-it-safe classic. And if that's what people want, it's no wonder that they're avoiding "Africa."

Although the educated public is reluctant to criticize such PC extravaganzas as the 1993 Whitney Biennial or the Museum of Modern Art's current "Thinking Print: Books to Billboards, 1980–95," the truth is that when people head for the museums they want a break from the culture wars. They want familiar classics, and they don't care if they're not quite first-rate. They'll settle for Winslow Homer—or Jan Steen, whose able but generally underpowered scenes of the seventeenth-century Dutch at play, which are at the National Gallery this summer, have been discussed in some quarters

as if Steen were in the same class as Vermeer. All that Vermeer and Steen and Homer have in common is how snugly they fit the museum context. They're reliable experiences, which doesn't mean much more than that they come in gold-leafed frames.

"Africa" may be overlooked because it comes without the frames. This show stirs up the museum, and that's not necessarily what people want on a weekend afternoon. It upsets expectations, perhaps especially for the likely core audience, which is sympathetic with politically correct thinking and may have a vested interest in believing that non-Western art and the Western museum are not an easy mix. In the catalog we are reminded more than once that many of the intentions of the men and women who created this work are alien to us. True enough. Bowls, spoons, headrests, and gold-weights inevitably lose much of their everyday, utilitarian feel when arranged in cases in a museum. And even experts in the field may be hard put to explain the complex magical significance of a particular type of mask, or the commemorative functions of figures that were often originally part of large quasi-architectural arrangements. Fertility figures were not de-signed to be contemplated behind Plexiglas.

But then what are we to make of the fact that so much of this sculpture takes to the museum environment with ease and authority? The organizers of "Africa," who seem to be unembarrassed about their Afrocentrism and unembarrassed about their appetite for quality, take the PC-twain-that-shall-not-meet and make them meet. These works are not safe classics. The show suggests an uncompromisingly integrationist aesthetic, and that's not especially popular today.

Just about everybody who visits "Africa: The Art of a Continent" is going to feel as if they're in over their heads. That's part of the excitement. The shifts in size and scale and material can make you hyperattentive—can put you

in a trance-like state. Every few yards you're discovering another kind of simplification or complication, another way of treating natural materials. The sculptors operate in some rare, privileged space between nature and culture. They draw strength from the very grain of the wood, which suggests emotional colorations, a range of moods.

I imagine that even people who are experts in one or another aspect of this huge subject are going to be confronted with unfamiliar material. The exhibition is divided into seven geographical sections, each of which ranges over the full historical spectrum of work created in that area. (The only exception is the section on "Ancient Egypt and Nubia.") If you really get into the show, you can't help but feel that you're trying to take in more information than you can reasonably be expected to absorb. The exhibition is a reach. Yet it's possible, if you go to the Guggenheim two or three times, to find yourself drawn to certain objects, and if you follow your intuitions you might just acquire the beginnings of an education. I kept gravitating to the section that focuses on "West Africa and the Guinea Coast." The 2,000-mile stretch from Guinea to Nigeria is one of those parts of the world where a feeling for sculptural form runs especially deep. (In this respect it reminds me of Burgundian France or the island of Java.) I started to play around with my reactions to some of the pieces in that part of the show. I wanted to see what sense I could make of them.

One of the kingpins of the exhibition comes from West Africa. It is a sculpture of a seated, middle-aged man, cast in almost pure copper by smiths in the city of Ife, in the Yoruba community in what is now Nigeria, sometime in the thirteenth or fourteenth century. This riveting image of a self-assured yet in some respects unprepossessing personality suggests a moment in the development of an art form when naturalism is fully achieved yet the bloom of discovery is still on it. My impression is that little is understood about the evolution that led to this miraculous realism, except that

the use of copper and brass in casting depended on the trans-Saharan trade routes (which were also instrumental in the spread of Islam in Africa). Yet the achievement of the Ife artists, which began to come to light early in this century but was not discussed in much depth until forty or fifty years ago, demonstrates conclusively that mimesis is very much a part of the African tradition. This seated Ife figure, with its full sensuous lips and eyelids, has the kind of unforced yet penetrating truthfulness that we know from van Eyck. And it's possible to feel that van Eyck represents a similar moment in European art, before a gap appeared between literalism and formal grace.

This Ife masterpiece, which was until relatively recently worshipped as a fertility figure in a village on the River Niger, is a rare, miraculous survival. Unfortunately, the current state of archaeological and art-historical research does not help us understand much about where this naturalistic poetry led; we may never know for sure. Yet the realization that on the African continent abstraction might flow out of realism jibes with much that we have come to understand about European art, too. In the years during which Ife sculpture has gradually become known, art historians such as H. P. L'Orange and Wilhelm Worringer have focused on the growth of abstraction in the late Roman Mediterranean and in Gothic Europe. They've suggested that representation and decoration—or whatever one wants to call these two impulses—are dynamically related. And if one accepts that idea, then the seated male Ife figure, far from being an anomaly in African art, announces an essential theme, which is the extraordinary power of the torso.

In European sculpture, all the way from the Greeks to Michelangelo and Bernini and Rodin, what's essential is the ability of the legs and thighs to defy gravity and free the figure from the earth. African figure sculpture is about something very different; it's about the weight that we carry on our shoulders, about our rootedness in the earth. In the great *Bafum King Returning from*

Victory—it's also West African, from the Cameroons, possibly early-nine-teenth-century—the upper torso has an awesome heft, and the broad, lean articulation of the shoulders serves as a springboard for the power of the neck and the haunting surprise of the head. A smile of feverish ecstasy animates every muscle of the king's face, as he shows off the severed head of a victim in his left hand.

Like the Ife sculpture, the *Bafum King* is a seated figure, but the focus in African sculpture is often on the torso even when the figure is standing. When you look at a female figure from the Baule people on the Ivory Coast—this piece comes from a private collection in New York—it's not the powerfully bent legs that catch your eye first, but the great inverted U-shape created by the unbroken flow up one long, long arm, across the shoulders (which almost include the breasts) and then straight down the other arm. Since the hands rest on the knees, it's almost as if the lower legs have become an extension of the smooth, lithe, tightly sprung upper torso. This figure has a monumental, centrifugal force.

The imaginative genius of African figure sculpture depends on the trans-formation of anatomical particulars into decorative abstractions. When this process is most persuasive, it's because it has an underlying naturalistic logic. And as often as not, that logic begins and ends with the torso. The trunk of a tree is related to the trunk of a body, arms and legs are reimag-ined as branch-like extensions of that central form. The ravishing visual flow in the elongated Oron ancestor figures depends on this essential metaphor-ical conceit. Preserving at least an echo of the trunk's primary form from head to toe, the sculptors alternate bands of broadly curved and tightly an-gled shapes to articulate a torso that then breaks into two legs that are not so much independent entities as recollections of that great singular column. The rhythmic control of decorative variations in the Oron ancestor figures, although in no sense realistic, is nonetheless grounded in a feeling for the

natural growth of forms. These artists can make big shapes sprout small shapes with the matter-of-factness of a hand's ending in five fingers or a twig's bearing leaves and flowers and fruit.

"Africa" includes a daunting range of material. There are dozens of tiny gold weights from the Ivory Coast, adding up to a universe in miniature in which every kind of form is present: abstract and figurative, geometric and expressionist. There are exuberantly simplified masks that are as tall as people, fetishes bristling with nails, finically carved pieces of ivory, fantastical triumphs of the ironmonger's art. No area of the show is without its high points, though the sections dealing with "Ancient Egypt and Nubia" and "Northern Africa" are neither so extensive nor so compelling in New York as they were in London.

Southern Africa is particularly strong in nonfigurative works, at least so far as this show goes. One lidded vessel by a Northern Nguni artist is a spectacularly complicated bulbous form, with its own weirdly grotesque kind of beauty. Carved from a single piece of wood, articulated all over with deep striped incisions, this imposing composition, with a central vessel ringed around with pipe-like tentacles, is an almost sci-fi-wild fantasy. A large collection of headrests, also from Southern Africa, adds up to one of the show's great variations on a theme. In one example, the base, carved from a single piece of wood, becomes a congeries of intertwined, rootlike forms. There are numerous variants on the basic V- or X-shape of the headrest, some starkly simple, others dizzily adumbrated. Here the wood often has a smooth, aged patina, so that the objects seem to give off a dark yet lustrous glow.

The work in "Africa: The Art of a Continent" has been gathered from a vast array of public and private sources. Europe's oldest ethnographic collections are represented, as are newer museums in Africa. The American leg

of the show includes strong work borrowed from American dealers and collectors. Much has happened to some of these objects since they left the hands of the artist. The life span of wood sculpture in a tropical climate can be brief. And attitudes about conservation and the place of the arts in society are as varied in Africa as anywhere else. When some of the older works in this show originally left Africa around the turn of the century, they were regarded more as cultural artifacts than as art. And although it's doubtful that anyone would any longer dispute their formal values, the question of how we can best make sense of this work remains a complicated one.

Many questions that museumgoing invariably raises—Do we go to a museum to feel things or to learn things? What do feeling and learning have to do with one another?—are heightened when the material is new to us. Confronted with so much that's so unusual, a museumgoer is going to ask lots of questions, and one of the criticisms that can be lodged against the Guggenheim show is that although it's strong on art, it's weak on explanation. This exhibition, which counts on our reacting visually and viscerally, can leave us in the dark as to the original function of many of the objects that we're reacting to.

It's exactly this question that seems to have dominated the rather scant press that the show has received during the first half of its run. Holland Cotter, in a review in the *New York Times,* complained that the show "makes little sense of what . . . objects might mean." Cotter thinks that the show attempts too much and delivers too little. Nobody can doubt that an exhibition that focused only on, say, headrests would give us a lot of valuable information; of course we want to know that these headrests were used to protect men's elaborate headdresses, and that they often include abstracted female figures, and that many of them were buried with their owners. Cotter does not dispute the formidable quality of much of the work in "Africa," but he worries that this high-profile anthology may distract attention and

funding from more tightly focused, information-oriented shows, such as some that are done at the Museum for African Art in SoHo. Funding is certainly a problem in the museum world, especially for unusual projects. But I think that Cotter is denying the seriousness of this overview when he states that "entire social and spiritual worlds are passed over for the sake of yet another scenic hike along the Guggenheim's ramps."

"Africa" appeals to our eyes—and why deny that power to non-Western art when we would not think of denying it to Matisse? On this point I am in agreement with Peter Schjeldahl, who wrote in the *Village Voice* that "labels explain . . . uses, uselessly—as if learning that something served for an initiation ritual made it accessible. If my own initiation into the work is Romantic, that's because I can't imagine a more practicable way to do it justice." If Cotter means to suggest that what Schjeldahl calls "the bliss of being blitzed" is somehow incompatible with a more ethnographically oriented experience, I do not agree. There's a danger of creating a false duality. The show that is at the Museum for African Art this summer, "Memory: Luba Art and the Making of History," which is the kind of circumscribed project that Cotter prefers, focuses on the Luba people of Zaire and how several types of objects have helped them to sustain a sense of historical continuity. It's a show in which the tilt is ethnographic—and yet we want to respond to the way the objects look, just as the beauty of the work in "Africa" presses us to ask all kinds of questions about use and context.

Formal values are symbolic values and vice versa. The African sculptor who worried about mastering his craft may not have been thinking all that differently from Brancusi. The anthropologist who initially asks why something was made will have to look at it closely. And the collector of modern paintings who acquires some African masks will quite naturally want to know how they were used. When it comes to understanding art, compartmentalized thinking doesn't get you very far. Iconographers need eyes, and

formalists need to know what they're seeing. Tom Phillips, who is an artist, spearheaded the Royal Academy's organization of "Africa: The Art of a Continent," and he is certainly not indifferent to the archaeological or anthropological aspects of the subject. (Michael Kan, a curator at the Detroit Institute of Arts, was chair of the committee that adapted the show for New York.)

Unfortunately, the grievously underfunded Guggenheim has published nothing but a skimpy greatest-hits catalog on the occasion of this important show. There isn't even a complete list of the works. The much larger and more complete Royal Academy catalog—which is being distributed in this country by Prestel and is available at the Guggenheim—is quite a help, but even this 613-page tome lacks the overviews that one might have hoped for. The Royal Academy catalog is a somewhat confused affair, with too many authors given too little overall guidance, but at least its packed, helter-skelter approach conveys a general feeling for the field. It's clear that many of the contributors have qualms about this encyclopedic survey, if only because it suggests how much the public has to learn. Yet these scholars also see this as a chance to gain a wider audience for some very great art and to reflect on how much remains to be done.

Schjeldahl predicted that 1996 would be the summer in New York "when Africa ruled. And we argued about it, probably." I would have thought so, too. But the arguments have not begun. From the art press to the black press, the reaction has been mostly silence. One can make too much of the nonresponse. It may have a lot to do with inadequate PR. But at a time when the very mention of non-Western art inspires guilt in some quarters and self-righteousness in others, the organizers of "Africa: The Art of a Continent" may have committed the unpardonable sin of expecting us to enjoy the show. As you make your way around the Guggenheim's ramp you keep coming face-to-face with the feverish ambition and the visual daring that you find

only in the greatest art. The names of the sculptors are almost all unknown, but the impact of their work is perfectly plain. Could it be that all this formal audacity has embarrassed New York into silence? Could it be that people simply refuse to believe that the art of Africa is this good?

SEPTEMBER 2, 1996

PAINTING IS A WOMAN

In Corot's masterpieces, which are seldom more than two feet high, all the fast-moving transformations of nineteenth-century Europe register seismographically, through the slightest shifts in color, shape, and scale. Jean-Baptiste-Camille Corot, who died in 1875, a year short of his eightieth year, was absolutely a man of his time, but he regarded everything from his own unique, at-an-angle perspective. He poured a tidal flow of artistic intelligence into a relatively restricted range of themes—over and over again, he painted a village road or a woman reading a book—and he relied on the concentrated emotional weight that he brought to every stroke of paint to mix poetry and pragmatism in startling new ways. I think he is right up there with the giants, an artist of Velázquez's caliber. He goes into the dusty prop room of nineteenth-century art, with its picturesque ruins and peasant costumes and mandolins, and he regards the humdrum items with such rapt attentiveness that they become magical tokens of a time and place that's becoming mythic as it disappears. Corot doesn't make a big deal about turning the mundane into the absolute, but once you see what he's up to you can glimpse, beneath the delicately worked surfaces, reserves of sneaky exhilaration.

I don't know that there's anything in all of art that makes me happier than what Corot does in these canvases. The density of his effects is heaven for anybody who really cares about painting. To pack so much into such a small compass suggests a controlled extravagance that has no equal. In the Roman views that Corot painted while he was in his 30s, all of paganism and Christianity passes before our eyes as the artist fine-tunes the color of a shadow on a crumbling wall. Corot's silvery views of trees and rivers around Paris define some catalytic out-of-time-and-space experience in which the twilight of Romanticism melts straight into the dawn of abstract art. And in the series of a half dozen views of a woman in the artist's studio that he painted in the late 1860s and early 1870s, Corot joins the Velázquez of *Las Meninas* and the Watteau of *Gersaint's Shopsign* as one of the immortal chroniclers of the artist's relationship to the audience. In Corot's studio paintings the audience has dwindled to a single visitor who sometimes scarcely seems to be looking at the canvas on the easel, and the result is a definitive description of the gathering solitude of the modern artist.

Corot's gift for pulling epochal shifts out of the tiniest formal decisions is what endears him to painters. They feel that on some transcendent level he's making the same kinds of judgments that they know from their everyday work in the studio. At the press preview for the Corot retrospective that is at the Metropolitan Museum of Art this winter, I saw more painters than I can recall at a comparable event. I can't think of a show to which artists have responded so immediately and so unequivocally. Weeks into the run, there are people taking in the paintings one by one, and you can tell from the way that they're moving close, studying the surfaces inch by inch, that many of them are artists. In the perfection of his tones, the originality of his forms, and the rhythmic lucidity of his compositions, Corot rivals even Titian, and artists may love him more, because Corot doesn't insist on the

grand scale and elaborate themes that sometimes threaten to depersonalize a genius's work.

There's an easygoing yet strong-willed feeling that runs through Corot's achievement. He was a prolific artist who experimented endlessly with the kind of big painting that ultimately earned him a hard-won popularity with the public of his day. Yet those efforts, however much they strained his gift for hairsbreadth-precise effects, never really deterred his independent spirit. I imagine that Corot's ability to remain himself while not totally rejecting the taste of his age fascinated Monet and Degas and other avant-garde artists who were establishing themselves during the last years of his life. Decades after his death, it was Corot's uncanny independence that made him such a touchstone for Picasso and Braque and Gris, and for Matisse, who in 1912 ranked Corot among his five favorite painters, along with Dürer, Rembrandt, Goya, and Manet. I would guess that anybody who truly loves Corot loves him for the huge freight of meaning that he packs into each brushstroke. But that Corot is not the artist whom the organizers of the large retrospective at the Metropolitan have placed beneath the spotlight.

The Corot exhibit is just about the worst structured retrospective that I've ever seen at the Metropolitan. An artist of Corot's caliber can't really be ruined, but this show comes dangerously close to turning him into a broken-down nineteenth-century period piece. The exhibit, which has already been in Paris and Ottawa, was organized by Michael Pantazzi of the National Gallery of Canada, Vincent Pomarède of the Louvre, and Gary Tinterow, the Engelhard Curator of European Paintings at the Metropolitan. These men are obviously competent scholars with a formidable knowledge of the documentary sources, but I don't think that they really grasp the restless intelligence that races through this achievement. Like so many students of nineteenth-century art, they tend to evaluate an artist in terms of career moves, not in terms of the play of his imagination. Some of the documen-

tary material in the catalog is very interesting, but it's pushed so far into the foreground that it sometimes seems as if the paintings are little more than illustrations of the journalistic accounts that were piling up, higher and higher, as the nineteenth century progressed.

In the last decades of his life, Corot became one of those Great Men whom the French public was glad to venerate, even if the man in the street had only an approximate idea of why this particular gent with a beret was a legend. It's this adorable-genius view of Corot, I think, that the curators of the retrospective want to revive. Pantazzi, Pomarède, and Tinterow have exhumed the woozy-warm atmosphere that swirled around the aged artist who found favor with both the academy and the avant-garde. By giving pride of place to the large, loosely-brushed imaginary landscapes that earned Corot a reputation as a forward-looking painter whom even conservatives could enjoy, the curators have explained why Corot gained in popularity and could be referred to by one critic as "the patriarch of landscape painters." But I suspect that Tinterow and his colleagues also find a certain perverse postmodern satisfaction in playing the populist card. By resurrecting the nineteenth-century blockbuster popularity of *Le Père Corot,* Tinterow and Company have uncovered an artist who fits with the blockbuster mood of our museums.

The show has a waxworks atmosphere, what with the deep red walls, tufted circular ottomans, and symmetrically hung paintings. All of this may be intended to honor nineteenth-century taste, but mixed with the scholarly earnestness is a strong dose of camp cynicism. The combination is unfortunately familiar. For at least the past thirty years, curators and art historians have been dismantling the old view of nineteenth-century art as a fast-breaking avant-gardist narrative in favor of a static image of the century as Europe's ultimate Temple of Bad Taste. At first, some of the revisionist dabbling in kitsch was a breath of fresh air, a welcome dissent from

an increasingly fossilized less-is-more vision of modern art. By the mid-'70s, however, the retro-chic thinking had degenerated into an automatic up-grading of anything the moderns didn't like. And then the French, who had often been the last to catch on to their own avant-garde, gave the gold seal of approval to the new disposition with the opening of the Musée d'Orsay in Paris in 1986.

The Orsay has turned into a huge tourist attraction, but I think it's fair to say that people who love painting get the willies in this place where In-gres and Courbet are left to jostle for space with Jules Breton, Jean-Charles Cazin, and Jules Bastien-Lepage. The Orsay celebrates a reverse snobbery that makes it fashionable to denigrate formal values, and it's this attitude that Tinterow and his colleagues have brought to bear on Corot. What we're seeing at the Met is the Orsayization of Corot. He's being cel-ebrated as a product—maybe even a victim—of nineteenth-century taste.

Tinterow will insist, of course, that he really admires those big paintings of Corot's. I'm sure he does. In the catalog some of them are called master-pieces, and the value judgments are backed up with lots of nineteenth-cen-tury opinion. Quality, as we all know, is a matter of opinion, and opinions are at least in part a function of one's experience. There is no mystery as to why a curator who works in the bread-and-circuses atmosphere of the big contemporary museums might feel a certain identification with the bread-and-circuses taste of an event such as the Universal Exposition of 1855, where Corot is said to have had his greatest popular success. The truth is that the small-is-beautiful side of Corot—which once earned him icon sta-tus among an elitist avant-garde—won't make much sense in a museum world where the corporate sponsor is king. And for those who went to the Metropolitan to see the Corot revered by Picasso, Braque, and Matisse, this show comes close to being an out-and-out lie.

Corot was a late starter. His parents, who owned a celebrated millinery shop on the rue du Bac, wanted him to go into the draper's trade, but by the early 1820s, when he was already in his 20s, he had set his sights on painting. Like many turning-point figures in nineteenth-century art, he could operate at a distance from established taste because he had an income from his family; he worked without giving much thought to sales, which only began to add up when he was well into middle age. This man, who never married and who lived with his parents until his mother died in 1851, was in many respects not an especially vivid figure, but he always seems to have known his own mind.

Right away, Corot fastened on landscape as his essential subject. He studied briefly with Achille-Etna Michallon, a significant Neoclassical painter who died young; he then worked for three years with Michallon's teacher, Jean-Victor Bertin. By the time Corot arrived in Italy in 1825—he ultimately made three extended trips—he had a startlingly idiomatic way of translating complicated vistas onto two-dimensional surfaces. And some of the feeling for clearly juxtaposed colors and forms that animates the oil sketches passed into Corot's early essays in Salon-size painting. *Hagar in the Wilderness* (1835), which is in the Metropolitan's collection, has a clean-lined, off-balance beauty that is far from Neoclassical conventions. There's something winningly uncompromising about the way Corot goes right ahead and paints an angel hovering above a highly specific landscape; this may not be a completely satisfying picture, but it's certainly the product of an original mind.

In the smaller paintings that Corot began to paint practically before he unpacked his bags in Rome, his originality is unfettered, and he brings a new kind of naturalistic inventiveness into art. Looking at the Colosseum and the Forum and the Tiber with the Castel Sant'Angelo, he sees much more in the familiar scenes than anybody had ever seen before. As he sur-

veys the Forum, he turns the cluttered ruins into a multidimensional checkerboard, a quirky topography of volumes and voids. Standing in front of the Villa Medici, he rhymes the nearby trees and fountain with the distant dome of Saint Peter's to create a visual spectacle that mirrors the city's historical overlays perfectly. Wherever Corot sets up his easel in the Eternal City and the surrounding countryside, he turns the Graeco-Roman tradition, with its strongly modeled forms, into paintings that have their own wonderful, something-old-something-new play of light and shade.

What's astonishing about these paintings is the immediate, peremptory impact that Corot achieves even as he celebrates nuance, paradox, and contradiction. He seems to be conveying some of the omnivorous excitement of a young man who's falling head over heels in love with the sunny south. You can see how really unique his achievement here is if you go to "In the Light of Italy," an exhibition that focuses on the open-air painting done in Italy in the late 1700s and early 1800s by artists from all over Europe; it opened at the National Gallery in Washington last spring and is at the Brooklyn Museum this winter. Organized by Philip Conisbees, Sarah Faunce, Jeremy Strick, and Peter Galassi, it's an immaculately lucid, medium-sized scholarly show. You feel the earnest and intrepid high spirits of the artists from all over Europe who congregated in Rome. There is much outstanding work. Especially the Welshman Thomas Jones and the Dane Christoffer Wilhelm Eckersberg can work marvels when it comes to picking some precious vignette out of the Roman spectacle, yet neither they nor any of the other artists in the show can match Corot's plangent color, or his rhythmic assurance, or his genius for transforming visual happenstance into formal arabesque.

Obviously the work that Corot did back in France looks different from the Italian achievement, if for no other reason than that there are so many differences in topography, light, and vegetation. Still, there's more of a

steady development through the whole of his landscape painting than is sometimes acknowledged. It's obvious that a work such as the brown-on-brown study of rooftops done in Orléans around 1830, after the first Italian trip, evinces the same eye for surprising juxtapositions that we know in the Roman work. But so too does a late masterpiece that is not included in this show, *The Bridge at Mantes* (1868–70), in which the juxtaposition of trees and bridge creates an end-to-end interwoven space that's as poignantly specific as any of the views of the Roman Forum.

In his bigger works, Corot struggled to become a generalizer, and sometimes he succeeded; but he always loved specificity, and the mind that brings a few tiny figures into a Roman view in order to suggest a social dimension is still hard at work in 1871, when Corot paints the town of Douai. In *The Belfry, Douai,* the corners of two looming buildings frame the foreground, a street full of figures and the elaborate belfry recede into the distance, and we have a view of the ordinary life of a French town that's quite as definitive as Vermeer's *Street in Delft*. Corot is absolutely Vermeer's equal when it comes to focusing so intently on everyday occurrences that time freezes and we slip through a trap door into eternity. The old man who painted Douai had lost none of the avidity for detail that fills to bursting the terra-cotta-and-blue visions of Italy that he did decades before. He is no longer inclined to hit the accents quite so hard; it is a more experienced kind of clearheadedness that you feel in his infinitely calibrated grays.

Corot set out to be a Neoclassical landscape painter, but almost immediately he gave the realist oil sketch an unheard-of geometric intricacy, and by the end of his life his close study of the rainswept northern atmosphere had ushered in a new kind of Romantic visual poetry. In Corot's work all fixed stylistic categories dissolve. This was fairly typical of the great artists of the nineteenth century. It was a dazzlingly exciting age for painting, for even as the collapse of art as a public avowal left many artists frozen in place, the

great minds turned catastrophe to their advantage and rushed forward unencumbered.

Corot was much more of an experimentalist than you would guess from this show. Tinterow's installation includes no drawings or prints, and although the reason for this is no doubt in part a practical one having to do with lighting levels, it's a pity to deny museumgoers the unconventionality of Corot's drawing. Especially in his figure studies, he explores contours and volumes with a lack of preconception that declares his complete freedom from academic standards. There's something almost naive about the way that Corot will underline an edge or turn the shaded side of an arm into an autonomous dark shape. But when you think of these exploratory sketches in relation to the beautifully resolved volumes and intervals in his figure paintings, you see that they are great working drawings, the kind of thing that painterly painters from Titian to Bonnard have done prior to turning to the canvas.

The landscape drawings have their own fascination, and there's also a lot to be said about Corot as a printmaker. He was a great etcher. And he is the only artist who made something truly original of the *cliché-verre,* a method of scratching into a blackened glass plate to create a negative that's then printed on photographic paper. These *clichés-verres* have some of the look of an etching, but with a softer, silvery sheen. Corot gives the new technology a moodiness that brings some of the chiaroscuro effects of early photography under the draftsman's control. A couple of *clichés-verres* are included in a concurrent exhibition at the Metropolitan that is devoted to the photographer Eugène Cuvelier, who was a friend of Corot's and helped him with his *clichés-verres.* But even though these few prints are up elsewhere in the museum, it's no substitute for their being included in the retrospective proper.

Curators need some wit, some feeling for the labyrinthine twists of a great imagination, to deal with an artist as subtly forceful, and sometimes as

carelessly prolific, as Corot. Corot paid his respects to the idea of the old-fashioned masterpiece, but the irony of the situation was that the very concept was so corrupted by his time that only an artist who knew how to handle slightly garish fortissimo effects could make a really big painting work. *The Evening Star* (1864), with its dramatic just-before-darkness sky and silhouetted figure, is the kind of lyric icon that a contemporary of Corot's such as Millet might have been able to imbue with the requisite syrupy drama. If Millet—a great artist, though not in Corot's league—had painted *The Evening Star,* he would have shown us why this woman is reaching toward the stars in a gesture halfway between hope and resignation. There would be a dramatic engine that focused the work. Corot is too refined—and too modern—to want to tell that story. He depends on his finely calibrated values to hold together the five-foot-wide painting. I understand what he's trying to do, but the result is a one-note composition that's as static and kitschy as a Maxfield Parrish.

By the 1860s, Corot liked to conceive of a large painting in terms of an end-to-end shimmering opalescence. He may have seen these tone poems—which reject the knock-'em-dead effects of mainstream mid-century taste—as anti-Salon Salon paintings, but their quietness is generally scaled way too big. Corot loses track of the inch-by-inch movements that ought to carry us through the painting; he ends up inventing his own kind of nineteenth-century cliché. Only rarely does he manage to make this idea of an almost evenly inflected immensity work for him, but it certainly clicks in the *Souvenir of Mortefontaine* (1864), in which the small figure of a woman reaching her arms up the trunk of a tree becomes a miraculous image of longing and hope. It is absolutely typical of Corot that this canvas is just over two feet high. In a sense, he's using an idea that goes all the way back to the Roman paintings, where grand scale is evoked through a relatively miniaturized format. And it is absolutely typical of Gary Tinterow's horrible

installation that visitors may miss *Souvenir of Mortefontaine,* in which Corot pre-figures in paint a kind of Debussyan orchestration, because it's nearly crushed by the juggernaut to its right, the ghastly *Impression of Morning* (1855), in which Corot's music turns to Muzak.

By the time you've arrived at the last rooms of the retrospective, where Tinterow has gathered together many of the great figure paintings that poured forth from Corot's easel in the 1860s and 1870s, the show has been overtaken by such a coarse-grained, gaudy Second Empire tone that museumgoers may be hard put to grasp Corot's ineffable emotions. Corot paints a few men—one in armor, another playing a cello—and they're superb, but it's the women who really hold the viewer. They are as innumerable and as beautiful as the maidens on the Parthenon frieze.

Sometimes the model is a sophisticated modern woman, dressed for an afternoon at home. More often she wears a costume that suggests a French or Italian peasant or a gypsy. In some paintings a dark beauty is draped in fabrics from a North African bazaar; in others she wears nothing at all and, reclining in a scrap of landscape, seems to consider the possibility of impersonating a goddess. Corot paints women playing mandolins and women reading and women who have closed their books. He suggests a muse, a sibyl, an allegory of contemplation. And there's a winningly informal feeling about all the make-believe, as if neither Corot nor his models take the role-playing especially seriously. The costumes are worn so casually that you feel they could just as easily be set aside. These women have more important things on their minds. But what? That's the question that holds you.

Corot had painted some beautiful figure studies in Italy in the 1820s and some accomplished though at times slightly stiff portraits back in France. Yet the obsession with the figure that seems to grow and grow in the last decades of his life doesn't exactly come out of the earlier work. What we're

seeing here is one of those profound shifts in appetite or attitude that sometimes overtake people in the middle of their lives. It's almost as if Corot suddenly found himself applying to the painting of the figure all the lyric-realist techniques that he'd developed during his long years as a landscape painter. And in these hundreds of studies of one or another beautiful young woman, he really invents a new kind of landscape. It's a topography of human feeling. In painting, a most concrete medium, mysteries must be spelled out, and the glory of Corot's figures is that they give the human enigma an up-front, unequivocal shape.

The selection of figures in the retrospective is large but by no means definitive, and they're hung with little awareness of the way that the internal scale of one painting can clash with that of the next. The installation doesn't flow. Still, there are so many peerless examples included that you should be able to get a feeling for the infinite variety of Corot's effects. Matisse once observed that Corot was one of those artists who "on each occasion paint the portrait of a hand, a new hand each time." And so he was. He tries all kinds of things, and he almost always succeeds. Certain examples, such as *The Greek Girl* (1870–73), are fully modeled volumes, with a feeling for sculptural form that rivals Leonardo (whose *Mona Lisa* Corot had challenged directly a decade earlier in his *Woman with the Pearl*). Other canvases, such as *A Woman Reading* (1869–70) from the Metropolitan, are almost anti-sculptural; here Corot turns the arms and torso into a series of idiosyncratic arc-like shapes that support the quietly shadowy face. It's in tightly-packed compositions like this *Woman Reading*—as well as in the cityscapes—that Corot prefigures Cubism. Picasso, Braque, and Gris looked at Corot's canvases and saw in his gray and tan and brown structures the prologue to everything that they were doing.

It's the astonishing solidity of the paintings that makes the metaphors click. The particularity allows the poetry to fly. "Who *are* they?" the poet

James Merrill asked about Corot's women in 1960, and we all know the happy bewilderment that he's describing. Merrill would admire Corot: the painter was a Northerner who loved the south and knew how to caress but never puncture the balloon of a big idea. Merrill wonders if Corot's women are "the last of the Lamias? The first patients of Freud?" And they do exist in some never-never land bordered by Keats and Freud. Corot touches on the unfathomable feelings of the bereft. Not included in this retrospective are several marvelously unexpected canvases from 1872, in which Corot brings together two or three of these lost souls in a twilit forest: a mother and daughter, a child on a pony and another woman with a walking stick. In these paintings Corot foreshadows the mysterious presences of Cézanne's *Bathers* and Picasso's *Saltimbanques*, in front of which Rilke wrote the great lines in *The Duino Elegies*, which could also apply to Corot's women (and no doubt inspired Merrill's question): "But tell me, who *are* they, these wanderers, even more transient than we ourselves?"

Looking at Corot's later figures, you sense how deep and secret an affinity he had with these woman. He comes closest to defining the nature of that relationship in the six paintings of a model seated before an easel in the studio, and luckily they're all in the retrospective. The key to these paintings is that Corot allows the model to take *his* place. She may be a visitor, but she's no interloper, and as she sits in the chair that he might have occupied only a moment ago, the distance between artist and model narrows. The studio, which is his home, becomes hers, and they become one.

I wouldn't want to choose among these paintings—each has its particular magnificence—but there are two of which I never tire. One is the version in the National Gallery in Washington, with its infinitely subtle browns. Here the seated woman is enveloped by the geometric complexity of the atelier, with its stove and wall full of pictures and elegant dog. This is Corot's hymn to the joys of everydayness, to the things that he must have

looked forward to seeing each morning when he began to work. In an entirely different vein is the canvas in the Musée d'Orsay. Now it's late in the day, and Corot uses a Caravaggesque play of light to pick out the woman's head, her right arm, a bit of her shoulder, and the upholstered back of a chair. Holding a mandolin, looking not so much at the painting on the easel as off into space, the model is transfixed by that melancholy hour when the light has finally failed. The model in this deep-toned canvas is a dreamer who's vanishing into her dream.

In his studio paintings Corot gave an account of his life in art that is in almost all respects the exact opposite of the story that Courbet told in the immense *The Painter's Studio,* done a decade earlier. In order to create an allegory of his modern life, Courbet believed, he had to resurrect the mural-scale masterpiece, and he nearly succeeded, in a work that includes elegant collectors, a rag picker, and a portrait of Baudelaire and that adds up to the strangest studio party of all time. Of course Courbet's picture is a wonder, but when I think of it in relation to the heart-stopping simplicity of Corot's studio paintings, I can't help but feel that what that notorious revolutionary Courbet has wrought is old-fashionedness incarnate. Courbet insists on placing himself center stage, with the model as a strong—though sensitive—woman standing by her man. Corot pares the allegory down to an incident and then vanishes.

In the last decade of his life, this man who never married was saying that painting is a woman, a woman who is as beautiful and complicated and undefinable as art itself. Gary Tinterow concludes the retrospective on a downbeat note, with three turgid landscapes that span the career, but by then museumgoers have had so many epiphanies that they hardly ought to care. The heroines that Corot painted in his last years have risen out of their century to join the women of Piero, Leonardo, and Watteau in a realm where understatement is the language of the gods. Of course each woman has her

appointed role—Queen, Madonna, Lover, Muse—but these immortal heroines understand that a role is nothing but a pretense. They know what Corot knows, which is that only by refusing to reveal anything will they be able to tell all.

JANUARY 6 & 13, 1997

A SERPENT, A SMILE, A PRAYER

The magisterial exhibition of ancient Cambodian sculpture that is at the National Gallery in Washington this summer begins with a many-headed serpent baring seven pairs of teeth and ends with a beautiful youth kneeling in prayer. What a museumgoer may initially respond to in these images of fury and quietude is their alien power; the serpent dates from the late twelfth or early thirteenth century, the worshipper from the fifteenth or sixteenth century. On reflection, though, the hail-and-farewell placement of such singularly contrasting statues will kick off thoughts of modern-day Cambodia, a country that many have hoped was at last emerging from decades as murderous as any in the annals of mankind. "Sculpture of Angkor and Ancient Cambodia: Millennium of Glory" is presented in darkly colored, subtly lit galleries; it has the dramatic impact of a look into the past that forces us to see the present a little differently. But few at the National Gallery could have imagined how dramatically the meanings of the glowering monsters and enigmatically smiling gods who fill room after room at the museum would resonate, for the simple reason that only somebody with a close knowledge of the Cambodian scene could have even

suspected how rapidly the situation in Phnom Penh was going to darken in the weeks after the exhibition opened.

The serpent sculpture, called a *naga,* is of a variety that is often placed at the entrance of Cambodian temples to signal the passage from the secular world to a sacred place. When the exhibition went up in Washington at the end of June, this many-headed monster felt like a wonderful felicitous touch, because the show was (among other things) a sign that Cambodia was putting behind itself the nightmare of the years between 1975 and 1978, when more than a million people (probably well over one-seventh of the country's population) died at the hands of Pol Pot's Khmer Rouge. The new coalition government, elected in U.N.-sponsored elections in 1993 with a huge voter turnout, was, to say the very least, not without its problems. Because he had the military clout to invalidate the election by force, Hun Sen, whose Cambodian People's Party (formerly the Communist Party) lost the election, was brought into the government as co-prime minister with Prince Norodom Ranariddh. Still, in the last few years Cambodia has experienced some economic improvement and the beginning of a startlingly independent press. Part of the reason the Cambodians sent out this grand horde of sculpture, much of it originally from the great Angkor complex of temples and palaces, was to reinforce a cautious international optimism about Cambodia and to give back something to countries that have been helping Cambodia get back on its feet. The show was first seen in Paris (which also contributed more than a third of the works, from the Musée Guimet) and is scheduled to go on to Japan.

When these ancient Cambodian gods arrived at the National Gallery, they were ambassadors of a rickety but still promising young democracy, a country that the praying youth at the close of the show assured us could only gain in strength. For Americans, the dozens of smiling deities who

filled the galleries might seem like a vision of hope emerging from a maelstrom that we had a hand in creating, especially in 1973, when U.S. planes carpet bombed the country. But now, only a few weeks after the opening, all the meanings are scrambled, if not reversed. Cambodia's coalition government is no more. Hun Sen, who has seized sole control, is rounding up and executing Prince Ranariddh's supporters; and the prince tours the world, begging for help. The *naga*'s defense of the sacred over the profane suddenly seems all pose, almost comic. The smiles of the gods have turned troublingly enigmatic—you're so aware of what they won't reveal. And the praying youth isn't sweetly optimistic but mutely despairing, eternally resigned.

International loan shows, especially ones such as "Sculpture of Angkor and Ancient Cambodia" that involve the transport of a significant proportion of a country's artistic patrimony, can be criticized on a number of counts. Shipping masterworks around the world probably involves far greater risks than most museum people are willing to admit, and the resulting exhibitions, though they are often attendance grabbers, can force unfamiliar images into an environment so alien that only a fraction of their true character comes to the fore. These issues are not irrelevant to the Cambodia show, but unlike so many endeavors of this kind, which are the products of executive decisions by tourist boards and corporate sponsors, this one has an almost frightening urgency. Art that was created some 700 or 800 years ago probably has no direct bearing on current events, but at least there is the possibility that museumgoers who have been touched by the greatest achievements of Cambodian civilization will give some more thought to what the Cambodians are suffering now.

Actually, Cambodian art and architecture have played a part in East-West relations for more than 100 years. In the 1860s Ernest Doudart de Lagrée, the French representative in Cambodia, along with the artist Louis

Delaporte and others, began bringing back to France information about the vast Angkor complex. (Although building at Angkor began in the ninth century, the structures that are best-known today date from the twelfth and thirteenth centuries.) In the years around 1900, the stylized mountain profiles of Khmer architecture, with its epochal bas-reliefs and huge faces smiling down from gates and towers, came to define an alien idea of beauty. Bruno Dagens's richly illustrated study of the Western fascination with Cambodian art, *Angkor: Heart of an Asian Empire,* reproduces the huge reconstructions of Angkor Wat that dominated the French Colonial Expositions of 1922 and 1931. Dagens also shows the lines of luxury cars carrying wealthy tourists from Saigon and Bangkok to the ruins in the '30s, as well as images of Angkor Wat that were used as a backdrop for ads selling everything from refrigerators to guns.

There was more than the pop-chic appeal of exoticism to this early-twentieth-century fascination with the Cambodian classics. In Southeast Asia, where the heaped-on-high elaboration of the architecture was contrasted with the pared-down lyricism of the sculptures of the gods, Europeans discovered something like the polar opposite to the classical Greek idea, which was to use the stripped-down power of the architecture as a striking backdrop for all the animation and complication of an increasingly naturalistic figurative art. Cambodian sculpture had its own kind of serpentine allure. You feel its effect in the drawings that Rodin did of the Royal Cambodian dancers who visited France in 1906. The dancers, whose style was quite evidently descended from the poses of the figures on the reliefs at Angkor Wat, actually performed at Rodin's house in Meudon. In the wash drawings that this last of the Romantic sculptors produced, Rodin is pushing beyond the alienness of first impressions; he's allowing his hand to be propelled by the surprising, off-kilter angles and curves of the Cambodian arabesque.

Through their systematic study of Cambodian sites, French archeologists and students of Sanskrit began to understand the full extent of the Khmer achievement. The Angkor Kingdom was begun by Jayavarman II in 802. He declared himself a *devaraja,* a god-king, and thereby inaugurated a line of rulers who associated themselves with Siva, king of the Hindu gods. The majority of what is today most familiar in the Angkor complex (which covers some forty square miles) was created by Suryavarman II, who built Angkor Wat, and Jayavarman VII, who was responsible for the city of Angkor Thom, which encloses the Bayon, the temple with the smiling faces.

Both Angkor Wat and the Bayon recapitulate the shape of the sacred Mount Meru, with its five peaks, which is the center of the Hindu universe and home of the gods. Surrounded by vast reservoirs (called *barays*) and reaching high into the sky, these man-made mountains, with their congeries of stairs and portals and arcades, impress us immediately as vast allegorical expressions of a primal relationship between earth, water, and air. Kamaleswar Bhattacharya, in an essay for the National Gallery catalog, observes that Cambodian religion is often "monistic, in the sense that it recognizes no duality between God and the world, the world being the manifestation of God." You feel that these temples are the entire world. The Cambodians gave the faraway land of the gods a concrete, here-and-now form.

Such a monumentally ambitious art might not be expected to convey any elusive shades of feeling, but in ancient Cambodia subtlety and grandeur were not irreconcilable. In a room at the center of the exhibition there is a huge, serenely smiling bronze head of the god Vishnu that has a surprisingly intimate allure. Together with the shoulder and two of the original four arms, this immense head (about a yard high) is all that remains of a vast re-

clining figure that once dominated an island in one of the *barays* at Angkor. The bronze was unearthed only in 1936, but we have a description of it from the late thirteenth century, when the Chinese envoy Zhou Daguan, who quite understandably mistook this paradisiacal figure for a Buddha, saw what is in fact Vishnu reclining in cosmic sleep on the serpent Ananta set in one of the *barays,* with water flowing from his navel. Vishnu is seen in the midst of the creation of the world; out of the lotus in his navel will emerge Brahma, or, in another version of the story, Brahma, Siva, and Vishnu himself. This is a religion that, like the art it inspired, is full of repetitions and echoes and trajectories that manage to return to where they began.

From a distance this Vishnu has a dazzling theatrical impact, even though the surface is much abraded and what were probably inlays of precious metals are gone. And as I move closer my impression of the God only becomes richer, more nuanced. Vishnu's head is at an angle; he gazes off, above and beyond us, into the distance. He is completely self-absorbed, but the effect isn't chilling. Quite the reverse, we are fascinated to be catching the divinity off-guard, in a private reverie that it is beyond our power to disturb. The size of the head obviously underscores the fact that Vishnu is different from us, but it also has the effect, something like that of a gigantic close-up in a movie, of creating a mysterious rapport. The scale amplifies the smile that plays across the face. Despite the badly damaged surface, the features are lucidly readable; we feel that we're seeing the God clearly. Vishnu has all the elegant enchantment and otherworldly delicacy of a dreamer in a painting by Watteau. But if Watteau's mysterious figures can only hope for their own happiness, Vishnu's dreams are for the whole world. This Cambodian masterwork carries Watteau's kind of flickering fantasy-shadings into the scale of cosmic myth.

The Khmer smile, which animates Vishnu's face, greets visitors almost everywhere they turn at the National Gallery. That smile appears in bronze

and in sandstone, on Vishnus, Brahmas, Sivas, Buddhas, and any number of other gods and goddesses and dancers and demons. Less tentative than the smile of the kouros figures of sixth-century Greece, less personal than the expression of the Madonna in the great stained-glass window at Chartres, it is a veiled smile—a glimpse of a mystery. Nowadays we tend to associate this smile with the deep inward contentment of Buddhism, a religion that has its origins in the spiritual odyssey of a Nepalese prince, Siddhartha Gautama, who probably died in 483 B.C. But Buddhism was not the official court religion at Angkor until the late twelfth century, and the smiles on many of the faces from Angkor are not those of mortals who achieved bliss but of gods who control man's fate and hold the secrets of the universe.

At Angkor, where the mix of Hindu and Buddhist influences is exceedingly complex, the smiles of the gods often achieve a fascinating intermingling of Buddha's sublime serenity and Vishnu's awe-inspiring knowledge. This smile is apotheosized in the imposing faces that dominate the towers of the Bayon. Pierre Loti, in his book *An Angkor Pilgrim,* recorded in 1912 how the expressions on those faces seemed to change with the weather and the time of day, going from ironic benevolence to peacefulness to pity. There's knowledge behind that smile, and for those of us who do not have that knowledge, there can be unease, too.

Angkor is part of the popular imagination, so much so that museumgoers may find that some of these statues carved half a world away are more immediately appealing to them than many a Madonna by Raphael. By now a vaguely Eastern idea of spirituality may be more familiar to a wide swathe of Americans than the stories in the New Testament. And it's also true that modern art, by declaring its distance from the High Renaissance, has prepared us for Asia, whose artists of course taught modern Europeans a thing or two. Gauguin, one of the most accessible of late-nineteenth-century radicals, drew inspiration from photographs of

the Javanese sculpture of Borobudur, in Indonesia; and from Borobudur to Angkor Wat isn't so far. No wonder that the American museumgoer who knows Gauguin's Tahitian idylls and Hermann Hesse's *Siddhartha* can strike up such an easy acquaintance with the Hindu gods of Cambodia, whose frequently serene demeanor suggests a deep Buddhist coloration. There's a formality to the strict, face-forward symmetry of these gods that can feel foreign, but their smiling aplomb strikes a chord in the contemporary audience, which may be all too quick to mistake this contemplative pose for some kind of post-Freudian bliss.

Helen Ibbitson Jessup, the guest curator who has organized the show for the National Gallery, has worked with the designer Mark Leithauser to create a daringly effective installation. (The other curators are Thierry Zéphir, associated with the Musée Guimet, and Ang Chouléan, an assistant to the Cambodian Minister of State in Charge of the Cultural Patrimony.) Jessup has wisely set freestanding statues in front of reliefs, so that the installation begins to suggest the enveloping experience of seeing Southeast Asian art in its original context. Generally, I do not care for dark walls and dramatic lighting in museums; the cast shadows may obliterate too much detail. This is sometimes a problem here. Yet on balance I prefer this rather souped-up presentation to the chillier, perhaps more museologically correct installation that I recall at the show of Indonesian sculpture at the National Gallery seven years ago. In the later rooms of the Cambodia show there are even some large blow-ups of engravings based on Delaporte's drawings of the temples as they looked in the nineteenth century and of photographs by Kenro Izu of the monuments as they are today, with trees coiled monstrously around the carvings. Some will say that these engravings and photographs have no place here. I would have expected to feel that way. Yet there's something to be said for giving some heat to the presentation; these stirringly romantic images re-

mind us of the tropical context, and of how marvelous these vast monuments look when seen from a considerable distance or a surprisingly close vantage point.

Not everything at the National Gallery derives from the Angkor complex, but Angkor is the fulcrum, the place where, over a period of decades and centuries, Cambodian artists absorbed the lessons of Indian art and went on to create an awesome serenity of their own. Cambodian art and architecture, like that of Indonesia to the south, flows out of and responds to the gigantic achievement of Indian art, which is so much a matter of repetitions and elaborations, of complicated arabesques repeated and adumbrated until they achieve an uncoiling power. Whereas in the Graeco-Roman tradition carved forms are generally regarded as a way to accent relatively uninflected architectural surfaces, in India and Southeast Asia the monumental impact of the architecture is generated out of the overflow of detail. Some would say that it is not in India itself but rather in the great monuments of Borobudur and Angkor Wat that this idea is expressed most perfectly. I haven't seen the red sandstone towers of Angkor, but I have been to Borobudur, and that astonishing experience leaves me willing to believe Helen Jessup when she remarks that although "some of the fabled wonders of the world fail to equal their reputation, Angkor blows its legend away, rendering it a pale shadow of the reality."

Of course, you can't have that experience in Washington. But you can glimpse Cambodia's architectural miracle in two large pediments from Banteay Srei, a relatively small temple located north of Angkor proper. Banteay Srei, which was built by Brahmin priests, was never connected with the cult of the king. With its intimate elegance, it has the special charm of a somewhat private monument created in an overwhelmingly public age—rather like Bernini's Saint Teresa in Rome.

It was to Banteay Srei, one of the jewels of Cambodian art, that André Malraux traveled in 1923, with the object of stealing a number of carvings that he hoped to take back to France. Malraux, his wife Clara, and a friend were caught red-handed in Phnom Penh. They were arrested and charged with trafficking in antiques. Malraux and his friend were tried and given prison sentences, but Clara managed to return to Paris and rallied Malraux's literary friends, who obtained his release. Not one to be embarrassed by his own nefarious deeds, Malraux put much of the experience into *The Royal Way,* the novel he published in 1930. He has the dubious honor of being the most distinguished man to be involved in the theft of ancient Cambodian art, but he's far from the only one, and the plundering has certainly not lessened in succeeding decades. You can understand why Cambodians hacked away at the temples in the grim years of Pol Pot's ascendancy, when a head from Angkor might be traded for a bowl of rice; but the adventurers and archeologists and government officials who have stripped historic sites, not to mention the dealers and collectors who receive such material, are another matter entirely.

The two Banteay Srei pediments that are in the National Gallery were removed from the temple site only after it proved impossible to reconstruct the portals on which they sat. One of them is now in the museum in Phnom Penh, the other in the Musée Guimet in Paris. The sandstone panels, each roughly four feet high, are essentially triangular, but with an elaborately carved border that gives the shape an undulating, flame-like complexity. Within these frames, which are masterpieces of a rococo fantasy that is emphasized by the rich, pinkish glow of the stone, unfold stories from the *Mahabharata,* the massive Indian epic that strikes foreigners with its dizzying narrative intricacy.

In both panels, an atmosphere of ceremonial grace that pervades even violent moments is announced by pairs of small flying deities just beneath

the peak of the triangle. Their flung-out arms and legs suggest a flower-like shape that harmonizes with the blossoming-and-flickering spirit of the frame. There are echoes of this same kind of bursting-outward form in the leaping warrior Bhima in one panel and, to a lesser degree, in the devils Sunda and Upasunda in the other. You feel the pressure of conflict in these panels, yet it registers as a dance-like experience that has no specific dramatic narrative. The sculptor has chosen to reveal his meaning not through the particularities of a dramatic confrontation, but through the coursing animation, the swirling fervor. To grasp the effect of a great Cambodian temple, you must imagine these effects multiplied—a hundred-fold at Banteay Srei, a thousand-fold (if not a million-fold) at Angkor Wat.

The result of all this multiplication is what Heinrich Zimmer, in his *Art of Indian Asia,* called a "wondrous life-abundance." The dynamic principle of Cambodian art is this decorative flood, which sweeps up fantastical curlicues, luxuriant plants, sleek animals, elegant dancers, and, in one of the most famous panels at Angkor Wat, a vast panorama of Vishnu churning the sea in the days when the world came into being. When integrated into architecture, these deeply carved reliefs, some of which may look a bit crude when seen close-up in a museum, take on a rich, allusive coloration, a shimmering play of light and dark.

There is something inexorable about this decorative flow, and a part of the appeal of the frequently symmetrical and near-immobile statues of the gods is in the counterpoint that they provide. They give us an interval of rest—a quiet inlet at the edge of the whirling rapids. The Cambodian gods often have a sensuousness that is subtler and more discrete than that of the Indian deities. These Khmer immortals absorb all the tensions that surround them; their stillness has a weight. That is certainly the impact of many of the most hieratic, almost stolid-looking works in the show; I'm thinking of some of the Preah Ko style statues from the ninth century.

These imposing figures may not impress a museumgoer quite as much as a number of the more refined images that appear later on, but you can't deny that statues such as the Siva and Vishnu from the late ninth century have a centered elemental power.

Khmer sculptors regard the human form not as a complicated mechanism but as a singularity, a totality. What matters is the enclosing silhouette; and so the articulation of the musculature is kept to a bare minimum. In the greatest of the statues, it is the sustained line of that silhouette, like a ribbon running through space, that defines and reins in the fullness of the form. The body's outward-pressing impact is present yet somehow veiled. The vehemence of muscular movement is gently enclosed. The two intertwined torsos of the *Wrestlers* (second quarter of the tenth century)— a motif that, with its *Laocoön*-like arrangement of coiled arms and legs, might have interested Michelangelo—in fact suggests a liquidity that is reminiscent of certain effects in Brancusi. The Cambodian gods assert their strength, but they frequently refuse to flaunt it. In one of the most beautiful works in the show, a male deity from the eleventh century (number 65 in the catalog), the gently modeled torso is as subtle as one of those Khmer smiles. And the incised carving that describes the folds of the god's simple cloth wrap gives a welcome bit of specificity. Those crisp creases are like apt bits of punctuation.

At the National Gallery, a museumgoer can appreciate the refinement that Cambodian artists bring to sandstone surfaces, and the aura of equilibrium that the clearest, most uncomplicated volumes exude. But when it comes to the miracle of the grandest, essentially sculptural monuments, such as the small temple of Banteay Srei and the huge Angkor Wat and Bayon, even the knowledgeable observer will be hard put to explain how a near-infinity of separate elements is united to create a totality that has an altogether dif-

ferent kind of power. Angkor Wat and the Bayon are religious architecture of a variety that bursts definitions and categories.

The builders used all the tricks of their trade—everything they knew about form and structure and light and interval—to invent a space with otherworldly resonances. And by bringing divine space into the here and now, they created a transcendent experience that is, incredibly enough, knit into the fabric of human experience. Everybody notices how these monuments have been worn down by time, but what is far more interesting is that their meanings are not diminished so much as transformed. The architecture takes on new implications even as the very idea of the sacred that brought the temples into being fades away.

The ancient Cambodians set out to recreate the sacred world as a palpable reality. That this reality has changed and transmogrified, like everything else in the world, is the most magnificent proof that their labors were not in vain. As intrigued as we are by what Angkor once was, those of us who are not close students of ancient Cambodia are perhaps even more fascinated by what it has become. The immense tree trunks and root systems that overrun doorways and towers and statues, creating a disquieting interweave of nature and culture, have a haunting fascination, perhaps because the red sandstone reliefs seem as much a part of the natural order as the vegetation that threatens to overwhelm them. Those sandstone walls look triumphant even in disarray. And even when Angkor Wat was losing its significance as the center of a cult of the Hindu god-king, it was acquiring a new meaning as the heart of Cambodian Buddhism. Angkor Wat's galleries have at times been full of almost casually heaped Buddhas, some of which draw the pious to prayer even today. In the French photographer Marc Riboud's album, *Angkor: The Serenity of Buddhism,* we see the gatherings of Buddhist monks, with their shaved heads and ascetic mien, still eating and praying and collecting alms in the shadows of these walls that were put up so long ago.

These stones do speak—of Hindu kings, of Buddhist monks, and, now, of the dream of a modern Cambodian democracy. During the darkest days of the '70s, when the world wondered if Angkor would survive at all, it was not only because people feared for its neglect, but perhaps even more because they understood that Pol Pot wanted to obliterate the very sense of history that had fueled interest in these ancient Cambodian monuments. Pol Pot wanted to return to "year zero"—his own brave new world—and in order to accomplish that feat he intended to destroy not only the people who remembered anything, but also the things they might remember. And for those who in recent years have hoped that Cambodia was becoming a place where freedom might flourish, these images of ancient gods and their mountainous retreats are at the heart of what must not be forgotten, of the knowledge of the past that is integral to the life of the mind without which democracy cannot survive.

On July 11, when the *New York Times* ran a photograph of a soldier from Hun Sen's Cambodian People's Party, rifle in hand, guarding Angkor Wat, there could be no doubt that Cambodia, of which Angkor Wat has become such potent a symbol, was again under siege. As for the mystery of how a building that originally honored the absolute power of a god-king could become the emblem of democracy's hope, that is only the most recent question to which the immense faces staring down from the towers of the Bayon have chosen to respond with their enigmatic smiles.

AUGUST 11 & 18, 1997

LATEST AND GREATEST

I have rarely been so happy at a museum show as I was at the exhibition of Georges Braque's late paintings that was at the Menil Collection in Houston over the summer. In the two decades preceding his death in 1963 at the age of 81, this master, who a half century earlier had banded together with Picasso and created Cubism, was taking issue with his own seamless virtuosity. It's fascinating to watch as a supremely accomplished artist reaches way, way beyond what he knows for sure. The series of paintings of the artist's studio, which preoccupied Braque in the late '40s and early '50s, is in many respects his summing-up achievement. These compositions are filled to overflowing with the palettes, brushes, easels, and canvases that must have felt, after all those years, like extensions of his own body, as familiar as his arms, legs, and hands. *Studio VIII* gives off a soft, peach-fuzz, early morning light. The rest of the canvases are mostly dark toned and shadowy, and of these I think the finest are *Studio VI* and *Studio IX.* Braque uses the nocturnal look of the paintings to create a sensation of boundless mystery; it's as if we're seeing the constellations in the night sky.

Many of the *Studios* suggest a burning-the-midnight-oil fever, yet Braque's juxtapositions are so elaborately labyrinthine that the ardor has a slowed-down, valedictory effect. The *Studios* are full of overlapping images and plunging spaces and pictures-within-pictures. They're about unfolding possibilities, and the something-from-next-to-nothing miracle of artistic creation. When the painter and photographer Alexander Liberman wrote about Braque in 1960 in *The Artist in His Studio*, he remarked that visiting this studio was like "standing in a luminous womb," and that is another, universe-in-miniature way of describing the experience of the paintings.

Braque is allowing himself to drift and wander. His movements are such an astonishing mix of deliberation and abandon that I find myself mesmerized and want to follow wherever he leads.

No artist has ever taken greater risks. Braque combines the most ordinary studio paraphernalia with images of birds, one perched on an easel, several others with full, soaring wings. These birds heighten the allegorical drama; we know instinctively that they represent the artist, ready to take off. Braque is exploring his playfully, daringly anarchic impulses—he's flying—and there is an awesome complexity to the way that a taste for fantasy and caprice complicates his passion for beautifully measured effects. Braque remains essentially a still life painter, but he brings such a concentrated attention to the most familiar objects that they acquire a new kind of dramatic presence, at once warmly inviting and eerily bizarre. These late works have their knotty, obtuse passages. They're an old man's aperçus piled high; that's their fascination. Braque is layering impressions to create an allegorical ruckus. The *Studios* are summing-up paintings unlike any others in the history of art, for the reckoning has less to do with putting matters in their proper place than with catching a definitive impression of the whirling, mysterious way that we take in the world.

"Braque: The Late Works" was organized by the English art historian John Golding and created a sensation at the Royal Academy in London last winter. Late style has fashion value in our fin-de-siècle-besotted times, but even so Braque remains a to-the-side kind of towering figure. Although he can satisfy an increasingly widespread craving for endgame dramas, he will disappoint those who think of late style as over-the-top style, and are focused on the hell-bent brushwork of Titian's *Flaying of Marsyas* or the sexual looniness of Picasso's Dionysiac explosions. There are great artists who, as they near the ends of their lives, seem to want to shatter each pictorial problem as they resolve it, and the result is work that achieves a startlingly un-

complicated availability—a peremptory, all-in-one impact. Braque goes pretty far, too, but he goes in a different direction. He is rather like Poussin, in that in his final phase he wants to give an elaborate, almost pedantic attention to the most specialized technical questions. Braque's late work has a veiled impact. He is elaborating mysterious, elusive effects. He is the aged Cubist king, surveying his domain, still meditating on and enshrining the very rules that he's done so much to invert and overturn.

The *Studios,* which filled one of six classically proportioned galleries that provided a grand setting for the show at the Menil, represent only a fraction of what Braque accomplished in the years after World War II. Braque was pushing in many different directions, and, especially after completing the last of the *Studios,* he seemed to want to clear the air, to adopt a spirit of radical simplification in paintings of bouquets, of beaches and fields, and, finally, of birds in flight. Coming near the end of his life, some of those intimately scaled landscapes and monumental birds have the unforgettable brevity of parting glances. In one small picture of a bicycle in the rain (which was not, unfortunately, included in this show), the dashes of rain suggest a tear-stained, final farewell poignancy.

When a great artist is still working at this kind of fever pitch at the end of his life, there is so much accumulated experience going into everything he does that even his tiniest move has a remarkable scale and sweep. In the '50s, when Braque was interviewed by John Richardson, he observed that painting was rather like "reading tea leaves." A part of the glorious complexity of Braque's late work has to do with his being not only the fortune teller who reads the leaves, but also the cook who prepares the brew and the seeker after truth who finds his next move determined by what the tea leaves tell. The somewhat contradictory impulses that come through in the late paintings reflect the personality of an extraordinarily refined man who is also an audaciously free spirit. We recognize this personality from the ear-

lier work, but the familiar elements are now heightened, underlined. Braque wants a palimpsest-like quality, with his youthful, Cubist and even Fauvist adventures echoing, ricocheting, becoming louder as he nears the end.

A number of American critics who wrote about the Braque exhibition while it was in London regretted that the show would not visit New York, the city that still leads taste in America if not the world. I agree. There are many artists in New York who adore Braque's late paintings, but the administrators who book the shows into the museums seem to be allergic to this work. This is not a new situation. In 1982, the Phillips Collection in Washington mounted another magnificent show of late Braque, and it, too, bypassed New York. There is a fundamental mismatch between the artist who summoned up those great dreams that are the *Studios* and the city that prides itself on the fact that it never sleeps. And if we reckon that the restlessness of New York is in some measure a paradigm for the restlessness of late-twentieth-century art, then we can begin to grasp Braque's paradoxical reputation at the end of a century whose art he helped to shape in so many essential ways.

Braque was a man who had his own aristocratic independence, which gave him the confidence to take those definitive steps away from Renaissance perspective at the beginning of the century. But by now, a generation and more after his death, his instinctive indifference to received opinion has turned him into a figure apart. Along with a number of other long-lived pioneers of the first quarter of the century, Braque found his work becoming familiar to the huge public that came to modern art after World War II; but if Picasso, Léger, and Chagall sought popularity and were loved for doing so, Braque earned his patriarchal status while pursuing the narrow intensity of an art designed for an older aristocracy of taste. In the era of the expanding art audience, he did not spurn the public, but he did not court it, either. The

audience loved him, but from afar. They respected the cloistered elegance of his art. They understood that he preferred not to reach out to them, that he expected them to come to him.

Braque works from instinct; he wants to sneak up on his subjects, to dream his way into them. He will muse on a motif as unexceptional as a wrought-iron garden chair in a series of paintings that stretches over a period of years and even decades. But these series have none of the orderly, prepared-to-be-exhibited, almost scientific-minded spirit that we know from Monet's *Haystacks* or *Cathedrals.* Braque is too deeply subjective an artist to ever exactly categorize his impressions. He seems to want to grapple with some initial impression, and that process involves indirectness, watchfulness. He will try to represent a single object—say, a palette—in as many different ways as he can possibly imagine. He pursues his motifs not necessarily until they have reached some clarified form, but until he has satisfied himself. By which time the motif may have nearly dissolved, as is the case in one of his latest and largest landscapes, which focuses on the shadowy, pointillist image of a plow.

Braque's subjects do not explain themselves easily; that is part of their fascination. He seems to be drawn to a particular stretch of land or a particular object without knowing quite why; and the painting becomes his way of finding out. Braque spent much of a decade painting interiors dominated by a billiard table, yet he was at best a casual billiard player and did not own a table. He probably found in the geometry of the billiard game some emblem for painting itself. He may have been aware that Chardin—the key figure in the art of the still life, at least before Cézanne—was the son of a cabinetmaker who built billiard tables for the king. And Braque probably liked the game's aura of masculine aplomb. A man as innately elegant as Braque would have seen billiards as part of a seductive atmosphere that also included comfortable leather chairs, soft evening light, good cigars, and old

Calvados. Braque evokes a whole range of associations without quite bring-ing them into focus; ultimately we're just glad to sink into the artist's con-templative mood.

All the later works have a meditative intensity. Braque lingers over famil-iar objects; he develops his own techniques for evoking the naturalistic daz-zle of ephemeral effects. He's fascinated by the way light glances off variously colored and textured surfaces, and he uses the substance of the paint to de-scribe everything from the softness of a flower to the gleaming hardness of a ceramic vase. In *The Stove* (1942), he becomes almost obsessed with the reflec-tive properties of metal surfaces. Yet his feeling for the representational basics is complicated—and even exploded—by a zeal, at once pragmatic and meta-physical, to see exactly how paint creates an illusion. A kind of now-you-see-it-now-you-don't magicianship had characterized his grandest Cubist paintings in 1912; and in these later decades Braque was enlarging on the drolleries and comic high-wire acts that had been Cubist grace notes, until he defined a new principle of radically naturalistic perception.

In *The Cauldron* (1947–49), Braque isolates the several strokes of precisely differentiated gray that create the highlight on a vase, so that each stroke takes on a freestanding significance—a life of its own. He is simultane-ously creating an illusion and pulling it apart. His handling of paint is al-ways thrillingly unpredictable. In some paintings a piled-high glob of pigment will be set right next to the thinnest, watercolor-like effect. And he uses wild, surprising colors to heighten his put-it-together-and-take-it-apart dramas. In the *Studios,* I see more subtly differentiated grays than I imagined could exist, and the breathtaking fine-tuning of those values be-comes a dimension of the artist's gutsiness. In other still lifes, flower paintings, and landscapes, Braque dreams up hues that fly off the color charts: shocking, zanily lush purples and oranges; light-drenched yellows; weirdly dissonant greens.

Braque is quite obviously deliberating over every move he makes, and it is a kind of deliberation that invites leaps into the unknown. The dissonance between the prosaic character of many of Braque's subjects and the elaborateness of his technique lends the paintings a peculiar gravity. A plain-as-plain-can-be wheat field or an ordinary stretch of beach takes on such powerful personal associations that you feel sure that you will remember it for a lifetime. Looking at these canvases, I feel that I'm going through a slow-motion process of discovery.

From time to time—especially, I think, in the later '50s and early '60s—Braque fails to integrate a composition, and you begin to wonder if his powers aren't declining. A painting called *Composition with Stars* (1954–58), unfamiliar to me, is so overworked yet fragmented that it's hard to look at, and that's uncharacteristic of Braque, who generally rises to the challenge of a loaded motif. The garden chair painting included here, *The Terrace* (1948–61), is fussy and diffuse; but this is a problem of selection, for *The Mauve Garden Chair* (1947–60)—another painting in this series, but one that is not included in the exhibition—is an idiosyncratic masterpiece. Braque remains a really surprising artist right to the end.

In those last years he allows the birds, which had appeared in the '40s as visitors in familiar interior spaces, to take off on their own and fill some fairly big canvases. These are among the oddest and most disquieting of all Braque's paintings. The subject provokes thoughts of soaring freedom, but there is often something terrifyingly earthbound about the compositions, with their heavily worked, hyper-materialized surfaces. Braque's birds are anything but streamlined; this most elegant of artists seems to be taking the risk of awkwardness. The nests that appear in some of the paintings suggest that a new life is beginning, but these nests also force the grown-up birds to stay close to home. Braque is thinking as much about the pull of the earth as the glory of flight.

There could be no better setting for Braque's paintings, which are at once imperious and austere, mystical and matter-of-fact, than the severely elegant galleries of Houston's Menil Collection. Dominique de Menil, who is the guiding intelligence behind this unique American institution, is a collector who knows that the absolute materiality of art can take on a spiritual dimension, and she has created a complex of buildings in which those transformations take place, time and again. Her museum includes beautiful Russian icons and South Seas and African idols (which Braque also collected). Nearby buildings house the Rothko Chapel and (the complex's most recent addition) a Byzantine Cypriot Chapel with remarkable thirteenth-century frescoes. At the Menil you are always aware of that leap into the beyond that some of the greatest art achieves, and in Braque's paintings you find a master of the close-to-home subject who is also one of the century's greatest poets of the impalpable, the evanescent. These are not paintings that you can feel half-way about. You may be made uncomfortable by their stand-alone assurance. But if you like them you will probably love them; and if you love them you may feel, while you are in their presence, that there is no other painter who matters.

I can't remember when I didn't love Braque's late paintings, and on a few occasions I have seen them under perfect conditions. There was the show at the Phillips in 1982, and several installations in France, one of late landscapes at the Léger Museum in Biot and another at the Fondation Maeght in St.-Paul-de-Vence. But I have never seen these latest and greatest of Braques presented as well as they were in the Menil Collection's luminous interiors. Braque's paintings can hardly be appreciated without natural light, and the Menil's ingeniously skylit galleries, which were designed by the architect Renzo Piano, gave Braque's dense and complicated surfaces the delicate natural illumination that is needed to bring out this artist's subtlest shifts in tone and touch. As I rounded a corner into the last

room, which was filled with the paintings of birds, the sun was breaking through a rainy Houston afternoon. A burst of light, streaming through the ceiling's louvered panels, turned this gathering of winged forms into a glimpse of paradise.

<div align="right">OCTOBER 20, 1997</div>

SETTING THE STAGE

At least since the Renaissance, painters, sculptors, writers, composers, and choreographers have fantasized about an art that would unite all the arts, and when these imaginings have come closest to becoming a reality it has generally been within the framing device of the theatrical stage. The theater brings together sight and sound, movement and metaphor; it is a place where all the arts can join forces, at least theoretically, to achieve a single goal. Of course the reality is always more complex, because sometimes talents fail to mesh, or various media prove irreconcilable, or a presiding genius obliterates all collaborators. In retrospect, the riskiness of even the soundest artistic alliances is underscored by their ephemeral nature. What remains after the audience has gone home—whether script, score, costume, set, sketch, memoir, photograph, or video tape—almost inevitably represents the interesting parts rather than the glorious whole. But even these fragments can exert a powerful attraction, for although we know from experience that each art form follows its own logic, our visceral responses to the greatest painting, music, and dance tell us that ultimately there are only a few sky-high places where art can go.

"Design, Dance, and Music of the Ballets Russes, 1909–1929," at the Wadsworth Atheneum in Hartford this fall, was about a time when the fantasy of a unity of the arts felt within reach and maybe, on certain nights in the theaters of Paris and London where Serge Diaghilev's company was performing, actually became a reality. At the end of the nineteenth century, Diaghilev had visited Wagner's Bayreuth almost annually, and two decades later he forged something like Wagner's *Gesamtkunstwerk,* but in the heterodox atmosphere of twentieth-century Paris. The glue that held together the variegated talents of Cocteau, Satie, Picasso, and Massine in *Parade* (1917), or of Derain, Respighi (adapting Rossini), and Massine in *La Boutique Fantasque* (1919), owed much to the star power of the dancers—and to the adrenaline of a sophisticated audience primed for a new experience. Many of the Ballets Russes events that had a strong visual arts component—such as Stravinsky's *Le Chant du rossignol* (1920), with sets by Matisse and choreography by Massine, or *Jack-in-the-Box* (1926), in which Derain and Balanchine worked together—now exist in such fragmentary form that any attempt to assess their success can be counted wishful thinking. And when there is so little concrete evidence, serious reservations that have been raised about the entire enterprise can't exactly be refuted. André Levinson, the greatest dance critic of the period, announced in 1918 that "the fact is the painterly side of a production contradicts drama's basic character and essence: movement, development, dynamics." That was before the major School of Paris painters got really involved. Later, counterarguments were made, as when Cocteau suggested that Braque's sets for *Les Fâcheux* were so dynamic, so full of movement, that they became a kind of choreography that rivaled and eclipsed Nijinska's. Which may of course be another way of describing the failure of a collaboration.

However imperfect many of these collaborations were, there has to be high drama when visual artists of the caliber of Picasso, Matisse, Braque, De-

rain, and Gris devote large amounts of time and energy to the dance. And the Wadsworth Atheneum, which has the finest single collection of material in this field, is surely the place to explore some of the elements that were involved. Much of its treasure trove of designs for costumes, scenery, posters, and programs was purchased in 1933 from Serge Lifar, a Ballets Russes star and Diaghilev's lover for much of the '20s. In recent decades, the Atheneum has further enriched its holdings, especially in costumes. True, the collection is spotty in some areas—it does not, for instance, include any material relating to *Parade,* the work that marked Picasso's debut at the ballet—but there were a few original costumes on display in Hartford that could single-handedly resurrect the temper of an age.

Juan Gris's *Costume for a Herald* comes out of a time when the giddy prosperity of the '20s became a hall of mirrors for artists, with whole lost epochs flashing into view. Gris casts his resurrection of the geometric formality of the Court of Louis XIV in through-the-mists-of-memory tones of mauve, gray, ivory, silver, and gold; he gives the sculptural actuality of the costume, with its crisply delineated panels, a painterly nostalgia. This fancifully dressed-up herald, whose almost absurdly beautiful livery suggests a delicious androgyny, stands at attention, tooting on a golden metal horn. He's a Cubist's version of a Baroque boy toy. And if boy toy sounds like a preposterous way to describe a '20s version of Louis XIV courtliness, remember that the Ballets Russes period was serious about being preposterous, as when Clive Bell remarked that "the inspiration of Jazz is the same as that of the art of the *grand siècle.*"

Working in the midst of a fashionable revival of interest in seventeenth-century costume and especially in the work of Jean Bérain, Gris took the Cubist's feeling for the geometrized universe of Poussin into the theatrical realm and found another area in which to play with a modern idea about the all-too-human appeal of an impersonal kind of order. This costume, al-

though originally designed for Boris Kochno's ballet *Les Tentations de la Bergère,* was actually first used in a pageant that Diaghilev organized at Versailles in 1923. "The theater for which Bérain and his fellows designed costumes," Levinson wrote a little later, "was aloof, abstract, removed to an heroic plane but splendidly human." And that paradoxical spirit, which Cubism had probably prepared twentieth-century Parisians to recognize in seventeenth-century décor, saturates Gris's herald, who is so grave and so adorable.

Alexander Schouvaloff wrote the detailed catalog of the collection, which has just been published by Yale. (The show was organized by three curators in Hartford.) Acting as archeologist and historian, he has produced entries of great sensitivity on work that ranges from a late version of the Léon Bakst costume that Nijinsky had originally worn for *Le Spectre de la rose* (1911), to Bakst's costumes for Diaghilev's legendary 1921 production of *The Sleeping Beauty* (called *The Sleeping Princess*), to André Derain's designs for *Jack-in-the-Box.* Yet no show could do justice to the multiple factors that underlay this period of intense (and often far from effective) collaborations. The basic plot, though, is simple. Diaghilev gradually shifted from productions based on the design talents of his Russian compatriots, especially Alexandre Benois and Léon Bakst, to an increased involvement with School of Paris painters, for many of whom he provided their first involvement with the theater. Behind this bare outline, there is the more complicated story of how Diaghilev made the one-act ballet, with its fully integrated vision of dance, music, and design, into the model for theatrical dancing in the West.

For artists such as Matisse, Picasso, and Derain, who had been collapsing illusionistic space in their own work in the years just after 1900, the stage held the fascination of a return to the deep box of air that they had left behind. But for choreographers, the elaboration of the décor could become an inhibition to the dance—sometimes literally so, when costumes restricted

movement. One of the main attractions in Hartford was a group of costumes designed by de Chirico for *Le Bal* (1929), which marked Balanchine's first attempt at choreographing a young-man-meets-fate-at-a-party ballet. You only had to look at these magnificently fantastic inventions, in which de Chirico turns men and women into architectural conceits—bristling with columns and capitals, bursting with his creepy Baroque fecundity—to see what Balanchine was in flight from later on, when he taught New York to expect practice clothes and an undecorated stage.

Everyone agrees that Diaghilev came closest to his dream of a fully integrated theatrical art in his joinings of music and dance, especially in some of his Stravinsky collaborations, which achieved an intricacy, flexibility, and concentration that had few precedents. Diaghilev never joined the visual arts to dance or music with that kind of hand-in-glove intensity; yet he was acting out of the most serious motives when he gambled that he could. Before Diaghilev devoted himself to the ballet, he had a part in introducing a modern approach to painting to Russian eyes with *World of Art,* the magazine that he published in Saint Petersburg. For Diaghilev, painting was a key to dance. One of the gifts he sent to Lifar when he was studying with the ballet master Enrico Cecchetti in Italy was a package of "pamphlets containing reproductions of paintings by about twenty famous artists." In his autobiography, Lifar recalls that later Diaghilev took him to see the Giottos in Padua, where "our two souls met together more than ever in an upsurge toward the Beautiful." It was after seeing the Giottos that Lifar's "destiny was sealed": he would be a commanding presence on the stage.

And if painting could do that for a dancer, why would Diaghilev not have expected that there were things that dancers and choreographers could do for artists, too? In *World of Art,* Diaghilev had said that "paintings either have merit or they don't, regardless of what style they belong to." He was saying that there were certain structural constants, whether a painting

was Rococo, realist, or Postimpressionist. He carried that principle into the theater when he joined forces with Fokine to create ballets that might be Oriental or folkloric or classical in feel but were always guided by an idea of the complete coherence and integrity of everything that the audience would see.

The painters who went to see the Ballets Russes from 1910 onwards, and it seems that all of them did, may initially have been struck less by Diaghilev's deep visual culture than by his ability to give a theatrical spin to some of their recent discoveries. The green and orange color scheme of *Schéhérazade* (1911) may have revolutionized Parisian taste in fashion and interior décor, but painters were well aware that Bakst's Eastern—or "barbaric"—palette would have been unimaginable if the Fauves hadn't put such colors in their paintings half a decade earlier. Picasso (according to Stravinsky) called *Schéhérazade* a masterpiece, but Matisse counted Bakst's schemes arbitrary, an "avalanche of color" that had "no force"—Salon Fauvism. We will probably never know exactly what these artists thought about the ballet before they became directly involved; probably their thoughts were barely formed. By 1913, however, the painters had to be aware that Nijinsky, in his choreography for *L'après-midi d'un faune, Jeux,* and *Le Sacre du Printemps,* was drawing on archaic Greek sculpture, Gauguin's Tahitian compositions, and maybe folk art, as he rethought the basis of figurative expression. And at that point, there was no longer a question of theater people borrowing effects from painters. Now painters and dancers were digging together down to the foundations of Western art.

The argument that Picasso and the rest of them were selling out the modern revolution when they took up with Diaghilev was well advanced by 1920, and it has never really gone away. Yet the closer you look at the synergy between the Ballets Russes and the artists, the clearer it becomes that painters of the caliber of Picasso and Matisse were finding in the dance world

a new key to the inner logic of their art. By the time these painters began to work in the theater, they knew they were not going to follow their own most radical revolutions into what seemed to some like the next logical step of pure abstract painting. And dance, a kind of abstraction that was nevertheless centered on the figure, that bedrock of Western art, must have had a deep, instinctive appeal. Dancers and choreographers understood that even the most startling innovations of the Ballets Russes were grounded in old ideas about movement. That feeling of groundedness in tradition would make sense to artists who, after the structural breakthroughs of Fauvism and Analytic Cubism, were thinking that all this would have been impossible without Poussin, Corot, and Cézanne, and that maybe the time was ripe to reexamine these ancestors.

Ballet presented a classical paradigm that couldn't be understood if all you saw were toe shoes and elegant poses. The discipline of the dancer, who submits to the strictest kind of daily regimen in the hope of finally bursting onto the stage as a unique individual, was the perfect metaphor for artistic originality. Classicism in ballet was grounded in the logic of the body. So was classicism in Western painting. The painters saw the connection. After World War I, when Matisse was designing *Le Chant du rossignol* for Diaghilev, he was also entering upon what was arguably to be the closest, most exacting study of the nude in his entire career. He was taking his own kind of daily class.

In 1919, Matisse said, "I want to depict the typical and the universal at the same time." He might have been describing what a dancer does. The mystery of ballet was that an impersonal discipline could reveal personality. Matisse's paintings of the '20s—in which the figure is more and more the form that, through the complexity of its muscular articulation, makes us understand the space—may present a distant analogue to what Balanchine began to do with the body a few years later. And it could be that the riot of

red and green in Matisse's odalisques of the mid-'20s was, among many other things, a comment on *Schéhérazade,* with Nijinsky's uncoiling slave replaced by a voluptuous woman.

In *Picasso Theater,* the best book ever written about the painters and the Ballets Russes, Douglas Cooper says that working with dancers "gave Picasso a unique opportunity to observe the human body in action, to draw freely from live models, and to take note of expressive poses and gestures." Both Matisse and Derain drew from the nude on a more regular basis, yet they were also fascinated by the intensely specialized nature of dance movement. By the early '20s, the idea of dancers as people who create out of the very essence of their being, which is their physicality, seems to have been on painter's minds, at least if we can trust Cocteau. Writing of Braque's décor for *Les Fâcheux,* Cocteau speaks of Braque as if he were a dancer: "He enters naked, an athlete sure of his beauty after twelve years in the stadium. He hides his calculations under firm flesh. He does not show his skeleton, which in an artist must be considered the only offense against modesty."

Picasso, Derain, and Matisse, who for a time were the Big Three of Parisian art, each had a distinct yet overlapping relation to the ballet. Picasso had been there first, and his five Diaghilev commissions probably had the most lasting impact on popular perceptions of the modern artist and the ballet. Yet it may have been André Derain, in the clarity and the sheer craft of his work, who suggested that a large pictorial imagination could achieve theatrical professionalism. In his own work Derain had already explored a vast range of historical styles, and as the Parisian master who had the deepest commitment to stylistic pluralism as a modern revelation, he was instinctively attracted to the kaleidoscopic nature of a Ballets Russes kind of theatrical imagination. Picasso and Derain immersed themselves in the theater. In his book *The Diaghilev Ballet in London,* Cyril Beaumont recounts that Derain

would create little drawings of faces, which the dancers kept in their dressing rooms to use in putting on their makeup. At the premier of Le Tricorne, Picasso appeared on stage "accompanied by a stage-hand carrying a tray of grease paint," and the great Spaniard did some of the dancer's makeup himself; the face was a new canvas.

In Picasso's, Matisse's, and Derain's encounters with the Ballets Russes you see different kinds of classicism. Picasso's is ironic and historicist, a matter not of essences but of surfaces. For Picasso at the time of Parade, as Douglas Cooper explains, stagecraft was a way of dealing with "the connection between Cubist reality, visible reality and the accepted pictorial reality of the naturalistic illusion." The curtain that Picasso painted for Parade, a naively classical scene of circus people at a table, inaugurated a whole tradition of Ballets Russes curtains that raised illusion-and-reality questions even before the action had begun. These painted curtains were hidden behind the ordinary theatrical curtains while the audience was coming into the theater. As the music began, the first curtain went up, revealing another curtain, which, in the case of Parade, was almost but not quite traditionally illusionistic. And then that curtain was raised to reveal the paradox of a world that was three-dimensional, but not necessarily in a normatively naturalistic way.

For Picasso, ballet was a déjà-vu-all-over-again experience, since the Spaniard, now well into middle age, was seeing phantoms of the circus performers of his already phantom-like Rose Period, but phantoms grown worldly, complicated, ironic, dangerously ambitious. Once the boys and girls and old men had made up a ragtag troupe seen at dusk on a tiny square in Montmartre. Now the old man was Picasso's not-so-old friend Diaghilev, and Picasso had married one of the girls, who was named Olga, and the boys standing at the bar were self-conscious young men who knew everything there was to know and then some. No wonder there's such a now-you-see-

it-now-you-don't ambiguity to the Ingresque line that Picasso uses to draw portraits of Stravinsky, Diaghilev, Massine, Bakst, Cocteau, and Satie.

As for Matisse's classicism, it is more abstract than Picasso's, closer in some respects to the root-cause Neoclassicism that Stravinsky and Balanchine would consolidate with *Apollon Musagète* in 1928. Matisse's pale décor for *Le Chant du rossignol* evoked not only a misty chinoiserie but also the silver and ivory universe of the nineteenth-century ballet. On display at Hartford was the famous pencil sketch for the curtain, with its chinoiserie dogs, and a costume for a chamberlain, of thin satin material with delicate flowers painted by Matisse himself. Matisse was a far more private personality than either Picasso or Derain, so it's not really a surprise that after *Le Chant du rossignol* he designed only once more for the stage. For *Rouge et Noir*, the 1939 ballet with choreography by Massine and music by Shostakovich, Matisse created some dazzlingly hard-edged costumes and décor and reportedly scored an enormous success. The ballet, about a cosmic battle between material and spiritual forces, must have made perfect sense to Matisse, who in the late '30s wanted to give stripped-down forms an explosive impact. He was reaching for the kinds of effects that we know from nonobjective art— from Brancusi, Arp, and Mondrian—and the cutout techniques that he used originally for some of the costumes for *Le Chant du rossignol* and then incorporated in his work for *Rouge et Noir* herald the paper cutouts of his last years. But then all of Matisse's ballet designs have a distilled power that prefigures his last and grandest meditation on a drama that takes place in real time and space: the Chapel of the Rosary at Vence.

Picasso's classicism is layered and evasive. Matisse's is abstract and speculative. As for Derain, he's a pragmatic Classicist. His studies for the *Jack-in-the-Box* costumes, with their flat folk-art color, may strike us as having little to do with ballet tradition. A moment later, though, we realize that Derain is that rarest of artists who has actually thought about his designs

in terms of the arm, hand, leg, and foot placements of classical dance. De-rain was a man of paradoxes. He valued equally surface and structure, fantasy and reality; and in the theater his paradoxes could work, because here paradox was an everyday reality. *Jack-in-the-Box*, the second of his Diaghilev ballets, had only a handful of performances, but *La Boutique Fantasque* was one of the most enduring works of Diaghilev's career, a creation with choreography by Massine and music arranged by Respighi after late piano pieces by Rossini that could still look "as fresh as ever" to Edwin Denby in 1939. *La Boutique Fantasque* is set in a toy shop in a resort town at the edge of the Mediterranean. The time is 1865. It is a fantasy about dolls that rebel against the shoppers who are going to buy them and then separate them. All of this is the occasion for a series of character dances—a tarantella, a cancan, and so on. *La Boutique Fantasque* is Victoriana honed until its quirks become essences.

To theatergoers after the war, Derain offered the style of their grandparents' youth as a particular past that was also every past—a hilariously wonderful lost world. The key is intensification through impersonalization. Dolls are simplified people. The dances are standard numbers, instantly recognizable. Respighi adapted Rossini's late piano pieces, *Les Petits Riens,* which are the tiniest bits of music. The backdrop, a view of a bucolic Mediterranean port with a paddle wheel boat, is the essence of a painting—painting reduced to the basic information, a distillation of every scene of the south. The studies that have survived bring to mind Stravinsky's saying that when he and Picasso were in Naples in 1917, "we both had a passion for old gouaches showing views of Naples or typical Neapolitan scenes, and on our many walks we raided the junk-shops in search of these." And this, in turn, recalls Gertrude Stein's remark, in her essay "Pictures": "I like to look at anything painted in oil on a flat surface. . . . I like a false window or vista painted on a house as they do so much in Italy."

In the souvenir program for the London season in 1919, Diaghilev praised Derain as "a renovator of the purest French classical painting" and observed that "to the bacchanalian splendor of the Russian decorators he has opposed the classic harmony of color." If you read accounts by Adrian Stokes in his *Russian Ballets,* or by Clive Bell, reporting in July 1919, in the pages of the *New Republic,* you realize that this décor was just one element in the expansive classical spirit of *La Boutique Fantasque.* What is most fascinating about Bell's observations is that he not only sees a connection between music, choreography, sets, and costumes; he also relates it all to a new kind of dance personality—or impersonality. He writes of Lydia Lopokova, who played one cancan dancer (Massine was the other), that she "is as little concerned with telling the public about herself as a painter, a poet or a musician should be. In that sense she is impersonal. But, of course, she is personal too; all artists are." (In the same year, T. S. Eliot, in his essay "Tradition and the Individual Talent," was suggesting that impersonality was an artistic ideal.) Lopokova is not an actress in the extrovert sense, like Karsavina, a dancer whom Bell had first seen half a decade earlier. Lopokova does not "express [herself] directly to the public." She "transmute[s] personality into something more precious." She pours herself "into works of art from which the public may deduce what it can." She is as impersonal—as charming, as quintessential—as Rossini's music, Massine's dances, Derain's Mediterranean vista.

Organizers of exhibitions of old costumes and sets are sometimes put in the curious position of emphasizing the least successful productions, since those are the ones from which the most material survives. When ballets are repeated over and over, sets and costumes get used up—they just disappear. The costumes for *The Sleeping Princess,* however, which was a financial disaster in London, are still resplendent. Preparatory studies and later reconstruc-

tions can fill in the picture, but any show of this kind will give a skewed idea of what audiences actually saw. And there was another problem at Hartford. Since the core of the collection came from Lifar—who acquired much of it from Diaghilev or his heirs—the exhibit reflected Lifar's workhorse view of the Ballets Russes, rather than the more overtly experimental spirits of Nijinsky, Stravinsky, Picasso, and Balanchine.

Thus the cover of the catalog shows Paul Colin's study for a poster of Lifar as the Violin in *L'Orchestra en Liberté,* which was mounted in 1931, two years after Diaghilev's death. This flimsy design suggests that School of Paris décor was already slipping into decadence. Yet two years later Derain was again engaged in immensely fertile collaborations with Balanchine, for Les Ballets 1933. To understand the trajectory of dance and décor after Diaghilev, you have to look to Balanchine, Diaghilev's last choreographer. He was not a strong presence in the show, but he is a kind of mythical figure in the history of the Wadsworth Atheneum. The Lifar collection was acquired for the museum by A. Everett ("Chick") Austin, who was director between 1927 and 1945, when this oldest of American museums was the country's premier showcase not only for modern art but for music and dance as well. It was a place, in short, where you could feel the Diaghilevian unity of the arts at work. It was Austin who, in 1933, not only bought the Lifar collection but also, together with his fellow Harvard graduate, Lincoln Kirstein, helped to bring Balanchine from Europe to Hartford, where he had first hoped to create the school and the company that would later become New York's greatest cultural institutions.

Balanchine was a behind-the-scenes figure in the show. He's the man who had to contend with a lot of the later School of Paris décor, some of which was truly overbearing. But he also seems to have found in Derain's transcendent professionalism—they worked together four times—a parallel to his own evolving method. Derain gave a lightness, a buoyancy, a clar-

ity of contour to the stage picture, which was perfect for Balanchine. During some of the earliest seasons in New York, Balanchine used Derain's costumes for *Les Songes* (1933). And *La Boutique Fantasque* was part of a Victorian-revival element in Ballets Russes décor that had echoes years later at New York City Ballet—in *The Nutcracker* and *Harlequinade,* though the transcendent silliness of Derain's designs would, in the hands of Horace Armistead and Rouben Ter-Arutunian, become merely adequate. But that was probably how Balanchine wanted it. In America he continued, at least for a time, to collaborate with only one visual artist from Ballets Russes days. This was Pavel Tchelitchew, who had designed *Ode* for Diaghilev (with choreography by Massine) in 1928.

Although Tchelitchew barely figures in the Hartford show, he loomed large at the Atheneum in Austin's day, when some believed that Neoromanticism was the next step after modernism. In 1936, Austin commissioned him to decorate the museums inner court for a Paper Ball which has gone down in high-bohemian party legend. Tchelitchew designed costumes for Austin and his wife to wear to the ball: a cancan dancer and an elegant equestrian that might be described as sub-Derain. Tchelitchew, of course, was a hero of Kirstein's, who once described the Russian's décor for the 1942 production of *Apollon Musagète* as that of "a contemporary Poussin." Yet when it came to describing the origins of classicism, nothing less than the truth would do. Although Picasso was never one of Kirstein's favorites, Kirstein argued, in his chronicle of the New York City Ballet, that the "neoclassic turnabout" of *Apollon* was a reaffirmation of "the importance of classicism . . . that had already been proclaimed by Picasso's renunciation of Cubism and his attraction to Pompeian wall painting."

The artists who collaborated with Balanchine in his early years in America tended to be Neoromantics such as Tchelitchew and Christian Bérard, who posed no great threat to the conventions of the theater, since their en-

tire feeling for art and illusion was derived from the stage. Speaking of Tchelitchew, Kirstein pointed out that his décor for *Ode* "used light instead of paint" and that his design for Balanchine's 1936 production of Gluck's *Orfeo* at the Metropolitan Opera "was conceived without an element of paint." This may have been theatrical genius, but for a painter it also amounted to setting aside his most essential tools, and it had little to do with the meeting of minds that Diaghilev had hoped for in his glory days. Perhaps Edwin Denby was thinking along these lines when, recalling art in New York in the '30s, he observed that "downtown everybody loved Picasso then, and why not. . . . For myself, something in his steady wide light reminded me then of the light in the streets and lofts we lived in. At that time Tchelitchew was the uptown master, and he had a flickering light."

Ultimately, it was a steady wide light that dominated the stage of the New York City Ballet, though Picasso was nowhere in evidence. Although the artists downtown were going to the ballet, they would have no role backstage. If Denby never stopped believing, as he wrote in the '40s, that "a ballet set has to stand up under steady scrutiny almost as an easel painting does," he would mostly have had to go to modern dance collaborations, especially Alex Katz's work with Paul Taylor, to see that idea put to the test. Isamu Noguchi, a longtime collaborator of Martha Graham's, did do the designs for the Balanchine-Stravinsky *Orpheus* in 1948. Robert Rauschenberg's dappled sets for Merce Cunningham's *Summerspace* appeared in a New York City Ballet revival in 1966. Yet Kirstein was determined to make the case against the unity of the arts, and to make it in no uncertain terms. In *Nijinsky Dancing,* he delivered these epigrammatic rulings: "An ideal partnership of all the arts is an imaginary concept that remains mythical in theatrical practice." "There is a pious fallacy that Diaghilev was a master commanding or adjudicating collaboration. Actually, he was a genius at improvisation with the available talent." "The Wagnerian formula of com-

plete art was efficient propaganda to promote conditions under which the composer-producer might reign supreme."

Kirstein was not wrong. Still, there had been a time when audiences in London and Paris had not been mistaken in believing that Picasso, Matisse, and Derain were engaged in a true partnership with choreographers, dancers, and musicians. Of course the New York School lacked artists on the Olympian scale of those School of Paris masters. But it must have occurred to Denby that the black-and-white paintings that his good friend de Kooning was doing in the late '40s would have been the perfect backdrops for Balanchine's new black-and-white leotard ballets. As for Balanchine, he had been there, done that, and would now, as Kirstein put it, "reign supreme."

JANUARY 5 & 12, 1998

ACROPOLIS NOW

I

The Getty Center, in the Santa Monica foothills with all of Los Angeles at its feet, may be the biggest cultural complex to open in this country since the Lincoln Center for the Performing Arts, and damned if it's not another heap of travertine. Richard Meier, who designed this good-taste extravaganza, doesn't go in for classical colonnades in the manner of Lincoln Center, where resurrecting Rome's Capitoline Hill was once presented as the latest in urban renewal, but there are plenty of old-meets-new metaphors at the Getty Center. This is an acropolis with a multilevel parking lot. The people at the Getty Trust made a spectacle of their hubris when they looked to

Greece for a guiding architectural metaphor. Still, you can't wonder that they had Athens on their minds. This union of museum, library, and research facilities is about the importance of elite art in a democratic society, which brings you to the four-billion-dollar question (that's roughly the size of the Getty's endowment). How does an institution, even with all the money in the world, go about nurturing something as mysterious as peoples' feelings about art? Obviously, the Getty Trust doesn't have all the answers, but they sure are thinking big thoughts and spending big bucks, and already you can see that their successes and their failures are going to be scaled to match.

For Richard Meier, the Getty is the biggest architectural commission of his lifetime; it is probably also the biggest commission that anybody has received in our time. Meier has an eye for drop-dead elegant detailing and interestingly elaborated asymmetrical facades, and the Getty's bottomless coffers have allowed him to indulge his every High Modern whim. What he has brought to the project is the aplomb of an international award-winning architect, a way of regarding modernism as a deluxe signature style that gives the Getty the all's-well-in-the-world shimmer that Harold Williams, who was president and chief executive of the trust during the thirteen years that the center was being built, obviously had in mind.

Meier is unable to conceive of large spaces in terms of the experiences of the people who are moving through them, but the powers at the Getty are making the best of this colossal failure of architectural vision. Although Meier's grids and circles and skylights are nothing but two-dimensional drawing-board conceits, they have an ad-campaign efficiency that seems to satisfy people, at least amid the center's opening brouhaha. When I visited the Getty in December, Los Angeles was smogless and the views from Meier's terraces and through his plate glass windows stretched spectacularly from the snowcapped San Gabriel Mountains to the sparkling Pacific.

Every one of the Getty's half dozen buildings was primed for a photo shoot. This is not architecture that pulls you in. It's a stand-offish kind of architecture. The buildings are there to pose, to vamp, to take their close-ups, Mr. Meier.

Set in the city that has built a multibillion-dollar entertainment industry out of the certainty that the public is never wrong, the Getty Trust may feel some embarrassment about its sworn goal, which is to teach people a thing or two. Museumgoers by and large want a cultural experience to go down easy, and that is where Meier comes in, with his sleek effects. High-end architectural projects have built-in powers of persuasion, so it's no surprise that the Getty had become an icon even before the public arrived. I suppose this is a case of the richest arts organization in America inventing its own reality. Art is supposed to create its own truth, of course; and there are certainly curators, scholars, and educators at the Getty who know something about that process. Under the direction of John Walsh, the museum has acquired a small selection of masterworks that prove the point. But when it comes to the devilishly complicated question of how best to present art to the public—and of whose reality art is, anyway—there are major disagreements, and the Getty can't help but send in its own specially trained Taste Police.

The Getty Center opens at a time when museumgoing is more of a national pastime than ever before, and with the Getty's parking lots already booked well into the spring, there can be no doubt that it is reaping the benefits. The Getty, though, is much more than a museum. The trust's commitments to elementary-school art education, to conservation worldwide, and to advanced art historical studies have a particular urgency now. The whole question of public support for the arts is in a tailspin of confusion, provoked by the NEA controversies and then deepened by a decline in corporate and public spending in the 1990s. The Getty is asking what people

should see and learn—and when, and why. The problem with these questions isn't so much that there are no simple answers, although that's surely the case, but that the most important answers are almost ineffable. Who's to say why Rembrandt's *Saint Bartholomew,* one of the greatest paintings in the collection, becomes a big experience for one visitor and not another? And how do you measure the success of a program that a hundred school children attend, when the best imaginable result would be that it changes a single kid's life?

Ada Louise Huxtable, the critic who was involved in the initial architectural selection process at the Getty, has produced an essay for *Making Architecture: the Getty Center,* an in-house publication, in which she argues for Meier's buildings. She believes that Meier has indeed given complex ideas of beauty a public face. "In a democracy," she writes, "excellence is supposed to be available to all." At a time when "excellence has been redefined as privilege" by politically correct thinking, Huxtable pleads for the seriousness of the Getty's attempt to reverse the trend. Broadly speaking, she is not wrong. But she is writing for the defense, and so she may give the Getty's approach more credit for depth than it deserves. Meier, Williams, Walsh, and everybody else involved with the Getty like to emphasize how many thousands of meetings they have all had, as if excellence has something to do with teamwork and consensus. Huxtable glides right past the thought that the problem-solving models of corporate culture, which seem to have a lot to do with how the Getty operates, might be responsible for turning "excellence" into a blandly correct label. It's too easy to blame the PC baddies for everything that goes wrong with culture, especially when the self-proclaimed defenders of the best that high culture has to offer are on a slick marketing campaign of their own.

Lampposts along the boulevards and avenues of Los Angeles have been hung with banners announcing "Your Getty Center." And if you can't resist

the thought that this we-are-all-one view of museumgoing has a philistine edge, I don't blame you. Perhaps the people at the Getty sometimes adopt this philistine-lite attitude because they're uncomfortable with the gap between their populist aspirations and the old modern faith in art as an exhilaratingly complicated private experience. By focusing some of its collecting energies on intimate works such as illuminated manuscripts, drawings, photographs, and cabinet-scaled paintings and bronzes, the Getty has emphasized the value of one-on-one experience. Yet even as the center was opening, Barry Munitz, the incoming president and CEO of the trust, was saying that part of what he brings to the Getty from his previous job as chancellor of the California State University system is the experience of working in "a large public institution whose mission is socio-economic mobility, urban outreach, global transformation."

I'm not sure that's quite what Huxtable has in mind. Yet Munitz has also said that "we live in . . . an uncivil age," and that "mass communication makes it worse, technology in many ways makes it worse." He's probably wondering what the person who comes to the Getty after seeing the banners on Wilshire Boulevard is going to think about the illuminations in a Byzantine manuscript of the New Testament. Those illuminated manuscripts are one of the glories of the collection, but they are almost certainly not what the public is coming to see. Can the folks at the Getty live with this paradox? Will they try to deny it? Will they try to do something about it? And what might that be?

II

Approaching the Getty Center along the San Diego Freeway, my first impression was that the buildings sit too high on their mountaintop—that there is something essentially artificial about the design. Reading *Building the*

Getty, the book that Richard Meier has published about his thirteen-year campaign, you begin to see why this might be. The Getty has treated that hill like a piece of silly putty, moving earth around to make a more artfully shaped mountain or to accommodate the demands of litigious neighbors, all the while honoring an agreement with the local homeowners association that not a teaspoonful of dirt could leave the site.

Once you have parked your car and taken the couple-of-minute tram ride up the hill, you are confronted with such a labyrinth of staircases and plazas and balconies and parapets that you may not have the faintest idea where earth ends and architecture begins. That may be Meier's idea of seamlessness, but the site is so enveloped with architectural frills that it ends up feeling like the bionic peak. Meier can't miss with those eye-filling vistas, yet he rarely frames them with the assured simplicity that they deserve. The profiles of many of the buildings are so complicated that they fight the landscape. Occasionally, though, Meier pulls everything together. At the south end of the site, you are confronted by a simple rectangular portal, between two pavilions of the museum, that gives the illusion of opening into thin air, and then leads to a wonderful long parapet, from which you can look across to the ocean or down to an elegant cactus garden.

Meier has created half a dozen autonomous yet interrelated structures: the museum (which itself consists of five pavilions set around a plaza), the Research Institute, a building that combines the education and conservation departments, an administration building, an auditorium, and a restaurant. He must have wanted to give this ensemble the variousness that you have at the Acropolis, where structures built over a century of rapid architectural change are provocatively juxtaposed. Southern California is a place where Mediterranean allusions come to mind naturally. One precursor of the Getty is the Huntington Library in nearby San Marino, where separate library and gallery buildings are set in a fine Italianate setting with plunging

vistas. The Getty is currently renovating its old home, a Roman-style villa in Malibu, where the classical collections are slated to be reinstalled in 2001. To be sure, Meier does not use classical forms, but his reruns of the International Style are themselves a kind of establishment classicism, and in the various buildings he mingles rectilinear grids and circles and cylinders as if they were his personal version of the classical orders.

Meier wants each building to contain echoes of the others. The most obvious consistency is in materials. A play of light beige metal and rough travertine unifies the surfaces of all the buildings and gives the center its picture-perfect, milk-and-honey skin. Meier has produced at least one reasonably successful building, the center for conservation and education, at the northeast end. Here the strong horizontal impact of the exterior, complicated by a series of elegant grids, is set against the edge of the mountain in a way that recalls the sleek California modernism of Richard Neutra and Rudolph Schindler. Yet this is not a building that becomes more exciting as you move inside, since the interior office spaces fail to produce the kind of inside-outside expansiveness that the exterior has led you to hope for.

The name of Frank Lloyd Wright has been invoked by Meier and others, sometimes in relation to the cylindrical space that forms the entrance to the museum. What this inert interior has to do with the soaring force of New York's Guggenheim, I can't say. Meier's entrance is more like a prefab grain silo with lots of cutouts. Scattered around the museum are Meier-designed furnishings and bookstalls that suggest a Wright-inspired arts-and-craftsy mood. (Or maybe the inspiration is Greene and Greene, whose greatest surviving house is in Pasadena.) But this is just trimming. Nowhere at the Getty does Meier make even a stab at the kind of part-to-whole rhythmic conviction that is Wright's glory. If California offers a precedent for the sort of vast civic scheme that Meier has attempted in Los Angeles, it is Wright's Marin County Civic Center, which has a lyric monumentality that reacts to and

reinvents the landscape. Meier's problem is that he cannot compose in time and space; his architecture works only in coffee-table books. The museum's entrance rotunda should expand on the human scale and get your eyes moving, so that you're prepared for what you're going to see in the galleries. Meier's spaces have no flow. There's no gathering force. The courtyard at the heart of the museum is bleak—a Nowheresville.

Meier has strategies aplenty, and for a while a visitor's eyes are kept busy. I enjoyed studying the complicated orchestration of banisters and railings in white or shiny or matte stainless steel. I was beguiled by hyper-refined details, such as the dark marble insets in white marble steps, or the shallow circular bird bath carved into a long stone slab behind the Research Institute. What all these touches suggest is a taste for Mannerist elaboration that lurks beneath Meier's cool facade. Meier has said that one of the first buildings he studied in preparing for the Getty was John Soane's Dulwich Picture Gallery, outside London; and Soane is another classicist with Mannerist tendencies. Meier has learned something from the clarity of the Dulwich galleries, but he doesn't create a flow of spaces that has any of Soane's loopy éclat. The arrangement of the Getty collections in virtually freestanding pavilions creates a confused, stop-and-start museumgoing experience. Ironically enough, it recalls the disastrous 1960s design of the Los Angeles County Museum of Art, a plan that that museum, despite later remodeling, has yet to live down.

Some of Meier's subterranean eclecticism is a good thing. The main picture galleries—which were the result of an elaborate negotiating process between architect, museum officials, and an interior designer—have a refined traditional character that is quite effective. They put me in mind of Louis Kahn. In other areas, Meier evokes the '60s corporate glamour of architectural firms such as Skidmore, Owings & Merrill and Kevin Roche, John Dinkeloo. A luxurious small garden, with verdant ferns and palms,

snuggled next to the administrative offices recalls the Ford Foundation in New York. And a little fountain composed of three jets of water, natural rocks, and travertine walls, near the southeast end of the museum, suggests the kind of thing that Noguchi did for Chase Manhattan. But these are good taste moments, not architectural ideas. For a complex such as this to work, there has to be some immediate, unifying image. You need to feel that all the leitmotifs and variations add up—that the slightest details are linked to the broadest characteristics. If you're looking for that kind of architectural imagination, Meier isn't your man.

Meier and the Getty worked together for thirteen long years, and obviously there were times when everybody felt that this was a marriage made in hell. After seeing the results of the battles that Meier lost, however, I concluded that once the Getty had thrown in their lot with him, they should have let him have his way. A good deal of press attention has been focused on Meier's defeats. The design of the decorative arts galleries was given to the New York architect Thierry Despont, and the commission for the central garden, which Meier was originally slated to do, went to the Environmental artist Robert Irwin. When Irwin's willfully eccentric garden has grown up, its silly anti-Meierian gestures, such as the jagged switchback path and the rusted metal elements, will be muted; but there seems little doubt that Meier's classical Tuscan hillside would have been a better bet. As for Despont's period rooms, they are pure Vegas kitsch, which is probably all you could expect from a decorator who wows computer-age moguls (among them Bill Gates) by proving that the super rich can customize reality.

There is a certain amount of anti-Meier feeling that crops up here and there in the design of the Getty Center. I can understand the sentiment, except that these bits of guerrilla theater don't seem to be about wishing that Meier did what he does better; they seem to be about wishing that he didn't

do this sort of modern thing at all. This bizarre in-house critique culminates in the restaurant, which is one of the most successful buildings on the site, with the cool drama of an Art Deco ocean liner and views to match. Into this lovely space the Getty has invited Alexis Smith, a Los Angeles artist well-known for her campy sensibility, to present some smart-alecky jokes on the theme of taste. Emblazoned over the walls of the restaurant are a cartoon silhouette of Adam and Eve, who took the first taste, along with a Chippendale chair, a classical vase, and a bottle of wine. This creates a sort of demented billboard version of a Greek vase painting. And it is just the warm-up for a direct hit on Meier. On one wall, Smith has surrounded a cartoon of a conventional modern-style living room of the 1950s with big letters that spell out MODERNISIMO and ELEGANTE. Those show-offishly spelled words may point to a problem with Meier's work, but why does an institution that has spent a billion dollars to realize one man's idea of excellence feel the need to parody it? Are they scared to death by the very excellence in which they claim to believe? Or do they know that they're falling short of it?

III

Every move at the Getty has been closely considered, and none more so than the lengths to which John Walsh has gone to isolate the collections that were essentially formed by J. Paul Getty himself, the oil millionaire who founded the museum in the '50s, from the collections that Walsh has built since he arrived at the Getty in 1983. This seems to be the very point of Despont's designs for the decorative arts galleries: to set them apart from the rest of the museum, as if with a Day-Glo red highlighter. We're meant to understand that whatever the unquestionable refinement of the craftsmanship in Getty's eighteenth-century furniture, this work exudes a gaudy

royalist aura that is no longer the museum's style. J. Paul Getty's other major collecting specialty, classical art, is also being fenced off by the current administration. There is a temporary show from the classical collections, but all of it will ultimately be installed in the museum's Roman-style villa in Malibu, which is being renovated for that purpose. By setting the old man's personal obsessions in italics, John Walsh distances himself from this Anglophile's historical-fantasy view of collecting.

Walsh understands that although he has one of the largest budgets in the museum world, the masterpieces necessary to create a world-class survey of European painting and sculpture are no longer available, and so he has wisely opted for a detached connoisseur's approach—an exemplary, not-quite-of-this-world kind of taste. Walsh wants to use Getty's millions to create a hushed, almost monastic vision. He wants a museum with a scholarly mien. He wants to set art in a place apart, where life's passions are diffused, transcended. This is a museum where every detail seems to exude the collective wisdom of countless postdocs. The Getty has the feel, on a rather large scale, of a great university museum. The holdings can be compared far more usefully with those at, say, the Fogg Museum at Harvard than with those at the Metropolitan Museum of Art or the National Gallery. Every selection has a point to make; the art-historical landscape is filled in with carefully selected vignettes.

There is a great deal of perspicacious, enlightened acquisition going on here. The move from Neoclassicism to Romanticism in the late eighteenth and early nineteenth centuries has inspired an especially intelligent group of purchases. In Pierre-Jean David d'Angers's *Mary Robinson,* the suavely severe treatment of the white marble has an erotic pull. The gallery containing this and other Neoclassical sculptures makes one understand why the Getty hoped for so long to acquire Canova's *Three Graces;* it would have capped an ambitious gathering of European meditations on the Greek experience,

which echo the Getty's impressive ancient holdings. The painting galleries contain an Italian landscape by Christen Købke, and several Géricaults, including a fascinating erotic scene with a man and two women in a shadowy alcove bed. And there have been some related decorative arts acquisitions, such as a magnificent, late-eighteenth-century Neapolitan chair with almost Art Nouveau arms, and paneling from a room by the eccentric French Neoclassicist Claude-Nicolas Ledoux, which unfortunately has been given what amounts to a Donald Trump-style installation by the awful Thierry Despont.

When it comes to acquisitions, the Getty goes for the most interesting opportunities, and the museum should be given full credit for the single-mindedness with which it has pursued work of quality even in areas that are not calculated to excite the general public. The Getty has acquired some absolutely extraordinary works on paper. Its very late Cézanne watercolor, a still life with blues and reds of almost Limoges-like depth and brilliance, was one of the highlights of the big Cézanne show in Philadelphia in 1996, and it looks every bit as beautiful in the drawing gallery at the Getty. There is also a magnificent Poussin wash drawing of a screen of trees, with long slim trunks overlapping and mirroring one another to suggest a serpentine dance.

The museum's decision to focus on illuminated manuscripts is especially daring. This is an area of little interest to today's collectors, not to mention the general public. What is now a separate department in the museum was begun with the purchase, in 1983, of the Ludwig Collection. It includes such spectacular items as a twelfth-century New Testament, with images of the four Evangelists on gold grounds that despite their slight dimensions have some of the architectural monumentality of mosaics in the grandest Byzantine churches. Among more recent manuscript acquisitions, I especially admired a mid-fifteenth-century Book of Hours with a stupendous double

page by Jean Fouquet of *Simon de Varie in Prayer Before the Virgin and Child.* This miniature has a transcendent richness, elegance, and clarity. Looking at Fouquet's composition, I feel as if all the tremendous opposing forces of a time in Europe when a chivalric feudalism was giving way to a bourgeois lucidity have been put under the microscope. Fouquet renders the sparkling beauty of the Virgin's dress and Simon de Varie's armor as if these garments were the rarest butterfly's wings.

This Fouquet miniature is one of the greatest paintings in the Getty collection, right up there with Rembrandt's *St. Bartholomew,* Martin Schongauer's *Mother and Child,* and Poussin's *Landscape with a Calm* (which the Getty owns jointly with the Norton Simon). Others will cite Masaccio's *St. Andrew,* Mantegna's *Adoration of the Magi,* and Pontormo's *Portrait of a Halberdier.* Still, we can probably all agree that there is not a single painting in the Getty collection without which we would feel that the history of painting was incomplete—nothing on the order of Bellini's *St. Francis* in the Frick, or El Greco's *View of Toledo* in the Metropolitan, or Titian's *Rape of Europa* in the Gardner. (I'm not sure there is a painting of that order in all of Los Angeles, except, perhaps, the Zurbarán still life at the Norton Simon.) As anybody who has followed the Getty's adventures in the art market over the past decade knows, it is not for want of trying that they do not own such paintings. Such works are simply not to be had. And in their stead, mostly what you find at the Getty is admirable, even excellent, but the kind of thing that in the greatest museums fills up the spaces between the masterpieces.

Still, the Getty does have its stronger and its weaker areas. The seventeenth- and eighteenth-century galleries have a brilliant consistency. A trio of works by Canaletto, Bellotto, and Tiepolo, arranged on one wall, epitomize the virtuoso heights to which painting had risen at the end of the Baroque age. In the later nineteenth-century galleries, though, the focus is not as sharp. The Getty has made some very expensive purchases, such as

the Van Gogh *Iris* and Manet's *Rue Mosnier with Flags,* but taken together these works don't give a very convincing picture of the later part of the century. The Van Gogh is too decorative to suggest his angular, wrenching spirit, and the Manet, although a peerless demonstration of the artist's devil-may-care casualness, doesn't offer even a glimmer of his gonzo, hell-bent ambitions. At the Getty, you get the feeling that later-nineteenth-century French art was getting bogged down in deft small effects, when nothing could be farther from the truth.

The Getty offers other versions of the nineteenth century, in its drawing collection, and in its extraordinary photography department, which began in the 1980s with the purchase of five of the most important private collections in the world. Quite obviously the museum is looking to these photographic holdings to provide a compelling portrait of the transition into the twentieth century, since the museum made a decision in the '80s not to collect twentieth-century paintings, in part because the Trust was worried about spreading thin what was then a much smaller endowment. By now almost everybody who watches the Getty agrees that whether or not the cut-off date of 1900 is maintained in the painting collection, the museum is willy-nilly moving into twentieth-century art. Alexis Smith is one of a number of artists, including Edward Ruscha, who have done commissions for various Getty buildings. The museum's holdings of work by Walker Evans, who is in my opinion the single greatest photographer of this century, are already the subject of a very impressive book and will be featured in an exhibition later this year. And around the time of the opening of the Getty, much attention was being paid to the purchase of David Hockney's huge photo-collage of the California desert, *Pearblossom Hwy, 11–18 April, 1986, No. 2,* which amounts to the museum's most substantial holding in contemporary art. This panoramic photographic work by a contemporary painter keeps from breaking the 1900 cut-off by a technicality.

IV

The twentieth century may be slipping into the Getty by several back doors, but in the painting and sculpture collection, which is by any definition the heart of the museum, the end comes resoundingly—apocalyptically, really—with James Ensor's huge *Christ's Entry into Brussels in 1889* (1888). It is not, strictly speaking, the latest painting in the collection, but Ensor's fourteen-foot-wide canvas, filled to overflowing with the manic ghoul-faces of Mardi Gras revelers, does eclipse everything else in the final gallery of this survey of European painting. Ensor was 28 when he painted his urban freak show, and the luridly rendered faces that fill practically every last inch of canvas, the masked ones and the unmasked ones, seem to be bubbling up from a young man's self-congratulatory paranoia. Ensor is not an artist who will leave well enough alone, and just in case you might miss the point, he has apparently turned the Christ figure, astride a donkey in the middle distance, into a self-portrait. The daylit nightmare becomes an allegory of the woeful mistreatment of the sainted artist in modern times.

This painting is John Walsh's parting shot, and it cannot be ignored. By presenting museumgoers with Ensor's raucously astringent panorama of fin-de-siècle pathologies, Walsh may mean to suggest that the public would not want to venture too far into an artist's view of the modern world. In the 1880s, many painters—among them Van Gogh, Renoir, and Seurat—were fascinated by men and women who lived lives very different from their own. The painter who observed a range of citizens at work and at play could feel an expansive attachment to the most casual acquaintance, but all that Ensor seems to see is the weird otherness of the crowd, which becomes a sea of creepy faces, one more self-absorbed and loutish than the other. This is the Painter of Modern Life with whom the Getty chooses to close the story of art. Could it be that some people at the Getty find a personal significance

in the painting's us-against-them theme? Could *Christ's Entry into Brussels* strike some curators, scholars, and officials as an emblem of the Getty Center's entry into Los Angeles?

Richard Meier's Getty Center completes a cycle of American philanthropy that had its origins around the time that Ensor, an ocean away, was painting his garish, self-congratulatory picture. J. Paul Getty was born in 1892, and the public-spiritedness that his Trust exemplifies today is distantly related to the ideas of Andrew Carnegie, whose money came from steel rather than oil and who was dedicated to public giving along principles that he described in *The Gospel of Wealth and Other Timely Essays,* which appeared in 1889. At the turn of the century, there were young men and women all across the United States who knew that cultural experience was a democratic birthright and a universal desire. You can read some of their stories in the fiction of Willa Cather and Theodore Dreiser. This generation of true believers crowded into the libraries and museums and concert halls that Carnegie and other philanthropists built, and their lives were forever changed. What you discover in Cather's work is that along with artistic illumination could also come tangled feelings of regret, dislocation, and loss, for to go to art was to give yourself over to an experience that you loved precisely because it was so far from ordinary life. The social situation has changed enormously since Cather's day, but the otherness of art is still a force to be reckoned with, even if arts organizations do not—and, indeed, should not—know what to do about it.

In the 1990s, some philanthropies are still building libraries and concert halls and museums, which is good news. The technological developments that you see at the Getty—the computerized information centers adjacent to the museum galleries, and ArtsEdNet, the support system for art teachers that is available on the Web—are in many respects the direct descendent of the educational programs of a hundred years ago. But the expectations

that they arouse may be changing. In a book called *Introduction to Imaging,* published by the Getty in 1996 in order to describe the digital techniques available "to display and link collections around the world," Howard Besser and Jennifer Trant explain that "the potential of reaching audiences across social and economic boundaries blurs the distinction between the privileged few and the general public." I would have thought that in a democracy any member of the general public is given the opportunity to *become* one of the privileged few. That description of blurring distinctions may not represent official policy at the Getty, but it does sound dangerously like dumbing down, and this would not be the first time that the museumgoing public had been sold short.

The Getty Center wears so many hats that it's no wonder that a visitor can come away with impressions of conflict, or at least of contrasting attitudes and styles. Some of these impressions suggest a tension between artistic or scholarly probity and the rabble-rousing unpredictability of the public. But in other instances the unpredictability is that of art itself, which is countered by a scholar's preference—maybe it's really a corporate preference—for logical, quantifiable experiences. Ensor's painting of a Christ-like artist enveloped by the mob comes to mind immediately. So does the sleek and serene travertine complex hovering above the rush-hour pulse of the San Diego Freeway. So does the experience of seeing a painting as emotionally overwhelming as Rembrandt's *St. Bartholomew* in this cool, elegant museum. And with Harold Williams and his perfectionist view of the Getty now being replaced by Barry Munitz, who might just give the Trust a more populist tilt, you have another snapshot to add to the Getty story.

The operating-room sensibility of Richard Meier's architecture is just right for an organization that wants to micromanage every aspect of the public's encounter with art. Is it any surprise that the scholars who have been invited to the Getty Research Institute this year are being asked to re-

flect on "Representing the Passions"? Those considering life's unruly emotions will do so in a group of state-of-the-art offices located in a chaste building surrounded by lemon and olive trees and some of the most beautiful views in the world. Scholars will also be able to study two small shows of items from the Getty's spectacular research collections, both of which focus on chaotic, uncontrollable forces. "Irresistible Decay," about the romance of ruins, is a rather predictable subject. The far more interesting show, organized by Kevin Salatino, is devoted to the history of fireworks, and it is winningly entitled "Incendiary Art." Salatino presents image after image in which crowds gather to watch the elaborately plotted displays that accompanied royal celebrations of births, marriages, and the like, mostly during the seventeenth and eighteenth centuries. These extravaganzas offer the fascination of fire being shaped into art, but in a brilliant catalog Salatino also takes the trouble to point out that the proceedings often fizzled and that the most sophisticated members of the audience were frequently bored.

All art is incendiary—that's the joke of Salatino's title. At the Getty they are playing the role of the director in these ancien-régime celebrations, who fences the pyrotechnics off, who tells the public where to stand and what to see. The Getty's Conservation Institute uses the most advanced scientific methods to stop and even to reverse deterioration in works of art; they have major projects underway in Mexico, in Italy, in China. But conservation is also an area of contemporary museological and archeological studies where there are serious conflicts between high-tech solutions that promise to restore objects to a bright-as-the-reproduction glow and mysterious stylistic questions to which a noninvasive, almost leave-it-as-it-is method may be the wisest response.

At the Getty, they want to make sense of art, so there is an Education Institute that has spent the past decade taking a hard look at the old art-as-self-expression idea. They want to teach school children about traditions

and formal systems; they want to show kids how all the elements go together. This is a nationwide program that encourages museumgoing through techniques as simple as bringing high-quality art reproductions into the classroom. So far so good. But here, too, the Getty may be straining to control what cannot be controlled and to rationalize the experience of art. According to David Perkins (a professor at the Harvard Graduate School of Education who has written one in a series of pamphlets published by the Getty), looking at art provides "an excellent setting for the development of better thinking, for the cultivation of what might be called the art of intelligence." Perkins may be passionate about art, but why does he need to sell it as a way of beefing up kids' brains?

At the Getty you see '90s-style cultural philanthropy putting on its best face, and it turns out to be a high-end corporate package with the requisite politically correct frills. Speaking of Richard Meier's buildings, Harold Williams has written that the Getty wanted architecture that would "be timeless and a work of art in itself." There may be no architect in the world who could have delivered something like that; but considering the bureaucratic hell that Meier went through, his failures must be counted as the Getty's failures, too. What Meier's work lacks is heat, an organic flow. He is trying to strategize and prioritize his way to greatness. And so is the Getty.

Meier's buildings are a case of lofty architectural ambitions run amok. Ada Louise Huxtable is right when she describes the architecture as a metaphor, except that what this contemporary acropolis suggests is the impossibility of creating an organization that will cover every aspect of a person's experience of art, from childhood education to family museumgoing to postdoctoral studies. The departments-within-a-campus arrangement turns out to be a new kind of juggernaut: the wrong temple in the wrong time in the wrong place. And yet there is this to be said for the Getty. If you listen carefully you can hear a shamelessly elitist heart

beating, even through all the layers of that something-for-everybody glass and metal and travertine carapace. When you step inside the galleries of the museum, you are in the presence of the old-time religion of art, and I say more power to it.

<div align="right">JANUARY 26, 1998</div>

BRING IN THE *AMATEURS*

Museum people are feeling cheerfully bewildered as the 1990s come to a close. Attendance figures are climbing, and although nobody really understands why this is happening, everybody seems to agree that there is no end in sight. It's impossible to be surprised by the attention paid to the Gianni Versace retrospective at the Metropolitan Museum of Art in New York this winter, an infomercial for art-and-fashion synergy. But there can still be some amazement at the general interest inspired by an event such as the show of drawings by Filippino Lippi and his fifteenth-century contemporaries, which has attracted reasonable numbers at the Met. By now, museum visitors may be willing to have a look at anything. More than a generation after museumgoing became a hot national pastime, the children of the people who stood in line for hours at the Met in 1961 to see the museum's $2.3 million painting, Rembrandt's *Aristotle Contemplating the Bust of Homer,* are taking their children, and that does say something impressive about cultural diffusion.

But the crowds in the museums can also mask a darker side of the current scene. When I talk to artists and dealers in contemporary art, I often find them reporting a steady erosion in the number of people who are fol-

lowing recent developments in art with any curiosity or avidity. The museum audience may be exploding, but even the minuscule percentage of that audience that you might expect to be seeking out the best new work (which is by no means the most visible contemporary art) appears to be dwindling into nothing. Museum officials are in seventh heaven. Meanwhile, contemporary artists and the dealers who are most concerned with their work are in a quiet panic. The audience that really matters to art may be evaporating—and, when you consider the skyrocketing attendance figures at the museums, the contrast can seem truly bizarre.

Many people will want to argue that the museumgoing and the gallery-going audiences are inevitably going to be as different as night and day. But if you look at history, you will see that for more than 100 years the taste of the museumgoer has been shaped by the visionary reach of the gallerygoer. Artists such as Degas, Renoir, and Monet—the subjects of exhibitions that have packed American museums this season—were originally supported by precisely the kind of small, intensely engaged audience that many artists fear is extinct. Ironically enough, the blockbuster shows of Impressionist work that have dominated museums this past summer and fall have a lot to tell us about how painters once managed, in the face of indifference and even hostility, to reinvent the expressive possibilities of paint and to renew taste. In the catalog of "The Private Collection of Edgar Degas," which was at the Metropolitan, Ann Dumas writes about a breed of men who in the nineteenth century were described as *amateurs* and who seem to have provided a support system for artists—by rejecting consensus thinking, by trusting their own responses.

The whole subject of nineteenth-century taste is immensely complicated. Present-day scholars, confronted by an art market that's always repackaging the cutting edge, are perhaps too inclined to focus on the various ways in which artistic experimentation affects the bottom line. Ann Du-

mas is surely correct in pointing out that by the time the Impressionists were making big money in the last decades of the nineteenth century, there was a powerful aura of nostalgia around the very idea of the *amateur,* who could be seen as the battered symbol of a vanished golden age. Dumas is mostly interested in the wealthier *amateurs,* the ones who built great collections, and she has interesting things to say about how their taste related to that of Degas. Still, if there was a generation of *amateurs* who were, as the painter Jacques-Émile Blanche wrote in 1919, "crushed by the stampede of irresponsible American millionaires or the new industrial aristocracy from Germany and Russia," there was also a spirit to the *amateurs* that had nothing to do with the vagaries of the market. That spirit lived on deep into the twentieth century.

The *amateur* is a make-up-my-own-mind kind of person. Some *amateurs* were aristocrats, and some were primarily focused on the glories of the past; but the independent-mindedness that was their most essential trait was one of the grand expressions of the soaring confidence of middle-class culture. I would define the type broadly. I see its beginnings in the generation that supported Watteau's astonishingly informal style in the early eighteenth century. And long after Degas's friends had passed away, there appeared Peggy Guggenheim and Betty Parsons, *amateurs* who went professional and opened the galleries in New York that gave the Abstract Expressionists their first significant public presence. *Amateurs* probably still exist, here and there, as isolated figures, but I think everybody will agree that their sense of shared purpose has not flourished in recent decades. Economic downsizing and shaken middle-class confidence have played a part, for they have left even people who are still doing just fine with a sense that artistic experience is too risky, too unstable, to absorb a person's attention. The sophisticated public views art as one more product of a rampant consumer culture. They know that caring too much could be seen as terribly uncool, and they are

inclined to leave the decisions about contemporary art to the experts (whose services are yet another high-end consumer product). People still want to look at art, but they don't want to make up their minds for themselves, or take a leap into the unknown. They are content with Andy Warhol's quick-fix model, according to which avant-gardism and blockbusterism are more or less the same thing.

Our biggest problem is that blockbusterdom has become *the* art world model, a model to which there no longer appears to be the kind of countervailing principle that elitism or avant-gardism or a combination of the two has produced for the past several hundred years. There is no longer a small but vocal audience that resists the trumped-up ebullience of Robert Rauschenberg's Guggenheim retrospective or the prepackaged scandal of "Sensation," the show of young British artists that was at the Royal Academy in London this fall. For English critics, "Sensation," which set the latest in porno-kitsch styles amid the fuddy-duddy galleries of the Royal Academy, became a face-off in a hall of mirrors. Whatever you said was just more fodder for an advance-guard-meets-rear-guard happening that had been masterminded by Charles Saatchi, the advertising mogul from whose collection all the work was drawn. When the most extreme adversarial airs fit so neatly into a PR campaign, you can't wonder why even the audience that knows better is going to be too demoralized to go out and look for something better. Many artists believe that they are now confronting the ultimate nightmare—which also happens to be the nightmare that the Impressionists and Postimpressionists confronted. What if an artist makes a breakthrough and there is no one who responds? What if there are a few people who get the point, but nobody in the wider world cares how they feel?

This season, museumgoers were afforded a rare insight into the mysteries of independent taste when they visited the Metropolitan's exhibition of "The Private Collection of Edgar Degas." Degas was a wealthy man who

could indulge on a vast scale the collector's mania that many artists can express only by accumulating the tiniest fragments. Yet the mixture of old and new work that Degas put together, mostly between 1890 and 1904, gave a good sense of the kind of creative tradition-building that always absorbs both artists and the *amateurs* who follow artists' evolving views closely. In the catalog of the show, Ann Dumas observes that Degas's collection of works by his contemporaries and by earlier artists "was not widely known: outside his circle of friends, dealers, and collectors, few knew of its existence." Might it be more accurate to say that Degas's collection was known to everybody who needed to know it, to the small group of artists and *amateurs* who were trying to rethink the history of art in the light of what was going on right there and then?

By joining an impressive group of works by Ingres, that exemplar of academic standards, with paintings by Manet, Cassatt, Gauguin, Cézanne, Van Gogh, and himself, Degas was suggesting an artistic genealogy that broke the stranglehold of official taste. He was showing how the insiders saw the history, and it turned out to be a history in which El Greco became a precursor of Cézanne, and in which Ingres and Delacroix, far from being the Classic-versus-Romantic adversaries that their supporters imagined them to be, were joined in their sense of color and line as expressions of an artist's free-flowing feeling for the power of style. In Degas's collection we see style less tethered to subject matter than heretofore. We see style becoming the transparent expression of artistic personality. It took time for that idea to take hold. It is gestating in Degas's collection, and the mix can become quite complicated, as when Daumier's graphic hyperbole seems to move naturalism one step closer to abstraction. And eventually, in the advancing decades of the twentieth century, as Manet, Cézanne, and Gauguin became almost universally beloved artists, these innovations became the status quo.

By now the Impressionists and Postimpressionists are box office gold, and American museumgoers are deep into a run of shows of their work that is going to extend into the spring and beyond. Many of these are fascinating exhibitions, in which particular aspects of an artist's career are dissected meticulously. Museums are to be applauded for supporting some adventuresome scholarship, though of course everybody knows that administrators wouldn't give a damn if they weren't sure of the public's support. "Renoir's Portraits: Impressions of an Age" is currently at the Kimbell in Fort Worth, after stops in Ottawa and Chicago. "Monet and the Mediterranean" was at the Kimbell last summer and went on to the Brooklyn Museum, where it posted the largest attendance the museum had seen, at least since the Van Gogh retrospective in 1971. At the Metropolitan, "The Private Collection of Edgar Degas" has just closed, but "Degas and the Little Dancer" has opened at the Joslyn Art Museum in Omaha, and the National Gallery, which will mount "Degas at the Races" in April, is also presenting "Manet, Monet and the Gare St. Lazare" (which is currently in Paris) later in the spring, as well as a major Van Gogh retrospective in the fall.

In truth, museumgoers have been pulled up a bit short by some of these shows because they present aspects of Degas, Monet, and Renoir that can be difficult to jibe with the blithe spirits of pop Impressionist legend. What we are seeing this season are the Impressionists of the *amateurs*. These painters experience confusions and uncertainties; they explore blind alleys, and sometimes they move rather slowly. "Monet and the Mediterranean," which focused on several cycles of paintings that Monet did in the South of France and Italy in 1884, 1888, and 1908, was a disappointment for many museumgoers, who came expecting a breezier side of this most famous Impressionist of all.

The show emphasized Monet's doggedness. Over and over again he attacked the same exceedingly pretty but not necessarily compelling motif:

the small Italian seaside town of Bordighera, or the fort of Antibes. Joachim Pissarro (a great-grandson of the artist), who organized the show and wrote its impressive catalog, focused on Monet's nose-to-the-grindstone determination. The show didn't have a seductive pace, yet if you lingered over Monet's considerations and reconsiderations of a motif, you could begin to grasp his enormous difficulties in clearing out all his preconceptions about how nature looked. And only after Monet had wiped the slate clean did he surge forward, into the miraculous purple-and-blue meltdown of the views of the Palazzo Contarini in Venice.

By the second half of the nineteenth century, painting had become such a popular vehicle for conventionalized emotions that even the most independent-minded artist could have a tough time getting back to some bedrock of feeling. Monet and Renoir had to struggle mightily to find new ways of saturating the entire surface of a painting with heady exhilaration. These men lived well into the twentieth century—long enough, indeed, to see many of their innovations turn into new forms of kitsch. But their extraordinary commercial success ought not blind us to the gambles that they had taken or to the desperately hard-won nature of their achievements. Monet found his own truth by maintaining an absolute skepticism about all artistic conventions. While working in Venice, Pissarro tells us, he "apparently only went to one museum (presumably the Accademia), and only with reluctance did he accompany his wife to a Venetian church—on the condition that they not stay too long!" His close friend Renoir had almost the exact opposite approach; for him the lessons of the masters became a virtual obsession, so that he would sometimes bend to tradition with a perverse willfulness. In the 1880s, this supreme master of the feathery, watercolor brushstroke spent years attempting to achieve an Ingresque hardness. It was as if all choices had to be considered—no, embraced—before Renoir could be sure of who he was.

The artist we see in "Renoir's Portraits" takes a zigzag course. Sometimes his work is labored and conventional, at other times almost arbitrary. And then, all of a sudden, he will come through with something so miraculously light and true and deft that you can't believe that he experienced a single conflict in his entire life. There is the whirling couple in *Dance at Bougival* (painted in the 1880s), one of a series of indelible visions of late-nineteenth-century bohemian youth in all their sunstruck, live-for-today glory. And later there are the portraits in which Renoir recaptures—and in certain instances maybe even transcends—Titian. Among the works in this show, I'm thinking in particular of the two portraits of Ambroise Vollard, one in which the dealer plays the supreme *amateur,* examining a small sculpture by Maillol (1908), and one in which he wears a toreador costume (1917). And then there is the portrait of the actress Tilla Durieux (1914). Durieux had the lush, golden looks that Renoir adored, and a radiant artistic intelligence that earned her starring roles in early productions of Shaw, Wilde, Hofmannsthal, Gorky, and Wedekind. She inspired what is probably the greatest of all portraits of an indomitable theatrical spirit. A half century later, Durieux recalled that Renoir had said to her, "I didn't want to paint any more portraits, but I'm glad that I agreed to do yours. I've made some progress, don't you think?"

Renoir's late style, with its massive figures and deep, saturated colors, can strike contemporary viewers as overwrought, but it should be pointed out that both Matisse and Picasso saw in the aging Impressionist's Renaissance recapitulations a very modern kind of density and weight. And if Renoir was able to express the full force of the painterly tradition only after going through a serious consideration of the antipainterly possibility, then perhaps the opening galleries of "The Private Collection of Edgar Degas," with their Classic-versus-Romantic drama, are not so strange after all. Degas wanted to present those apparently opposing impulses through the

work of Ingres and Delacroix as braided-together themes, as linked elements in the nineteenth century's increasing focus on style as abstract value and as the ultimate expression of artistic personality.

Those first several galleries full of works by Ingres and Delacroix, so densely packed with small, often relatively unfamiliar preparatory works, were the most thrilling in this wonderful show; they told you much of what you needed to know to understand Renoir's portrait of Durieux (which is in the Met's collection). Degas had thought of leaving his collection intact, as a museum that would essentially focus on nineteenth-century art, and in the Metropolitan exhibit you could feel the logic of his planned presentation. As the show unfolded, and you realized that Daumier's roiling forms echoed Delacroix's rhythmic self-assurance, and that a magnificent diptych of women bathing by Utamaro was positively Ingresque, you began to enter into Degas's mysteriously cyclical vision of tradition.

Degas was a traditionalist with radical ambitions. Come to think of it, that is probably the only kind of artist worth being at any time in history, and surely today. Degas was radicalizing the past when he grounded his account of the new French painting in Ingres, a director of the French Academy in Rome whose triumphantly idiosyncratic society portraits and nudes were produced almost in spite of his own reverence for an ossified brand of traditional thinking. This approach of Degas's, which assumes that you will see the path to the future only when you have discovered a new perspective on the past, remains more controversial than many visitors to the Metropolitan could possibly have imagined. Ultimately, the artistic revolutions that Degas and his generation ushered in were subsumed in the Dadaist maelstrom, which left many artists and historians believing that the past is nothing but a doormat. And now, painters who want to look back don't find the past ossified so much as evaporated. They are left with the over-

whelming job of resurrecting tradition before they can begin to reshape it or rebel against it.

Everybody knows that each successive artistic revolution spawns its own academy, but now we are confronting know-nothing academies, and their know-nothing assumptions have become so ingrained that many people actually mistake them for artistic ideas. When taste has sunk to this level of confusion, artists can't really reform it. They have to walk away from it and start again. Perhaps contemporary artists are only confronting an ever-deeper version of the crisis that led Degas to dream up his museum. In that case, they would do well to join forces with the *amateurs,* as Degas did a hundred years ago. *Amateurs* have always been the people whom you call in when the professionals have failed. But where are the *amateurs*? That is what contemporary artists want to know.

MARCH 9, 1998

BEING GENIUSES TOGETHER

One day in November 1945, the Finnish architect Alvar Aalto, who had recently arrived in Cambridge to teach at MIT, flew down to New York for the opening of a show of new work by his friend Alexander Calder at the Buchholz Gallery. In a letter to his wife Aino, he reported that after the opening, Sandy (as everybody referred to Calder) and "all our old friends gathered at a suburban Italian restaurant." The painter Léger was there, Aalto told Aino, "with a new blonde," along with dozens of other people whom they knew, though Aalto wasn't sure about a lot of the names.

It's wonderful to think of Aalto, Calder, and Léger, three artists who had first become friends in the furiously experimental '30s, gathered in a family-style Italian restaurant in New York in the year that the war was over. When Aalto left the restaurant at midnight—he was still suffering from the time change from Europe—the party was far from over. And in spirit the party is still going strong more than a half century later. Or at least it was a month ago, when the giddily ecstatic Calder retrospective opened at the National Gallery in Washington while, a short flight north in New York (and Aalto, who was an aficionado of air travel, would definitely have taken the shuttle), Aalto's deliciously complicated elegance filled one floor at the Museum of Modern Art and Léger's modern-age classical wit filled another.

The more I think about the convergence of these three shows, the more I find that they resonate with one another. Aalto met Léger and Calder in Paris in the '30s, and from then on they kept turning up in one another's lives. In 1937, Aalto organized a two-man show of their work in the gallery of Artek, the Helsinki company that had been set up to produce Aalto's bentwood furniture. The next year, when Calder had an exhibition in Springfield, Massachusetts, Léger and Aalto were there and gave lectures. Also in 1938, Calder had the first show devoted exclusively to his jewelry at Artek; Maire Gullichsen—who had helped establish Artek and commissioned Aalto's most famous house, the Villa Mairea—seems to have bought more than a few of Calder's fanciful necklaces. In their published writings and their conversations, Léger and Aalto quote one another and refer to shared experiences. And in the '50s, Calder and Léger encouraged the Parisian art dealer Louis Carré, who represented both of them, to consider "their miraculous friend Aalto" for the commission to design his country house. This house, with its dramatically pitched roof and walls lined with Légers, can be seen in a series of photographs in the Modern's Aalto show.

What brought these men together was much more than a mutual sociability. They shared a similarly open-hearted and easygoing relationship with the grand adventure of modern art, in which they were taking their places not as founders but as second-generation pioneers. Both Aalto and Calder were born in 1898 and died in 1976; by the time they turned 20, abstract art was an established fact. Léger was born a generation earlier, in 1881, which makes him a contemporary of Picasso and Braque; but his first great paintings, the bold *Contrast of Forms* series, with their black outlines and swaths of primary color, are second-act Cubism, in that they take Picasso's and Braque's initial discoveries for granted. In much the same way, Aalto came to prominence with some variations on Le Corbusier's and Gropius's International Style, and Calder found himself as a sculptor after a visit to Mondrian's studio.

In the late '20s and early '30s, these three men were princes in the expanding kingdom of modern art. They were all involved in one way or another in the 1937 International Exposition in Paris, that last, glorious and desperate stand of interwar optimism; Calder's *Mercury Fountain* was in the Spanish Pavilion, not far from Picasso's *Guernica.* And after the war was over, Calder, Léger, and Aalto found that a new generation was looking to them to bring back some of the old utopian '30s playfulness.

No modern furniture is more warmly elegant than Aalto's chairs and tables, no vision of modern man more hilariously seductive than what Léger offers with his late construction workers and circus performers, no sculpture more effortlessly lyrical than some of Calder's mobiles of the 1940s. Still, for people who are going this spring to see the work of these tremendous creative spirits, the experience is anything but uncomplicated. These are artists who come on easy, but once they have pulled you in, they turn out to be demanding seducers. That kind of deepening drama is what gives the Calder retrospective at the National Gallery its gathering force. The

show, which has been organized brilliantly by Marla Prather, the curator of twentieth-century art at the Gallery, is in Washington this summer and moves to San Francisco in the fall.

Calder is the most resolutely yet slyly American of all American artists, and so he is a terrific choice for a National Gallery show. And the first phase of the retrospective, which is dominated by the caricatural wit of Calder's wire figure sculptures, is great popular entertainment—the perfect thing for Washington's casual museumgoers. The audience responds immediately, unreservedly, and their reactions are right on target. Although Calder's *Circus,* the elaborate miniaturized universe with which he enchanted '20s Paris, no longer leaves the Whitney Museum in New York (where it has just been splendidly reinstalled), the National Gallery does provide a remarkable film of Calder putting his toy performers through their paces. That nifty film (done by Carlos Vilardebo in 1961), together with the blithely confident hijinks of the early wire sculptures, gives visitors Calder's Rube Goldberg side. It's love at first sight. And why not? People are glad to spend some time with an artist whom they may be inclined to think of as a slightly mad but endearing relative, who dreams up nutty contraptions in the garage.

As the show progresses, however, a lot of museumgoers may fall out of love with Calder. Of course there is a feeling of drift—and plain tiredness—that often comes over visitors in the middle of a long, complicated retrospective; but I think there is something else going on here. Initially, people warm to Calder's audience-friendly humor. After a while, though, they begin to realize that most of his work is resolutely, purely abstract. And here the uneasiness comes in. Although Calder is still offering balancing acts and now-you-see-it-now-you-don't magic, this is all expressed in terms of abstract forces and absolutist distillations. The artist who visitors first regarded as a wackier version of themselves turns out to be a highbrow—more Mon-

drian than Rube Goldberg. It may occur to people that Calder isn't really such an all-American guy; he did, after all, spend half his time in France. The lovable ragamuffin of the early galleries is actually an austere modern. His comedy is more aloof than earthy. And the audience, though not exactly disappointed, is certainly bemused. A twentieth-century master who the crowds expected to love unreservedly keeps his distance. That circus of Calder's is an ivory tower, too.

This is not a time when Calder or Aalto or Léger is likely to affect the way we look at art. Their unembarrassed Olympian fun rubs people the wrong way. They are too unambivalent for the '90s; even their ironies are untroubled, and what are we to make of that? Consider the case of Fernand Léger. Even as his taste for the silly kick of kitsch unnerves whatever is left of a tradition-minded audience, his suavely classical compositional gifts make his work look antiquated to the hip crowd that, incredible as it may seem, still hasn't wised up to Jeff Koons. Of course Léger is such an established figure in the history books that museumgoers are unlikely to reject him out of hand. Still, I can't help but feel that in the Modern's retrospective such ebullient paintings as *La Ville, Three Women, Les Constructeurs,* and *La Grande Parade* are being presented and accepted as position papers in some high-meets-low argument, rather than as the deliciously confident juggling acts that Léger had in mind.

Carolyn Lanchner, who is a curator in the Modern's Department of Painting and Sculpture and who organized the show, is partly to blame. Although she writes convincingly in a catalog essay about Léger's casually varied painthandling, her installation never establishes the rhythmic flow from painting to painting that would pull us into Léger's world. The total exclusion of any of Léger's pre-Cubist landscapes robs the show of a real beginning. And Lanchner presents enthralling summing-up works such as *La Ville* and *Three Women* in cramped spaces, so that there's no sense of occasion, not

to mention any space to look at them. Lanchner has squandered valuable square footage on oversized marginal works, such as the wanly ornamental *Composition with Two Parrots,* which is nearly sixteen feet wide and gobbles up the biggest room. (A much smaller retrospective, mounted at the Albright-Knox in Buffalo in 1982, was truer to Léger's spirit.) Lanchner includes none of the poignantly lovely classical landscapes of the '20s. Her selection feels like a recitation of Léger's concerns. Lanchner shows us the influence of the movies; she shows us Léger the Surrealist. What's missing is Léger's awesomely confident mood. I didn't feel the full force of Léger's color, which, once he hits his stride in 1913, gives the work a sure, buoyant tone straight through to the end, some forty years later.

Surely visitors want to be seduced by that exhilarating color of Léger's. There is no other artist who knows how to set off the boldest blues and reds and greens against soft platinum grays. Those orchestrations are heavenly. But a sociological scourge lurks in the minds of a lot of museumgoers, and that devil tells people that they should be skeptical about Léger. Just as they are falling head over heels in love with the flamboyance of the *Three Women,* that puritanical demon may start them wondering why they're getting such a charge out of these sheet-metal babes. Right-thinking people may worry that they are so amused by paintings that have such machine-age subject matter, so many robotic or pneumatic or paper-doll figures. The question is an old one, considering that Léger, already in the early '20s, was explaining that "the mechanical element, like everything else, *is only a means, not an end.*"

Léger wants us to understand that he is a visual poet who is enthralled with popular subjects, not a social theorist or critic. He loves to give pop themes a magisterial—classicizing—aura; it's that simple. Yet even though his sense of fun is infectious, people have a hard time accepting this imaginative freedom, probably because we are living at a time when art that deals

with popular culture is generally left to PC-bookkeeping minds. Of course, Léger also lived in a period of socially correct thinking. He was an ardent Leftist and a member of the Community Party in France after World War II. Before everything else, however, he cared for visual poetry, and to those on the left who would impose open-and-shut interpretations of his work he struggled to explain that he regarded mechanical forms metaphorically. He speaks of wanting to create "the equivalent of the 'beautiful object' sometimes produced by modern industry." He is not saying that a beautiful woman is a machine. He's saying that the sleekness of a machine is exciting—and so is the human body. Indeed, he's going further and arguing that the unity of a machine and the unity of a masterpiece by Poussin are not totally different. "A picture organized, orchestrated, like a musical score," he wrote, "has geometric necessities exactly the same as those of every objective human creation (commercial or industrial achievement)."

Léger has ideas, but he organizes them intuitively. So do Aalto and Calder. All three artists suggest a particularly between-the-wars view of the unity of tradition and innovation, of high style and everyday experience. There is a glamour, an éclat, a utopia-now craziness to their elegant syntheses. They had already seen the black downside of modern civilization in World War I; Léger had been in the trenches. And so they're skeptical, but in an imaginative way that enables them to reshape their skepticism as intuitive freedom.

An architect who studied with Aalto at MIT in the '40s recalled that he was "very much an intuitive architect. . . . He did not like to discuss architecture on any abstract or theoretical basis. . . . The whole idea was to cultivate the 'eye' for form, there is no method for this." Aalto—and Léger and Calder—use older, artisan-like sensibilities to interpret the modern world. Yes, Léger is interested in the peculiar impersonality of the machine, but he's also enamored with the Neoclassical tradition that runs from Poussin

to David. His big paintings are at least as much about the old-fashioned splendiferousness of French painting as they are about the wonders of the assembly line.

Calder uses ordinary materials to create out-of-this-world effects, and the National Gallery show catches this exciting metamorphosis beautifully. This is a big show, but each light-filled room is so packed with beguiling compositions that I could happily have seen it go on longer. Calder first went to Paris in 1926. In 1930 he saw Mondrian's studio, and from then on he was unstoppable. The idea that sculpture might move—and thereby in some way conquer the fourth dimension—had been swirling around in avant-garde circles even before Naum Gabo and Antoine Pevsner announced in their 1920 "Realistic Manifesto" that "kinetic rhythms" would have an essential place in the new art. Calder brought to that grand experimental spirit such a nothing-to-it, fast-forward ease that we are sometimes in danger of forgetting how unique an artist he is. He is the only sculptor who gives kinetic art a boundless lyricism.

In recent decades, Calder's unabashedly experimental work of the '30s has often been reckoned a more formidable achievement than his best-known mobiles of the '40s and '50s. In those early years, Calder used herky-jerky mechanical structures and unequivocally rectilinear and circular forms to create enchanted, toy-like variations on themes that he had first seen in the art of Mondrian and Miró. These works have the aura of mad-cap cosmological fantasies: Calder's circular configurations evoke astronomical models, and his proscenium rectangles framing intergalactic encounters suggest a plainspoken absurdist theatricality. Calder's work of the '30s is bursting with promise; I think that's what people respond to. These constructions reflect a young man's can-do ingenuity, but considering that they are supposed to be about movement, they don't have much flow. Often they're little more than three-dimensional realizations of other

artists' ideas. And when they do actually move, the movement is awkward. For all its freshness and insouciance, I don't think this work can compare with the unfurling drama that Calder first achieved in the mobiles of the '40s. Their swooping-diving-soaring forms easily—triumphantly—command a space.

Calder gives his metal-and-wire mobiles a seductively naturalistic flow. His mechanisms are keyed to the infinitely subtle dynamics of the air. There is something of Leonardo in the way that Calder hitches his mobiles to the ineffable—to the mysteries of air currents and gravitational pull. His greatest mobiles, with their lilting, meandering progress and their astounding asymmetries, have a rococo fascination. I'm thinking of the black cascade of *S-Shaped Vine* (1946), the twinkling whiteness of the immense *International Mobile* (1949), the spiny redness of *Sumac II* (1952), and the unity in diversity of *Black: Flower and Seventeen* (1959). These are peerlessly carefree works. Calder's forms—those boomerangs and wing shapes and stylized flowers—are beautifully worked out; but his subject is not form, it is what air does to form.

Marla Prather's installation of the work from the '40s and '50s has been inspired by the profusion of forms that we see in photographs of Calder's Roxbury, Connecticut, studio; she also evokes museum installations that were done while Calder was alive. Prather overlaps the mobiles, so that initially you take them in as a gaggle of undifferentiated elements—a sort of mechanical hanging garden. Although the air in the galleries is stiller than one would like, there is some movement, and the play of shadows on the walls is something to behold. As you linger, you begin to pick out particular favorites. Even if the crowding suggests a slight downgrading of this work, at least compared to the way that Prather has handled the earlier galleries, it's a lovely installation.

I have only a few regrets about the show. Prather includes paintings and drawings, but she doesn't give space to the delicate side of Calder's drafts-

manship, to small works such as a witty portrait of Sartre, with the smoke from his cigarette spelling his name, or the sketches of the mobiles and stabiles that Calder created for the catalogs of his shows in the '40s and '50s, thereby turning these pamphlets into precious little illustrated books. Prather includes some of Calder's jewelry, but I would have liked to see a selection of his household objects, too. As for the work of the '60s and '70s, we could have used more guidance than Prather gives. It would be an understatement to say that the gargantuan structures of those years—including the large mobile in the East Wing of the National Gallery—are among Calder's less inspired works, but I think that the selection of late stabiles could have been better. Yet these are minor complaints. The show has a glinting beauty that holds in the mind. This is the most grandly lighthearted museumgoing experience of recent years.

In the gentle yet precipitous arabesques of the Calder mobiles, you feel the freedom that comes when an artist knows how to play with the horizontal of the earth, the vertical of everything that rises heavenward, and the gravitational pull that brings it all back down. Calder dances around the basics; that's his way of saluting them, and that's what you feel in Léger and Aalto, too. Each of these artists has his own teasingly loving relationship with the fundamentals. Léger, for example, doesn't limit himself to the primaries, as Mondrian did. Even in paintings that are essentially red, yellow, and blue, he will permit himself a little vacation and add a bit of green or orange. This is Léger's humorous way of showing his muscle. And although Aalto first came to prominence with a number of buildings in the back-to-essentials International Style of Le Corbusier and Gropius, he gave these impersonal forms a quirky warmth. He regarded rectilinearity as one possibility in a vast democracy of possibilities.

No exhibition in recent memory has represented a confidently undogmatic modern spirit with such deep understanding as the Aalto retrospective that Peter Reed, associate curator in the Modern's Department of Architecture and Design, mounted this winter. Aalto has been admired at the Modern for more than half a century—the first book devoted to his work was the catalog of MOMA's 1938 show—and Reed has built on that institutional history with an optimism that many of us had feared was no longer possible at the Museum of Modern Art. Without slipping into postmodern polemics or ironic nostalgia, he has honored one of the museum's old favorites even as he has demonstrated why that achievement is still urgently appealing all these years later.

Architecture exhibitions are always difficult to do, and with Aalto, the majority of whose work is in Finland (after World War II he also worked in Germany a good deal), the task of giving American audiences a feeling for the achievement may seem impossible. Yet this is exactly what Reed has done. Aalto's marvelous drawings are one of the wonders of this show. These—together with plans, photographs, architectural models, furniture, glassware, full-scale mock-ups of architectural details, and some very impressive video walk-throughs of major projects—leave you with a strong feeling for the atmosphere of this greatest of Finnish artists.

The show is magnificently laid out. Aalto is the most mysterious of all the major architects, and Reed's installation is true to the unprepossessing way that he weaves his enfolding spell. I think that what first strikes a visitor to Aalto's buildings is the elegant refinement of individual parts—the way blue tile is arranged on a wall, or the wavelike rhythms of a wooden ceiling. Aalto always gives you a lot to look at, but initially you may feel that many of these impressions—your reaction to the ceiling, the windows, the hardware—are discrete and unrelated. Only as I go from part to part to part

do affinities and relationships emerge. The impressions begin to add up without my realizing that I'm doing the addition. After a time I feel that the building has been growing up—blossoming—around me, and in my mind, too.

I have never been to Finland, but the Baker House dormitory at MIT, a key work of the '40s, is enough to give a firsthand feeling for Aalto's magic, though a lot of the original details are lost or in a down-at-the-heels state. What may seem initially like just another red brick Cambridge building has many different moods. There is the intimacy of the entrance, with its doors pierced by port holes. Not far inside, a fireplace with a wide, raised hearth suggests the welcoming vision of a living room in a friend's house. Then there is the dining hall—with its grandly miniaturized staircase, wonderful skylights, and slim, horizontal windows that turn the views of the Charles River into a Japanese scroll. Even if you can't see the dorm rooms upstairs— almost all of which have eccentric floor plans and magnificent river views, though most of the original Aalto furniture is gone—you can still enjoy the idiosyncratically meandering halls.

Back outside, the building makes several different impressions, depending on which side you see. The facade on the campus side, with two angular staircases rising in a V-shape from the entrance, is a bit fortress-like. Facing the river, Baker House becomes curvaceous, meandering—a mirror of the waterway. And then there are the short ends of the dorm, which are almost comically abbreviated. Later on, if you catch a sight of Baker from across the Charles, what will impress you is the astonishing forceful chiaroscuro shadow play of the winding facade; that's something you're unaware of up close.

Aalto's buildings don't leave you feeling overwhelmed or spoiled for other architecture, the way, say, some of Frank Lloyd Wright's masterpieces do. Léger once wrote of Calder that "he uses all these elements scattered

throughout our daily life. . . . He has amalgamated and coordinated every-thing." Léger might have said that about Aalto, too. Aalto gives us a height-ened admiration for ordinary materials—for red brick and inexpensive wood. His buildings reflect the sensibility of a man who must have looked at the most modest houses and streetscapes and seen details and elements that delighted him, that he figured he could bring into his subtlest compositions.

It has often been observed that the Villa Mariea, in which Aalto used a great variety of materials—different woods and stone and brick and tile and stucco—achieves an effect akin to Cubist collage. I think that's right. The subtle unity of Aalto's buildings is not unlike the unity of the greatest col-lages that Picasso and Braque did before World War I. Even as the artist is achieving an overarching flow, the elements that go into the composition retain their individuality. There is a Cubist transparency to Aalto's method—a sense of order so sure that it needn't be insisted upon.

Peter Reed calls his exhibition "Between Humanism and Materialism," and what he has done is to remind the architectural profession, which is wracked with ideological strife, of an architect who regarded the analytical process as a sensuous experience. I find it interesting that Aalto was such an inspired designer of libraries, both public and private. He obviously re-sponded immediately, intuitively, to the physical beauty of books, which give mental processes a mysteriously encoded concrete form.

In the years when Aalto was a young man, both a self-consciously Northern Romanticism and a stripped-down classicism were powerful forces in Scandinavian architectural circles, and although early on Aalto was a Neoclassicist, it is obvious that he took from everywhere and everybody. His first Modern show, in 1938, featured the bentwood furniture that was his inspired—and humanized—variation on Marcel Breuer's tubular metal furniture. Aalto was not a man who believed that the new wiped away the old. While teaching at MIT, he took his students into Boston to look at the

work of Charles Bulfinch, an American classicist who designed the Massachusetts State House in the late eighteenth century.

A part of what Aalto shared with Calder and Léger was a genius for being lucidly romantic about modern experience. They were gambling that the excitement of modern style might bring a new audience to art. But if they were optimistic about this, they were by no means naive. Around 1950, Aalto tried to persuade the town of Säynätsalo to include a painting by Léger in the council chamber of the Town Hall that he was designing, but he was rebuffed. Still, Aalto and Léger hoped that popular taste might expand. In the 50s, when Léger wrote several essays about the use of color in architecture, he recalled a visit he had made with Aalto to some housing that Aalto had design for workers and engineers. (I suppose this was the Sunila Pulp Mill complex, which was owned by the Gullichsen family.) Aalto had painted the walls in strong colors, and Léger wrote that "our fine gentlemen, the engineers, put up wallpaper with parakeets while the workers didn't touch anything (of course, perhaps they didn't dare to)." Léger wanted to argue that the architecture had a positive effect on the working man. He theorized that "the influence of color and light affected [the workers]; their clothing was better cared for." And he quoted Aalto as saying, "All in all, the people aren't bad."

All of this can be dismissed as one more episode in the twentieth-century intellectual's misbegotten romance with the common man. Of course that is a part of the truth; but when Léger mused that the workers might not have changed anything because "they didn't dare," he showed that he had a sense of humor about his hopes. These artists knew that their love affair with the public was a crazy gamble. They were up-for-anything spirits who realized that in order to expand taste they would have to go out and prove to the public that the modern style, when presented with wit, elegance, and agility, was a magnificent spectacle. This, no doubt, was why the

idea of the circus performer held such a fascination for them. Calder had established himself in Paris with his playfully miniaturized jugglers and acrobats. Léger's career closed with the same theme. In a series of autobiographical conversations, Calder recalled that when Maire Gullichsen took him to see Aalto's pulp mill at Sunila, the "great wheels in pairs, rolling on paper pulp in vats . . . looked like circus elephants doing a stunt." I do not think Aalto would have disliked the analogy.

These men wanted to be ringmasters in the modern circus. They were uncomfortable with the conventional boundaries between the arts. Aalto painted and did bentwood sculptures; Léger was fascinated with architectural decoration; Calder's mobiles and stabiles sometimes approach the size of small buildings. Late in life, Aalto was asked by an interviewer what he thought about the relationship between architecture, painting, and sculpture, and he responded by quoting Léger's thought that "the arts form an orchestra, which the architect conducts." Yet Aalto was also skeptical about collaboration, saying, "I . . . think it better if three artists are hidden in one person," which would be possible, since "the three art forms of architecture, painting, and sculpture are linked to one another in that they are all manifestations of the human spirit based on *materia*"— on the concreteness of materials.

These modern friends wanted to create paradisal visions out of what Aalto referred to as the artist's confrontation with materiality. And that is precisely what you see them doing in the shows this season: in the ecstatic carnival spirit of Léger's *Grande Parade,* in the scintillating red-hot vision of Calder's *Sumac II,* and in the heavenly blue-and-white interior of Aalto's Essen Opera House. Despite some impressive attendance figures, however, none of these retrospectives has been an unequivocal hit with the museumgoing public. I would not conclude from this that people are unsympathetic or unwilling to respond. To the contrary, museumgoers feel the tug of these

visionary artists even when they don't know quite what to make of them. My guess is that people are feeling a bit bewildered as they leave these shows. Even our postmodern know-it-alls are realizing that they have not yet fully grasped what modern is.

JUNE 1, 1998

THE ART OF SEEING

The Time Element

Every couple of months, I hear an artist or an art historian announce, in a voice suggesting both amazement and frustration, "Nobody knows how to look anymore." They may be thinking of the nonplussed reactions of students whom they have taken to a museum, or of the smug theoretical pronouncements of colleagues, or of the anxious uncertainty with which friends who are not in the arts discuss the exhibitions that they see. These artists and art historians are not censorious so much as they are rattled. They believe that a lot of people are robbing themselves of a tremendous experience. I know exactly how they feel because there are many days when I go to the galleries in New York and find myself concluding that none of the people who are selecting and promoting contemporary art know how to look. I am sure that some artists are doing work that is worth a second or third look, but most of what the galleries and museums show and most of what people talk about repels curiosity. I find myself going through whole buildings and streets and neighborhoods full of galleries that are operated and patronized by people who seem to care so little for seeing that they might as well have shut their eyes.

Confronted with this situation, my initial reaction is to say that people have lost the ability to look. But the reality may be stranger still. I suspect that what I am encountering is not a generation that doesn't know how to look, but several generations that have been trained to look in a particular way. If you make any effort to follow the way that art, especially contemporary art, is discussed in the art magazines, the museums, and the universities, you will find it difficult to avoid the impression that there is a method to this widespread inattention. People have an idea that to look at art in a

sophisticated and up-to-date way means that you do not look at it very long or very hard. There are late-modern and postmodern variations on this approach. Some trace it back to Duchamp, others all the way to Diderot. Whatever the genealogy (and it can get fairly complicated) the result is an almost universal feeling that art ought to be taken in quickly, even instantaneously—that a painting or sculpture should hit you with a bang. After which, of course, you can talk or theorize about it forever.

Let's be absolutely clear about what kind of visual experience has been, if not yet lost, then marginalized. What people are no longer prepared for is seeing as an experience that takes place in time. They have ceased to believe that a painting or sculpture is a structure with a meaning that unfolds as we look. This endangered experience is not a matter of imagining a narrative; it involves, rather, the more fundamental activity of relating part to part. We need to see particular elements, and see that they add up in ways that become more complex—and sometimes simpler—as we look and look some more. The essential aspect of all the art that I admire the most, both old and new, is that it makes me want to keep looking. A painting or a sculpture—by Sassetta, by Corot, by Brancusi—engages the viewer by means of a range of particularities and unities. We take in these elements and combinations of elements in different ways, at different speeds. Sometimes we take them in serially, sometimes as overlapping impressions, sometimes simultaneously. We may approach the same element—a figure, a curve—from different directions. A work of art can reveal alternative, even in some ways contradictory, kinds of logic. And logic can collapse into illogic, from which a new logic can emerge. Of course the artist exerts considerable control; but the greatest artists enable us to make our own way through a composition, so that we find our own kind of freedom within the artist's sense of order. If I were asked to name one group of twentieth-century paintings that epitomizes the shaped yet boundless experience that I am attempting to describe,

I would point to Braque's *Studio* paintings, those symphonic celebrations of the particularity of seeing, of the insistence on unity as a delicious, forever-just-beyond-our-grasp dream.

If there is so much to be said for particularity and paradox, why has the unity idea triumphed so totally? The first thought that comes to mind is that this is not really so strange, considering that we live in a world where art marketing dominates art, and where the work that reveals its meaning instantaneously is probably going to be the easiest to sell. I mean sell in the broadest sense—not just to collectors, but also to curators and museumgoers and critics. There are kinds of work, such as Conceptual Art, that by definition defy extended looking (while inviting endless discussion). Those who have never much cared for theory may want to argue that with theory ascendant, there is simply less and less time left to look. But I would point out that the ideal of immediate, all-in-one impact has become a touchstone even for people who by and large reject theory. In 1982, when Peter Schjeldahl wanted to praise David Salle's canvases, which were then at the forefront of a fashionable return to painting, he described Salle as "an artist who evokes virtual Rorschach readings of critics' pet tendencies." What could provoke a quicker reaction than a Rorschach test? And just this spring Dave Hickey—a critic who, like Schjeldahl, has a reputation as a postmodern aesthete—saluted some new paintings by Ellsworth Kelly (in a catalog for the Matthew Marks Gallery) as "an irrevocable fait accompli." Hickey hastened to add that this "demands narrative," but his protracted "accounting of the contexts and processes" belongs not to seeing but to thinking about seeing, which is something else.

Seeing is not easy to talk about, because the talk can easily shift attention away from the primary experience, which is by definition nonverbal. You can talk yourself into distinctions where none exist, and you can end up confusing talking about seeing with seeing. Recently, as I made my way

through a number of books that deal with how art has been seen and understood in the past fifty years, what occurred to me was that large areas of agreement among leading art theorists and historians are often masked by all the arguments that have been waged between the Greenberg-type formalists, the advocates of French-style theory, and several other varieties of late moderns and postmoderns. I am aware that there are substantial matters of philosophy, taste, and outlook that separate Clement Greenberg, who died in 1994 at the age of 85 and is now, a few years later, the subject of *Clement Greenberg: A Life* by Florence Rubenfeld; and Michael Fried, who was much influenced by Greenberg in the '60s when he wrote an influential series of essays that he has finally made into a book called *Art and Objecthood*; and Yve-Alain Bois and Rosalind Krauss, whose book *Formless: A User's Guide* is a leading example of the French-style theory for which Fried does not care. But I would argue that they are all inclined—together with a post-structuralist such as Norman Bryson and a postmodern aesthete such as Dave Hickey—to use their eyes in the same way. The people who are now regarded as the most sophisticated interpreters of art are instinctively disposed to believe that a great work of art is a work that they see totally at once, and this belief is grounded in such a pre-analytical mix of old-line academic, antiformal Dada, and postwar high-modern assumptions that even the finest minds cannot escape from what amounts to a visual prejudice.

The phenomenon is complicated by the fact that immediate impact and seamless unity are legitimate and recognizable values in art. But the immediacy and the unity that now dominate fashionable taste are shallow. The new unity has neither weight nor force; you feel no struggle, no resolution. And there is no surprise lurking in the immediacy of a lot of recent art. Nothing mysterious or submerged is being brought forth—in the way, say, that the near-symmetry of Mark Rothko's paintings can be exciting because (as David Smith said about his own work) "the afterimages of parts lie back

on the horizon, very distant cousins to the image formed by the finished work." When, thirty years ago, Michael Fried praised paintings and sculptures for their "*instantaneousness*" and "*presentness*" the italics helped to convey the electric-shock quality that he was after. By now, however, unity and immediacy have become uninflected, tyrannical experiences that rob art of all its ambiguous fascination.

In offering a response to the big-bang theory of seeing, I cannot enter an ongoing dialogue, because those of us who believe that seeing-through-time is simply how art was, is, and will be experienced have by and large been shut out of the discussion. What I can offer is an alternative view, a view that is grounded, I believe, in the very beginnings of modern art, as well as in earlier traditions. Much more than a theoretical argument is at stake. The experts who deny the time element in art so insistently have brought us to a point where contemporary painting and sculpture that requires concentrated, adventuresome attention—whether the work is representational or abstract or somewhere in between—is regularly shunted to the side, if not eclipsed. If there has been one sure rule in recent years it is this: the more that an artist asks us to look at a work over a period of time, the more a work drops beneath the radar screens that criticism has set up to track the contemporary scene. So far as I am concerned, if you are looking for an all-in-one impact, you're missing most of the important painting and sculpture that artists are doing today.

Chardin's Complications

Just to make sure that there is no confusion about the kind of experience I am defending, let's consider what happens when we look at a transcendentally great work of art. The painting I have in mind is a still life by Chardin, *The Brioche*, from 1763, in the Louvre. This is a small painting—just over a

foot and a half high and just under two feet wide—and so you might expect to be able to take it in all at once. But when I first look at *The Brioche,* it is Chardin's way of differentiating one substance from another that holds me. And I linger over his distinctions. He gives us the exact character of cherries and peaches, of biscuits and a crusty brioche, of porcelain and glass. And even as this naturalistic virtuosity is astonishing me, I am also noticing (as people have noticed since the artist's day) Chardin's habit of playing a hide-and-seek game with his own peerless illusionism by enriching his surfaces with strokes of strong, virtually unmixed color. I begin to be caught up in the poetic mood that Chardin spins, as he turns our attention back and forth, between paint-as-paint and paint-as-illusion, between paint-as-illusion and paint-as-paint.

Initially, I am not especially caught up in the totality of Chardin's composition, though I am aware of the overall—and on first glance, not especially daring—symmetry, which fans out from the grand spiral of the brioche that is topped with a sprig of orange blossom. There is something pleasing about the simplicity of the arrangement, about the way that Chardin draws me into an almost childlike game of counting things. I notice that there are three cherries and three biscuits, but only two peaches. And then I find myself studying those three cherries to the exclusion of everything else, and that is the moment when the composition really begins to kick in. Damned if Chardin hasn't turned these cherries into a sort of reeling circle dance, with their gleaming fruit and curled stems creating a mesmerizing red-and-green whirlpool. That tiny cyclone might be the engine that powers the whole composition. The force of those cherries is certainly out of all proportion to the space that they occupy, but then this is a painting full of strange, almost Manhattan-skyline-like shifts in scale. So now I may have found the key that unlocks *The Brioche.* I want to compare objects in the extreme foreground, such as the cherries, with forms that

tower over them, such as the glass carafe full of liqueur and, of course, the brioche.

I find myself making lots of comparisons. I notice that the whirlpool of the cherries is echoed, in a slowed-down version, by the spiral of the brioche. Soon I am observing that the handle of the Meissen bowl points deep, deep into space. And if I connect that imaginary trajectory with another imaginary trajectory, suggested by the angle of one of the biscuits, I find them converging to create a sort of triangle, with an apex that's "behind" the brioche. Chardin's symmetries are beginning to be interestingly echoed and reiterated. The still life is becoming landscape-like. I can think of the brioche as a sort of Mont Sainte-Victoire—surmounted by a flower-tree, that is, the orange blossoms—that I move away from and return to by several different paths.

By now I feel the multiplying complexity of Chardin's compositional architecture: the curves and curls of brioche, cherries, peaches, patterned bowl, all set in an inexhaustible counterpoint with the relative rectilinearity of the liqueur carafe, the shelf, the biscuits. Chardin uses his lyrically there-but-not-quite-there handling of paint to interweave episodes of intense hue, earth-toned shadings, and diffused, grayish atmosphere. And of course I am also considering the peculiarities of this particular arrangement of objects—the Meissen bowl without an accompanying coffee or tea service; the elegant liqueur bottle next to the biscuits that haven't even been set on a plate. The painting is about differentness and connectedness, and the relationships are so thrillingly elaborated that you never want the complications to come to a conclusion.

A picture by Chardin is a dream of unity that we glimpse through an atmosphere saturated in particularities, and it is our feeling for those particularities, and for their connectedness, that carries us into the dream. I believe that the same can be said for many, if not all, of the greatest works of

art. In the museum and in the gallery, I want the parts to add up—and to multiply—in unexpected ways. This is the process that gives art its rhythm, its flow, its mesmerizing time element. This is certainly what holds us in Analytical Cubist paintings, those anatomical blueprints for the art of our century, which often seem composed of the bones and sinews of Chardin's still lifes. In one of the great Picassos or Braques of 1911 or 1912, we will pick out a naturalistic detail (a bit of rope or wood, say) set next to a line that's suspended in thin air. We see shapes that are apparently solid at one end and fade off into nothingness a few inches farther on. In Braque's *Homage to Bach,* words, a musical instrument, and echoes of classical architecture play a fascinating hide-and-seek with one another, and we follow the clues.

In his "Creative Credo" (1920), a classic text of modern art, Paul Klee observes that "space itself is a temporal concept." Klee focuses on the narrative possibilities of Cubist construction, and in doing so he insists on the indissoluble connection between modern structures and earlier European art. He asks: "And what about the beholder: does he finish with a work all at once? (Often yes, unfortunately.)" Klee goes on to say that a painting is "first of all genesis." "In the work of art, paths are laid out for the beholder's eye." These paths create movement, an opening-up sensation. The same idea is reframed, a generation later, in the writings of Hans Hofmann, the great teacher among the Abstract Expressionists. He argues that "movement is the expression of life. All movements are of a spatial nature. The continuation of movement through space is rhythmic." Hofmann also celebrates immediacy, but he wants the immediate sensation to pull the viewer into an experience that expands as we look and look some more. And if you are susceptible to the rhythmic impulse that fuels those movements, you will find that many of the conflicts between form and content that have preoccupied the theorists for decades and even generations begin to vanish.

If there is time to look, then there is no conflict between noticing the character of a smile in a portrait one moment, the way the tones of flesh vibrate against the distant landscape a little later, and the cut of the sitter's clothes later still. What people tend to divide into form and content is woven together into the rhythmic movement of a visual experience.

The Quick Fix

Why has this expansive way of looking, which is lodged so deep in our experience, been rejected? And why has this way of looking often been said to be anything but modern? Familiarity is no doubt an element here: inevitably, taste is conditioned by the work that people know best, and for years a great deal of the painting and sculpture that has been displayed most prominently has not exactly encouraged anybody to look long or hard. No matter what one's particular feelings about the work of Duchamp, Pollock, Judd, Warhol, and Stella happen to be—and these are artists of radically different characters and values—we can probably agree that the audience that has grown up regarding this as standard fare is going to believe that they should take art in quickly, instantaneously, all at once. And many people would argue that this speed-reading fits right in with the pace of contemporary life.

The obsession with unity may be grounded in a belief that today's artists must create products that can compete in an environment in which it sometimes seems that nothing is left but brand identity. Many people are convinced that the modern world, with its acceleration, commercialization, and cultural homogeneity, is always hostile to particularity and idiosyncrasy. In some parts of the art world it is now assumed that no artist, no matter how gifted, can hope any longer to establish a detailed, particular, extended relationship with anybody in the audience. These ideas, of course, are not all that new. You can trace them back to the go-go mood of the

postwar years, when a hip triumphalism became the upscale mood in New York City, and it didn't take any particular intelligence to see Color Field painting and Pop and Minimal Art as spin-offs of a slam-right-through way of life.

I think I know why Clement Greenberg's ideas held such a fascination for many people, especially in the early '60s. By arguing that artists, at least since the Renaissance, have sought a seamless, peremptory impact, he gave the sleekly upbeat painting of his own day a sophisticated traditionalist sheen. Greenberg was without a doubt the most searching exponent of the idea that we take in great art all at once. Of all the critics who flourished in those years—I am thinking not only of an art critic such as Harold Rosenberg, but also of literary critics such as Philip Rahv and Lionel Trilling—Greenberg is surely the greatest prose stylist. He knew how to use his blunt lucidity to put over his big idea. He could make people believe, as he believed, that twentieth-century art was moving toward its own kind of bluntness—toward a way of treating "the whole of the surface as a single undifferentiated field of interest [which in turn] compels us to feel and judge the picture more immediately in terms of its over-all unity." There is no question that Greenberg's ideas are grounded in the artistic excitement of his early manhood, when a new kind of stripped-down abstraction was the hot news in New York. I suspect that what happened to Greenberg was that after a while he began to want to make that part of the truth into the whole truth; he wanted to line up the whole history of art behind the Pollocks that he adored. By the early '60s, he had turned "instantaneous unity" into his mantra—a key to all mythologies. When he announces that it was the fifteenth-century Italian painters who discovered "that instantaneous, compact and monumental unity . . . to which Western pictorial taste has oriented itself ever since," I have to wonder if this isn't closer to a description of a billboard than of a Masaccio.

If there is anything to be learned from the tone of mixed bewilderment, anger, and awe that marked the discussions of Greenberg in many of the reviews of Florence Rubenfeld's workmanlike 1997 biography, it is that even now nobody quite knows what to make of him. There are a number of reasons for this ambivalence. Greenberg had a flair for playing the art world game that is rare in a man of his refined intelligence, and he convinced many people who should have known better that taste was a marketable commodity. In the process he was not averse to steamrollering anybody who did not get with the program, and those people have not always been quiet, nor should they be. It would be absurd to argue that Greenberg's opinions are directly affecting the taste of gallerygoers and museumgoers today. The contemporary audience has only the vaguest familiarity with his ideas. By the same token, Duchamp's thoughts (to the extent that one can determine what they are) remain the purview of specialists; and the same goes for the ideas of such contemporary writers as Michael Fried, Rosalind Krauss, Yve-Alain Bois, and Norman Bryson. But I do believe that the sophisticated public is picking up on fragments—inevitably popularized and frequently corrupted—of all of these thinkers' ideas; and by now there is a kind of theoretical gestalt that hangs heavy in the art world air.

Everybody from the formalists and the Neo-Dadaists through the poststructuralists and the academic Marxists seems to believe that for at least the past 100 years the artist and the public have been becoming increasingly alienated from one another. This process is felt to have a historical inevitability, which in turn leads people to imagine that the kind of controlled journey that the artist might once have provoked in the viewer is now an impossibility. Duchamp, reflecting on the situation in a famous statement made in Houston in 1957, said that "to all appearances the artist acts like a mediumistic being." For Greenberg, the result of this historical development was an increasingly self-critical and inward-turning artist. I do not

mean to say that the aesthetics of Duchamp and the aesthetics of Greenberg are the same, but their divergent ways of thinking about art do depend on a related assumption that the artist can no longer count on communicating complicated, expansive experiences in a detailed, lucidly articulated way. The Museum of Modern Art curator Robert Storr, in a deeply unsympathetic account of Greenberg's influence that he published at the time of the museum's 1990–91 exhibition, "High and Low: Modern Art and Popular Culture," remarked on the convergence of a formalism for which he did not care at all and a Dadaism for which he cared a great deal. Storr argued that if Greenberg's essential idea was that modern art was self-critical, then "junk assemblagists, Neo-Dadaists, and Pop artists" were continuing that process, since they "used the castoffs of mass culture to criticize that culture from within." Now self-criticism is at the heart of the unity idea; you keep whittling things away. The new unity is really a new simplicity. The logic of Storr's argument may be a bit difficult to follow, but I think it comes down to the rudimentary thought that a Johns *Flag* or a Warhol *Marilyn* is a distillation of the pop ethos, and as such is analogous to a Morris Louis stain painting, which (at least for Greenberg) is a distillation of the Western color tradition. The aim of art is distillation. In both cases what's contemporary is unitary.

Many people have made this connection. As early as the '40s, and frequently since the '60s, critics have observed, with varying degrees of comfort or distress, that the absoluteness with which Dada rejected all traditional ideas of composition and structure could seem to be leading in the same direction as Purist art of one kind or another. Even Michael Fried—in "Three American Painters," the introduction to a 1965 show of work by Noland, Olitski, and Stella, the abstract artists he admired and wanted to isolate from what he called the literalism of Minimal Art—had to admit that "just as modernist painting had enabled one to see a blank

canvas, a sequence of random spatters, or a length of colored fabric as a pic-ture, Dada and Neo-Dada have equipped one to treat virtually any object as a work of art." Both modernist painting and Dada, in other words, were all-in-one experiences. By the end of the '60s, all the art that the tastemakers believed was worth talking about, whether they wanted to praise it or damn it, was big-bang art.

The unity idea is by now accepted so widely as to defy analysis. Marxists admire Warhol for the same reason that the auctioneers at Sotheby's do; he makes a big, fast impact. And if you are a historian, you may want to wend your way back from Warhol's gay-themed all-overness to Pollock's macho version. At least that is what Rosalind Krauss has done in *Formless,* when she considers Warhol's oxidation paintings, the big metallic surfaces on which he had friends urinate in order to get the paint to change color. "Warhol's 'urinary' reading of Pollock's mark," she explains, "was insisting that the verticality of the phallic dimension was itself being riven from within to ro-tate into the axis of a homoerotic challenge." The urinary, the unitary. Krauss uses her newfangled theory like camouflage, but if you peel it off you find that her eye is still seeking the all-in-one experience that she learned from Greenberg years ago.

So far as the academy is concerned, the whole history of Western art, at least since the Renaissance, is based on instantaneous unity. In the '70s, Michael Fried turned from art criticism to art history and began to study the Salon painting of anti-Rococo France in the late eighteenth century. (Maybe this wasn't such a reach after Color Field, which was the Salon painting of the '60s.) Fried believed that he had found, in Diderot's defense of the narrative paintings of Grueze, another critic who saw "the essence of painting in terms of instantaneousness." Fried became immersed in old-guard mainstream French art theory, which insisted on a unity of time in classical history painting. Never mind that some of Poussin's most evocative

masterpieces are temporally elastic, if not temporally ambiguous. It some-
times seems that contemporary theorists such as Fried and Norman Bryson
are determined to repeal the elements of paradox and ambiguity that are
right there before our eyes in the Old Masters. In his influential *Vision and
Painting* (1983), Bryson observes that what Titian—and Vermeer—create is
"a single moment of presence. For the painter, the irregular and unfolding
discoveries of the glance are collected and fused into a single surface whose
every square inch is in focus." This is a description that jibes with no experi-
ence that I have ever had with a Titian or a Vermeer.

Fried is a discerning thinker; he is troubled enough by the idea of instan-
taneousness to argue that you can look for a long time, just so that "at
every moment the *claim* on the viewer of the modernist painting or sculp-
ture is renewed totally." And Bryson is in fact opposed to the monolithic vi-
sion of painting—that Tyranny of the Gaze—that he would like to reject in
favor of the freedom of the Glance. Krauss, too, in the discussion of Cubist
collage in her book *The Picasso Papers* (1998), may be understood as reinvent-
ing an idea of seeing-through-time that is really the most natural thing in
the world. But these historians are not necessarily in control of the ideas
that they purvey. And because they are inclined to believe that they are
close to the mainstream of taste, which for that very reason they regard as
never far from the truth, they have a way of ending up in cahoots with
some of the big-time museum and gallery people who stuff the latest ver-
sion of instant unity down our throats.

When Fried managed to demonstrate, at least to some people's satisfac-
tion, that the campy melodramatics of Greuze's paintings were protomod-
ernist, he performed a great service for the postmodernists, and it hardly
matters whether he planned this or not. If Greuze's overcrowded narratives
lead us to Manet, then why can't that road just keep on going all the way to
the get-it-in-an-instant Cibachrome surfaces of Cindy Sherman's postmod-

ern Greuzian allegories? As for Bryson, he has made it possible to see Green-berg's celebration of instantaneous unity as a sinister ideological plot, and what could be more politically postmodern than that? Unity becomes the white male artist's way of not letting the viewers make up their own minds. What is lost, once again, is the idea of looking as an extended, responsive, evolving, back-and-forth interaction.

Unity and Particularity

There is no mystery as to why unity exerts such a pull. We do go to art for clarity. When you talk about a painting or sculpture, you say, "Now it's all coming together for me," or "I see how it adds up." We all hope for coher-ence. But there are many ways for a work to come together, and the char-acter of even the most seamlessly convincing painting or sculpture is to be found in the unique confluence of elements and forces that makes up the whole. This is the important point that Meyer Schapiro made in 1966 in the essay "On Perfection, Coherence, and Unity of Form and Content." In that understated way of his, Schapiro chose not to place his remarks in a con-temporary context, but I do not think it was an accident that the essay ap-peared in the mid-'60s, when Greenberg's idea of instantaneous unity was at its most influential. Surely Schapiro is lodging a protest against the whole drift of '60s aesthetics when he writes that "to see the work as it is one must be able to shift one's attitude in passing from part to part, from one aspect to another, and to enrich the whole progressively in successive perceptions."

Like Greenberg, Schapiro had been fascinated by the move toward all-in-one expression in the paintings of the Abstract Expressionists. But he never-theless insists that wholeness is at best an elusive thing. Schapiro shrewdly points out that we sometimes experience paintings that are in a fragmentary state as magnificent wholes. He insists that certain kinds of incompleteness

or irresolution can be precisely the elements that give a work its life-giving energy. He bids us to remember that there are many, many different ways in which a work of art can satisfy us, and that in order to arrive at this feeling of glorious complication, we may find ourselves approaching a work from a number of radically different directions.

Schapiro does not ask why this kind of peremptory unity might have become such an obsession in the '60s. He could well have pointed out that the idea of unity—if not the unity of perception, then the unity of action in painting—had been a theme among the authors of treatises on aesthetics since the Renaissance. Certainly, this idea has a way of coming to the fore when the general conversation about art has lost its vital connection with the hands-on experience of the studio. By the late '50s, many artists in New York feared that American art's age of experimentation was moving toward academicism. And as Pop and Minimalism gave way to Conceptual and Environmental Art and then to postmodernism, the underlying problem remained the same. Perhaps the most recent guise that unity has taken is an obsessive narrative busyness, an image so saturated with small, frequently cartoonish elements that although they present an idea of variety, they are visually impenetrable—a postmodern anti-unity unity. A leading proponent of this approach is Lari Pittman, the painter whose labyrinthine pop extravaganzas were featured in three consecutive Whitney Biennials during the 1990s. From the '60s down to our day, fewer and fewer mainstream artists have been committed to the kind of pragmatic studio practice that acts as a brake on theorists who associate excellence with one or another brand of monolithic unity.

Anybody seeking a countertradition in recent decades will want to read the extraordinarily intelligent criticism that the painter Fairfield Porter wrote in the '60s. Porter was always unequivocally dedicated to paradox, particularity, and the ambiguities of looking, and he frequently grappled

with the difficult question of why taste was veering in such a different direction. Time and again, Porter came to the conclusion that the mysterious process of looking at a work of art was in some fundamental way at odds with the push toward standardization that has characterized modern times. "Standardization," he wrote in 1966, "is the victory of the most probable; art is for the improbable and against the standard." In a 1969 essay on "Art and Scientific Method," he observed that "with the arbitrary and the particular, there can be no 'logical' communication at all, for the arbitrariness of the original experience will not survive a generalization that is necessary for logical communication." If Porter is correct, this may explain why the quickie-unity of late-modern and postmodern art has been such a success among corporate collectors. What, after all, would captains of industry make of the art that Porter preferred—an art whose aim, as Porter said, quoting Wallace Stevens, was "without imposing, without reasoning at all, to find the eccentric at the base of design"?

I do not mean to suggest that corporate standardization is the same thing as the unity that Greenberg celebrated, or that the unity that Greenberg saw in the masterpieces of the past is the same thing as the inscrutable self-sufficiency of the found object. But I do believe that in the minds of the majority of contemporary tastemakers all of this is related. And I cannot avoid the conclusion that a rigid concept of unity that is as old as academic art theory itself has now been resurrected in a particularly pernicious form, a form that fits the art world's no-time-to-wait globalized vision to a T. The people who shape contemporary taste are inclined to believe that if a painter or sculptor pulls them in gradually, incrementally, the artist is probably not really doing much at all. Anyway, they have another appointment.

Even a lively, unstuffy writer such as Dave Hickey, the columnist for *Art Issues,* the hip Los Angeles magazine, seems so pessimistic about finding his

preferred kind of quirky beauty in a painting or a sculpture that he ends up filling his essays with comments on anything but art. Hickey ranges from the Las Vegas show of Siegfried and Roy to old TV programs such as *Perry Mason* to his feelings while he "sat shivah for Chet Baker." I read Hickey's voice of unnervingly sweet sanity as a particularly clever and seductive response to the art world's closed-down horizons. Is there any wonder that people who have lost—or systematically denied themselves—the capacity to see should now talk in a way that is fancifully vague or theatrically over-elaborated? Having convinced themselves that they have nothing much to look at, how could the people who are most involved with contemporary painting and sculpture not be in a state of perplexity—even of downright self-disgust? How could they not feel querulous and belligerent? And if the professionals feel like this, how can we expect the wider audience that goes to galleries and museums to believe that your imagination opens up as the work unfolds in time?

What is so demoralizing about the situation in which we now find ourselves is that the very painters and sculptors who offer us works of art with complicated, multiple points of entry are often rejected as presenting poorly organized, incoherent experiences. Artists who actually attempt to communicate with the audience are now generally the first ones to be dismissed as messy, as emoters—as vulgarians. That may be how many people regard Joan Snyder, one of the very best painters we have. Although the steady stream of visitors to her show at Hirschl & Adler Modern in the spring of 1998 demonstrated that there is still an audience that knows how to look long and hard, I had to wonder when a work as absolutely extraordinary as *A Sad Story Told by an Optimist*, the centerpiece of this exhibition, was passed over by the official art world as a nonevent.

This is a painting in which Snyder rages against order and unity. It's a huge composition—more than sixteen feet wide—full of structures that

are shattered and reconstructed, just barely, before our eyes. This gorgeous three-part invention, with its overall orchestration of lemony greens and cadmium-alizarin-and-pinkish reds, offered an experience so complicated, in so many parts and passages, that a visitor couldn't take control of it; you just had to go with it and see what happened. In the beginning, at the far left of the painting, Snyder is literally tearing things up, as she unglues a corner of a collaged square. The viewer is taken through a series of metamorphoses in this painting, from the dream of absoluteness that is a grid of colored squares, through a chaotic landscape scattered with skull-like masks, and finally into a flowering field. In the center, Snyder punches a hole in the canvas and pulls us down into a slit filled with dark, crushed fabric. There's so much to see. You don't see it all at once.

Much of the power of the painting is in the way that you go through changes with Snyder and find things out in time. Only after a while did I notice, at the extreme lower right, in the midst of all her glorious orchestrations, this shocker: a black handprint and the crudely scrawled word "MOM." Here Snyder is daringly emotional. I would not have thought that an artist could get away with giving an elegy for a dead parent this crude immediacy; but it works because you discover the weight of Snyder's cry for her mother as an undercurrent, like the soprano's last, low moan at the end of a grand aria. Snyder is an artist who wants to communicate on multiple levels. She goes into the whole question of remembering a person and remembering their suffering and their death. She is in search of lost time. And since she believes in the time element in painting, she finds it. But will a public that has been encouraged for decades to swallow art in a single gulp find the time to look at a painting until it begins to reveal its secrets?

To the extent that contemporary artists can make people look longer and harder, they must dare to give their work a complicated openness, a

surprising particularity. Artists have to find ways to pull the audience in, for only when people come to understand that within a painting or a sculpture they can find a time that is outside of time will they want to keep looking. Only then will they see that although nothing in a painting moves—at least in the sense that sound moves in music or bodies move in dance—everything in a painting is alive. And then the surface opens up, and effects multiply, and you see more and more. You enter into an intimate imaginative collaboration with the artist. If the very idea of instantaneous unity comes out of a feeling that in the world things can happen with this much speed, a more circuitous and layered way of looking suggests a release from the compressed, fast-forward pace of daily life, which has always troubled people, and surely does today. If you can unlock a moment, you can enter a realm of freedom. Artists show the way. To look long is to feel free.

ACKNOWLEDGMENTS

The critic who hopes to make a connection between artists and audiences does not work alone. Most of the material in this book appeared originally, in somewhat different form, in *The New Republic*. Leon Wieseltier, the magazine's literary editor, has been unstinting in his support, as has Martin Peretz, the magazine's chairman and editor-in-chief. I would like to thank both Leon and Marty for creating an environment in which criticism can flourish. I would also like to acknowledge the help at *The New Republic* of Ann Hulbert, Melanie Rehak, and Adam Kirsch.

I am glad that John Donatich brought me to Basic Books, where he is publisher. Tim Bartlett, my editor at Basic, has brought his keen intelligence to this book. I'm appreciative of the work of Vanessa Mobley, editorial assistant at Basic. My agent, Jennifer Lyons, has on more than one occasion gone beyond the call of duty.

Deborah Rosenthal, both through her paintings and her thinking about painting, has deeply affected my understanding of contemporary art. I believe that her canvases of the past ten years, especially her variations on the figure of the biblical Eve, are an important part of the story that is told in this book. As we have been married for more than a quarter of a century, I can't take the role of the critic in relation to her work, but I am glad to agree with the critic Lance Esplund, who recently wrote in the English quarterly *Modern Painters*, thinking of the astonishing richness of these canvases, that "each painted world . . . suggests a myriad of possibilities as various as we are."

INDEX

Printed in the United States
40176LVS00002B/229